Architecture
of Greece

Architecture of Greece

JANINA K. DARLING

Reference Guides to National Architecture

David Albert Hanser, Series Adviser

Greenwood Press
Westport, Connecticut • London

Library of Congress Cataloging-in-Publication Data

Darling, Janina, K.
 Architecture of Greece / Janina K. Darling.
 p. cm. — (Reference guides to national architecture)
 Includes bibliographical references and index.
 ISBN 0–313–32152–3 (alk. paper)
 1. Architecture—Greece. I. Title. II. Series.
 NA1091.D37 2004
 720'.9495—dc22

 2004042526

British Library Cataloguing in Publication Data is available.

Library of Congress Catalog Card Number: 2004042526
ISBN: 0–313–32152–3 $49.95

First published in 2004

Greenwood Press, 88 Post Road West, Westport, CT 06881
An imprint of Greenwood Publishing Group, Inc.
www.greenwood.com

Printed in the United States of America

Contents

Entries by Location

Entries by Architectural Style

See the Introduction for descriptions of major architectural styles and periods in Greek history.

Archaic (Circa 600–478 B.C.E.)
Acropolis, Athens
Agora, Athens
Altis, Olympia
Athenian Treasury, Delphi
Sanctuary of Apollo, Delphi
Sanctuary of Hera, Samos
Siphnian Treasury, Delphi
Telesterion, Eleusis
Temple of Aphaia, Aegina
Temple of Apollo Pythias, Corinth
Temple of Apollo Pythias, Delphi
Temple of Artemis, Corfu
Temple of Hera, Olympia
Temple of Hera, Samos

Byzantine
Early (Circa 300s—500s C.E.)
Agia Sofia, Thessaloniki
Agios Andreas, Peristera
Agios Demetrios, Thessaloniki
Panagia Acheiropoietos,
　Thessaloniki

Middle (Circa 800s—1204 C.E.)
Agioi Anargyroi, Kastoria
Agioi Apostoloi, Athens
Katholikon, Daphni
Katholikon, Nea Moni, Chios
Katholikon, Osios Loukas, Stiris
Katholikon of the Great Lavra,
　Mount Athos
Monasteries, Mount Athos
Panagia ton Chalkeon, Thessaloniki
Panagia Koumbelidike, Kastoria

Late (Circa 1261–1453 c.e.)
Agioi Apostoloi, Thessaloniki
Panagia Hodegetria, Mistra
Panagia Parigoritissa, Arta

Classical (Circa 478–337 B.C.E.)
Acropolis, Athens
Agora, Athens
Altis, Olympia
Choregic Monument of Lysicrates,
　Athens

Erechtheum, Athens
House A vii 4, Olynthos
North Suburbs, Olynthos
Panathenaic Stadium, Athens
Parthenon, Athens
Propylaea, Athens
Sanctuary of Apollo, Delphi
Telesterion, Eleusis
Temple of Apollo Epicurius, Bassae
Temple of Athena Nike, Athens
Temple of Hephaestus, Athens
Temple of Poseidon, Sunium
Temple of Zeus, Olympia
Theater, Epidaurus
Tholos, Delphi

**Cycladic Vernacular
(Circa 1500s–1900s C.E.)**

Churches, Mykonos
Houses, Mykonos

Geometric (Circa 1000–700 B.C.E.)

Altis, Olympia
Sanctuary of Hera, Samos

**Hellenic Neoclassical
(Circa 1830–1900 C.E.)**

Academy of Sciences, Athens
National Library, Athens
Observatory, Athens
University of Athens, Athens

Hellenistic (Circa 336–100 B.C.E.)

Agora, Athens

Stoa of Attalos, Athens
Temple of Apollo Pythias, Delphi
Tower of the Winds, Athens

Minoan (Circa 2000–1400 B.C.E.)

Palace of Minos, Knossos

**Mycenaean
(Circa 1500–1100 B.C.E.)**

Acropolis, Athens
Citadel, Tiryns
Palace of Nestor, Pylos
Treasury of Atreus, Mycenae

Orientalizing (Circa 600s B.C.E.)

Sanctuary of Apollo, Delphi
Sanctuary of Hera, Samos
Temple A, Prinias

**Renaissance Revival
(Circa 1900s C.E.)**

Schliemann House, Athens

Roman (Circa 148 B.C.E.–300s C.E.)

Agora, Athens
Mausoleum of Galerius,
 Thessaloniki
Odeum of Herodes Atticus, Athens
Panathenaic Stadium, Athens
Sanctuary of Apollo, Delphi
Telesterion, Eleusis
Temple of Olympian Zeus, Athens

Entries by Time Period

In the following chronological divisions, "Ancient" covers structures built prior to the fifth century C.E., "Medieval" covers structures built between about the fifth and fifteenth centuries C.E, and "Modern" covers structures built or reconstructed since the fifteenth century C.E.

Ancient

Acropolis, Athens (12th–15th centuries B.C.E)

Agora, Athens (6th century B.C.E–2nd century C.E)

Altis, Olympia (8th–4th centuries B.C.E.)

Athenian Treasury, Delphi (5th century B.C.E.)

Choregic Monument of Lysicrates, Athens (4th century B.C.E.)

Citadel, Tiryns (13th century B.C.E.)

Erechtheum, Athens (3rd century B.C.E.)

House A vii 4, Olynthos (5th–4th centuries B.C.E.)

Mausoleum of Galerius, Thessaloniki (3rd century C.E.)

North Suburbs, Olynthos (5th century B.C.E.)

Odeum of Herodes Atticus, Athens (2nd century C.E.)

Palace of Minos, Knossos (17th century B.C.E.)

Palace of Nestor, Pylos (13th century B.C.E.)

Panathenaic Stadium, Athens (4th century B.C.E.; 2nd century C.E.)

Parthenon, Athens (5th century B.C.E.)

Propylaea, Athens (5th century B.C.E.)

Sanctuary of Apollo, Delphi (7th century B.C.E.–2nd century C.E.)

Sanctuary of Hera, Samos (10th–6th centuries B.C.E.)

Siphnian Treasury, Delphi (6th century B.C.E.)

Stoa of Attalos, Athens (2nd century B.C.E.)

Telesterion, Eleusis (6th, 5th, and 4th centuries B.C.E.; 2nd century C.E.)

Temple A, Prinias (7th century B.C.E.)

Medieval

Modern

Preface

The *Architecture of Greece*, one of the Greenwood Reference Guides to National Architecture, is intended for the use of those who are curious about architecture and Greek history. In writing the essays about the buildings, I do not assume that the reader has an extensive background in either Greek history or architecture. Each entry begins with some information that places the building in its historical context—location, architectural style, dates of initial construction and any major reconstructions, and architect(s). This information is followed by a discussion of the building that includes its plan (or design), its appearance, and its particular significance in the history of architecture in Greece. The entry ends with a short summary of what has happened to the building since it was constructed.

As the reader will quickly notice, most of the buildings from ancient Greece are incomplete. This fact makes it necessary to work from ground plans (which are like maps) and from the archaeological record. Things are missing. Often we do not fully know the appearance of the superstructure (upper part) of a building, or we lack information about its decoration. In cases such as these, scholars have arrived at tentative reconstructions—on paper or at the actual sites of the buildings—based on similar buildings, the descriptions of ancient writers, etc. These reconstructions are reliable and have been used in the entries.

In the case of the postantique, or medieval, Greek buildings, the situation is a little clearer. Most of the structures are religious because the Orthodox faith was the dominant force in Greece while it was part of the Byzantine Empire. The churches have been damaged by fires, earthquakes, rebuilding, and other vicissitudes over the centuries, but most are essentially intact. In many cases there is little or no documentation to provide information about the founding and construction of a church. And occasionally the experts disagree on some details, such as roofing designs and additions or rebuilding. In

these cases, I have followed the majority opinion. Finally, since the churches were turned into mosques during the Turkish occupation of Greece, many lack a good deal of their original decoration. Only in the nineteenth century do we have plentiful information about the buildings and the architects who designed them.

These drawbacks notwithstanding, there is still a great deal to learn from the study of Greek architecture, as I hope the entries will make clear. A few words about the technical organization of the book are necessary here. The entries are arranged in alphabetical order by the name of the building or sanctuary. Each entry is an essay that is complete in itself. However, in many instances the building discussed will be related in one way or another to others in the book. To make the connections clear, the names of the related structures that are covered in the entries are set in **boldface** type as a cross-reference to the related entry. As further aids to making connections and finding information, *Architecture of Greece* also includes a detailed subject index and three lists that categorize entries by location, architectural style, and general time period.

Technical terms, although kept to a minimum, could not be entirely eliminated. In general, they are defined when they first appear in an entry. I have used the Latinate spelling for as many names as possible. However, there are cases in which the original Greek is generally accepted in English writing, and there are other cases in which Latinate spelling would distort the name and make it difficult to comprehend. In these cases, I have kept the Greek spelling. For the Orthodox churches, I felt that removing the names from their original language was damaging to the aura and mystery of the buildings. Hence, "Saint" is rendered as "Agios," "Agioi," or "Agia" depending on gender and number. Titles or popular names given to the Byzantine churches are explained in the entries.

A few words of explanation are also necessary for the Introduction. I urge readers to at least skim through it, because it contains important information that will make the entries more comprehensible. For example, rather then define and describe the Greek orders in almost every entry about ancient buildings, I have placed the information in the Introduction. The Introduction also includes discussions of the most important church plans and other aspects of Greek history and architecture.

In the sections of the Introduction dealing with ancient Greece, I have used the names "Hellas," "Hellenes," and "Hellenic" in place of the usual "Greece," "Greeks," and "Greek" because these are the words the ancient occupants of what is now Greece called their country and themselves. I change to "Greek" with the advent of the Romans, when this name was given to the Hellenes by outsiders. For the benefit of those who do not read the Introduction, I use "Greek" and "Greece" in the entries.

Because considerations of space and cost limited the number of illustrations and called for black-and-white reproduction, I urge the reader to consult the books and web sites listed in the "Further Reading" sections following the entries and in the Bibliography at the end of the book. The Internet is also a

marvelous resource for verbal descriptions of many of the buildings included in this book as well as for photographs of the structures. The Perseus Digital Library, at www.perseus.tufts.edu, is excellent for all things Greek and a lot of things Roman as well. The *Perseus Building Catalog* (www.perseus.tufts. edu/cgi-bin/ptext?doc=Perseus%3Atext%3A1999.04.0039 [Click on table of contents]) will be most helpful, as will its online version of the *Princeton Encyclopedia of Classical Sites* (www.perseus.tufts.edu/cgi-bin/ptext?doc=Perseus%3Atext%3A1999. 04.0006). Greece has some fine cultural Web sites that are worth consulting: the Hellenic Ministry of Culture at www.culture.gr/home/welcome.html and Macedonian Heritage at www.macedonian-heritage.gr are particularly good. Finding the buildings on these sites takes a little effort because of the way they are listed, but it is effort well spent. For nineteenth- and twentieth-century architects, the European Union's Culture 2000 program at www.culture2000.tee.gr is extremely useful, with good photos and descriptions of architects' work. The Google search engine at www.google.com has listings for almost every building in this book, but the quality of the articles and photographs varies from very good to useless.

The buildings in the entries span many centuries, so the designations B.C.E. (B.C.) and C.E. (A.D.) are important. To avoid tedious repetitions of these indicators, I have done the following: the first date in the entry is in the citation at the top of the page. If this is B.C.E., all dates following it are B.C.E. When buildings have a long history and the dates change to C.E., that designation will be noted in the first instance and all following dates will be C.E.

Finally, all measurements are approximate. Most have been rounded off to avoid fractions. The dimensions are principally for the purpose of giving the reader a general idea of the size of each building. In some cases dimensions were impossible to find, so they do not appear in the entries.

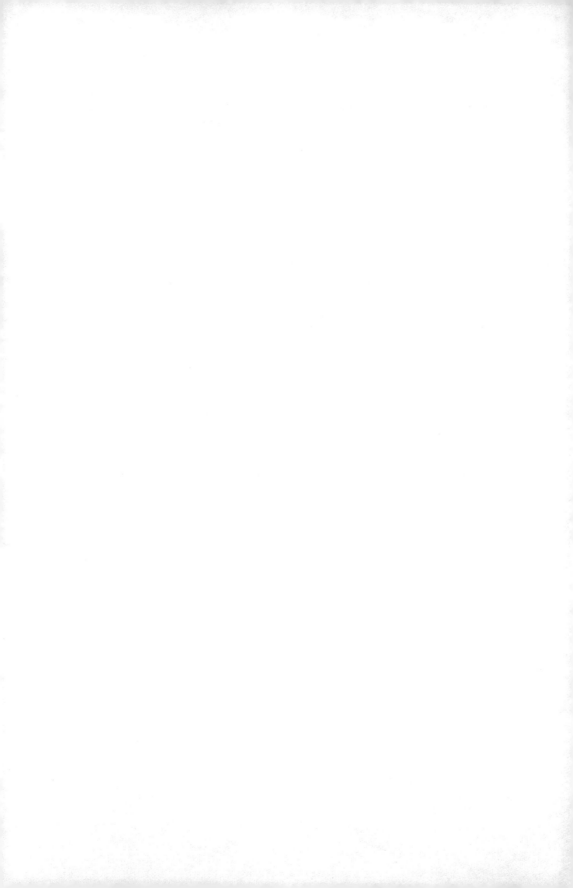

Acknowledgments

Like every writer, I have benefited enormously from the help and interest of friends, colleagues, and family members. My husband, Jeff C. Morriss, supported this work financially as well as intellectually and provided much-needed help with computer problems. He took over many of my usual duties so that I could devote my time to research and writing. While I was in California for three months teaching at UCSC and working on this book, Jeff made sure that everything I needed was provided. My son, David, gave me a place to stay in California and took me out for outstanding Asian cuisine when I needed a break.

The accumulation of affordable illustrations for any book is a difficult and time-consuming process. I owe an enormous debt of gratitude to Caroline Buckler, who not only donated her own photographs but also transformed those of others into images suitable for publication. Caroline is a wizard when it comes to restoring and reformatting photographs, and she did all of the work without gratuity. Her love for the field and the opportunity to contribute to Greek architectural studies is, she maintains, her greatest reward.

A friend for more than thirty years, Dr. Judith Snyder Schaeffer, a woman of many talents and great intellect, provided her personal photographs of many of the ancient monuments. Dr. Jennifer Tobin was kind enough to send me images of buildings from her excellent book *Herodes Attikos and the City of Athens*. I am grateful to Drs. Lisa Heer and Susan Petrakis for putting me in touch with Dr. Tobin. "Griff" Griffey, an accomplished amateur archaeologist and world traveler, courteously offered some of his photographs and video stills. San Francisco architect Michio Yamaguchi shared opera, great dinners, and his very fine slides of several buildings. And the late John Kurtich of the Art Institute of Chicago allowed me to include two of his photographs of buildings in Athens.

I especially appreciate the help of Carol Hershenson, of the Department of Classics at the University of Cincinnati, for granting permission to publish the

beautiful reconstruction of the throne room of the Palace of Nestor by Piet de Jong. The Numismatic Museum in Athens was particularly helpful in sending me information about Schliemann's Iliou Melathron, which has been beautifully restored.

Quite a few people took the time to read various entries and to comment on them. All were very encouraging, and I wish to thank them here. Michael Bullard, a gifted communicator, offered strong editorial suggestions. Dr. Virginia Jansen commented on the nineteenth-century buildings with her usual astuteness and intellectual rigor. Dr. Karen Matthews not only read numerous entries but also suggested contextual material that drew my attention to some subtle aspects of the interior decoration of Byzantine churches. Sister Maenad Dr. Frances Hatfield—poet, scholar, and healer—experienced the Delphi of my imagination and continues to wander with me through the Labyrinth in search of ancient numina. Finally, my beloved teaching assistants, Jordan Rose and David Jacobson, took time away from their studies in London and Rome, respectively, to scrutinize the tone of the entries and to offer incisive comments about details and terminology suitable for the intended audience.

Encouragement from close friends kept the work steady and helped to maintain my engagement with the world beyond Greek architecture. Dave Morton elevated my spirits with his positive outlook on life and wonderful messages from his Etruscan explorations in Italy. Victoria Edgell was always there to share polenta and offer a logically grounded and sensible view of antiquity. Dr. Richard Jensen, fellow Fulbright and Italophile, introduced me to the gracious hospitality of Louisiana culture as a break from my work. Dr. John Hay and Susan Young provided joyful conversation and fine cuisine while I was working in Santa Cruz.

Since this book is intended for amateurs and nonspecialists, I am most appreciative that my father, Fred B. Kacena, read and then circulated entries to his friends who are interested in archaeology. I wish to thank two of these gentlemen: Ron Brown and Bob Young. As always, my sister, Marianna K. Dyal, was unwavering in her support of my work.

I am grateful for the intellectual sparring with series adviser Dr. David A. Hanser. Both he and my editor at Greenwood, John Wagner, demonstrated great patience in putting up with my interminable questions about format and illustrations. I thank them for that and also thank my copy editor, M. Yvonne Ramsey.

My closest companions day to day, after my husband, were my friends Major and Tosca. These beautiful and affectionate Maine Coon cats tolerated the lack of my usual attention with typical feline grace and condescension.

Finally, I am forever indebted to my outstanding teachers of many years, Dr. Ann Perkins and Dr. Minerva Pinnell. They taught me the rigors of scholarship, writing, and research—and were always incredibly supportive of me, both professionally and personally.

All errors and omissions are my own.

Introduction

This is a book about fragments. Like the Greek statues we see in a museum, there are bits and pieces missing. Sometimes only a nose is lost, so we can get a good sense of what the artist created. But just as often only a torso and an arm remain of something that was once truly beautiful. Appreciating the value and humanity of fragments requires thoughtfulness and imagination.

Beginning in the eighteenth century, scholars were confident that they could understand and reconstruct ancient Greek culture. Now, we realize that Hellas (Greece) is an elusive entity and that the picture we have constructed of the Hellenes is both biased and incomplete because it is based on the chance survival of bits and pieces of material culture and fragments of texts written by a thin stratum of Hellenic society. Similarly, it is difficult in our secular and positivist culture to understand the mysticism and religiosity of the Byzantine Greeks. How are we to interpret reports of an emperor whose throne hovered in midair while mechanical lions and birds roared and sang? Our knowledge and interpretation of these two cultures is compromised by both the limitations of our cultural biases and the fragmentary nature of the evidence.

In contrast to Italy, where much remains to be seen of Greek, Roman, Medieval, Renaissance, and Baroque architecture, the outstanding architectural achievements found in Greece are frequently damaged or in ruins. This is because the country has suffered enormously from a lack of unity as well as political strife, invasion, religious controversy, earthquakes, poverty, and occupation. The incomplete state of the ancient buildings is also related to the great shift from paganism to Christianity that occurred in the early centuries c.e. During the Byzantine period of the Middle Ages, the Greeks came to think of themselves as Christians, not Hellenes, and they forgot the world of Homer, Pericles, and Plato.

Major architectural monuments are symbols of culture and, as such, are vulnerable to vandalism and destruction by outsiders and conquerors, and by

adherents of conflicting faiths. Pagan temples meant little to Byzantine Christians, so they were either deserted and left to ruin or were turned into churches. During the Ottoman domination, Christian churches became mosques and their exquisite mosaics and majestic paintings were whitewashed or covered with plaster. In each stage of culture, something was lost—something of the original intent of the builders disappeared or was hidden from ordinary observation. Only fragments remained.

Yet, despite all this, or perhaps in spite of it, the modern Greeks have a sense of cultural unity that is based largely on language, folk traditions, the revival of their ancient heritage, and their Orthodox faith. These things are the bonds that unified the Hellenes and that still bind the fragments of Greek civilization together into a vibrant whole. They are the source of the intense loyalty of the Greek diaspora and the inspiration for the modern Greek state.

In *Architecture of Greece*, I present a group of fragments that trace the architectural history of Greece as we understand it in the twenty-first century. Each fragment is worth study in its own right, but when the fragments are assembled in a group, like a mosaic, they provide an idea of the diversity that characterizes the history of built culture in Greece. Of course, the selection is subjective and one may question my process. I have attempted to present monuments of architecture that express aspects of Greek history and culture at different times and in a variety of places. I hope this selection will coalesce into a satisfactory general overview of Greek civilization and its artistic production.

Geography of Greece

Greece is a small country with a land mass of 50,944 square miles located at the southern end of Europe's Balkan Peninsula. To the north, Greece's neighbors are Albania, Yugoslavia, Bulgaria, and the European extension of Turkey. By far, the greater part of the country is surrounded by water—Homer's wine-dark sea. In addition to 9,300 miles of coastline, Greece also includes more than three thousand islands. Mountains extend in complex patterns throughout the country and the seabed, separating valleys and coastal plains from one another and forming islands. In all, two-thirds of the land mass is mountainous as a result of the upthrusting and downfaulting of the continental plates, a process that has continued from early geological times. Throughout its history, Greece has suffered from destructive earthquakes caused by the friction of the African, Aegean, and European plates that converge in the eastern Mediterranean.

Greece is divided into three distinct areas by the mountain chains and the sea: (1) the mainland, which is part of the Balkan Peninsula; (2) the Peloponnesus, a hand-shaped land mass attached to the mainland by an isthmus; and (3) the islands that form a chain from Crete to the western coast of Turkey. But the mountains and sea were not simply divisive; it might be said that they

provided the Greeks with the materials and mobility that fostered the development of their unique culture.

Greece in the Bronze Age (c. 2000–1000 B.C.E.)

The earliest Bronze Age culture in Greece flourished in the islands. In a relatively secure and fertile area on the north side of Crete, the settlement at Knossos developed into the largest of the island cities. Sir Arthur Evans, who excavated the **Palace of Minos** at Knossos in the early twentieth century C.E., named the culture Minoan after the legendary King Minos, son of Zeus and ruler of a vast maritime empire.

Minoan economic power was based on trade and on the production of pottery and luxury goods for export. The palaces on Crete were actually economic centers where commodities were manufactured, stored, and distributed. They also served as the sites for religious activities and festivals and for political assemblies. Because of fires and earthquakes, the palaces were frequently damaged and rebuilt. This circumstance makes the archaeological reconstruction of Minoan chronology difficult because evidence for absolute dates is lacking. Historians generally agree that the mature Minoan culture extended from around 2000 to around 1400 B.C.E. when invaders from the Peloponnesus seem to have seized Knossos and taken over administration of the island. Between 1400 and 1375, Knossos and several other smaller palaces were destroyed and the Minoan culture more or less disappeared.

The invaders who took over Knossos were the Mycenaeans, the second Bronze Age culture in Greece. Heinrich Schliemann named this culture after the citadel of Mycenae, which he partially excavated between 1874 and 1876 C.E. The tombs at Mycenae contained precious grave goods, including the famous gold Mask of Agamemnon. Mycenaean skill in engineering is demonstrated in the **Treasury of Atreus**.

Usually identified as the first Greeks, the Mycenaeans were warriors and traders who gradually took over the Minoans' commercial routes and island outposts. By the fourteenth century B.C.E., they were the strongest power in the Aegean region. This dominance eventually brought them into conflict with a trading community on the coast of present-day Turkey called Troy, which Homer memorialized in the *Iliad*.

Mycenaean culture was organized in a feudal system in which lords or princes ruled the surrounding countryside populated by their subjects. Instead of the colorful open places of Crete, the Mycenaean prince lived in a strongly fortified citadel usually located on top of an easily defensible ridge or outcropping. The **Citadel** at Tiryns, with its massive walls and complex entryway, is typical of Mycenaean architecture.

Within the citadel were residential quarters, workshops, and storage areas. In contrast to the Palace of Minos and other Minoan compounds, there seem

to be only a few indications of spaces set aside for purely religious activities. Instead, at the heart of the citadel is the megaron, or king's hall, a lavishly decorated space in which the lord of the community carried out the business of administration, entertainment, and politics. The megaron of the **Palace of Nestor** at Pylos in the western Peloponnesus had extensive wall paintings and a plaster floor painted with decorative motifs. Pylos is unusual in its lack of fortifications, but the layout of rooms is typically Mycenaean. Especially interesting at Pylos are the inventory inscriptions and the thousands of pottery cups and vases (most likely made for export) found stored in several rooms.

In the twelfth century B.C.E., the Mycenaean civilization went into a serious decline. The reasons for this are not fully understood, but economic collapse, earthquakes, competition and conflict among princes, and environmental changes have all been proposed. Whatever the causes, the Mycenaeans were weakened and were thus vulnerable to invasion from the north. The Dorian Invasion marked the end of Mycenaean culture. The great citadels were destroyed, except at Athens, and the Greek Dark Ages began. Many people fled from the Dorians and founded the Ionian colonies on the west coast of Turkey. In Greece, poverty and diminished material life were the norm. Technologies were forgotten, and there was no architecture. Contact and trade with neighboring communities and the Mediterranean world ceased, and the art of pottery making deteriorated to a low level of competence.

The Geometric Period (c. 1000–700 B.C.E.)

Because of the lack of absolute dates, art and architectural historians have divided ancient Greek history into a number of periods. These divisions are based on stylistic developments in the major arts and provide a convenient relative chronology when an absolute chronology is not possible. The three centuries after the Dark Ages are called the Geometric period because pottery decorated with geometric motifs is the outstanding art form.

The Geometric period saw Greece emerge from the Dark Ages and begin the formulation of a society and culture that can be recognized as specifically Hellenic (the ancient Greeks called themselves Hellenes). Pottery thrown on the fast wheel was introduced; metalworking was revived; and commerce, especially the export of vases, began again. Populations spiked as improved agriculture and settled living conditions prevailed. As with all ancient cultures, the economy was based primarily on agriculture, so society was divided between an aristocratic class that owned the most, and best, land and the small farmer. Aristocrats ruled the community and displayed their wealth and power with elaborate funeral celebrations and grave markers. Towns were formed, and artisans left the land to ply their trades in a proto-urban environment.

The most significant development of the Geometric period was the institution of the polis, or city-state, in the middle of the eighth century. A polis was an independent political entity that had its own institutions and had citi-

zens who could trace their families back for generations to the foundation of the community. Ancient Hellas would not become a single political entity until it was forced to do so late in its history. Because of the institution of the city-state, the Hellenes would spend much of their history engaged in wars that pitted one polis against another or one league of city-states against another.

Even though rivalries were sometimes fierce, all the Hellenes felt a special kinship with one another. This unity was based on the commonalities among the Hellenes, most notably their religion and their language. These two institutions emphatically differentiated Hellenes from all other people in the world—to be a non-Hellene was to be a barbarian, or one whose speech is garbled. Cultural cohesion among the Hellenes was also fostered by the institution of the Olympic Games in 776 B.C.E. Every four years, men from all the communities would gather in the **Altis** at Olympia to honor the gods with athletic competitions. The joining together in sport reinforced the spirit of commonality and encouraged the exchange of ideas.

Architecture was rediscovered in the Geometric period mostly in the service of religion. Early on, worship occurred outdoors in simple sanctuaries that were marked off from daily life and the profane earth by a surrounding wall. There was no temple, just an altar in the center of the sacred space. At some time during the Geometric period it was deemed necessary to build a house for the god that would be included in the sanctuary.

Evidence for early temples is sparse, but some can be plausibly identified from the eighth century. They have various shapes that suggest experimentation in design. All were made of sun-dried brick with stone foundations and thatched roofs. The elongated apsidal temple, such as that of Hera Akraia at Perachora, faced east and had a flat facade, long straight flank walls, and a west wall that was curved into a semicircle to form an apse. At the Sanctuary of Artemis Orthia near Sparta, there was a temple house that had porches supported by columns at the corners and a rectangular cult room with wood poles to support the ridge beam of a steeply pitched roof. Although the date is controversial, many scholars include the **Temple of Hera** at Samos in the late Geometric period (see **Sanctuary of Hera**). Its conversion from a simple long, narrow room with columns down the center to a colonnaded building was innovative and set the generic temple plan for future religious architecture.

Orientalizing Period (Seventh Century B.C.E.)

This century or so of Hellenic history takes its name from the influx of goods, technologies, and artistic styles from the Near East. As trade expanded and there were surpluses of exportable materials, the Hellenes began to import luxury items from workshops in the eastern Mediterranean. The polis of Corinth became an important and wealthy commercial center because it controlled traffic to and from the western Mediterranean across the isthmus that connected the Peloponnesus to the mainland. Other city-states set up trading

depots in Egypt and on the Levantine coast. Hellenic soldiers went to Egypt as mercenaries, and there they saw enormous stone buildings and monumental sculpture. This was also the time when the Hellenes founded colonies in Sicily, southern Italy, and the Black Sea region.

Politically, the seventh century was a time of turmoil when the aristocrats who had previously controlled the polis were challenged by the lower orders of society. This shift in power is usually attributed to a change in military organization resulting from the development of the hoplite. Hoplites were citizen-soldiers armed with breastplates, grieves, helmets, swords, spears, and large shields. They were organized in a tightly cohesive formation called the "phalanx." In the Geometric period, the aristocrats had controlled warfare by leading their own dependants into battle. They had the finest armor, while many of the lower-class warriors had none at all. The hoplite phalanx changed this system. Now all soldiers had the same armor and a common position within the phalanx. Aristocrats fought next to common men and thus lost some of their monopoly on political power.

The seventh century also saw the rise of a new form of government—the tyranny—in a number of city-states. In Greek, the word "tyranny" does not carry the negative connotations that it does in English, but rather means something close to "the big man." The earliest tyrants were those of Corinth, most importantly Cypselus and Periander, but the idea of tyranny spread quickly to other communities. Tyrants were good for the arts. They sponsored architecture and sculpture and encouraged artisans such as vase-painters and metalworkers to produce high-quality objects for export.

There was much experimentation in architecture in the seventh century B.C.E. Builders were inspired to begin building in stone using the post-and-lintel system. This is a method of building that uses vertical posts, or columns, to support horizontal beams, or lintels. Architects did not directly copy Near Eastern and Egyptian forms but instead formulated structures appropriate to Hellenic institutions. **Temple A** at Prinias represents a fusion of the ancient megaron plan with sculpture inspired by Eastern examples. The **Sanctuary of Hera** on Samos is the first Hellenic sanctuary to be formally laid out, and it contained a prototypical stoa (covered, colonnaded walkway). Orientalizing was an important process in Hellenic art and architecture, providing new designs, building materials, and construction techniques that would be the foundation of Archaic architecture.

Archaic Period (c. 600–478 B.C.E.)

The Archaic period was an exciting time in the history of Hellenic art and architecture; it combined conservative types with an increase in technical skill and the observation of nature. Decoration and linear details were plentiful, and both sculpture and architecture were brightly painted. Freestanding stone statues of young girls and adolescent boys, called *korai* and *kouroi*, served as

grave markers or as votive gifts given to the gods by men. Sculpture was now regularly applied to religious buildings such as the **Temple of Artemis** at Corfu and the small treasury buildings found in major Greek sanctuaries (see **Siphnian Treasury** and **Athenian Treasury**). Marble was now the building material of choice in the islands and the eastern Greek city-states, but on the mainland and in the Peloponnesus, limestone was most common. In Athens, potters developed elegantly shaped vases that were decorated with beautifully drawn narrative subjects by professional vase-painters. The Hellenes were the only artists in antiquity to represent stories on their pottery.

The flourishing of architecture and the visual arts in the Archaic period was largely the result of the civic pride of the city-states and the support of leaders of the communities, many of whom were tyrants. For example, Polycrates of Samos, known for his extravagant court, initiated the construction of a temple to Hera on his island that would be the largest temple in the Greek world (see **Temple of Hera, Samos**). Solon, the leader and lawgiver of Athens, began the organization and development of the civic space called the **Agora** to foster community relations and provide a spacious marketplace. When Pisistratus became tyrant of Athens, he funded new buildings on the **Acropolis** and further developed the civic structures in the Agora.

Although temples represented the greatest financial investment for a city-state, they became increasingly numerous. At Corinth, the **Temple of Apollo Pythias** was one of the first buildings in Hellas to incorporate a series of optical refinements, which are very fine adjustments in dimensions. At Aegina, the relative proportions of columns to superstructure in the **Temple of Aphaia** were adjusted to make the building appear lighter and less ponderous than other Archaic temples. Optical refinements such as these demanded precise craftsmanship that increased building expenses but were considered necessary to perfect the appearance of the temple. As the house of a god, the temple must be without flaws.

In the various all-Hellenic sanctuaries, political conflict within a polis or among city-states could manifest itself in buildings. One aristocratic family exiled from Athens offered to rebuild the **Temple of Apollo Pythias** in the **Sanctuary of Apollo** at Delphi in exchange for the priests' political support for the family's return. Control of Apollo's sanctuary was constantly contested. The first in a series of Sacred Wars over the site was fought early in the Archaic period.

The most important events at the end of the Archaic period were the foundation of Athenian democracy in 508 and the Persian Wars. In 545 the huge Persian Empire had taken over the Hellenic city-states on the west coast of Turkey. Some of these communities revolted in 499 with the aid of Athens. In revenge, the Persians invaded Hellas in 490 but were repulsed by the Athenian hoplites at Marathon. This Persian attack was the first invasion of Hellas since the end of the Bronze Age. The Persians returned in 480 and sacked the Athenian Acropolis. Victories by Athens in 480 and by a league of Greek city-states in 479 ended the conflict with Persia.

Aesthetics of the Greek Temple

For the Hellenes, religion had a sense of place. Sanctuaries were located at places in the landscape that had some primal relationship to the divine. Sometimes, as in the **Sanctuary of Apollo** at Delphi, a steaming chasm or some other geological feature might signal the presence of a deity. In other instances, like the Sanctuary of Apollo near the **Katholikon of Daphni,** a tree or grove of trees suggested that a god was nearby. Myths often relate the importance of a place to a god or goddess who has left a sign, such as Athena's olive tree and the marks from Poseidon's trident on the Athenian **Acropolis**.

Once the sanctuary was identified, an altar was set up for the sacrifices that were central to worship and votive offerings were left for the god. Often a wall was built around the holy place to keep it secure from unwanted intruders or those who were not ritually pure. Worship was conducted outdoors.

At some time in the late Geometric period, the Hellenes began to build temples, which they called "homes for the gods." The temple was not involved in the sacrifices and other rituals that continued to be enacted outdoors. Traditionally, the building was oriented in an east-west direction with its entrance on the east and its closed-off back to the west. A cult image "lived" in the temple and was placed at the west end of the interior space across from the entrance door, which was the only source of light. Very little illumination was actually necessary since the interior of the building was visited only by priests who tended to the cult image.

The lack of utilization of the interior of the building is the most likely reason that a Greek temple is designed to be experienced from the outside. Like a piece of sculpture, the visitor to a sanctuary would admire the exterior of the home of the god by walking around it. When it was time for the sacrifice(s), the eastern facade of the temple formed an impressive backdrop behind the altar. Sometimes the sculpted decoration on the facade represented a myth that warned mortals about their weakness in the face of divinity. The vertical columns, pointed roof, facade finials, and smoke from the altar fire led the eye upward toward the heavens, where the gods inhaled the fragrance of the meat being roasted below. In front of the temple was the place where the awesome transition, the negotiation, between the human and the divine took place.

Plan and Elevation

The Hellenic temple was traditional and changed little over the centuries. Its plan originated during the late Geometric period and was well developed by the beginning of the sixth century B.C.E. Scholars have suggested that the plan was derived from the Mycenaean megaron, or king's hall, but recent scholarship has called this hypothesis into question. Whatever its source, the temple is basically a long hall surrounded by a colonnaded walkway. The evolution

from simple hall to colonnaded building can be observed in the history of the old temple in the **Sanctuary of Hera** at Samos.

A canonical temple plan is based on a series of straight lines and right angles. The structure is usually a long rectangle with a solid base, or platform, of three steps. A long hall—the cella (or naos)—occupies the center of the platform. This is the cult room where the image of the god makes its home. The walls are solid masonry without windows of any kind. At the east end of the cella is the single entrance door. Two porches are formed by extensions of the long flank walls with an even number of columns (the number varies) between them. The porch on the east end is the pronaos, while the back porch, which has no access to the cella, is the opisthodomos. Its purpose seems to be only to balance the pronaos so that when divided in half transversely, the plan is symmetrical. The core of the building is surrounded by a portico, or covered colonnade; its roof is an extension of the one that covers the core. Usually the number of columns on the flanks is twice plus one the number on the front and back. These numbers allow the viewer to comprehend the proportions of the building, which are 1:2+1.

The temple plan just described is peripteral, which means that it is surrounded by a single row of columns. But there are other options for the arrangements of columns. One is the dipteral temple, which has a double row of columns arranged around the core. A prostyle building has columns only across the front, while an amphiprostyle structure has a colonnade on the front and back but none on the sides.

The elevation of a building is the appearance of its external faces. Because Hellenic temples were built in the post-and-lintel system, the elevation emphasizes vertical and horizontal elements joined at right angles that are crowned by the diagonals of the gabled roof. The base of the building is a

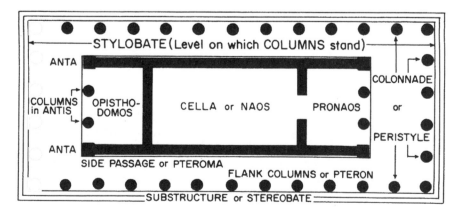

Plan of typical Greek temple with parts labeled.

stepped platform; its top step is called the stylobate. Resting on the stylobate are the columns that support the superstructure (upper part) of the building. The superstructure is divided into two horizontal zones: the architrave (a continuous line of lintels), and above this the frieze. Visually, the architrave and frieze are continuous horizontal bands that wrap around the temple, but structurally they are made up of many long narrow rectangles of stone that are held together by metal clamps. A strong molding runs along above the frieze and forms the base of the pediment. This is a long low triangle formed by the eaves of the gabled roof. On the flanks, the elevation of the temple is the same as that of the front and rear facades, but it lacks the pediment.

The Orders

Orders are systems of design and decoration of the parts of the temple. There are three orders: Doric, Ionic, and Corinthian. Doric seems to be the oldest of the orders and is the most frequently used for temples in the mainland and the Peloponnesus. In antiquity, it was considered the masculine order because it projected an image of strength and sobriety. Its restrained austerity can be appreciated in the **Temple of Hephaestus** at Athens.

In the Doric order, the column is made of several sections, or drums, and stands directly on the stylobate. The column has a series of vertical grooves, or flutes, cut into its surface and tapers toward the top where it joins the capital, which consists of the echinus, a circular cushionlike member, that supports a square block known as the abacus.

Resting on the capital is a plain undecorated architrave, or lintel. Above the architrave is the Doric frieze, a horizontal band that is composed of alternating triglyphs and metopes. Triglyphs are rectangular blocks with three vertical grooves cut into them, and metopes are flat panels that can be plain or can carry paintings or relief sculpture. The triglyphs are distributed around the building in a precise system. There must be one over each column, one over the center of the space between columns, and one at each corner.

Above the Doric frieze is the horizontal cornice that is made up of several decorated moldings. The cornice forms the base of the pediment—a long low triangle formed by the sloped ends of the gabled roof. Moldings called raking cornices are attached to the edges of the eaves and form the upper borders of the pediment. Pediments frequently contain elaborate groups of statues that illustrate myths associated with the god to whom the temple is dedicated. Color was applied to the parts of the superstructure and the statues in the pediment, but little of it has survived. Red and blue predominated and served to accent various parts of the building, such as the metopes and some moldings.

The Ionic order differs from the Doric in decoration and column design. Instead of resting directly on the stylobate, Ionic columns have circular bases with several tiers of convex and concave moldings that can be elaborately carved with decorative patterns. Unlike Doric columns, where the flutes on the shaft meet at a sharp angle, the flutes on Ionic columns are separated by

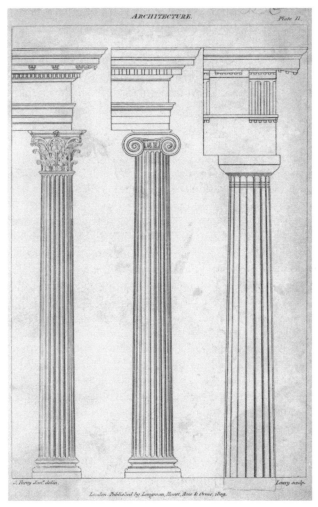

The three orders of Greek columns (from left to right)
Corinthian, Ionic, and Doric. © *Bettmann/Corbis*.

narrow flat bands. Ionic capitals have a pair of volutes, or scrolls, on the front
and back above a band of decorative patterning. The architrave is divided into
three horizontal bands, each projecting slightly beyond the one below. Finally,
instead of triglyphs and metopes, the Ionic frieze is continuous and is fre-
quently decorated with relief sculpture. For the Hellenes, the Ionic order was
a feminine style because of its grace and delicate ornamentation. The **Tem-
ple of Athena Nike** in Athens is one of the most beautiful examples of the
Ionic order.

Hellenes did not use the Corinthian order very frequently. Corinthian is a
variation on the Ionic that was used for the first time in the **Temple of Apollo**

Epicurius at Bassae in the late fifth century. Later on, Corinthian appears on the exterior of the **Choregic Monument of Lysicrates** in Athens. The order became more popular in the Hellenistic era but was most appreciated by the Romans, who had a taste for heavy and elaborate ornamentation on their buildings. Column capitals are the major feature of Corinthian. They are lush and elaborate with attenuated volutes and floral forms arranged above bands of acanthus leaves.

Optical Refinements

The Roman architect Vitruvius preserved in his book *On Architecture* information about how to make a Hellenic temple "look" perfect. He described a series of deviations from strict geometry and measure that are intended to give the building an internal dynamism and to correct for visual distortions produced by its large scale and the surrounding light conditions. Vitruvius's sources were Hellenic treatises on architecture, and the remains of some Hellenic temples, most notably the **Parthenon**, confirm that the temples' designers intentionally introduced numerous adjustments, or optical refinements, into their buildings.

As noted above, the temple is based on horizontal and vertical lines and right angles. But for some reason not fully understood, the human eye tends to distort these pure orientations when looking at architecture. For example, long horizontal lines seem to sag in the middle. To compensate for this, the stylobate of a Greek temple is gently bowed up toward the center in both directions from the corners. Once this curve is introduced, all the other elements of the building have to be modified. Every horizontal line in the superstructure has to parallel the curvature of the stylobate.

Since vertical lines appear to distort concavely, the columns have entasis—a slight convex curve, or bulge, that is introduced into their vertical contours. Variations in normal dimensions are also found in the columns. Because the ones at the corners of the building are illuminated from two sides, they tend to appear weak and thin. To compensate for this distortion, the corner columns are thicker than the others in the colonnade. Another method for visually strengthening the corners of a temple is angle contraction, in which the last two columns at each corner are placed closer together than their neighbors. In some instances, double angle contraction, in which the narrow space between the columns is repeated, occurs. With the exception of the **Temple of Hera** at Olympia, double angle contraction is confined to the Greek temples of Sicily.

To make the temple appear stable with truly vertical lines and planes, a series of inclinations are consistently carried out throughout the whole building. The columns lean slightly inward toward the cella, while above them the entablature is also inclined inward. Inside the colonnade, the walls of the cella also lean inward.

Symmetria, or the commensurability of parts, is also an important part of the design of a Hellenic temple. An ideal interrelation of the size of the component parts to one another and to the whole was considered necessary to achieve a harmonious and totally unified composition. Exactly how the ratios of the parts were determined is still the subject of much discussion among scholars. Some advocate an arithmetical system, while others believe that the key to symmetria is geometry. In many examples, the radius of a column seems to be the module from which all the other dimensions of the temple are determined.

Constructing the optical refinements in a Greek temple was expensive and labor intensive. But such corrections for the fallibility of the eye or of human perception were obviously of special concern to both architects and patrons. Famous architects such as Ictinus of Athens and Rhoecus of Samos wrote books about their temples that presumably addressed the issue of refinements and explained the theory behind it.

Classical Period (c. 478–337 B.C.E.)

The first fifty years of the classical period have been considered the apogee of Hellenic culture. It was a time in which Athens saw itself as the leading polis in Hellas as it transformed its league of allied city-states (formed to fight the Persians) into an empire. Athenian naval power was supreme and was used to extort tribute from the allies that would eventually be used to rebuild the **Acropolis** some thirty years after it had been sacked by the Persians. Great optimism and a surge of creativity followed the defeat of the foreign invaders, who were characterized as less than human barbarians who had been conquered by the civilized Greeks.

A new, more natural style of sculpture was created, and bronze casting reached a high level of refinement. Pindar composed his famous victory *Odes*, while Aeschylus and Sophocles vied for first prize in the dramatic competitions in the Theater of Dionysos. The Sophists taught that "man was the measure of all things" and elevated rhetoric to a high art.

Architecture of the first part of the classical period was not greatly innovative. Instead, architects concentrated on refining the details and proportions of the Doric order. Stoa designs were elaborated, and their potential as framing elements for urban spaces was discovered. The most imposing monument was the **Temple of Zeus** at Olympia, the largest temple in the Peloponnesus.

About thirteen years after the construction of the Zeus temple, Pericles decided to rebuild the ruined **Acropolis** at Athens, where the art and craft of architecture attained such a high level of excellence that many consider it to be the finest work in all of antiquity. Four major structures of the classical period crown the Acropolis: the **Propylaea**, the **Parthenon**, the **Temple of Athena Nike**, and the **Erechtheum**. Made of gleaming painted and gilded Pentelic marble, these four buildings, some bearing elaborate sculpture, express the

prosperity and optimism of a polis entering its golden age. The architects of the Acropolis program employed optical refinements to an extraordinary degree and introduced the mixing of the orders (Ionic and Doric) in a single building. Pericles intended that the Acropolis should be a symbol of Athenian superiority, and so it has been for more than two thousand years.

During the period of Athens' domination of the Aegean, relations with the land power Sparta were frequently tenuous. Sparta and her allies were uneasy with expanding Athenian power, and a major clash between the two city-states became inevitable. The first Peloponnesian War (461–451) ended in a fragile truce. A second Peloponnesian War began in 431 and lasted for ten years. During this conflict, Athens was devastated by plague in 430 and Pericles died the following year. Eventually, Athens overextended itself by trying to keep her allies subdued and by launching a reckless attack on Syracuse in which the Athenian navy was destroyed. In 404, Athens capitulated and its empire was dismantled.

In the later phases of the classical period, the Hellenes were exhausted and many became skeptical, questioning received opinion about politics, social conditions, and religion. After the death of Socrates in 399, his brilliant pupil Plato founded an academy in Athens. Plato was followed by Aristotle and other thinkers. Athens became the home of philosophy and education. In the meantime, Sparta, Thebes, and Athens continued their old rivalries as each tried to establish a dominant political position. This conflict left Greece vulnerable to attacks from the outside, and in 338 B.C.E. Philip of Macedon (not a part of Hellas in antiquity) established himself as overlord of the Hellenes.

Despite the unsettled conditions in late classical times, building continued and some of the most renowned Hellenic sculptors, such as Praxiteles and Lysippos, were inundated with commissions. Civic buildings such as the **Theater** at Epidaurus and the new court and fountain house in the **Agora** at Athens kept architects and workers busy, as did designs for private citizens such as the **Choregic Monument of Lysicrates**. The Macedonian takeover introduced royal patronage and demanded commemorative art and architecture celebrating Philip and his son Alexander, soon to be called "the Great."

At the **Altis** at Olympia, major renovations were undertaken. A new stadium and the Echo Stoa were more or less secular buildings, but there were also two new temples, the Metroon and the Sanctuary of Artemis. The Philippeion was a royal foundation of Philip and Alexander built to commemorate their victory over Athens and Thebes at the battle of Chaeronea in 338—the battle that ended Hellenic independence.

Hellenistic Period (c. 336–100 B.C.E.)

Alexander became king of Macedon in 336. He was not much of a builder because he spent most of his thirteen years as a ruler on an extended military campaign. The territories he invaded, as far east as Afghanistan and the Pun-

jab, became the Hellenistic world. When he died in Babylon in 323 he had no immediate successor, so his generals vied for control of his empire. After an enormous power struggle and many murders, the generals made peace in 311 and divided the territory into five monarchies. Hellas was united with Macedon under Cassander. Athens became an educational center where young men came to study at schools of philosophy and rhetoric. It was no longer a political power of any consequence.

The Hellenistic monarchs were great patrons of the arts. Architecture was an important part of their political policy; they used Hellenic-inspired buildings as a means of displaying their power and as a way of spreading Hellenic values and culture to the populations they ruled. One of the most interesting royal families was the Attalids of Pergamon, who built a magnificent city on a steeply sloping site near modern Bergama in Turkey. They were men of letters as well as generals and sent their sons to Athens to be educated. Eumenes II and Attalos II felt a special affinity with the Hellenes, which they demonstrated by giving gifts of architecture to the major sanctuaries and to Athens. Both kings built stoas in the city: Eumenes on the south side of the Acropolis, and Attalos in the Agora. The **Stoa of Attalos** is an elaborate variation on the classical stoa and has been rebuilt by the American School of Classical Studies.

Antiochus IV Epiphanes of the Seleucid kingdom fancied himself the avatar of Zeus and built a number of temples to the god in Seleucia. When visiting Athens, the king saw the remains of the huge **Temple of Olympian Zeus** that had been begun and abandoned by the tyrants Hippias and Hipparchos in the sixth century B.C.E. Antiochus was inspired to finish the building and hired a Roman architect who labored over the work for ten years. When Antiochus died, the temple was only half finished and would remain that way for another four hundred years.

Hellenistic monarchs also funded libraries and live-in scholars and philosophers. Some of these men were scientists who studied astronomy, mathematics, geometry, and medicine. Often the scientists moved from court to court or visited Athens, where they could share their theories and argue with their competitors. One such man was Andronicus of Cyrrhus, who came to Athens and built the **Tower of the Winds** to illustrate one of his theories. Other cities and sanctuaries in Hellas received gifts of buildings from the Hellenistic monarchs, but those in Athens were the most significant.

Roman Period (c. 148 B.C.E.–Fourth Century C.E.)

Rome turned its attention toward the Greek world when the Hellenistic ruler Philip V of Macedon supported Hannibal in the Second Punic War. Philip was removed from power after the battle of Cynoscephalae in 197 B.C.E., and in 196 Rome detached Greece from the kingdom of Macedonia and declared it a free region. Resentment of Roman intervention caused a rebellion in 146 that was led by Corinth. The Roman general Mummius put down the insurrection and

as punishment totally destroyed Corinth. This action broke the back of Greek resistance, and a period of Roman occupation followed.

In the first century, Mithridates of Pontus took over most of the Aegean islands and, with the help of Athens, much of mainland Greece. This action provoked the First Mithridatic War, during which the Roman leader Sulla captured Athens and tore down its defensive walls. After a period of political maneuvering on both sides, Greece became the Roman province of Achaia in 27.

The country was poor, and Corinth and Athens had both been devastated by warfare and mismanagement. However, the Romans valued Greek culture, and over time several individuals made important contributions for the renovation and upkeep of historic structures and shrines and also for the construction of completely new buildings. The first of these men was Julius Caesar, who in 44 funded the building of a completely new Corinth. Caesar also seems to have initiated the building of the Roman marketplace in Athens. After Augustus Caesar came to power in Rome in 31, he continued funding for the marketplace. The Temple of Ares in a deserted town in Attica was dismantled, moved to Athens, and reassembled in the **Agora**. Augustus also built a small temple to Rome and himself on the **Acropolis**. Agrippa, Augustus's colleague and son-in-law, gave Athens a beautiful Odeum, or concert hall, that was located in the Agora.

Several other Roman emperors supported architecture in Greece. The Julio-Claudian dynasty (the descendants of Augustus) continued funding the reconstruction of Corinth, and in the first century C.E. Nero seems to have paid for repairs to the **Temple of Zeus** at Olympia and the Theater of Dionysos in Athens.

But the most generous of all Roman leaders was Hadrian, who was nicknamed "the Greekling" because of his love of Greek culture. Hadrian made several visits to Athens and endowed a number of architectural projects there. To the east of the old city he added a new quarter that included an ornamental arch at the place where the old area joined the new. In 132, Hadrian dedicated the enormous **Temple of Olympian Zeus**, which he completed some seven hundred years after it was begun. A library and stoa were also gifts from Hadrian.

Between 140 and 161, the Athenian millionaire Herodes Atticus restored the **Panathenaic Stadium** and built an odeum, dedicated to the memory of his wife, on the south side of the Acropolis (see **Odeum of Herodes Atticus**). He was also responsible for the construction of fountains and an odeum at Corinth and a nymphaeum (water display) at Olympia. Herodes was a Romanized Greek and the friend of three emperors—Hadrian, Antoninus Pius, and Marcus Aurelius. Antoninus Pius and Marcus Aurelius expanded the area of the sanctuary around the **Telesterion** at Eleusis by adding a large courtyard and a propylaea. Although many individual Roman monuments are scattered across Greece, only Corinth and Athens have coordinated building projects

from the Roman period. After the second century, there was no construction of any importance in the country.

Beginning in the third century, Greece, like the rest of the Roman Empire, suffered the ravages of barbarian invasions that would last for several centuries. The first raids into Greece were made by the Herulians, who devastated Athens and many old Greek sanctuaries. In 293, to defend against invaders, the Roman emperor Diocletian resorted to dividing rule among a group of four emperors, called the Tetrarchs, who were stationed in various parts of the empire. One of the four, Galerius, chose Thessaloniki in Macedonia as his capital. There he built a hippodrome, a triumphal arch, a palace, and a round building called the **Mausoleum of Galerius** so that the city would reflect his royal position and suitably impress visitors. In 330 in another relocation of the seat of Roman power still further to the east, Constantine, the first nominally Christian emperor, founded a "New Rome"—Constantinople, named for himself—at Byzantium on the Bosphorus. Today the city is known as Istanbul.

Early Byzantine (Fourth–Sixth Centuries C.E.)

During the reign of Theodosius the Great, Christianity was formally adopted as the official religion of the Roman Empire. In 394, the emperor banned all pagan cults and closed the ancient sanctuaries and temples. When he died in 395, Theodosius divided the empire into two parts to be ruled by his sons. The eastern half included Greece, Turkey, Egypt, and the Balkans and was administered by the court in Constantinople. Although the Byzantines called themselves Romans and considered their state to be the continuation of the Roman Empire, theology and a new conception of the relationship between heavenly and earthly power would soon separate them from the Latin west.

The Byzantine Empire was an Orthodox Christian state in which religion and politics were intimately interwoven. Defense of the state was the job of the emperor, while the patriarch was charged with the preservation of the true faith. Each promoted the other. Common belief of the time was that the hierarchy of the Byzantine court was an earthly reflection of the order of heaven and thus was permanent. Theology and church dogma had a crucial role to play in the internal development of the state, because error and heresy not only threatened the souls of the people, but also undermined the security of the empire.

And security was a precious commodity. Throughout its long history, the Byzantine Empire was constantly threatened by invasion from all sides. In an almost rhythmic pattern, territory was lost, recovered, then lost again. After the threat of the Herulians had dissipated, migratory Germanic tribes began moving toward the Balkans. At the beginning of the fifth century, the Goths took over Thrace, Macedonia, mainland Greece, and the Peloponnesus. The Goths were then followed by the Vandals and the Huns.

Conditions in the empire finally stabilized with the accession of Justinian I in 527. A stern and capable ruler with a daring general and an intelligent wife at his side, Justinian reclaimed lost territory and even increased the size of the empire. During Justinian's thirty-eight-year reign, Constantinople reached its cultural and economic peak and the empire expanded to its greatest size. Even Italy was reclaimed, with Ravenna as its capital. The church of San Vitale at Ravenna has stunning mosaic portraits of Justinian and Empress Theodora with their retinues, rare examples of early Byzantine artistry.

Justinian's patronage of architecture was substantial. The stupendous church of Agia Sofia (Holy Wisdom) in Constantinople is daring in its huge scale and design, a truly imperial sanctuary where human beings are dwarfed in a high domed space with column screens, subsidiary spaces, and numerous windows creating varying light effects that dance across mosaic surfaces. By most accounts, the czar of Russia was converted to Orthodox Christianity because of the majesty and mystery of Agia Sofia.

Ecclesiastical architecture in Greece during the early Byzantine period is not so extraordinary. Most of the early churches are basilicas, a plan that was developed early in the West and quickly disseminated throughout the Roman Empire. A basilica consists of a long hall, or nave, that can be solitary or flanked by lower narrower halls, or aisles. Aisles can be separated from the nave either by colonnades (columns supporting lintels) or by arcades (columns or piers supporting arches). Frequently there are galleries above the aisles. Both nave and aisles are covered by a timber roof. Light is provided by a clerestory, which is a row of windows in the nave walls above the aisles or galleries. The basilica is oriented west to east, with the entrance at the west. Interestingly, this is exactly the opposite of the orientation of Hellenic temples. In Greece, there is usually a narthex, or transverse vestibule, that precedes the entrance door. At the eastern end of the nave is an apse, or semicircular space covered with a half-dome. The clergy have seats in the apse, and the altar is placed in the space in front of it.

A variation on the simple basilican plan is the cruciform basilica. This type of church adds a transverse hall, or transept, that intersects the nave before it joins the apse. The resulting shape is that of a Latin cross, which has a long lower arm. The basic basilican plan was an adaptation of the Roman secular basilica, which functioned as a law court or a place for commerce. Basilican plans were also used for audience halls in the homes of the Roman elite and in the palaces of the emperors. Their long shape was perfect for the elaborate processions that were part of court ritual. Because the basilica was never used as a pagan temple, its plan was acceptable to Christians.

Although there were once many basilicas in Greece, most are now known only from foundations and bits and pieces of columns and masonry. Fortunately, two churches of this type survive in Thessaloniki, also known as Salonica. Thessaloniki was the second city of the Byzantine Empire and, as might be expected of a large and usually affluent community within a culture based largely on religious belief, has many churches. **Panagia Acheiropoietos**,

dedicated to the Virgin Mary, is one of the earliest extant Christian buildings in Greece. Its wide nave and gallery on three sides is spacious and full of light. The beautifully sculpted column capitals, colored marble veneers and columns, and mosaics preserved in the church evoke the splendor of early houses of worship and the craftsmanship and expense that were involved in their construction and decoration.

Agios Demetrios, a martyr church built over the Roman bath complex in which Saint Demetrios was murdered, is a basilica with a transept that has aisles all around. Although damaged by fire twice in its history, it has been carefully restored. Measuring 180 feet in length, Agios Demetrios is the largest basilica in Greece.

The Dark Centuries and the Iconoclast Controversy (Seventh and Eighth Centuries C.E.)

Justinian's great Byzantine Empire began to disintegrate even before his death. Pressures from outside the extended borders and the difficulty of defending against them led to a succession of disasters as pieces of the empire fell into the hands of outsiders. To make the situation worse, there were also internal disorders in the late sixth century that began to considerably weaken the Byzantine state. Greece was particularly hard hit by a series of catastrophic events, including bubonic plague, drought, crop failures, and earthquakes. The depopulated country was vulnerable to invasion and, beginning in 580, was occupied by the Slavs. Only Athens, Corinth, Monemvasia, and Thessaloniki remained in Byzantine control, and even in these cities urban life was totally disrupted.

Constantinople could not aid the Greeks in any way because the empire was constantly fighting defensive wars. A war with the Persians ended in a siege of the capital city in 626. Then, the Arabs seized the eastern Mediterranean and all of North Africa and laid siege to Constantinople in 674–678 and 717–718. Eventually, Emperor Constantine VI, who ruled from 780 to 797, launched a partially successful offensive against the Slavs in Greece. But it was not until the late ninth century, with the establishment of the Macedonian dynasty in Constantinople, that Greece began to emerge from poverty and a low level of culture. A further invasion by the Bulgarians around 900 lasted until Basil II drove out the invaders and restored Greece to the empire in 1018–1019.

In addition to the military, economic, and cultural upheavals of the Dark Centuries, the Byzantines also suffered from internal dissension that lasted from 726 to 842. This period witnessed the Iconoclast Controversy, a bitter conflict between those who insisted on the abolition of images in churches and private worship and those who believed in the sacredness of icons and the efficacy of representations of holy persons and Biblical narratives in sanctuaries. Since church dogma was an integral part of the state, the Iconoclast Controversy had political as well as spiritual ramifications. Passions ran high; there

were riots by the laity, and the monastic communities defied the Iconoclast emperors.

As might be expected, the unsettled and impoverished conditions of the Dark Centuries did not allow for much architecture of consequence to be built. Scholars have noted that between approximately 610 and 850, Byzantine architecture stagnated as funds were diverted to repairing defensive walls and patching up old churches. In Greece, Thessaloniki weathered the storm of invasion better than most cities, and it is here that a rare example of a church dating to the end of the eighth century is located. **Agia Sofia**, an early cross-domed plan, may have been funded by Constantine VI and his wife Irene to commemorate their offensive against the Slavs. Since the church was built during the Iconoclast Controversy, its interior decoration and redecoration reflect both the ban on images and their later restoration.

Middle Byzantine (Ninth Century–1204 C.E.)

When the Byzantine Empire began to recover from the Dark Centuries, it was no longer a major power in the Mediterranean region. The small amount of territory that it still nominally controlled included only Asia Minor, Greece, the Crimea, southern Italy, and Sicily. Because of the Arab conquest and the Slavic invasions, these regions were underdeveloped and in a long process of recovery. The Byzantines no longer controlled the trade routes, and their empire reverted to a rural condition without vigorous urban centers. Only two cities—Constantinople and Thessaloniki—flourished.

When the Macedonian dynasty came to power in the late ninth century, its rulers began a process of stabilization. These rulers were military leaders who strengthened the boundaries, annexed the territories of the Bulgarians and others, and used diplomacy and intrigue as well as warfare to keep their enemies at bay. By the tenth century, intellectuals in Constantinople were writing about the renovation of their city and culture. The renovation continued under the Macedonians until the eleventh century, when the empire was reestablished as a major power that controlled the entire Balkan Peninsula and territory in the east extending from Syria to Armenia. Greece now entered a period of recovery and security—conditions that led to the revival of architecture.

Middle Byzantine architecture signals a definitive departure from that of the early period. New designs were formulated, and the basilica was forgotten. Builders now developed the centralized plan, a round or polygonal domed structure in which the parts of the building around the center are of equal, or almost equal, dimensions. This plan was descended from the tombs, temples, and baths of the Roman Empire and was not much used in the West, where the basilica remained the preferred church plan.

The centralized middle Byzantine churches are small intimate structures that could rarely accommodate more than a hundred worshipers. They appear

to have first been developed in Constantinople and then spread westward into Greece. The reason for the diminutive size of the buildings is not fully understood, but most scholars attribute it to the rise in monasticism, which is such a striking feature of the middle Byzantine period. This phenomenon began after the Iconoclast Controversy when the monks, who had supported icons, freed themselves from the rule of secular clergy, who were government appointees and supporters of the ban on pictures. **Monasteries** such as those on Mount Athos became large institutions located in remote areas away from the temptations of secular life. But a new type of monastery—the urban monastery—was developed in the middle Byzantine period. These monastic communities in Constantinople and Thessaloniki were funded by private benefactors.

By the eleventh century, the most common church type in Greece was the cross-in-square plan. This plan is a structure of nine bays, or spacial units. The central bay is a large square with a dome on four supports that can be either piers or columns. Projecting from the center square are four barrel-vaulted bays of equal length that form a Greek cross. In the spaces between the arms of the cross are small bays, either domed or groin-vaulted. These bays fill in the cross and thus inscribe it in a square shape. At the west end of the building is a vaulted transverse hall, or vestibule, known as the narthex. Occasionally there are two of these, the outer narthex and the inner narthex. The east end of the square is prolonged by the addition of apses, semicircular spaces roofed with half-domes.

A variation on the cross-in-square plan that is common in Greece is the domed octagon plan in which the square central bay is turned into an octagon by bridging the corners with arches called squinches. The **Katholikon of Osios** Loukas is a complex version of the domed octagon plan, while the **Katholikon of Nea Moni** is of a plainer type.

The exteriors of Greek churches are quite distinctive. They are worked in cloisonné masonry, a decorative technique in which rectangular blocks of stone are separated, or "framed" on all four sides, by bricks. Frequently, Kufic designs—figures that imitate an abstract style of Arabic writing—are arranged in decorative bands or friezes. These designs give an exotic flavor to the tapestry-like effect of the cloisonné work. Some of the most interesting middle Byzantine cloisonné masonry in Greece is found on the little vernacular churches of Kastoria, the **Panagia Koumbelidike** and **Agioi Anargyroi**.

The interior decoration of Greek churches varies from fresco paintings to colored marble veneers worked in geometric patterns to mosaics, with all three sometimes used in combination. Mosaic was the most labor- and material-intensive art and was therefore the most expensive medium. When mosaic was used in profusion, as in the katholika of **Nea Moni, Daphni,** or **Osios Loukas,** it covered the upper levels of the walls and all the ceilings and domes. The cycle of images in these and other Byzantine churches was canonical and hierarchical in its arrangement because it illustrated the dogma of the Orthodox faith.

The Latin Conquest (1204–1261 C.E.)

When the Fourth Crusade set out for the East in 1204, the crusaders' stated purpose was to rid the Holy Land of the Muslims who controlled the shrines associated with earliest Christianity. However, many of the knights and their followers saw the Crusade as a means of acquiring plunder and land, while the Venetian and Genoese expected to capture lucrative trading posts and commercial routes.

Instead of reclaiming the Holy Land, the Crusaders attacked Constantinople and on 12 April 1204 sacked the city, defiled its churches, and deposed the emperor. A Frankish knight was put on the Byzantine throne, and the empire was divided among the Crusaders. The Franks partitioned Greece into several feudal states. The fragmentation of the empire would have long-lasting effects, even after the Latins were expelled from Constantinople in 1261.

Frankish control of most of Greece introduced elements of Western architecture into the country, but these had little lasting effect. There are ruins of castles in many locations, but most of them were altered during the Turkish occupation of Greece. Several Gothic churches are known, and Western adaptations or additions to local churches are fairly common. For example, at the monastery at Daphni, Cistercian monks added a Gothic porch, which was built in the style of the monastery at Citeaux in France. French and Italian Gothic architecture introduced Byzantine builders to the pointed arch and rib vault as well as the bell tower.

The period of Western occupation was more important politically than it was artistically. Shortly before the Latin Conquest, the unity of the empire was threatened when several territories broke away from imperial control and became independent principalities. The Latin Conquest accelerated this process, and by the thirteenth century four states with rather pompous names—the Empire of Trebizond, the Despotate of Epirus, the Empire of Nicaea, and the Principality of the Morea—were ruled by members of the Byzantine nobility. When Michael VIII Paleologus expelled the Latins from Constantinople in 1261 and reconstituted the Byzantine Empire, his territory consisted only of the city itself, parts of Greece, and about half of Asia Minor (modern Turkey).

Late Byzantine (1261–1453 C.E.)

Despite the breaking up of the empire, Byzantine art and culture flourished during the last two centuries before the Ottoman domination. The Palaeologan dynasty maintained a splendid court and supported poets, writers, and artists. Mural painting achieved a high level of perfection as artists of the late period created an expressive and monumental style. Architects, however, concentrated not on new designs but rather on the elaboration and refinement of middle Byzantine plans.

To the older church types were added additional spaces beyond the nave to accommodate burials and funeral monuments. Chapels, designed like minichurches, became numerous, and the narthex was lengthened and deepened. Rooflines became more complex as tall domes proliferated. The exteriors of the buildings were highly ornamental with arcades, blind arches, and increasingly rich cloisonné work. Verticality, both externally and internally, was emphasized as the parts of the building became taller and narrower.

In Greece, the Epirus and Morea despotates became locations for the development of regional styles. Architects were daring and initiated new church plans, such as that of **Panagia Hodegetria**, the first of a series of "Mistra type" buildings that combines a basilican plan with a domed cross-in-square. The extraordinary **Panagia Parigoritissa** at Arta includes Western details and a unique support system for its central dome.

Thessaloniki became a center for architectural experimentation in the fourteenth century. The monastic church of **Agioi Apostoloi** includes the wide ambulatory and open arcades that were typical features of late Byzantine churches. But the most remarkable aspect of the building is its decoration. Inside are marble columns, mosaics, and mural paintings, while outside the walls carry a profusion of complex cloisonné work. In the twilight years of Byzantine civilization, Greece played an active role in the development of architecture.

Ottoman Occupation (1453–1830 C.E.)

When Constantinople fell to the Ottoman Turks in 1453, parts of the Balkans had already been occupied. For the next four centuries, during the Ottoman occupation, Greece suffered from oppression and neglect. The Turks settled on fortified acropolises in cities such as Athens, while the Greek population occupied the more vulnerable areas below. In Athens, Turkish streets and houses were constructed all around the Parthenon, which was turned into a mosque.

The Greeks were kept in a subservient position and were forced to work for their Turkish overlords. On large farms in the countryside, Greeks labored much like serfs. There was a heavy burden of taxation as the country was exploited and its resources depleted. Particularly hated by the Greek people was the practice of abducting young boys and training them to be soldiers in service to the Turks. To escape the harshness of the occupation, many Greeks fled into the wild mountains and founded communities there.

Religion became the cohesive force that helped the Greeks maintain their identity during the years of occupation. Christians were allowed to practice their faith, and the patriarch of Constantinople was appointed by the Turkish government to act as the temporal leader of the Orthodox Greeks. The patriarch was responsible for maintaining good behavior and acceptance of the

Turkish domination and for dealing with the internal affairs of the Greek communities. Involvement of the church in the everyday lives of the people made it a powerful force for preserving the language and traditions of the Greeks. And, as in earlier times, the monasteries, especially those on Mount Athos, became centers for the preservation of Greek culture.

Independence and the Reconstruction of Athens (1830–c. 1900 C.E.)

Although there had been sporadic revolts against the Turks in the seventeenth century, not until the end of the eighteenth and beginning of the nineteenth centuries did the spirit of Greek nationalism begin to grow. This development was directly inspired by the Orthodox church, which had set up schools in which young Greeks secretly and illegally learned about their heritage. Secret societies of Greeks were also founded that were inspired by the French Revolution. Bands of rebels who lived in the mountains and local militia units began harassing the Turks. On 25 March 1821, Patriarch Germanos raised a flag with a white cross on a blue background at the Agia Lavra monastery, and the War of Independence began.

The long and bloody struggle eventually attracted the attention of Europe, where intellectuals and liberals began to spread word of the Greek cause. Money was raised, and troops were sent. Germans, English, French, Russians, and even some Americans went to Greece to fight against the Turks. In 1828, the Treaty of Adrianople declared the independence of Greece. This status was recognized by the European powers in 1830 and finally accepted by the Turks in 1832.

The new country was set up as a monarchy, and in 1834 its first king, Otto Wittelsbach, the eighteen-year-old son of Ludwig I of Bavaria, was chosen by the European powers. Appointment of a European, non-Greek monarch was symbolic of the new direction Greece would take away from its Oriental, Turkish past and toward Western civilized Europe. The new cultural and intellectual orientation of the country was focused on being accepted into the European community as a modern state, achieving internal political unity, and establishing a strong connection, or reconnection, with its classical past. In recognition of Greece's ancient history, the capital was moved from Nafplion to Athens in 1834.

During the war, Athens had been besieged and bombarded by the Turks for almost a year. The new capital was in ruins when King Otto arrived, and the population numbered only four thousand, most of whom were desperately poor. Housing was almost nonexistent—according to some reports, only twenty-five houses remained intact. Because of the desperate condition of the city, starting a reclamation project and rebuilding Athens in a manner that would rival other European capitals were immediately necessary. To accomplish these tasks, Otto relied on German, French, and Danish architects. Leo

von Klenze provided a new city plan, while other architects, such as Ernst Ziller and the Hansen brothers, designed buildings in neoclassical or neo-Byzantine style.

The romantic neoclassicism of Europe in the nineteenth century had been partly inspired by renewed interest in Greece during the War of Independence and was further advanced by a fascination with archaeology and ancient monuments. European schools of art and architecture sent their best students to Italy and Greece to study the "perfection" of classical art. Athens thus became a city of the ancient classical and the neoclassical. By the end of the nineteenth century, Athens had more neoclassical buildings than Vienna and Budapest.

The leaders of the neoclassical movement to rebuild Athens were Christian and Theophilos Hansen, two brothers from Denmark. They participated in the archaeological work undertaken on the **Acropolis** and carefully studied the ancient buildings there. Their own buildings were inspired by the **Parthenon**, the **Temple of Athena Nike**, the **Erechtheum**, and the **Propylaea**. Christian designed the **University of Athens**, while Theophilos was responsible for the **Academy of Sciences** and the **National Library**. These three buildings make up the Athenian Trilogy, one of the most majestic groups in the city. They are also among the finest examples of Hellenic neoclassicism, an original style used by the Hansens and others that makes specific reference to Athenian classical monuments and thus establishes a connection between the old and the new. From the fragments of the Acropolis emerged the elegant marble buildings that symbolized the birth of the new European Greek nation.

Architecture
of Greece

ACADEMY OF SCIENCES, ATHENS

Style: Hellenic Neoclassical
Date: 1859–1885 C.E.
Architect: Theophilos Hansen

In 1826, during the Greek War of Independence, Athens was besieged and bombarded by Turkish troops for almost a year. The city was devastated—some reports claimed that only twenty-five houses were left standing. But in spite of its ruinous condition, Athens was chosen by the Greeks to be their capital in 1834. A year later, King Otto arrived in the city and began an extensive program to rebuild the capital in neoclassical style. The refurbishing of Athens took on nationalistic overtones as a symbol of the new free Greek state. After centuries of Byzantine and Ottoman domination, Greece now discovered its roots in the classical past and the new Athens became the focus of a revival of the glorious era of Pericles.

The rebuilding of Athens was begun by architects from Denmark, France, and Germany. In the 1830s, a group of Danes settled in Athens and worked extensively on restoration of the monuments on the **Acropolis** while attracting commissions to design buildings for both the state and private individuals. The leaders of the group were the brothers Christian and Theophilos Hansen, both of whom had been trained at the Academy of Fine Arts in Copenhagen—an important center of neoclassical art and theory.

Theophilos went to Athens in 1838 to assist his brother in the building of the **University of Athens**. He then studied the ancient monuments and worked on the reconstruction of the **Parthenon** and the **Temple of Athena Nike**. Because of this experience, Theophilos became passionately interested in the proportions of the buildings, the details of the orders, and the use of polychromy on the exteriors of the temples. To create a new Hellenic neoclassical style for Greece, he trained local craftsmen in the materials and techniques of ancient builders. Although Hansen left Greece in 1846 for Vienna and then Copenhagen, his work in Athens was so successful and his reputation so strong that the Greeks commissioned two vitally important monuments from him: the Academy of Sciences and the **National Library**. These buildings, along with Christian Hansen's University of Athens, form a group called the Athenian Triad.

Money for the establishment of the Academy of Sciences was donated by the expatriate Simon Sinas, son of Georgios Sinas who had financed Hansen's **Observatory** in Athens in the 1840s. Simon Sinas was a wealthy banker and

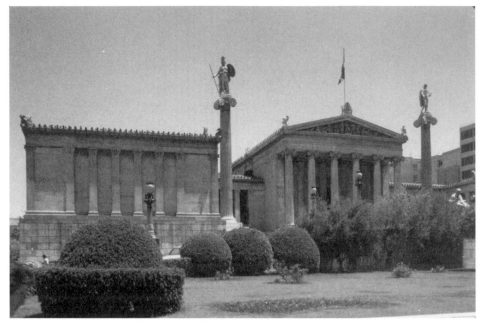

Academy of Sciences, Athens. *Courtesy of Michio Yamaguchi.*

also served as the Greek ambassador to Vienna, Berlin, and Munich. He shared his father's enthusiasm for, and support of, the development of science in Greece. Because of his contributions, the Academy of Sciences is also known as the Sinas Building.

Construction of the Academy of Sciences began in 1859 and, for political and financial reasons, was achieved in two campaigns: the first from 1859 to 1863, and the second from 1869 to 1885. Hansen supervised the work until 1861 and then turned the project over to Ernst Ziller, who would later design the **Schliemann House**. The completed building was formally presented to the Greek government on behalf of the Sinas family in 1887.

In designing the Academy of Sciences, Hansen relied heavily on his studies of the buildings on the Acropolis, most importantly the **Propylaea** and the **Erechtheum**. He published his measured drawings of the latter and praised the ability of the ancient Greeks to create a fusion of architecture, sculpture, and painting. In the Academy of Sciences, Hansen set out to achieve a similar unity and balance among the three branches of art.

In plan, the Academy of Sciences is composed of three long rectangular blocks interconnected by two lateral corridors. The building is perfectly symmetrical and is unified by the use of Pentelic marble and the Ionic order throughout. The central block is conceived of as a classical temple with colonnades on either end: two rows of six columns on the front, and a single row, also of six, on the back. Behind the front colonnade is a reception hall, and

beyond that is the large assembly hall with tiers of seating arranged in an oblong configuration with curved ends.

The connecting corridors are recessed behind the facade of the central block, and courtyards occupy the spaces in front of and behind the corridors. On either side of the central section of the building and the courtyards are the outer blocks. These are lower in height than the central block and terminate in pavilions perpendicular to the main axis of the building. The pavilions resemble small rectangular temples with four columns on each end and low gabled roofs.

Although not a direct copy, the influence of the plan of the Propylaea is obvious here. The U-shaped arrangement of the front of the Academy of Sciences with projecting wings on either side of a templelike entrance is a design similar to that of the Greek architect Mnesicles. This arrangement, slightly simplified, is repeated at the rear of the building. Hansen has arranged the masses and planes of the parts of the building into a series of projecting and receding forms with a dominating tall central feature flanked by clearly subordinate units.

Hansen's desire to create a neoclassical style rooted in the practices of the ancient Greeks is abundantly evident on the exterior of the building. The proportions of all the elements of design are worked out in great detail; the use of sculpture is striking; and Hansen's exquisite watercolor designs for painted and gilded decoration on the exterior indicate his reliance on the traces of polychromy on the Erechtheum.

A curved parapet marks the entrance to the Academy of Sciences grounds. In its center is a flight of stairs flanked by seated statues of the two great Greek philosophers Plato and Aristotle. Across a court, the facade of the central block is framed by two tall, freestanding Ionic columns that support statues of Athena, goddess of wisdom, and Apollo, god of the arts, medicine, and prophecy.

The facade of the main block is based on the Erechtheum. Both the bases and the capitals of the Academy of Sciences' twelve Ionic columns are copied rather directly from that building. The lotus and palmette bands below the capitals and the ornamental moldings in them are picked out with paint, as were the ancient prototypes. Above the columns is an architrave, or lintel, divided horizontally into three bands. Painted rosettes and colored squares are applied to two of them. The horizontal frieze above the architrave is uncolored, but it is surmounted by moldings carved in relief designs that are brightly colored. Perched on the lower corners of the pediment, or low triangular space formed by the eaves of the gabled roof, are statues of exotic winged sphinxes. Within the pediment are marble statues by Leonidas Drosis, inspired by the east pediment of the Parthenon, depicting the birth of Athena.

The connecting corridors and the outer blocks of the Academy of Sciences also demonstrate the influence of the Erechtheum, in this case the design of its west wall. The side walls of these parts have engaged Ionic pilasters standing on a base of finely cut stone blocks. Above the pilasters runs a three-band architrave painted with rosettes and a meander pattern. Either blank walls or

windows are placed between the pilasters. The walls carry painted friezes of laurel crowns and plump owls, symbols of Apollo and Athena.

Because of the temple shape of the pavilions at the ends of the outer blocks, there are a total of eight pediments (one on each end of each pavilion) that carry sculptural decoration. The statues here are of terra-cotta and represent Athena flanked by a pair of gods or mythical figures. For example, the goddess is shown with Hermes and Hephaestus, Urania and Prometheus, Poseidon and Aolus, and Spring and Autumn. All eight pedimental groups are the work of F. Melnizki.

Painting and gilding are also extensively used in the interior of the Academy of Sciences. Its most important room is the large assembly hall. Ionic columns flank the entrance doors, and the gabled ceiling is elaborately coffered. The lower parts of the walls are divided into three zones—a dado, or baseboard; a course of rectangular orthostates; and a frieze topped by a projecting cornice. This type of wall division is best known from examples in Pompeii but is also found in Hellenistic buildings. The upper parts of the walls carry monumental paintings by Christian Griepenkerl. On the front wall the Battle of the Gods and the Giants is depicted. The long side walls have the life of Prometheus with double pilasters framing each episode.

Fortunately, all the painted decoration, both inside and out, has been preserved and was restored to its original brightness in 1980. Between 1990 and 1992 the wood roofs of the Academy of Sciences were restored. The assembly hall has been maintained in its original condition.

Further Reading

Bastea, Eleni. *The Creation of Modern Athens: Planning the Myth.* Cambridge: Cambridge University Press, 2000.

European Union's Culture 2000. www.culture2000.tee.gr.

Jorgensen, Lisbet B., and Demetri Porphyrios. *Neoclassical Architecture in Copenhagen and Athens: Architectural Design Profile 66.* London: The Academy Group Ltd., 1987.

Travlos, John. *Neo-Classical Architecture in Greece.* Athens: The Commercial Bank of Greece, 1967.

ACROPOLIS, ATHENS

Style: Mycenaean; Archaic; Classical
Date: Twelfth–Fifth Century B.C.E.
Architect: Unknown; Mnesicles; Ictinus; Callicrates

The Acropolis of Athens stands on top of a majestic limestone and schist platform that rises steeply to a height of 512 feet above the plane of Attica. *Acropolis* means "upper city" and describes the relation of the mighty rock to the town of Athens that grew from settlements at its base. The platform has sheer faces of more than 300 feet on the north, east, and south sides that make it easily defensible. Access to the summit is possible only on the west. The Acropolis proper measures 885 feet long and 512 feet wide and covers an area of about ten acres. It has been occupied continuously since 5000 and seems to have been a cult center from the very beginning.

The Acropolis was sacred to Athena, who was originally the goddess of citadels and the patron deity of Athens. In Athenian mythology, the upper city was the home of snakes and owls—creatures associated with Athena—and the residence of the city-state's earliest kings. The tomb of the first monarch, the half-man half-serpent Cecrops, was located on the Acropolis. His three daughters, the Dew Maidens, also had shrines there. Erechtheus, the second king, was born from the earth of the upper city and was said to have instituted the first official festival for Athena and to have built her earliest temple. Mementos of the contest between Athena and Poseidon for the right to be patron god of Athens were also to be seen, and Artemis, Zeus, Hephaestus, and Hermes were honored with shrines. From the earliest times, the focus of these Acropolis cults was primarily on the north side.

Myths of early royal residences on the Acropolis were probably based on memories of the citadel that was built on top of the rock in the Mycenaean age (see **Citadel, Tiryns**). The citadel was an impregnable fortress that withstood the Dorian invasions and the population shifts of the Dark Ages. A massive wall of Cyclopean masonry more than ten feet wide fortified the perimeter. On the west side was a double gate guarded by a tower, and on the north side was a postern gate. Inside the battlements, also on the north side, was a palace complex with a megaron suite for domestic and administrative activities and a number of altars and shrines.

For several centuries after the Dark Ages, the old fortress on the Acropolis remained the mythical and religious center of Athens, but little was built there. The rock first enters recorded history in the seventh century when, according

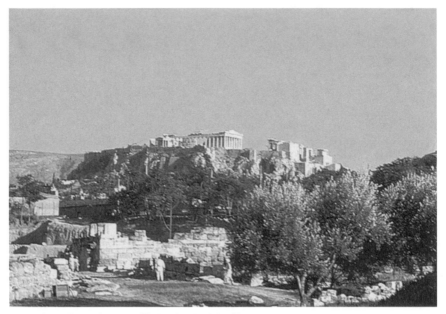

Acropolis, Athens. *Courtesy of Judith Snyder Schaeffer.*

to the historian Herodotus, an aristocrat named Cylon attempted to use economic injustice as a justification for establishing a tyranny. On the advice of the oracle at Delphi, Cylon attempted to seize the Acropolis at the time of the Olympic Games when the opposition party would not be in Athens. Cylon's attempt was a miserable failure but indicates the importance of the Acropolis as a political symbol.

The sixth century was a time of rising prosperity in Athens that is reflected in a series of architectural monuments built on the Acropolis. Motivation to build on the rock came from a new emphasis on Athena as the unique guardian of Athenian institutions and as the warrior-maiden who protected her city and supported its civic and military ambitions. In 570, on the bastion south of the Mycenaean gate, the leader Solon dedicated the first altar of Athena Nike (Athena Who Brings Victory). A few years later, a large temple for Athena was begun on the site where the Parthenon stands today. The investment in a splendid new building was most likely tied to the institution of the Great Panathenaic festival in 566.

Inscriptions call the temple the Hekatompedon (the hundred-footer), a nickname that drew attention to its size. The temple was 100 Doric feet (107 feet) long and 50 Doric feet (53½ feet) wide. There were no surrounding colonnades, but the order was Doric. The cult room, or cella, was a long rectangle with a file of five columns inside on the central longitudinal axis. These supported a gabled roof and divided the interior space into two aisles. On the front and back of the temple were porches, the pronaos and opisthodomos.

Each porch contained three columns between the end walls of the cella. In accordance with Greek religious practice, the temple was entered via the pronaos and a single door on the east. There was no access to the opistho-domos from the rear of the cella. Each porch had a Doric frieze of triglyphs and metopes and, above that, a pediment with sculptural decoration. The east, or front, pediment had two confronted lions attacking bulls flanked by a pair of large snakes. At the west, the paired lions were repeated but were flanked by narrative groups of Hercules fighting Triton and a hero confronting a mys-terious triple-bodied half-human half-serpent creature. On the apex of each pediment perched a statue of the Gorgon Medusa. The Hekatompedon was made completely of limestone except for some moldings and the roof tiles, which were marble.

In 561 Pisistratus and his personal bodyguard seized the Acropolis in an unsuccessful attempt to stage a coup and institute a tyranny. Following a period in exile, he returned in 546 with a private army and established himself as sole ruler of Athens. Herodotus describes Pisistratus's celebrated return in which he rode up to the top of the Acropolis in a chariot accompanied by a very tall young girl disguised as Athena. Pisistratus was a popular ruler who understood the political value of public works and architecture. Among his numerous projects was the Temple of Athena Polias (Athena the Founder of the City) on the Acropolis.

This building, now usually called the Old Temple of Athena, was begun around 529 and completed by 520. It occupied a space to the north of the Hekatompedon close to the very ancient shrines and perhaps over the remains of the Mycenaean palace. As the principal Athena temple in Attica, the build-ing housed the sacred olive wood image of the goddess, which had been kept on the Acropolis since the earliest times. The image was the goal of the Pana-thenaic Procession, the most important religious event in Athens. Each year several young girls wove a new garment for the image, and the whole city climbed up to the Acropolis to present the garment to the goddess. Athena shared her temple with several other important deities: Poseidon, Erechtheus and his twin brother Butes, and Hephaestus. Because of this, the interior of the Athena temple was divided into several chambers and can be understood as the spiritual and architectural precursor of the Erechthuem, which also housed several different cults.

The Temple of Athena Polias stood on a platform that measured approxi-mately 70 by 142 feet. A colonnade of six Doric columns on the front and rear and twelve on each flank surrounded the rectangular block of cult rooms. Above the columns was the traditional superstructure made up of the archi-trave (or lintel), the horizontal Doric frieze of triglyphs and metopes, and on the front and back the pediments. Figures sculpted in the round were placed in the pediments. The west/rear pediment showed the Battle of the Gods and the Giants, while the east/front included a pair of lions and a downed bull. Inside the colonnades, the block containing the cellas had abbreviated inter-nal porches, the pronaos and opisthodomos. In front of the porches were four

Ionic columns that supported an architrave and, above that, an Ionic frieze about four feet tall decorated with relief sculpture. The inclusion of Ionic features in a Doric building is an early example of the mixing of the orders found later in several of the fifth-century buildings on the Acropolis.

Because of the multiple cults housed in the temple, the interior block was divided into several spaces. The major cella, where the olive wood idol was kept, faced east and was entered through the pronaos. This cella had two rows of three columns each that divided the room into three aisles. The other cellas were oriented toward the west and were entered through the opisthodomos. First was an anteroom that occupied the whole width of the block. Beyond this was a pair of smaller inner rooms that could only be entered from the anteroom. This suite of three chambers was dedicated to the male deities who shared the building with Athena. The Temple of Athena Polias was built primarily of limestone, but imported island marble was used for the metopes, gutters, and roof tiles and, for the first time, in the pedimental sculptures.

Also during the sixth century, a number of small buildings were constructed to the west of the Hekatompedon. They are usually identified as treasuries where expensive gifts to Athena were stored (see **Siphnian Treasury**). At least two of them were decorated with pedimental sculpture. To the south of the treasuries Pisistratus founded the sanctuary of Artemis of Brauron, the goddess who supervised Athenian girls in their transition from child to wife and mother.

The Sacred Way of the Panathenaic Procession entered the Acropolis on the west side and moved past the treasuries, along the north flank of the Hekatompedon, and finally turned north to approach the Temple of Athena Polias and the altar of Athena. All along the route, and in the spaces around the buildings, were hundreds of statues and votive offerings that were dedicated by Athenian citizens to their patron goddess.

By the time Athens became a democracy in 508, the Acropolis had lost its significance as a fortress and showplace for tyrants and had become a purely religious center. Building there began anew after the spectacular victory at Marathon in 490 in which nine thousand Athenian citizen-soldiers defeated the huge Persian navy and prevented a massive invasion of the Greek mainland. Redevelopment of the Acropolis was both a celebration of Athenian military valor and a thank offering to Athena. Fine white marble became the building material of choice when new stone quarries were dug on nearby Mount Pentelicus.

The first project, begun in about 485, was the construction of a propylon to replace the old Mycenaean gateway on the west. A propylon is a monumental entrance gate that marks the transition from the profane space of everyday life to the holy space of ritual and worship. The propylon was made of marble and had two porches, back to back, that imitated the shape of the front and rear of a Doric temple. Because the terrain was steep, the back porch was at a higher level than the front and the two units were connected by a flight of stairs. The porches had four Doric columns between flanking walls. To the

south of the propylon, a small limestone temple was built for Athena Nike on the bastion close to Solon's altar.

At about the same time, the Hekatompedon was dismantled and a new marble temple, now called the Older Parthenon, was begun. A large masonry platform, 103 feet wide and 252 feet long, was constructed on the south side of the Acropolis to act as a terrace for the new temple. The building was in the Doric order and stood on a three-stepped platform that was 77 feet wide and 219 feet long. Surrounding the cella was a colonnade of six columns on the front and rear and sixteen on the flanks. A file of four columns at either end of the cella formed the pronaos and opisthodomos. The cella was divided into two rooms. At the east was a long cult room with two rows of ten columns each placed in such a way as to divide the space into one wide and two narrow aisles. At the west, a nearly square room, with no access from the east room, opened into the opisthodomos. Inside the room were four columns arranged in a square. The Older Parthenon was, in many ways, a model for its famous successor. Ionic details, subtle adjustments of measurements, curved lines, and even the division of the cella are related to the fifth-century **Parthenon**.

In 480, the Persians took their revenge for Marathon. The city of Athens was occupied, and the Acropolis was sacked and burned. Hundreds of statues were hacked to pieces; shrines and altars were violated; and precious votive gifts were looted. The Older Parthenon, still under construction, and the Pisistratid Temple of Athena Polias, as well as the treasuries, were destroyed. The following year, in an oath made before the Battle of Plataea, the Greek forces swore not to rebuild the sanctuaries violated by the Persians but to leave them as a memorial to the war dead and a reminder of the sacrilege committed by the eastern barbarians. Following the Oath of Plataea, the Acropolis lay in ruins for more than thirty years.

To defend against future Persian threats, Athens and her allies from around the Aegean established the Delian League. This began as a voluntary alliance led by Athens. Each member of the league was expected to contribute either ships or money (actually, tribute) that would be supervised by Athenian officials. In a short time, the Delian League became, in reality, an Athenian empire and the allies became subjects rather than voluntary contributors. A prime mover in the establishment of the Athenian empire was Pericles, leader of Athens from about 460 until his death in 429. He facilitated the relocation of the league's treasury from its original location on the island of Delos to the Athenian Acropolis in 454. Eventually, in 448, a treaty, called the Peace of Callias, was negotiated between Athens and Persia. Pericles then maneuvered to revoke the Oath of Plataea so that he could institute a rebuilding of the Acropolis that would symbolize Athens' revival after the Persian destruction and would make Athens the most glorious city in the Greek world. Sacred architecture would be used to make a powerful imperial statement. Funding for Pericles' ambitious building program would be provided by—or, in reality, stolen from—the treasury of the Delian League.

The Periclean Acropolis has become an icon of classical Greece and is the destination of scholars and thousands of tourists annually. Even in its mutilated state, the beauty of the conception and execution of the architecture are striking. Pericles' Acropolis projects an image of Athens as the political, cultural, and artistic leader of the Greek world—the model of the ideal democratic community, a fiction that even the Athenians themselves believed despite their exploitation of the Delian allies.

In 447 Pericles engaged the architects Ictinus and Callicrates to build a magnificent new temple for Athena over the unfinished Older Parthenon. The sculptor Phidias was appointed as general supervisor of the work. Originally called the Hekatompedon, after about a century Pericles' new temple became known as the Parthenon, the house of the Maiden, because it housed the great gold and ivory statue of Athena Parthenos (Athena the Virgin) by the Phidias. The temple, which was larger than its predecessor (110½ by 237 feet) but incorporated the older foundations and some of the columns that had remained in place, stood on a massive platform on the highest part of the Acropolis close to the south wall. The Parthenon is a Doric temple with eight columns in front and back and seventeen on the flanks. Its exterior was elaborately decorated with pediments representing the birth of Athena on the east and the contest between Athena and Poseidon for possession of Attica on the west. Ninety-two metopes had relief sculpture depicting battle scenes that were allegories for the victory of the Greeks, led by Athens, over the Persians.

Inside, there were the pronaos and opisthodomus, each preceded by a row of six columns. The interior block was divided into two separate chambers. The one to the east, the actual cella, had a double colonnade that ran around three sides of the room. Here the statue of Athena Parthenos was displayed. The chamber on the west was originally called the Parthenon and appears to have been the treasury where the tribute from the Delian League was stored. Four Ionic columns supported the roof. Also of the Ionic order was the great sculpted frieze depicting a Panathenaic Procession carved on the exterior of the walls of the interior block. The Parthenon was the most extensively decorated of all fifth-century Greek temples. Phidias designed and supervised the sculptural program, which was not completed until 432.

When the Parthenon was substantially complete, the architect Mnesicles was engaged to design a new entrance to the Acropolis. The **Propylaea,** or gates, were begun in 437, and work continued until it was interrupted by the Peloponnesian War between Athens and the Peloponnesian city-states in 432. The Propylaea were made up of three units: a long hall aligned west to east that housed the actual entrance gates to the Acropolis, and two projecting wings on the west side. On the west and east, the facades of the hall resembled a Doric temple. The wings were also Doric. Inside the central hall was a wide ramp flanked by three Ionic columns on each side. Behind the columns, parallel to the ramp, were elevated sidewalks for pedestrians.

Directly across from the Propylaea stood the colossal bronze statue of Athena Promachos (Athena First in Battle) made by the sculptor Phidias

between 465 and 455. The image was thirty feet tall and depicted Athena in military garb as the warrior goddess who ensured Athenian military success. Some accounts say that her helmet and the top of her spear could be seen from the port of Athens ten miles away.

The third project on the Acropolis was the building of the small but elegant **Temple of Athena Nike** on the bastion to the south of the Propylaea. This was the location of the altar built by Solon in the early sixth century and a small shrine of slightly later date. An inscription identifies Callicrates as the architect who designed the temple as early as 449, but construction was delayed until about 425; the specific date is a matter of controversy.

The building is tiny, just 27 by 19 feet, and its delicate Ionic order is highly refined. Its plan is amphiprostyle, which means that instead of a surrounding colonnade it has columns only on the front and back. Above the columns is a three-band architrave, or lintel, supporting a continuous Ionic frieze that runs all around the building and is sculpted with scenes of Greeks defeating Persians. Sculpture in the pediments, now lost, completed the exterior ornamentation. The cella was open to the east where two piers between the flank walls probably supported metal grills that functioned as doors. It is tragically ironic that a temple to victorious Athena was constructed during the early years of the Peloponnesian War when Attica had suffered a horrible plague and was being invaded annually by her enemies.

The first phase of the war ended in 421 with the negotiation of the Peace of Nikias. This was the same year in which the most unusual temple on the Acropolis, the **Erechtheum**, was begun. It was perhaps designed by Mnesicles as a replacement for the Temple of Athena Polias, which had been destroyed by the Persians. The Erechtheum was positioned to the north of the older temple in an area where it would not compete visually with the prominence of the Parthenon. Also, the size of the building was calculated to avoid comparison and competition—it is about half the size of the Parthenon. Because it was located on steeply sloping terrain that, for religious reasons, could not be leveled, and because the building had to accommodate multiple shrines, the plan and exterior elevation of the Erechtheum are unique. All four sides of the temple are different, and the floor levels are varied. The building is given aesthetic unity by the use of a very ornate painted Ionic order inlaid with glass beads. Attached to the central block, which resembles the shape of a traditional temple, are two porches (north and south) that are not symmetrical and are very different from one another. The north porch is large, very tall, and contains an elaborately decorated door. On the south, the smaller caryatid porch has an unusual flat roof and statues of young women in place of columns. The Erechtheum, not the Parthenon, was the goal of the Panathenaic Procession, for it was the Erectheum that housed the ancient olive wood statue of Athena, who was given a new garment every year by the Athenians.

Two other buildings belong to the fifth century but were not strictly part of the Periclean redevelopment. The first was the Chalcotheca, or arsenal. Located to the southwest of the Parthenon, the Chalcotheca was an oblong

hall with a file of six columns inside and three doors on its long north side. At a later date, a colonnade of seventeen columns was added on the north. Between the Chalcotheca and the Temple of Athena Nike, the Sanctuary of Artemis Brauronia was enhanced by a stoa. This was a long hall with two small projecting wings that was aligned parallel to the south wall of the Acropolis. Across its open north side, a colonnade formed a stately visual backdrop for Artemis's open-air shrine.

The Acropolis remained substantially unchanged after the fifth century. Some small structures and many honorary and votive monuments accumulated, and later Roman generals left their portraits there. Emperor Augustus built a small round temple, with decorative details in the style of the Erechtheum, to himself and Rome in front of the Parthenon. In the Middle Ages, the Parthenon and Erechtheum were converted into Christian churches. Under the Ottomans, the Acropolis was once more a fortress. The Parthenon became a mosque; the Prolylaea was used to store gunpowder; and the Erechtheum was transformed into a harem. In 1687, during a siege of Athens, the Venetians bombarded the Acropolis and seriously damaged the Parthenon. At the beginning of the nineteenth century, Lord Elgin sent most of the Parthenon sculptures to the British Museum. Today, emissions from automobiles and industry are causing the marble in the buildings to crumble into dust. Attempts to repair the damage and to halt further deterioration are ongoing.

Further Reading

Berve, H., G. Gruben, and M. Hirmer. *Greek Temples, Theaters and Shrines.* London: Thames and Hudson, 1963.

Dinsmoor, William B. *The Architecture of Ancient Greece,* 3d ed. New York: W. W. Norton, 1975.

Rhodes, Robin Francis. *Architecture and Meaning on the Athenian Acropolis.* Cambridge: Cambridge University Press, 1995.

AGIA SOFIA, THESSALONIKI

Style: Early Byzantine
Date: Eighth Century C.E.
Architect: Unknown

Thessaloniki was one of the most important cities in the Byzantine Empire, second only to the capital of Constantinople. A certain amount of rivalry existed between the two communities that manifested itself in the building of churches. Agia Sofia was most likely named after the enormous Constantinople church built by Justinian in 532–537. Like its namesake, the smaller building in Thessaloniki was dedicated to Holy Wisdom. There are considerable difficulties in establishing a date of construction for the church because of a total lack of documentation. Similarly, the name of the patron, or patrons, who paid for the building is not known. The most probable date is sometime in the eighth century.

The history of Byzantine architecture is difficult to trace between 610 and 850. Only about a dozen churches from this period are known, and most are in ruins. Yet this was the time when Byzantine architects moved away from building traditional basilicas, such as **Panagia Acheiropoietos** and **Agios Demetrios**, and formulated a new centralized design known as the cross-domed plan. A cross-domed church takes the form of a cross with short, roughly equal arms that is enveloped on three sides by aisles and galleries and on the fourth side by an apse and two chapels. A dome supported on heavy piers marks the crossing, while the four arms are roofed with barrel vaults. Agia Sofia is the best preserved example of a cross-domed church—a church plan that perfectly accommodated the ritual of the fully developed Orthodox liturgy.

Viewed from the exterior, Agia Sofia is very plain. The building, which measures 115 by 141 feet, is constructed of bricks and cut stone blocks mortared together and arranged in alternating bands of five. Its western facade is a low rectangle with a large central arched doorway flanked on each side by three lower doors. The entrance is visually emphasized by its location and size and by the inclusion of two columns that support the decorative brickwork of the arch. Above an area of blank wall is a file of ten arched windows. A low square drum with three windows on each side conceals the lower part of the central dome so that only its crown is visible from the outside. The overall effect is solid and heavy.

Directly inside the facade is the narthex, or vestibule, used for baptisms and funerals; the narthex is about twenty feet deep and two stories high. On the upper level is a gallery dimly lit by the nine windows in the facade. Rectangular

Agia Sofia, Thessaloniki. © *Gian Berto Vanni/Corbis.*

piers alternating with columns supporting arches create an arcade that separates the space of the gallery from that of the cross core. The lower story has a large central door opening directly into the west arm of the cross. On either side of it is a small door that opens into a barrel-vaulted space tunneled into a large pier. A barrel vault is a continuous arched ceiling that is semicircular in shape.

The narthex is divided into five bays, or rectangular units, separated from one another by arches. Four bays have domical vaults, while the bay at the south end of the narthex has a groin vault. A domical vault has a flat dome-shaped summit; a groin vault is a ceiling made up of two barrel vaults intersecting at right angles. The north and south bays have two doors each, one on the west and another on the north and south, respectively. These bays interconnect with the aisles, or halls, that flank the central part of the building on the north and south.

At the center of the cross is the dome, thirty-three feet in diameter, that rises high above the gallery level. The dome is supported by four corner piers and the ends of the barrel vaults that cover the four arms of the cross. At the base of the dome, nine arched windows introduce a band of illumination that contrasts with the darkness of the lower arms of the cross.

Joining the east arm is the chancel, a deeper barrel-vaulted space in which the high altar of the church was located. The chancel connects the cross core to the apse, or semicircular east end of the building, that is roofed by a half-dome and has three windows. This part of the church was the sacred space in which the miracle of the Eucharist occurred and was usually separated from the cross core by an iconostasis, or screen, with three doors. On either side of the chancel is a domed chapel—the diaconicon on the south, the prothesis on the north—with doors opening into the aisles and the chancel. The design of these chapels is determined by the liturgical ritual of the Two Entrances. In the Lesser Entrance, the Gospel book is ceremoniously carried from the diaconicon to the chancel. The Great Entrance conveys the elements of the Eucharist from the prothesis to the altar. These two processional acts precede the great mystery of the Communion Mass.

Only the clergy were permitted to enter the central core of the church of Agia Sofia. The congregation was relegated to the aisles (for men) and the upper galleries (for women). They watched the ceremonial from an angled point of view in spaces that were half the height of the core. The barrel-vaulted aisles were separated from the arms of the cross by arcades made up of alternating columns and piers. Above the aisles, the same design was used for the arcades of the galleries. Small windows in the exterior walls provided very subdued lighting at both levels. The narthex gallery, mentioned earlier, was connected to the north and south galleries and continued the same arcade design. Thus, the galleries, aisles, and narthex envelope the cross core on three sides.

Agia Sofia was designed as a mysterious interior space that enhanced the majesty of the Mass. Its walls, covered by marble veneers in somber colors, contrast with the shimmering gold grounds and brightly colored designs of the mosaics that covered the vaults. But Agia Sofia was also a church that was built during the Iconoclast Controversy when the government prohibited figural decoration in houses of worship (see the Introduction). In the barrel vault above the chancel, a great cross inscribed in a circle of deep blue floats in an expanse of glittering gold. This is a typical Iconoclast mosaic in which Christ is represented symbolically, not in human form. Monograms on either side of the cross are those of the Byzantine emperor Constantine VI (780–797) and his mother, Irene. Theophilos, bishop of Thessaloniki, has also left an inscription here. In the half-dome of the apse, a post-Iconoclasm mosaic shows the Virgin Mary seated on an elaborate throne with the infant Jesus on her lap. Since Mary was called the Throne of Wisdom, she is, in a sense, the patron of the church. The mosaic that decorates the central dome is probably from the end of the ninth century and is the only known representation of the Ascension in a church dome.

As with so many churches and temples in Greece, Agia Sofia was transformed into a mosque in 1585. In 1890, while still a mosque, it was damaged by fire and not completely repaired until 1907–1910. At that time, a lot of painted plaster decoration was added to the interior. The church was restored to Christian worship in 1912.

Further Reading

Hetherington, Paul. *Byzantine and Medieval Greece: Churches, Castles and Art.* London: John Murray Publishers, Ltd., 1991.

Krautheimer, Richard. *Early Christian and Byzantine Architecture.* Harmondsworth, England: Penguin Books, 1975.

Mango, Cyril. *Byzantine Architecture.* Milano: Electa Editrice/Rizzoli, 1978.

AGIOI ANARGYROI, KASTORIA

Style: Middle Byzantine
Date: Eleventh Century C.E.
Architect: Unknown

The Macedonian city of Kastoria is well known for its more than fifty small churches built in a colorful popular style by members of the community (see **Panagia Koumbelidike**). Of the seven that belong to the Byzantine period, Agioi Anargyroi is the oldest and, at thirty feet long, one of the largest. It was built in the early eleventh century and redecorated at the end of the twelfth. Agioi Anargyroi means "the holy penniless ones" or "the moneyless healers," which refers to Saints Cosmas and Damian, two Christian brothers famous in Cilicia for their knowledge of medicine. They never took money for serving their patients and were martyred at the end of the third century. Cosmas and Damian are the patron saints of pharmacists.

Although it is not known who built the church, its redecoration in around 1180 is explained by a long poem in the narthex, or vestibule, stating that the work was sponsored by Theodore Lemniotes and his wife Anna Radine. Theodore was in poor health and surely donated the money to refurbish the building as an offering to the healing saints. Inside Agioi Anargyroi is a fresco painting that depicts Theodore, Anna, and their son Ioannis as donors. Theodore offers a model of the church to the Virgin Mary and the infant Jesus.

Agioi Anargyroi is a miniature basilica, a church plan that was rather old-fashioned in the eleventh century. Its roots go back to Roman secular buildings and to early Christian traditions. In its simplest form, the basilica consists of a long hall, called the nave, aligned west to east. The nave is flanked by lower spaces, or aisles, and is closed at the east end by a semicircular termination, or apse. Added to the basilican core is the narthex, a transverse hall on the west end where baptisms and funerals were celebrated. The basilican plan is the most popular type of church design in Kastoria, where it seems to have been a local traditional form.

Although the exterior of Agioi Anargyroi has been heavily restored, it is a fine example of the cloisonné masonry that is typical of Kastorian Byzantine churches. Cloisonné is a decorative type of masonry in which rectangular blocks of stone are separated, or framed, by thin bricks and pieces of tile. On Agioi Anargyroi, conspicuous bands of bricks create strong horizontal accents. Kufic designs, which imitate an abstract style of Arabic writing, are repeated in wide bands between the courses of bricks. Arches of dog-tooth brick patterns

projecting from the surface of the walls frame the doorways, blind arches, and windows.

The cloisonné decoration at the east end of the building is particularly colorful and dense. In addition to large rectangular tiles and abbreviated Kufic designs, a double arch of projecting voussoirs (wedge-shaped blocks or bricks) tops the small window in the apse. Above the roof of the apse, a wall terminating in a small gable carries a horizontal band of rhombuses and, in the center, a spoked wheel design. This is paralleled by the larger gabled roof that covers the nave. Below the gable, a single arched window is framed by bricks of alternating light and dark colors; inside the upper part of the arch are two semicircles containing spokes, a variation on the design of the lower part.

One enters Agioi Anargyroi via the narthex, a transverse hall that extends the full width of the building. Its west facade has a single entrance door in the center with a blind arch on either side. Blind arches are filled with masonry, here cloisonné work, instead of being open like windows. The narthex has three bays, or rectangular units, separated by transverse arches. While the outer bays are covered by groin vaults, that in the center, connecting the narthex door to the nave door, has a barrel vault. The outer bays are linked by doors to the aisles. Above the narthex is a gallery space, or loft, for the women. The loft has a double arched window that looks down into the nave so that the women could discreetly watch the all-male service.

The nave is a very tall space that towers over the narthex, aisles, and apse. This sort of extremely elevated central space is typical of the Byzantine churches of Kastoria. The barrel vault over the nave springs from tall upper walls that rest on the robust walls and arches below. In a rather odd arrangement, the north and south sides of the nave are not symmetrical. There are two arches on the north but only one on the south. Since the arch on the south is roughly in the center of the hall while those on the north are at either end, all three arches open onto a wall across the space of the nave.

In the upper walls of the nave are pairs of double arched windows that form a clerestory. These windows are the major source of light, so the interior is rather dark. At the east end of the nave, the apse has a single small window that admits a little of the bright early morning sun but is cast in shadow most of the day.

The aisles that run parallel to the nave are much lower than the central hall and have separate shed roofs. Apparently, they were once covered with barrel vaults, but these have now disappeared. The aisles are quite broad; in fact, they are just as wide as the nave. In Agioi Anargyroi the view of the nave and apse from the aisles is rather restricted, and the aisles are very dark. Access from the exterior is provided by a door, flanked by blind arches, that opens into the center of each aisle. A semicircular niche carved into the west wall at the end of each aisle takes the place of the side chapels that are traditionally found in large basilicas.

The interior of Agioi Anargyroi is decorated with frescoes from the eleventh, twelfth, and thirteenth centuries. Numerous elongated figures of standing

saints look out from the walls, and there are also scenes from the cycle of the life of Christ. Perhaps the finest is a Lamentation full of pathos and spirituality. Agioi Anargyroi, a provincial church built in the tradition of folk architecture, is evidence for a host of vernacular buildings that were common in the Byzantine period but rarely survive.

Further Reading

Hellenic Macedonia. www.macedonian-heritage.gr/HellenicMacedonia/en/C2. 5.2.html.

Hetherington, Paul. *Byzantine and Medieval Greece: Churches, Castles and Art.* London: John Murray Publishers, Ltd., 1991.

Krautheimer, Richard. *Early Christian and Byzantine Architecture.* Harmondsworth, England: Penguin Books, 1975.

Mango, Cyril. *Byzantine Architecture.* Milano: Electa Editrice/Rizzoli, 1978.

AGIOI APOSTOLOI, ATHENS

Style: Middle Byzantine
Date: 1000–1020 C.E.
Architect: Unknown

During the early Middle Ages, the city of Athens experienced a steady decline. Symptomatic of this loss of wealth and prestige was the closing of Athens' schools of philosophy by Emperor Justinian in 529. As could be expected, no major building was undertaken in the impoverished city for many hundreds of years. Although Athens would never again during the Byzantine period be the preeminent city that it had been in antiquity, there was a revival of modest prosperity and relative security that began in the late tenth century. This was due to the accession to the Byzantine throne of the Macedonian dynasty, a family of warriors.

The Macedonians set out to reestablish the borders of the empire and to end the invasions of barbarian tribes from the north and Arabic pirates from the south. Basil II, a strong, practical military emperor, defeated the Bulgars in 1018, a victory that brought peace and stability to the Balkans for the first time in centuries. After the war, Basil celebrated his victory with a triumphal march through Greece. His procession ended in Athens where a festival of thanksgiving was held in the **Parthenon**, which had been turned into a church.

The victory of Basil II marked a period of renewed building activity in Greece, and although now a provincial city, Athens participated in this revival. There are several churches and monasteries there that date to the middle Byzantine period. The most interesting and innovative of all these buildings is the church of Agioi Apostoloi, a small masterpiece only fifty by thirty-eight feet, located at the southeast corner of the **Agora**.

The church is dedicated to the Holy Apostles, a group of seventy disciples, apostles, preachers, and bishops who are mentioned by Saint Paul in his letters and were later listed by Dorotheus, bishop of Tyre, in the fourth century. There is no documentation for the founding and building of Agioi Apostoloi, so it is dated by stylistic and structural criteria. Most scholars agree that the building be assigned to around 1020, while others prefer 1000. Whatever the exact date, Agioi Apostoloi is one of the oldest churches in Athens and has a plan that was not repeated at any other site in Greece.

The plan is based on the cross-in-square, which is a centralized structure with a large central bay, or spacial unit, covered by a dome carried by columns. Projecting from the central bay are four arms of equal length that form a cross.

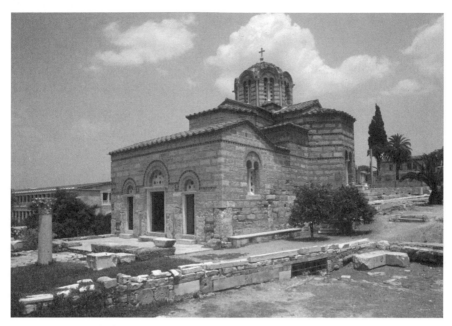

Agioi Apostoloi, Athens. *Courtesy of John Kurtich.*

The spaces between the cross arms are filled with smaller bays that give the church its square shape. But, the plan of Agioi Apostoloi revises the traditional cross-in-square by stressing curved surfaces and spaces and by expanding the space around the dome.

This revision is accomplished by terminating each arm in an apse, or semi-circular space covered by a half-dome, and by inserting four absidioles, or shorter and shallower apses, between them. The eight curved compartments expand the space around the central bay by merging with it to create a feeling of expansiveness that is, however, strongly unified. In the center of the church four columns, with reused classical capitals, support an octagonal drum that carries the dome. Additional support for the dome is provided by the strong wall system that is reinforced by the half-domes of the apses and absidioles. Eight windows in the drum provide the major light source for the building; the descending illumination subtly accentuates the central space.

As in all Orthodox churches, the sanctuary of Agioi Apostoloi is located in the eastern arm and apse. While the sanctuary is not set off architecturally from the rest of the plan, it would originally have been partially closed off by an iconostasis, which is a wood screen with a central door.

On the west side of the building is the narthex, or vestibule, that, despite being a later addition, is beautifully integrated into the overall design. There are three doors on its west facade and a single window in its narrow north and south sides. Transverse arches divide the interior space into three bays, each

of which carries a shallow dome. A door in the east wall of the narthex opens directly into the western arm of the nave. This door is flanked by two others that lock narthex and nave together very effectively. The space of the outer bays merges with that of two corner spaces adjacent to the absidioles on either side of the west arm. Thus, only two piers interrupt the continuity of space from the narthex into the cross-in-square.

On the exterior, Agioi Apostoloi presents a pleasing interplay of three-dimensional volumes and linear decorations. The polygonal shapes of the apses and absidioles rise at different levels and draw the eye up to the octagonal drum and the dome. At the corners of the drum are slender colonnettes supporting tall arches over the windows that push upward into the eave line of the roof to create the scalloped roofline that is characteristic of middle Byzantine churches in Greece. The roofs are covered with tiles that create a nice texture on the tops of the various parts of the building.

The walls are worked in cloisonné, a style of masonry in which blocks of stone (here grayish-white limestone) are enclosed, or framed vertically and horizontally, by courses of brick. In the upper levels of the walls, horizontal courses of brick dog-tooth molding run continuously around the building like decorative ribbons. There are also inserts bearing geometric designs and Kufic motifs. Kufic designs are patterns that are intended to imitate Arabic letters but don't reproduce them accurately. The contrast of limestone and brick gives a subtle polychromy and a restrained ornamental quality to the walls.

Agioi Apostoloi is the only church of any age or cult that still survives in the area of the Agora. This whole quarter of Athens was demolished so that the ancient marketplace could be excavated. The excavations were carried out by the American School of Classical Studies, which saved the church and restored it to its original form in 1954–1957. Although there is evidence that the building was once decorated with fresco paintings, they are completely lost.

Further Reading

Hetherington, Paul. *Byzantine and Medieval Greece: Churches, Castles and Art.* London: John Murray Publishers, Ltd., 1991.

Krautheimer, Richard. *Early Christian and Byzantine Architecture.* Harmondsworth, England: Penguin Books, 1975.

Mango, Cyril. *Byzantine Architecture.* Milano: Electa Editrice/Rizzoli, 1978.

AGIOI APOSTOLOI, THESSALONIKI

Style: Late Byzantine
Date: 1312–1315 C.E
Architect: Unknown

In the fourteenth century, Thessaloniki, the second most important city in the Byzantine Empire, was the leading center for original architectural experimentation. This was most likely due to a gradual but consistent increase in the prosperity of the city and the fact that its occupation by the Franks lasted for only twenty years (1204–1224), while the Crusaders of the Latin Conquest remained in Constantinople until 1259. Undoubtedly, civic pride in Thessaloniki was also a factor, for there had always been a subtle competition with the capital city. But even more importantly, religious fervor definitely played a part as patrons, both clergy and laity, raised churches to honor their patron saints, the Virgin Mary, and Christ. The Byzantines were deeply religious people, and their yearning for salvation and their anxiety about the afterlife were reflected in almost every aspect of their civilization. This is why new building projects abounded when the empire experienced periods of relative peace and economic security. Although reduced in size and political influence, the Byzantine Empire remained a powerful cultural force that was vital and creative during the last two centuries of its existence. And Thessaloniki played a major role in the development of late Byzantine architecture.

Most of the new churches in Thessaloniki were monastic, a trend that had been established in the middle Byzantine period. The finest of these is Agioi Apostoli, a church dedicated to the Twelve Apostles that was once the katholikon, or principal church, of a monastery consecrated to the Virgin Mary. The church was founded by the patriarch Niphon and constructed between 1312 and 1315. Niphon made certain that both God and the congregation entering the church would not forget his generosity. On the front wall of the building and on several of the columns are Niphon's monograms, and his name appears in an inscription over the major entrance to the church.

Agioi Apostoloi is a late form of the cross-in-square plan that was characteristic of Byzantine Greek churches. It is a centralized structure with a square central bay, or spacial unit, covered by a dome supported on four columns. Although earlier domes were wide and covered most of the square, the dome in Agioi Apostoloi is narrow and its height is emphasized by the vertical aspect of eight tall windows in the drum. Projecting from the central space are four arms of equal length that form a Greek cross. These carry barrel vaults that

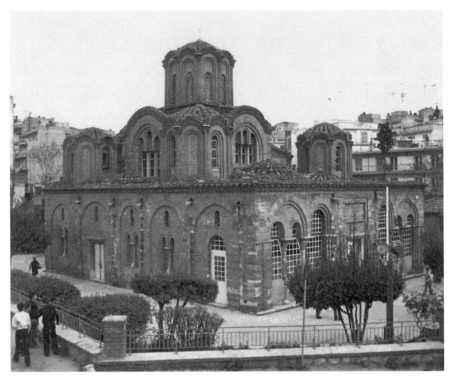

Agioi Apostoloi, Thessaloniki. *Courtesy of David A. Hanser.*

help to support the dome. A barrel vault is a continuous semicircular ceiling. Four small vaulted bays fill in the spaces between the arms of the cross and give the building its square shape.

The eastern arm of the cross is slightly prolonged by the addition of the apse, a semicircular space roofed with a half-dome, while two small rooms, also apsed, are inserted on either side. These are the prothesis and diaconicon, special chambers that were used for preparation of the Eucharist (Communion) and for storage of sacred books and priests' vestments.

The cross-in-square that forms the core of Agioi Apostoloi is quite small in comparison to the rest of the building and accounts for less than half of the total floor area. This is because three of its sides (the north, west, and south) are joined to a U-shaped ambulatory, or continuous aisle, with domes at its four corners. The ambulatory is quite wide in proportion to the cross-in-square and expands the interior space outward, while its four domes provide additional light at the corners. Although the liturgical function of the ambulatory is not known, it became one of the constants in late Byzantine church design. On the south side, the ambulatory originally had an open arcade—a

series of arches supported by columns. This is another distinguishing feature of many late Byzantine churches such as **Panagia Hodegetria** at Mistra.

On the west side of Agioi Apostoloi, the ambulatory is preceded by a vaulted narthex, or vestibule. The facade of the narthex is notable for the triple arcades that flank the entrance door. Each contains a pair of narrow arches framed by a wide blind arch and a third arch that is tall and narrow.

The exterior of Agioi Apostoloi is quite remarkable. Made of unattractive but practical mixed brick and stone, the exterior walls are concealed by the most lavish and beautiful brickwork in all of Greece. The excellence of the craftsmanship is evident in the textilelike patterns that are so carefully constructed and, in places, quite complex. Horizontal bands made of interwoven zigzags—some worked very tightly, others more loosely—run across the wall surfaces. Hook patterns, pendant triangles, net patterns, rosettes, and abbreviated meanders are contrasted with plain horizontal courses and dog-tooth moldings. Weave patterns and hexagonal stars as well as bricks alternating with white stones in window frames appear on the west facade. The east end of the church is the most impressive area, with richly textured two-dimensional designs playing across the curved surfaces of the three apses while tall blind arches, filled with patterns, introduce a vertical accent into the design.

The exuberance of the exterior decoration of Agioi Apostoloi was matched, if not superceded, by the ornamentation of the interior. Patriarch Niphon could boast that he had built the most lavishly adorned church in Thessaloniki. The columns that supported the central dome were antique and had beautifully sculpted capitals. In the vaults and domes were glittering mosaics, the most expensive type of church decoration and a rarity outside of Constantinople in the late Byzantine period. The mosaics followed the traditional scheme: Christ Pantocrator (Lord of the Universe) is represented in the large dome with ten prophets in the drum. In the vaults are Gospel scenes that symbolize the Twelve Feasts of the Church, the Anastasis (Harrowing of Hell), the Transfiguration, and the Dormition of the Virgin.

Below the color and sparkle of the gold-ground mosaics, the remaining interior wall surfaces are painted. Niphon apparently had intended to use marble veneer in the core of the church, but it was never installed. His successor, Paul, was responsible for finishing the decoration of Agioi Apostoloi, which was completed around 1334. Standing saints appear in the lower parts of the walls, and in the ambulatory vaults are scenes from the Old Testament, the Gospels, and the Apocrypha. The vaults of the narthex have the cycle of the life of the Virgin Mary, and the small corner domes have images of Christ and of the Virgin Mary.

Agioi Apostoloi, which remains a major monument in Thessaloniki, was used as a mosque from 1520 to 1530 during Turkish occupation of the city. The Turks removed the gold tesserae (cubes) of the mosaics, covered what remained of the images with plaster, and whitewashed the paintings. When Thessaloniki was liberated in 1912, the church was returned to the Orthodox

congregation. It was restored in 1949, and further conservation work was necessary after a series of earthquakes in 1978. The paintings were cleaned and restored at this time. In 1995, excavations in the surrounding area were initiated and continue today.

Further Reading

Hetherington, Paul. *Byzantine and Medieval Greece: Churches, Castles and Art*. London: John Murray Publishers, Ltd., 1991.

Krautheimer, Richard. *Early Christian and Byzantine Architecture*. Harmondsworth, England: Penguin Books, 1975.

Mango, Cyril. *Byzantine Architecture*. Milano: Electa Editrice/Rizzoli, 1978.

AGIOS ANDREAS, PERISTERA

Style: Early Byzantine
Date: 870 C.E.
Architect: Unknown

The modern village of Peristera is located in a mountainous region some twenty miles southeast of Thessaloniki. Known to the Byzantines as Peristerai, it served as a refuge for Saint Euthymius the Younger, a hermit who came from Galatia and was a follower of Saint Methodius, known as one of the apostles to the Slavs. In 870, during a chaotic and dark period in Greek history, Euthymius built a church dedicated to Saint Andrew that was possibly the katholikon, or principal church, of a monastery but today stands alone, a parish church in the center of the village. The area is said to have been infested with demons that had to be exorcized before construction could begin; the hermit built the church by himself with the aid of just three or four workmen. This story is important, since it would seem to explain the crudeness of the masonry work.

Agios Andreas has a complex yet remarkably unified and sophisticated plan. It is a quatrefoil, which is a figure with four lobe-shaped projections. The core of the design is a Greek cross with a slightly lengthened east arm. At the center of the cross is a square bay, or spacial unit, covered by a dome supported on four columns. Each of the four arms of the cross has a smaller dome, making a total of five. Five-domed churches are rare in Greece but much later become typical features of sanctuaries built in Bulgaria and Russia.

The Greek cross is complicated by the design of the arms. Each one becomes a triconch, which means that the sides and end of the arm have three deep semicircular niches covered with half-domes. On the exterior of Agios Andreas, the niches on the ends of the arms create a curved surface that gives the building its quatrefoil shape. Another complication is the addition of the barrel-vaulted prothesis and diaconicon on either side of the slightly elongated east arm of the cross. These two rooms were vital to the Orthodox service. The paraphernalia of the Eucharist were stored in the prothesis, on the north, while holy books and vestments for the clergy were stored in the diaconicon, on the south.

As is typical of middle Byzantine churches, Agios Andreas is quite small, only fifty feet long. There are only a few windows on the ground floor, and they are not large. The exterior of the building lacks ornamentation and has a heavy appearance. Its walls are made of rough rubble that lacks an attractive

finish. The five domes that rise above the roof create visual interest. The largest, in the center, has an octagonal drum pierced by several windows. Grouped around the central dome are the four lesser domes that have cylindrical drums.

Like the outside of the church, the interior is very modest with no frescoes or mosaics. On the floor are the remains of a simple pavement without decorative patterning. The four columns that support the central dome are crudely carved and have very simple capitals. Because the windows are small, the light is subdued. Such austerity seems appropriate for a church built by a hermit saint.

Originally, Agios Andreas did not have a narthex, or front vestibule. The one that now adjoins the church is a much later addition. At one time, the building apparently was transformed into a mosque. A broken minaret stands close by; it has been turned into a bell tower as a symbol of the return of the church to Orthodoxy.

Further Reading

Hetherington, Paul. *Byzantine and Medieval Greece: Churches, Castles and Art.* London: John Murray Publishers, Ltd., 1991.

Krautheimer, Richard. *Early Christian and Byzantine Architecture.* Harmondsworth, England: Penguin Books, 1975.

Mango, Cyril. *Byzantine Architecture.* Milano: Electa Editrice/Rizzoli, 1978.

AGIOS DEMETRIOS, THESSALONIKI

Style: Early Byzantine
Date: Late Fifth–Seventh Century C.E.
Architect: Unknown

Saint Demetrios is the patron saint of Thessaloniki and one of its earliest Christian martyrs. He was said to have been the victim of the Roman ruler Galerius, who ordered Demetrios's death during the persecutions of 303 to 311. Before his execution, Demetrios was imprisoned in a bath complex near the Agora, or town square. He was buried in the same building, and by 313 a small shrine for the martyr had been built over his tomb. In the late fifth century, the shrine was replaced by a huge church 180 feet long, the largest of its kind in Greece. A fire in the seventh century seriously damaged this building, but it was repaired using the original plan and incorporating the undamaged materials from the ruined church.

In 1917, another fire destroyed a great deal of Agios Demetrios. Because of the church's great spiritual significance to the faithful of Thessaloniki, a decision was made to reconstruct the damaged parts of the building and to preserve and incorporate the remnants of the original church. These remnants include a large portion of the exterior walls, the east end of the structure, many columns and other decorative material, and the major entrance to the church.

Agios Demetrios is a basilica with a cross transept. A basilica is a long hall, or nave, aligned west to east; flanked by lower spaces, or aisles; and closed at the east end in a semicircular termination called the apse. The cross transept is a transverse unit between the nave and the apse that, like the nave, is divided into a central space flanked by one or more aisles. Inclusion of a cross transept gives the basilica the shape of a cross with an elongated lower section, creating a Latin Cross. Agios Demetrios is the prototype for the basilica with cross transept in Greece, a design that spread throughout Macedonia, Thrace, and Bulgaria. The basilica, however, did not remain an important church type in the Byzantine world. By the middle Byzantine period, the centralized plan had become the standard for most Orthodox churches.

One enters Agios Demetrios through a narthex, or vestibule, that is flanked by low towers. Three stories of arched windows punctuate the facade, which is very plain and undecorated. Access to the nave is via a tribelon, which is an elaborate triple-arched doorway in the east wall of the narthex. The decorations of the tribelon—green marble columns with white capitals, red and green

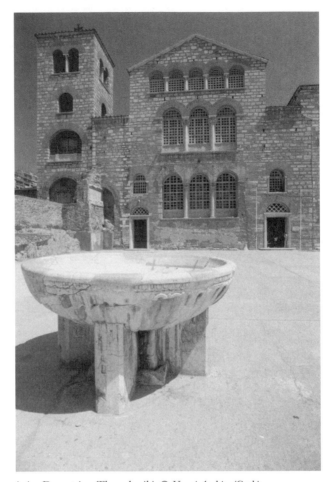

Agios Demetrios, Thessaloniki. © *Vanni Archive/Corbis.*

voussoirs (wedge-shaped blocks) in the arches, and piers sheathed in marble—are most likely remnants from the first basilica and give an idea of its sumptuous ornamentation. Two less ornate doors flanking the triple arch provide access to the inner aisles that run parallel to the nave.

The nave, which is nearly 120 feet long and is covered by an open timber roof, is the tallest space in the building and has an elevation of three stories. The lower two are arcaded, while the uppermost, called the clerestory, has arched windows. An arcade is a file of posts that supports a series of arches rather than a horizontal lintel. In Agios Demetrios, the alternation of piers and groups of columns in the arcades on either side of the nave creates a varied rhythm that moves the eye toward the transept and apse. The sequence is a pier, three columns, a pier, four columns, a pier, three more columns, and a pier. In the second story the scheme is repeated in a reduced scale. This locks the two stories together and creates strong vertical unity. Whether the

clerestory windows continued the rhythmic sequence of the arcades is not known.

The columns of the arcade are especially rich in color and have a variety of capital designs. There are composite capitals with tendril scrolls and acanthus leaves, capitals with eagles or other figures, and capitals with windblown acanthus leaves. These all appear to have originated in the fifth-century church. The arches have voussoirs of alternating colors, and the walls above them were originally decorated with thin slabs of variously colored marbles arranged in geometric patterns. In the second story, the columns and piers are linked by parapet walls because there is a gallery behind them. They support simple impost blocks, the wedged-shaped stones on which the arches rest.

The nave is flanked by two aisles on each side. As subordinate spaces, the aisles decrease in height; the aisles directly next to the nave are lower than the central hall, and the outer aisles are again lower. An arcade runs between each pair of aisles. There are windows in the exterior walls that provide illumination.

At the east end of the nave, the transept introduces a subtle transverse axis in front of the apse and also creates a rectangular unit at the crossing, called the chancel, where the altar is located. The height of the transept wings is somewhat less than that of the nave. An aisle of even lower height runs parallel to the main space of the transept. To the east of the transept the wall that frames the apse has two small windows at the clerestory level. The apse is the only curved space in the basilica and is roofed with a half-dome. Five windows in the apse create a burst of light at the end of the building behind the altar.

The half-dome that covers the apse was originally decorated with mosaic that would have reflected and refracted the light like a surface made of crystals. Other mosaics have been preserved, but most are incomplete. They depict St. Demetrios in various contexts, such as greeting small children and accepting the dedication of his church. These striking images were part of the original fifth-century building, and there are a few others that were added later. They are important works not only for their beauty, but also for the valuable evidence they provide of early Byzantine mosaic art before the prohibition of images during the Iconoclast Controversy of the eighth and ninth centuries.

Agios Demetrios has been the spiritual center of Thessaloniki for centuries and remains an enormously popular site for pilgrimage. The faithful come to worship and to visit the tomb of Saint Demetrios, which is located in a crypt beneath the south transept wing. A sacred oil with miraculous healing power is said to issue from the grave.

Further Reading

Hetherington, Paul. *Byzantine and Medieval Greece: Churches, Castles and Art*. London: John Murray Publishers, Ltd., 1991.

Krautheimer, Richard. *Early Christian and Byzantine Architecture*. Harmondsworth, England: Penguin Books, 1975.

Mango, Cyril. *Byzantine Architecture*. Milano: Electa Editrice/Rizzoli, 1978.

AGORA, ATHENS

Style: Archaic; Classical; Hellenistic; Roman
Date: Sixth Century B.C.E.–Second Century C.E.
Architect: Unknown

The agora in any Greek city was the heart of the local community, a place where people congregated daily and all manner of activities took place. The Greek word *agora* cannot be translated into a single English word because it had many meanings and encompassed the Greek concept of the mingling of diverse secular and religious actions in a single urban space. While the verb *agorazein* means "to go to market" or "to buy," it has other forms that signify concepts such as "to address a public meeting." The agora was thus an arena in which the vitality of life in the city-state was enacted. Religion, law, administration, politics, military planning, entertainment, philosophy, commerce, gossip, and even water distribution all took place in the agora.

The Athenian Agora is a fine example of the use of urban space and architecture to contain and monumentalize the social and civic rituals of the city. It is also closely linked to some of the most important personalities in Athenian history who were aware of the cultural and political capital that could be gained by support of urban building projects.

From the Mycenaean period until the end of the seventh century B.C.E., the area that would become the Agora was a gently sloping space in the lower part of the town, northwest of the **Acropolis,** that was used primarily as a cemetery. Early in the sixth century, Solon, the poet and statesman who wrote a famous law code and attempted to settle long-running disputes among the social classes of Athens, created the Agora. He cleared a rectangular area of about six acres for public use and sponsored the construction of the first group of buildings along the west side. These were administrative centers associated with the city council, or Boule, that met outdoors on the grounds of the Agora.

From 566 until 510, Athens was ruled by the tyrant Pisistratus and his sons. In addition to building projects on the Acropolis and elsewhere in the city, they contributed to the development of the Agora. A building resembling a house, constructed at the southwest corner, was probably used for the domestic needs of the city councilors. On the west side, north of Solon's buildings, an early temple of Apollo Patroos (Apollo the Father) seems to have been erected at midcentury. Next to this temple was a shrine dedicated to Zeus Eleutherios, the god who maintained the freedom of the city.

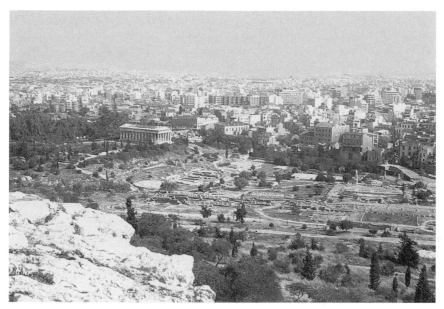

The Agora, Athens. *Author's Photo.*

The northernmost building constructed on the west side was the Royal Stoa, or Stoa Basileios. In its most basic form, a stoa was a long hall comprised of an open colonnade in front of a wall with a roof covering the space in between. Stoas were used to frame public spaces and were the setting for shopping, public administration, legal proceedings, informal meetings, philosophical discussion, education, social interaction, and shelter from the elements. The Royal Stoa was fifty-eight feet long and twenty-three feet wide. Solid walls of limestone enclosed the space on three sides. The colonnade, which opened onto the Agora, had eight columns in the Doric order above two steps. Inside the stoa was a file of four Doric columns that supported the roof. Like the walls, the columns were made of limestone. The stoa was the seat of the Royal Archon, the official who was responsible for religious and legal matters, and on the walls were displayed copies of the venerable law codes of Draco and Solon. Directly in front of the stoa was a massive block of limestone on which the city officials stood when taking the oath of office.

A large fountain house at the southeast corner of the Agora has been identified as the famous Enneakrounos (which means "nine-spouts"), part of the Pisistratid restructuring of the city's water system. Women and slaves would congregate here daily because there was no indoor plumbing in Athenian houses. Fountains were notoriously places of seduction; men worried about the virtue of their wives and daughters when the females left the family home to collect the day's water supply.

Pisistratus sponsored the enlargement of the most important religious festival in Athens, the Great Panathenaea. This was a series of religious games and competitions held every four years in honor of Athena. A major feature of the festival was a solemn procession from the lower city up to the Acropolis on the Panathenaic Way that crossed the Agora from roughly north to south. During the Panathenaea, a section of this road was used as a racetrack and a venue for gymnastic events, while an area in the center of the Agora called the orchestra (which in Greek means "dancing place") was the setting for musical and dramatic competitions. Pisistratus's grandson and namesake set up the Altar of the Twelve Gods in the northern part of the Agora by the side of the Panathenaic Way. The altar was a place of asylum and also marked the starting point for the Attic milestones.

In 508, following the expulsion of the Pisistratid tyranny in 510, Cleisthenes enacted a series of constitutional reforms that laid the foundation for the establishment of the Athenian democracy. Statues of the Harmodios and Aristogeiton, the assassins of one of Pisistratus's sons, were dedicated in the Agora as a memorial to the heroic tyrant slayers who liberated Athens. During the following years, at the beginning of the fifth century, the Agora received a number of substantial structures that were designed for civic and religious activities. Marble posts that bore an inscription—translated as "I am the boundary marker of the Agora"—were installed at the entrances to the square, marking the space as a sacred precinct forbidden to certain types of criminals. On the south side of the Agora was the Heliaia. It was an unroofed structure, 87 feet wide and 101 feet long, surrounded by a wall of carefully squared limestone blocks. The Heliaia, the oldest and most important civil court, takes its name from the sun god Helios because court sessions were held before sunrise.

A great drain that ran in front of the buildings on the west was constructed to channel rainwater into the Eridanos River. The old buildings on the west were demolished and replaced with the so-called Old Bouleuterion, a formal meeting hall for the newly established democratic Council of Five Hundred. To accommodate speeches and debate, the building was designed as a square, 65 feet long on each side, with seating on three sides. An entrance corridor gave access to the auditorium, which had five columns, placed in a U-shape, that supported the ceiling and framed the open speaker's space in the center of the seats. North of the Old Bouleuterion, the Metroon, a small temple dedicated to the Mother of the Gods, was built.

When the Persians invaded Athens in 480–479, they sacked and burned the Agora. The Heliaia, Bouleuterion, and Royal Stoa were damaged but not destroyed. They were repaired and continued to be used after the Greek victory in the Persian Wars. In the 460s, under the leadership of the general and statesman Cimon, two new civic structures were added to the Agora. At the southern end of the west side, next to the Bouleuterion, was the Tholos, a circular building sixty feet in diameter that was made of limestone and had six columns inside supporting a conical roof. The Tholos was the temporary

dwelling place of one-third of the fifty Prytaneis, the councilors who were required to take turns living in the Agora at all times.

For the pleasure of the citizens, a new stoa was built at the north end of the Agora and became one of the most famous buildings in Athens. The Stoa Poikile, or Painted Stoa, was a double-aisled hall, facing south, with nineteen Doric columns opening onto the Agora and nine Ionic columns, supporting the ridge of the gabled roof, in the interior. This building was decorated with murals painted by the most famous artists of the time, including the acclaimed Polygnotus. Four scenes of victory were depicted: the Greeks taking Troy, the Athenians defeating Amazons, the Battle of Marathon, and the Battle of Oinoe. Although the Painted Stoa housed civic and legal proceedings, it was best known as a place for people to promenade and to encounter entertainers, beggars, poets, and philosophers. Zeno of Citium taught here in the late fourth century, and the building gave its name to his philosophical school, the Stoics. To further enrich the citizens' enjoyment of their civic center, Cimon planted plane trees to provide shade in the open square.

From 461 until 429, while Pericles was leader of Athens, little work was done in the Agora. This was because the major efforts in public building were concentrated on the reconstruction of the Acropolis. One structure, the Strategeion, roughly trapezoidal in shape and containing seven or eight rooms surrounding a central courtyard, was added to the west side of the Agora south of the Tholos. The Strategeion was the headquarters of the ten generals, and here military commanders met to dine, transact business, and sacrifice together. On Kolonos Agoraios (Market Hill), beyond the western buildings, the **Temple of Hephaestus** was begun.

In the last third of the fifth century, there was a burst of building activity in the Agora. Previously, the main area of development was on the west side of the open square, but now buildings appeared also on the south. South Stoa I marked the southernmost boundary of the Agora and presented a long Doric portico running between the Enneakrounos and the Heliaia. The stoa, which seems to have been the location of the commissioners of weights and measures and of other civic offices, had two aisles separated by an internal colonnade. Behind the aisles was a series of fifteen rooms designed to hold seven dining couches each. Here the officials who worked in the stoa would enjoy the midday meal together. The exterior walls and columns of South Stoa I were made of limestone, but the walls of the dining rooms were sun-dried brick on top of a limestone base. Between the Enneakrounos and the Panathenaic Way, a large building with rooms of various sizes arranged around a central court has been identified as the Mint of Athens. The identification is based on two inscriptions and on the discovery of blanks for making coins and furnaces for smelting the metal.

The west side of the Agora was enriched by two new structures. A New Bouleuterion was constructed to the west of the old one, which was not demolished but became a state archive. The new rectangular meeting hall stood on a terrace cut back into a hillside. Inside, wood benches stood on a surface that

was hollowed out to form a rising floor on three sides similar to the auditorium of a theater. Two columns close to the front wall and a similar pair close to the back wall supported the ceiling without obstructing the view of the speaker's space. Entrance was from the long hall on the east side.

To the north, the Stoa of Zeus Eleutherios was built over the old sanctuary of Zeus just south of the Royal Stoa. This magnificent building, dedicated to the god who delivers the city from danger and preserves its freedom, had a recessed central colonnade and projecting wings ending in temple-shaped facades at either end. The outer colonnade, which stood on steps of blue-gray Hymettian marble, was made of white marble in the Doric order. Nine columns ran across the recessed part of the stoa, while four were placed in the offsets and six made up the facade of each wing. The wings had Doric entablatures that included a Doric frieze and pediments without sculpture. On the corners of the pediments were sculpted finials of flying Nikai (Victories), a feature rarely found in stoas. Nine Ionic columns, also of white marble, divided the interior space into two aisles and supported the ridge of the gabled roof. The building was lavishly decorated inside with mural paintings by Euphranor. Their themes—the Twelve Olympian Gods, the hero Theseus with personifications of Democracy and the People, and the Battle of Mantinea—document the close relationship of religion, public policy, and military supremacy in Athenian society. On the walls were hung the shields of warriors who had died fighting for Athens. In front of the building was a statue of Zeus Eleutherios.

Finally, the late fifth century saw the construction of the Monument of the Eponymous Heroes. Although the monument is mentioned by the comic writer Aristophanes in the *Peace* of 421, its exact location is unknown. A possible site at the southwest corner of the Agora has been proposed. The monument carried statues of the ten legendary heroes of Attica who became patrons of the ten tribes of Athenenian citizens that were created by Cleisthenes in 508 and were therefore closely associated with the founding of the democracy.

In the fourth century, building in the Agora was directed toward improvement of both civic and religious facilities. A splendid new fountain house was constructed at the southwest corner next to the Heliaia. Because it was situated alongside a road at the entrance to the Agora, the fountain house supplied water for people going in and out of the square as well as for the crowded residential area to the south. The building was L-shaped with a continuous colonnade running along its front. An interior row of columns divided the space into two parts: the water basin with a thick parapet in front and a porch that provided shelter from the elements for those who came to draw water. Water was delivered to the fountain house by an underground channel, made of limestone, that ran under the street at the south end of the Agora.

Shortly after the middle of the century, the Monument of the Eponymous Heroes was redesigned and moved to the area in front of the Old Bouleuterion. The monument, which consisted of a long rectangular pedestal that supported slightly more than life-sized bronze statues of the Athenian ancestral heroes,

served a civic function as the official notice board of the city. Drafts of proposed laws, written on whitened wood tablets, were affixed to the sides of the pedestal, as were the lists of men called for military duty and the announcements of pending lawsuits. A fence of stone posts and wood rails surrounded the monument.

When the famous orator and prosecutor Lycurgus was appointed to supervise Athens' finances in 338, he instituted a diverse building program that included work in the Agora. On the west side, two temples dedicated to the patron deities of the civic organization of Athens were constructed. The Temple of Zeus Phratrios and Athena Phratria was located directly to the south of the Stoa of Zeus Eleutherios. This temple was a small building, really only a rectangular cella with a door on the east side. Despite its diminutive size, the temple was an important religious and political monument because it was the sanctuary of the deities who presided over the ancestral religious phratries (brotherhoods) that were the basis for Athenian citizenship. Immediately to the south of this temple, a new Temple of Apollo Patroos was built. It was a small Ionic structure with a rectangular cella and a deep front porch with four columns. On the north side was a small room, or adytum, entered from the cella. The adytum is a feature of many Apollo temples, such as the **Temple of Apollo Epicurus at Bassae**. In Athens, Apollo was worshiped as Patroos, "the Father," because his son Ion was the founder of the Ionian race, the race of the Athenians. The children of all Athenian citizens were formally inducted into their father's brotherhood at a ceremony associated with the Temple of Apollo Patroos. Also on the west side of the Agora, a portico was added to the south face of the New Bouleterion and a monumental entranceway, or propylon, was built to mark the approach from the open space of the square.

Various structures on the south and north sides of the Agora were used for legal business and trials. In the fourth century, a formal meeting place was constructed at the northeast corner in an area that contained a series of fifth-century buildings identified as law courts by the discovery of ballots and other objects known to have been used during legal proceedings. These structures were demolished to make way for the new court building, the Square Peristyle. The structure consisted of a large open court surrounded by roofed colonnades, much like stoas, on all four sides. Large spaces were necessary for the court proceedings of the fourth century, because the juries were commonly made up of five hundred citizens. A final project, which seems to date to the late fourth century, was the addition of projecting wings at each end of old Royal Stoa. The wings looked like small temple facades with three columns and pediments without sculpture. On the central axis of the Royal Stoa, a larger than life-sized statue of the goddess Themis, protector of vows and the law, was set up close to the stone on which the city officials took their oath of office.

During the period of Athens' dwindling military and economic power, which began in the late fourth century and lasted for a century and a half, no significant construction projects were undertaken in the Agora. Building activity only resumed in the second century when the economic situation had

stabilized and the kings of the Hellenistic monarchies in the eastern Mediterranean area took a special interest in Athens. The largest and earliest of the second-century buildings was the Middle Stoa, which was begun around 175. It was 482 feet long and 57 feet wide, and because it was located in approximately the middle of the Agora, it divided the old civic square into two parts, north and south. The building stood on a platform of three steps, and a colonnade of 160 unfluted Doric columns enclosed all four sides. Inside, 23 columns (probably Ionic) connected with screen walls divided the interior into two long halls. Essentially, the structure was a pair of back-to-back stoas that shared a party wall made up of the interior columns and screen walls. A variety of materials and generous use of color made the Middle Stoa a magnificent building. The platform and columns were made of limestone. In the Doric frieze zone above the columns, limestone triglyphs painted blue alternated with white marble metopes. The gutters on all four sides, with lion-head spouts, were made of brightly painted terra-cotta.

The area south of the Middle Stoa is referred to as the South Square because it became a separate spacial unit in the second century. Around 150, an unusual structure, the East Building, was constructed on the east side of the square. Its function seems to have been to close off the east side of the South Square from the city and to serve as an entrance to the square. The building was long and narrow and was divided lengthwise into two distinct parts on two different levels. On the east side, the exterior consisted of a plain masonry wall interrupted by several doorways; the exact number is not known. Inside, a line of columns divided the hall into two aisles. The west wall of the hall was broken only in the center where it contained a central rectangular space with a staircase leading down to the South Square. Four other rooms on a lower level abutted the wall and opened toward the west. The two flanking the staircase were open in front, except for two columns, and had marble benches on three walls. These rooms were presumably resting places where the Athenians could sit and enjoy a view of the South Square. Each of the outer two rooms on the west side had a single door that opened onto the square.

The renovation of the southern end of the Agora was completed around 150 by the construction of South Stoa II. This building was situated on the southern edge of the Agora on approximately the same location of South Stoa I, which was demolished to make way for it. South Stoa II was a single-aisled colonnade of thirty Doric columns standing on a platform of two steps that opened onto the square. The building's solid, short end walls and long back wall were made of limestone. Off-center in the back wall was a fountain fed by the same underground aqueduct that provided water for the southwest fountain house. At the east end, South Stoa II had a door that communicated with the East Building. The design of the South Square differed from that of the old Agora in that it was conceived of as a unified space enclosed by long buildings. The Doric colonnades of the Middle Stoa and South Stoa II echoed one another across the space, while the East Building presented a simple facade marking the easternmost boundary of the square.

Attalos II, king of Pergamon from 159 to 138, financed the building of a grand two-storied stoa slightly to the north of the Middle Stoa on the east side of the Panathenaic Way. The **Stoa of Attalos**, 380 feet in length, was a gift to the people of Athens from the powerful monarch, who had been educated in Athens and valued the city as a cultural and artistic center. The outer colonnade of the building was Doric on the lower level and Ionic above. Within, the stoa was divided into two aisles by a file of columns on each floor. The lower colonnade was Ionic, while the columns in the second story had Egyptianizing palm capitals. On each story, twenty-one rooms, used as shops, were arranged behind the double-aisled hall. Stairways on the north and south ends of the stoa provided access to the upper hall and shops.

At some time between 150 and 125, a final construction project was undertaken on the west side of the Agora in the area where Solon's buildings had once stood. This was the Matroon, or sanctuary of the Mother of the Gods, which was built over the Old Bouleuterion and the foundations of the fifth-century Metroon. The building had four units that faced east into a colonnade of fourteen Ionic columns. The southernmost unit was a simple rectangular room, while the unit next to it took the form of a small temple with a rectangular cella and front porch with two columns. Next to the temple room was a slightly larger rectangular chamber. The northernmost unit was the largest of the four and contained a square colonnade, or peristyle, of twelve columns that surrounded an altar. Two more columns stood opposite the entry between flights of steps leading to an upper gallery. The Metroon was a building in which very ancient cult and political activity coexisted harmoniously. The simple rectangular rooms functioned as a state archive, while the temple-shaped room was the shrine of the Mother of the Gods. Although the function of the large unit has not been identified, the altar in the center of the square colonnade suggests that it surely had cultic significance.

The building projects of the second century fixed the layout of the Agora for the rest of antiquity. During the Roman period, there was destruction and rebuilding on the site. In 86, during a war with Mithradates VI, king of Pontos, the Roman general Sulla stormed the Agora and destroyed a number of buildings. The South Square was demolished and never rebuilt; it became an industrial quarter. Augustus Caesar was especially generous to Athens, and a number of structures that filled in the previously open north part of the Agora can be dated to his reign. The most notable of these were the Odeum of Agrippa, which was a covered concert hall, and the Temple of Ares. In the later first century c.e., a pair of temples and some new civic offices were built. Hadrian, the emperor known as "the Greekling" because of his admiration for all things Greek, reconstructed Agrippa's Odeum, built a nymphaeum (an elaborate water fountain), and added a library to the already crowded space of the Agora. For the Romans, the Agora was a symbol of Greek culture, a place to be enriched and preserved because of its glorious history.

The Agora today is a confusing accumulation of foundations, broken columns, fractured architectural details, and empty statue bases. Identifying

the monuments and appreciating their historical and cultural significance takes time and careful study. The destruction of the Agora began in 267 when the Herulians, a nomadic tribe from the north, sacked and burned Athens. Following the raid, material from the damaged buildings in the Agora was used to build a circuit wall around the Acropolis and a small part of the lower town. The Agora was outside the wall and therefore subject to depredation. Further invasions by northern tribes, this time the Goths, in the fourth century resulted in extensive destruction. After yet more raids in the sixth century, the Agora was gradually abandoned. It became a residential district in the tenth century.

Excavations in the Agora have been long and complex because of the many layers of buildings that have accumulated over the centuries. The Greek Archaeological Society began clearing the site at the end of the nineteenth century. Thanks to the financial support of John D. Rockefeller, excavations conducted by the American School of Classical Studies began in 1931. In the 1960s, the Ford Foundation funded further digging. The Stoa of Attalos has been rebuilt and today houses a museum where artifacts found in the excavations are on display.

Further Reading

Dinsmoor, William B. *The Architecture of Ancient Greece*, 3d ed. New York: W. W. Norton, 1975.

Lawrence, A. W. *Greek Architecture*, 4th ed. R. A. Tomlinson, ed. Harmondsworth, England: Penguin Books, 1983.

Thompson, Homer A. *The Athenian Agora*, 3d ed. Athens: American School of Classical Studies, 1976.

ALTIS, OLYMPIA

Style: Geometric; Archaic; Classical
Date: 776 B.C.E.–Fourth Century B.C.E.
Architect: Unknown; Libon of Elis

The sacred precinct at Olympia, located in the wide valley of the Alpheios River in the western part of the Peloponnesus, is called the Altis—a word derived from *alsos*, meaning "the grove"—because the area was thickly wooded with oaks, plane trees, poplars, and olives. The site was continuously inhabited from Mycenaean times until the sixth century c.e. Cult activity apparently began at the foot of the hill of Kronos where altars to Rhea, Gaia, and Eileithya have left their traces. The hero cult associated with Pelops and Hippodameia was focused on the burial mound, or tumulus, of Pelops, the master of the chariot who won the hand of Hippodameia by defeating her father in a race. The Pelops legend probably gave rise to the earliest athletic contests celebrated in honor of the heroes and the gods. The Greeks believed that their gods took pleasure in watching the *agon*, or competition, among men for pre-eminence. Originally, the contests seem to have been purely local religious affairs, but before long they attracted both competitors and spectators from neighboring communities.

During the time of the Dorian invasions, around 1100 b.c.e., settlers from northwestern Greece inhabited the Altis and introduced the worship of Olympian Zeus and Hercules. The Altis was given the name Olympia in connection with the Zeus cult.

The eighth century was an important time of consolidation and organization. In 776, the games were reorganized and the date of their celebration was fixed at four-year intervals, called Olympiads. A Sacred Truce was initiated so that participants and spectators could attend the athletic competitions without fear. The truce, which was valid for all of Greece, prohibited all hostilities for one month, declared the territory around Olympia sacred, and forbid men or armies carrying weapons to cross its borders.

Only one sport was played at this time: the footrace over the distance of one stadium, which was said to have been introduced to Olympia by Hercules. The fame of Olympia and its religious games spread throughout Greece, and this led to increasing numbers of athletes and spectators. Olympia became a Panhellenic religious center, a place where Greeks from many different city-states could meet, compete, exchange ideas, and celebrate their common religious beliefs. At this time, the Altis was enclosed with a fence and contained a few

simple structures. There were altars of the gods; the hero shrines of Pelops and Hippodemeia; the "column of Oinomaos," said to be the only remnant of the house of Hippodemeia's father; and a sacred olive tree that, according to myth, was brought from the land of the Hyperboreians to the Altis by Hercules. The site of the eighth-century racecourse is not known.

In the seventh century, there was much expansion of the games held in the Altis. Competitors traveled to Olympia not only from the city-states of mainland Greece, but also from the numerous Greek colonies scattered around the Mediterranean Sea. New events such as the double-course footrace, the long footrace, the pentathlon, wrestling, boxing, and horse and chariot races were added.

Following the expansion of the games, a great deal of building took place in the Altis. Early in the sixth century, work began on the **Temple of Hera** located at the south of Kronos Hill where the oldest altars and shrines were located. Later in the century, the Prytaneion was constructed in the northwestern corner of the Altis. This simple square building was the residence of the magistrates in charge of the sanctuary. The Prytaneion contained the hearth of Hestia, goddess of the sacred fire, and a dining hall where victors in the contests and special guests dined and were entertained. Bordering the north edge of the Altis was a series of fifteen small temple-shaped buildings, the treasuries, that were built over the course of the sixth century and the beginning of the fifth century. Each treasury was constructed by a city-state to commemorate its participation in the Olympian cult and to house its treasures, that is, the expensive gifts and offerings dedicated at Olympia by its citizens.

The ancient tomb of Pelops received a new enclosure wall that was pentagonal, and altars to Zeus, Hera, and the Mother of the Gods were set up close by. The altar of Zeus has not survived—it was a large mound made up only of sacrificial ashes that have washed away over the centuries. The sixth-century stadium for footraces was laid out to the east of the Temple of Hera at the lower end of the terrace where the treasuries stood. The finish line of the track was opposite the altar of Zeus. Embankments on either side of the track allowed for spectator seating. Finally, the horse and chariot races were provided with a separate racecourse, the Hippodrome, that was 1,783 feet long. Although it has not been excavated, ancient sources state that the Hippodrome was located to the south of the stadium and ran parallel to it.

The most important architectural project of the fifth century, and the largest temple in the Peloponnesus, was the incomparable **Temple of Zeus**, designed by Libo of Elis. Throughout antiquity, the temple was considered the most perfect example of the Doric order, and its fame only increased with the installation of the great cult statue of Zeus, made by Phidias, proclaimed one of the Seven Wonders of the World. Other building activities of the fifth century were situated outside the Altis and were primarily secular in nature.

In the fourth century, as the Olympic Games became progressively more secular, there was a wave of new construction in the Altis. A circuit wall with five gates was built around the precinct, and a new stadium was constructed

outside the Altis, an indication of the loss of the religious significance of the athletic contests. The course of the stadium was 702 feet long, and the track was flanked by earth embankments. Only a few seats for important visitors and officials were provided; the remaining forty-five thousand spectators sat on the ground.

The separation of the new stadium from the Altis was marked by the construction, around 350, of the Echo Stoa, which ran along the eastern boundary of the sacred precinct. A stoa was a long building closed at the back and open at the front where a continuous file of columns supported the roof. Stoas were frequently used, as here at Olympia, to frame public spaces and to provide shelter from the elements. The Echo Stoa, 325½ feet long and 40 feet wide, had an interior colonnade in the Ionic order and an outer colonnade, opening onto the Altis, in the Doric order. The name Echo Stoa was given to the building because of its strange acoustics: an echo would be multiplied seven times in the long hall. In the Roman period, the building acquired a new name, the Painted Stoa, or Poikile, because of the paintings that decorated the interior.

Also in the fourth century, the Metroon, or Temple of the Mother of the Gods, was built in front of the terrace of the treasuries. The building, in the Doric order, was rectangular and had a rectangular cella with a pronaos and opisthodomos, each with two columns. A single row of columns surrounded the cella, six across the front and back, eleven on the flanks. The Metroon was 32 feet 10 inches long and 67 feet 9 inches wide. Later on, in the Roman period, the temple was used for the worship of the imperial family. On the route from the Metroon to the stadium were the Zanes, sixteen bronze statues of Zeus, that were set up beginning in the fourth century. These were paid for by fines imposed on athletes who cheated. The names of those who had broken their oath to participate fairly were recorded on the statue bases. At the south end of the Echo Stoa, a rectangular building with four rooms enclosed on three sides by a file of Doric columns has been identified as the sanctuary of Hestia.

Finally, located to the south of the Prytaneion was a round structure, or tholos, called the Philippeion. It was built by Philip II of Macedon and his son Alexander the Great to celebrate the victory at Chaironeia in 338 B.C.E. The building stood on a raised marble base and had a colonnade in the Ionic order. Inside the circular cella the walls were enriched by fourteen Corinthian half-columns, and opposite the entrance door were five ivory and gold statues, sculpted by Leochares, that represented Alexander, his parents, and his grandfathers.

The Altis remained an important Panhellenic shrine during the Hellenistic and Roman periods. The emperor Nero even participated in the games! After the Herulian Raids of 260–270 C.E., the Olympic Games continued in the damaged sanctuary until the last Olympiad was celebrated in 393. In 394, the emperor Theodosius I outlawed worship at pagan sanctuaries, effectively ending the twelve centuries of Olympic contests. Theodosius II ordered that the buildings at Olympia be dismantled in 426, and in 522 and 551 disastrous

earthquakes seriously damaged what little remained. The site was gradually covered by a thick layer of earth, the result of floods and landslides. It was first explored by a French team in 1829, and in 1875 systematic excavations were begun by the German Archaeological Institute.

Further Reading

Ancient Olympics, The. Perseus Digital Library. www.perseus.tufts.edu/Olympics.

Lawrence, A. W. *Greek Architecture*, 4th ed. R. A. Tomlinson, ed. Harmondsworth, England: Penguin Books, 1983.

"Olympic Games, The." Hellenic Ministry of Culture. www.culture.gr/2/21/211/21107a/og/games.html.

Princeton Encyclopedia of Classical Sites. Perseus Digital Library. www.perseus.tufts.edu/cgi-bin/ptext?doc=Perseus%3Atext%3A1999.04.0006.

Yalouris, Nikolaos. *Olympia.* Paul J. Dine, trans. Munich and Zurich: Verlag Schnell and Steiner, 1972.

ATHENIAN TREASURY, DELPHI

Style: Archaic
Date: 500–485 B.C.E.
Architect: Unknown

Facing the Sacred Way in the **Sanctuary of Apollo** at Delphi is the Athenian Treasury. A treasury is a small one-room structure with a front porch that was built to house expensive objects that had been left as offerings to a god, in this case, Apollo. Each treasury was constructed by a single city-state and became a testament to the wealth and piety of its citizens. In the competitive spirit that was such an important factor in Greek culture, the city-states vied with each other in the decoration and costly materials lavished on their treasuries.

According to the Roman travel writer Pausanias, the Athenian Treasury was paid for by the spoils of the Battle of Marathon, which implies a date of construction shortly after 490. But this information is disputed. Some modern scholars have used the style of the architecture and sculpture to arrive at a date of about 500, while others suggest that the treasury was built shortly after the establishment of the Athenian democracy in 508. Since these theories cannot be reconciled, it is reasonable to assign a more generalized date of 500 to 485.

The treasury resembles a miniature temple in the Doric order. It is made completely of marble, a significant fact. Marble was not often used on the mainland in the sixth century, but it became the material of choice in the fifth. The Athenian Treasury is the earliest known Doric building made entirely of the new material.

There are no steps on the rectangular base, about three feet tall, on which the treasury stands. This made entering the treasury extremely difficult and indicates that the building was to be experienced mainly from the outside, like a beautiful work of sculpture. Also, since the treasury stored expensive and precious offerings, it had to be secure, like a modern vault, and was not open to the public.

The plan of the Athenian Treasury was quite simple. The storage room was a rectangle with solid walls on three sides and a door in front. Its interior walls were decorated with horizontal bands of incised and painted palmette chains. The flank walls were extended beyond the front wall of the storage room to form a porch with two Doric columns between the ends of the walls. This was the same design that was traditionally used for the pronaos of a Doric temple.

The treasury was twenty-two feet wide and thirty-two feet long. Above the lintels that rested on the columns was a continuous band, or Doric frieze, made

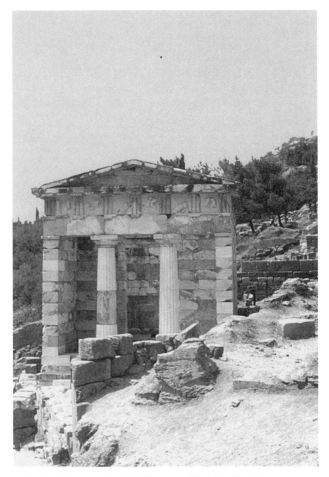

Athenian Treasury, Delphi. *Courtesy of Caroline Buckler.*

up of alternating triglyphs and metopes. Triglyphs are rectangular blocks with vertical grooves cut into their surfaces; metopes are the flat panels between the triglyphs. The frieze ran around all four sides of the building and contained thirty metopes with relief sculpture. Above the frieze, on the front and back of the treasury, were the pediments, triangular areas shaped by a molding above the frieze and the slanting eaves of the gabled roof. Since the roof was pitched low, the pediments were unusually squat, but fragments of statues indicate that they once contained sculpture. An unidentifiable battle was represented on one end, and on the other there were chariots and a figure that may have been Athena, patron goddess of Athens. Statues of Amazons on horseback served as finials at the three angles of each pediment.

The frieze with thirty sculpted metopes was an innovation in Athenian architectural decoration, the first of its kind. As is usual in Greek architectural decoration, the subjects represented were taken from mythology and surely

had some sort of allegorical function. On the front, facing the Sacred Way, was a battle between Greeks and Amazons, the fearless warrior women from the eastern frontiers. On the south flank the adventures of Theseus were depicted, and on the north flank and the back the labors of Hercules appeared. The choice of the two heroes, Theseus and Hercules, may be related to historical events in Athens. Theseus's adventures are located on the two most conspicuous sides of the treasury. A visitor approaching the building would have seen them first and would have to stop and reverse direction to see the Hercules metopes.

This sculptural arrangement has suggested to some scholars that the treasury celebrates the institution of the democracy at Athens in 508. For much of the sixth century, Athens had been ruled by the Peisistratid tyrants who associated themselves with Hercules. The hero was a favorite character in Athenian vase-painting during this period. But Hercules was eclipsed to a certain degree when the democracy was founded.

The Athenian hero par excellence was now Theseus, legendary king of Athens, who unified the districts of Attica into a great city-state under Athenian leadership. During the Persian Wars, the Athenian soldiers claimed that the ghost of Theseus had led them to victory at Marathon. After the war, the bones of the hero were transported from his tomb on the island of Skyros to Athens, where he became the patron of the democratic regime.

Both Hercules and Theseus fought Amazons, but the most popular myth in the democracy was the victory of Theseus and the Athenians over the warrior women who tried to storm the Acropolis. A parallel to the Persian assault on the Acropolis in 480 would have been obvious to the ancient viewer. The conspicuous position of the Theseus metopes, and the secondary position of the ones depicting Hercules, would be most appropriate on a building constructed by the Athenians after they took credit for winning the Persian Wars and had set up their new and revolutionary government.

French excavators, with financial aid from Athens, reconstructed the Athenian Treasury in 1904–1906 c.e. During the work, they discovered that the walls of the treasury were covered with more than 150 inscriptions. Most important among these were two hymns to Apollo complete with musical notations, a very valuable contribution to the history of music. Casts of the sculpted metopes were used in the modern rebuilding; the originals are displayed in the Delphi Museum.

Further Reading

Berve, H., G. Gruben, and M. Hirmer. *Greek Temples, Theaters and Shrines.* London: Thames and Hudson, 1963.

Dinsmoor, William B. *The Architecture of Ancient Greece*, 3d ed. New York: W. W. Norton, 1975.

Lawrence, A. W. *Greek Architecture*, 4th ed. R. A. Tomlinson, ed. Harmondsworth, England: Penguin Books, 1983.

CHOREGIC MONUMENT
OF LYSICRATES, ATHENS

Style: Classical
Date: 334 B.C.E.
Architect: Unknown

The Street of the Tripods, a very ancient route that connected the Theater of Dionysus to the Athenian **Agora**, derives its name from the numerous fourth- and fifth-century choregic (also spelled "coragic") monuments along its sides. These monuments were built to display the bronze tripod cauldrons awarded to the sponsors of plays in annual theatrical competitions. Such a sponsor was called a choregos, and his responsibilities were expensive. The choregos recruited the men for the chorus, hired trainers to direct them, and provided costumes and accessories. He was one of the Athenian elite, and the lavishness of his provisions often was a way of promoting favorable public opinion and political support for himself.

The Athenian choral and drama competitions were both religious and political festivals. All were dedicated to the god Dionysus and took place annually. At the performances, all the citizens of Athens came together not only to worship the god of wine and the theater, but also to celebrate their unique form of government and the values that were the foundation of their democratic way of life.

In 334, a choregos named Lysicrates won the prize tripod for the chorus he had financed in a competition of tragic plays. He commemorated the event by constructing a special monument on the Street of the Tripods. The Choregic Monument of Lysicrates is the best known of the choregic monuments and by far the most inventive. The purpose of the miniature building was twofold: first, it was a votive monument where the prize tripod was dedicated to Dionysus; second, the monument, with its inscription, was a form of self-aggrandizement reminding passersby of Lysicrates' generosity in paying for public entertainment.

The architect who designed Lysicrates' monument is unknown, but his design and the rich ornamental quality of the building suggest a man with a lively imagination. The lower part, or podium, of the building is a square measuring about nine feet on each side, made of beautifully cut white limestone blocks. A course of blue-gray Hymettian marble runs around the top of the podium to mark the upper edge of the square unit. Above this, three circular stairs form the base of a cylindrical structure, or miniature tholos, made of white Pentelic marble. The tholos is hollow and has a diameter of seven feet. There

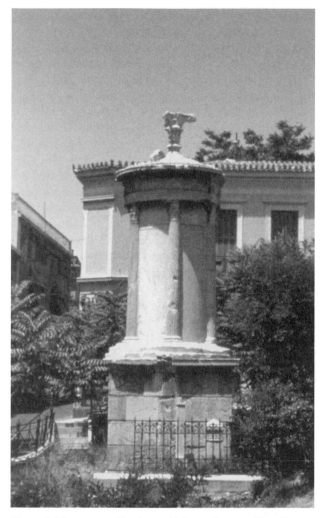

Choregic Monument of Lysicrates, Athens. *Courtesy of Jennifer Tobin.*

is some evidence that the tholos had a door on its east side. The juxtaposition of matte limestone and gleaming white marble, with the horizontal accent of Hymettian marking the boundary between, exploits the natural textures and reflective properties of the stones traditionally used in Greek architecture.

On the exterior of the tholos, six Corinthian columns conceal the joints between the walls, which are large curved slabs of marble. Corinthian appears here for the first time on the exterior of a structure. Traditionally, the order was used only in temple interiors and seems to have been considered the most sacred of the three orders. The columns, which have twenty vertical grooves, or flutes, stand on circular bases that are made of two discs, the lower convex

and the upper concave. A floral molding marks the transition from base to column. Atop the columns, the bell-shaped Corinthian capitals bear acanthus leaves, rosettes, and scrolls called volutes that imitate floral forms. Between the capitals, at the top of the wall slabs, is a horizontal frieze of tripods carved in relief.

The lintel, or architrave, carried by the columns has three horizontal bands, each projecting slightly above the one below. Lysicrates placed on the architrave the inscription giving the date and details of his choregic victory. Above the architrave a continuous frieze ten inches high was carved with reliefs representing the myth of Dionysus and the pirates. According to the story, a group of piratical Tyrrhenian sailors kidnapped the young Dionysus from the island of Icaria. Because the men abused him, the god summoned wild beasts who appeared on the ship and so terrified the pirates that they jumped into the sea and were turned into dolphins. This myth was perhaps chosen for the monument because it was the subject of the prize-winning drama that Lysicrates had sponsored. Above the frieze was a row of small cubes, or dentils, and a wide horizontal molding that served as a base for the roof.

The roof was made from a single block of marble carved into a shallow cone and decorated with a pattern in low relief simulating laurel leaves. From the apex of the roof rose an elaborate acanthus finial upon which the prize tripod was displayed. At the bottom of the finial were three heavy floral scrolls that may have supported bronze statues of dolphins. The monument is fifty-four feet tall from its base to the top of the finial.

The Choregic Monument of Lysicrates survived the devastating Herulian raids of the third century c.e. and remained a curiosity in medieval Athens. Athenians called the monument the Lantern of Diogenes because they believed that the philosopher once inhabited it. In 1669, the monument was acquired by a French Capuchin convent and used as a library and reading room. The convent was destroyed in 1821 during the Greek War of Independence, but Lysicrates' monument survived. In 1845, French archaeologists cleared the area around the structure and reclaimed some of its architectural details. Further restoration was carried out between 1876 and 1887 by the architects F. Boulanger and E. Loviot and the French School of Archaeology in Athens. The Choregic Monument of Lysicrates is a tribute to the great Athenian institution of the public theater but, ironically, does not belong to Greece; rather, it remains the property of France.

Further Reading

Dinsmoor, William B. *The Architecture of Ancient Greece*, 3d ed. New York: W. W. Norton, 1975.

Pollitt, J. J. *Art in the Hellenistic Age*. Cambridge, Cambridge University Press, 1986.

Travlos, John. *Pictorial Dictionary of Ancient Athens*. London: Frederick A. Praeger, 1971.

CHURCHES, MYKONOS

Style: Cycladic Vernacular
Date: Fifteenth–Twentieth Century C.E.
Architect: Citizens of Mykonos

In the tumultuous Battle of the Gods and the Giants, Poseidon seized a rock and threw it at his enemies. The rock landed in the Aegean Sea, buried the giants, and became the little island of Mykonos. This is how the ancient Greeks described the origin of this place of granite mountains and moderately fertile soil. In the sixteenth century, Mykonos was a haven for the pirates who preyed on Aegean shipping. By the eighteenth century, the island became a provisioning port for ships on the Smyrna to Istanbul route. Its famous windmills ground grain into flour that was used to produce bread and zwieback. Now, instead of buccaneers and traders, the island attracts tourists who come to enjoy its lovely beaches. But the island has much more to offer than beaches and cafés. It is a pristine example of the vernacular architecture of all of the Cycladic islands.

There are more than three hundred chapels and churches on Mykonos—they are found in the towns, in the fields, and on hillsides. These modest structures are the property of local families who have built them close to or even joined to their homes. All are made of local stone and mortar and are whitewashed frequently to maintain their perfectly white surfaces. They were built between the eighteenth and twentieth centuries.

Many of the little churches of Mykonos were erected to fulfill a vow, made by a sailor or fisherman, to build a church if he was saved from danger and death at sea. Often, the mariner constructed the building with his own hands. There is a story that one man used wine in the mortar of his chapel because he had sworn to do so. Most of the churches are dedicated to God, to the Virgin Mary, or to Saint Nikolaos, the patron saint of seafarers. Personal saints are also honored. But, the buildings can have a more practical use. Some are family bone vaults where, according to local tradition, the remains of the dead are placed in caskets that are inserted into the walls or buried under the floor.

Most of the Mykonos churches are small, about the size of a one-room house (see **Houses, Mykonos**). The smallest are called "Holy Cats" because they are simple chapels perched on the flat roof of a house. Next are the churches that are part of farming complexes found all over the island. These are freestanding structures of rectangular shape roofed by a simple barrel vault that is painted red. There is often a window in each long side of the rectangle,

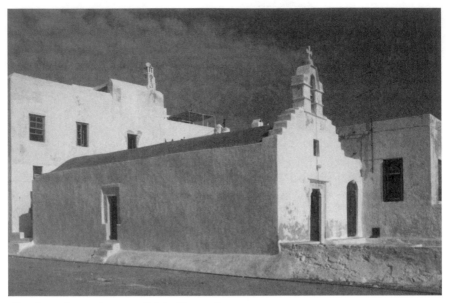

Church, Mykonos. *Courtesy of Michio Yamaguchi.*

while the entrance is on one of the short sides. The entrance facade has a triangular false pediment, which conceals the curved roof of the vault and a brightly painted wood door. Often the false pediment has straight sides, but a steplike articulation is also used. At the top of the triangle is placed either a simple cross or an arched belfry. Windows and doors are painted with intense blue, turquoise, or green paint to create a strong contrast to the brilliant white walls.

Churches in Mykonos Town, also called Khora, are similar to those in the country. The grander ones have domes that are painted red, blue, or black. Some also have tiny apses (semicircular spaces covered with a half-dome) that mark the area of the sanctuary. Most have blue, turquoise, or green woodwork like the rural buildings. Because of their thick masonry walls and few windows, the interiors of the churches are cool and shady. In front of the sanctuary, the more affluent families have an iconostasis, or wooden screen, with or without icons attached. In other churches, icons are hung on the walls. Iron candelabra are common, and there are oil lamps that are never extinguished. The overall impression in a Mykonos church is one of simplicity and tranquility.

Paraportiani, though often called a church, is really a complex of five small interconnected churches. The complex is one of the most photographed religious structures in the world because of the picturesque quality of its brilliant white walls and the cubistlike buildup of its simple geometric forms. Paraportiani, the popular name for the group of churches, means "by (next to) the side door" and is derived from the location of the small upper domed building near a side gate in the wall of a ruined medieval castle that no longer survives.

The five churches are arranged on two levels. On the lower level are four of the churches, arranged in the shape of the letter T. Three of the buildings

make up the horizontal bar of the T. Agios Efstathios, the eastern building, is consecrated to a second-century Roman general who converted to Christianity after seeing the crucifix in the horns of a stag. In the Roman Catholic Church, he is known as Saint Eustice. The second church is dedicated to Agioi Anargyroi, which means "the penniless doctors" and refers to Saints Cosmas and Damian (see **Agioi Anargyroi**). To the west of Agioi Anargyroi is the church of Agios Sozontas, also known as Sozon the Martyr, who was beaten to death as punishment for destroying pagan idols in 288 or 304. Agia Anastasia's church forms the vertical bar of the T and is connected to Agioi Anargyroi. Anastasia was a Roman matron, martyred by fire in 290, who tended the wounds and bodies of Christian martyrs and the poor. She is called the Deliverer from Potions because through her intercessions she has saved many people from the effects of spells, potions, and poisons. All four of the lower churches are rectangular in shape with barrel-vaulted roofs and resemble the traditional single-room structures found all over the island. On the facades, two of the churches have belfries and one has a stepped gable.

Located on the upper level is Panagia Paraportiani, or "the church of the Virgin Mary next to the side door," which gives its name to the whole complex. Panagia Paraportiani is a simple structure with a circular drum and dome. Its elevated position, literally on top of the lower church of Agios Efstathios, is reminiscent of the "Holy Cats," or chapels built on the roofs of private houses, described above. A staircase on the east side of the complex provides access to Panagia Paraportiani.

The beauty of the complex of Paraportiani lies in the contrast of its very simple geometrical sculptural masses and also from the stepped gables, the arched belfries, and the smooth hemispherical surfaces of the barrel vaults that are all crowned by the curved shape of the dome. All five churches are brilliant white except for their wood doors.

Historians generally agree that Agioi Anargyroi is the oldest of the five churches, but dating the other buildings and understanding their chronological sequence is difficult due to a complete lack of documentation. Work apparently began in the middle of the fifteenth century and continued slowly through the seventeenth. Parts of the Paraportiani complex are now in ruins, but this seems only to increase its picturesque quality.

Further Reading

"Greek Churches of Mykonos." www.magicaljourneys.com/Mykonos/mykonos-interest-churches.html.

Melas, Evi, ed. *DuMont Guide to the Greek Islands: Art, Architecture, History.* Russell Stockman, trans. Cologne: DuMont Buchverlag GambH & Co. Limited, 1985.

Romanos, Aristeidis. *Greek Traditional Architecture: Mykonos.* Philip Ramp, trans. Athens: MELISSA Publishing House, 1992.

CITADEL, TIRYNS

Style: Mycenaean
Date: Thirteenth Century B.C.E.
Architect: Unknown

The great Bronze Age citadel of Tiryns covers the top of a rocky ridge that rises like an island in the alluvial plain of the Argolid on the east coast of the Peloponnesus. The citadel was the center of a community that grew up on the flat land below, where evidence of extensive building has been found. A Mycenaean prince or local warlord, who ruled the surrounding territory much like a medieval baron, had his palace inside the walled fortress. But the citadel was more than just a well-defended royal palace. The warlord's family and his retainers, scribes, and slaves lived there. Workshops for producing military equipment, leather goods, and textiles occupied part of the fortress, and there were storage facilities for products such as pottery and oil that were traded locally and exported around the Mediterranean. Political conferences, legal procedures, and trade negotiations as well as the sacred ritual of hospitality would be enacted in the prince's residence.

The most conspicuous aspect of the citadel is its circuit of defensive walls. These reflect the warrior society of Mycenaean Greece that is memorialized in Homer's *Iliad*. Great kings, such as Agamemnon, and their princely allies, such as Menelaos and Diomedes, had mighty citadels that were famous for their well-built fortifications. The earliest sections of the walls at Tiryns date to the sixteenth century. In the fourteenth century the walls were extended to enclose the entire top of the ridge, and in the thirteenth century the palace was built. The citadel covers four acres divided into three terraces surrounded by massive walls and battlements that are 2,297 feet long. Huge irregular limestone blocks, some measuring as much as 8 to 10 feet long and 3 feet wide, were fitted together to create the fortifications that were as much as 35 feet tall and varied in width from 16 to 28 feet. These walls became the stuff of myth and legend. Homer called the fortress "wall-girt Tiryns," and the Roman writer Pausanias compared the ruins of the citadel to the Pyramids of Egypt. Because of the great size and weight of the stones, the historical Greeks suggested that the walls had been built by the Cyclopes—the one-eyed giants described in Homer's *Odyssey*.

The entrance to the fortress was on the east side at the top of a ramp that ran parallel to the east wall and was designed to allow warriors on the walls to

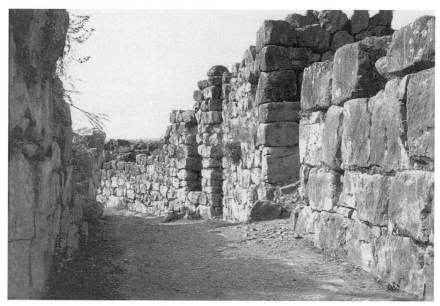

Walls of the Citadel, Tiryns. *Author's Photo.*

attack assailants as they moved up the ramp and then made a sharp right turn into a narrow passage. Once inside, one had to make a sharp left turn into a corridor containing two gates with thick doors that could be bolted shut. The design of this entry system forced the enemy to expose his unshielded right side to the defenders and to slow his movements in the congested space of the corridor. The second gate opened onto a roughly rectangular forecourt with columns on the east side and a row of six small dark rooms inside the structure of the east wall. Similar rooms and a long gallery were incorporated into the south bastion as well. These rooms may have been used for storage of goods, but some scholars believe that they were simply a way of reducing the amount of material and labor necessary for building the battlements.

On the west side of the forecourt was an ornamented entrance, or propylon, that gave access to the palace of the ruler of Tiryns. The propylon was almost square, measuring 44 by 46 feet, and had a wide central doorway flanked by pairs of columns on the front and the back. A large irregular courtyard, surrounded by buildings, lay to the west of the propylon. On the north side of the court was a second propylon, 36 feet square, with two columns on the front and back. This propylon opened onto a rectangular court, 66½ feet wide and 51½ feet long, with columns on three sides. To the right of the propylon was a circular altar, and directly across from it, centrally located on the north side of the court, was the megaron, or the lord's great hall. This was the heart of any Mycenaean fortress, a place where the ruler held meetings, received visitors, and hosted lavish entertainments for his guests.

The plan of the building was simple: a porch, an anteroom, and a large rectangular hall aligned on a single longitudinal axis. The front porch was created by extending the flank walls beyond the front wall of the anteroom and installing two columns between them. To provide visual emphasis on the entrance to the megaron, the porch projected slightly forward into the court and was elevated two steps above it. The porch was forty-one feet wide and eleven feet deep; its side walls were decorated with slabs of carved alabaster inlaid with blue glass paste. Three doors at the back of the porch opened into the shallow antechamber. In the center of the south wall was a single door opening into the great hall. A small door in the west wall led to a group of rooms, including a bathroom; the floor of this room was a single slab of limestone, eleven by thirteen feet, weighing twenty tons.

The great hall was thirty-two feet wide and thirty-nine feet long. In the center was a round hearth enclosed by four columns that helped to support the span of the ceiling. On the east side of the hall, facing the hearth, was a raised platform for the ruler's throne. The hall was elegantly decorated. Its plaster floor was painted in a checkerboard pattern with alternating squares containing a net pattern, a pair of dolphins, and an octopus. The walls were decorated with scenes of hunting, the favorite sport of kings and heroes.

To the east of the megaron were a series of rooms and courts that included two reception rooms that are simplified forms of the megaron plan. Each one had a porch and hall, but there were no columns in the porch, no anteroom, and no columns in the hall. This complex seems to antedate the large megaron complex and was probably used for private or domestic activities. A group of rooms to the west of the great megaron appears to be a late addition to the palace complex. The function of this complex is not known.

The palace occupied the highest terrace on the ridge of Tiryns. Behind and below the palace was a middle terrace that was mostly open space. The lowest terrace, extending to the north, was once thought to have been an empty area of refuge for the people who lived outside the citadel. However, recent excavations have revealed that military, economic, and service quarters were located there.

The fortifications at Tiryns were made of limestone with mud mortar. All the columns were wood set on flat stone bases to protect them from moisture. The floors of the open courts were covered with a mixture of plaster and pebbles; interior floors were plastered and painted. Moderate-sized stones laid in clay mixed with straw formed the lower parts of the walls of the buildings in the palace complex, and mud brick framed with wood beams was used for the upper parts. The walls of the important rooms were plastered with lime that made a good surface for painted decorations.

Around 1125, the citadel of Tiryns was destroyed by fire. The site continued to be occupied by a small population until the fifth century, when the community was destroyed by neighboring Argos. In 1884–1886 c.e., the famous discoverer of Troy, Heinrich Schliemann, excavated the south terrace. Work at the site continues on and off.

Further Reading

Chadwick, John. *The Mycenaean World.* Cambridge: Cambridge University Press, 1976.

Preziosi, Donald, and Louise A. Hitchcock. *Aegean Art and Architecture.* Oxford: Oxford University Press, 1999.

Samuel, Alan E. *The Mycenaeans in History.* Englewood Cliffs: Prentice Hall, 1966.

Vermeule, Emily. *Greece in the Bronze Age.* Chicago: University of Chicago Press, 1972.

ERECHTHEUM, ATHENS

Style: Classical
Date: 421–406 B.C.E.
Architect: Mnesicles(?); Callimachos; Philocles; Archilochus

The Erechtheum on the Athenian **Acropolis** is a unique and complicated building. Some scholars praise it as an excellent solution to problems of site and cult, while others see it as an unsatisfactory design that uses heavy decoration to disguise a lack of unity in its design. The temple replaced the sixth-century Pisistratid Temple of Athena Polias and, like the older building, had to house numerous cults and ancient shrines in a single structure. The ground on the site, on the north side of the Acropolis, sloped both to the north and west but religious practice forbade the leveling or rearrangement of the sacred space to accommodate a temple of traditional form. Unlike any other Greek temple, the four sides of the Erechtheum are all different in design and are on two different levels.

The building history of the Erechtheum is also quite complicated. Construction was begun in 421 at the end of the first phase of the Peloponnesian War, perhaps to celebrate the Peace of Nicias between Athens and Sparta. Work was interrupted during the disastrous campaign against Syracuse in 413. In 409, construction began again and was completed in 406. The name of the original architect is unknown, but Mnesicles, designer of the **Propylaea**, has been proposed because of the Erechtheum's split-level design. Other architects or supervisors—among them Callimachos, Philocles, and Archilochus—seem to have been appointed annually.

Externally, the main body of the building is a rectangle, 38 feet wide and 75 feet long. The east and south sides are 10½ feet higher than the west and north sides. As is traditional in Greek temples, the primary entrance to the building is on the east. Across the entire width of the east end is a porch with six Ionic columns that are about 22 feet tall. To visually strengthen the corners of the porch, the end columns are inclined slightly toward the center and toward the wall behind them. The columns support an Ionic three-band architrave, or lintel, and a horizontal frieze of black Eleusinian limestone that originally had figures made of marble attached to it. Above this was the pediment, the long low triangular space formed by the slanting eaves of the gabled roof. At the rear of the entrance porch, the east wall of the temple is pierced by a large central door flanked by two windows.

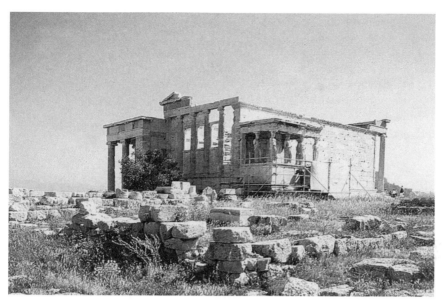

Erechtheum, Athens. *Author's Photo.*

The north side of the block is a blank wall of ashlar masonry with a large porch at its western end. This porch is one of the richest structures in all of Ionic architecture and incorporates optical refinements borrowed from Doric design. Moldings of many forms decorate the porch; the beautifully carved details are picked out by glass beads as well as bronze wires and gilding.

The porch has four columns, a little more than twenty-five feet tall, across the front and a single column behind each corner. These have entasis, which means that there is a slight bulge in the middle of the shaft that helps to maintain the visual integrity of the column's vertical outline. All the columns have a double inclination, meaning they are not perfectly vertical but instead lean (incline) slightly toward the center and also toward the back wall of the porch. Optical refinements such as these were incorporated into Doric buildings to correct for visual distortions of vertical and horizontal elements and to improve the overall appearance of the structure. The mixture of Ionic and Doric traditions is characteristic of the fifth-century buildings on the Acropolis (see **Propylaea** and **Parthenon**). As on the east porch, the columns of the north support a three-band architrave, a frieze of black limestone with white figures, and a pediment.

There are two doorways in the north porch. The central one was famous in antiquity for its great elaboration. Its jambs and lintels are carved with numerous moldings of various designs that were originally painted and gilded. To the west of the great doorway is a minor undecorated door that gives access to outdoor shrines connected with the Erechtheum. On the east side of the

porch is an opening in the floor that provides access to a subterranean crypt and a den for snakes.

The west side of the Erechtheum was the most difficult to design because it had to reconcile the two levels of the building. To do this, a ten-foot basement wall of ashlar masonry, pierced by an undecorated door, was built to support the western colonnade. The base of this wall corresponds to the level of the north porch, while its upper horizontal molding is related to the higher south side of the building. On this basement stands a row of four Ionic columns aligned between the ends of the flank walls. They are partly built into a low wall that connects them in a parapet arrangement. Above the wall, between the free parts of the columns, wood grills closed off the interior. The southernmost space, between the column and the flank wall, was left open for reasons that are not clear. As on the east and north porches, a three-band architrave, a frieze zone, and a pediment are carried above the colonnade.

Like the north flank of the Erechtheum, the south side is made of simple ashlar masonry. At the western end of this blank wall is the caryatid porch, also called the Porch of the Maidens. It forms a pendant to the north porch but is only about half its size. The lower part of the porch has a wall, about six feet tall, on three sides. Instead of columns, six statues of young girls, four across the front and two behind, stand atop the wall and support a flat roof. The Greeks considered the Ionic order to be feminine because of its slender proportions and ornate decoration—stereotypical female characteristics. As early as the sixth century, caryatids appeared in place of columns on small Ionic buildings such as treasuries (see **Siphnian Treasury**). Those on the Erechtheum may possibly allude to young girls who served the priestess of Athena. On their heads are simple capitals that support a three-band architrave. On the uppermost band is a continuous row of rosettes. The frieze zone found on the other porches is omitted. Above the architrave are a course of abbreviated Ionic dentils (rectangular cubes) and several horizontal moldings that articulate the roofline.

Because of alterations made in the Middle Ages and later, the interior design of the Erechtheon is problematic. Most scholars believe that it was divided into four separate rooms on three different levels. The east room, on the upper level, was about twenty-four feet long. This room was the cella, or cult room, of Athena Polias and housed the ancient olive wood statue of the goddess. The center part of the temple was divided longitudinally into two rooms with entrance doors on their west walls. These rooms were about ten feet above the east cella; their floors were at slightly different levels, the north a little more than two inches lower than the south. The north cella seems to have been sacred to Boutes, brother of Erechtheus, while the south cella was dedicated to Hephaestus (see **Temple of Hephaestus**). At the west a narrow antechamber occupied the whole width of the building and contained the doors to the two cellas. Beneath its floor was a cistern that contained the salt spring offered to the Athenians by Poseidon in his bid to be patron of their city-state. Some scholars believe that the western antechamber was also the

location of the den of the sacred serpent that was an incarnation of Erechtheus, the second king of Athens. His tomb may also have been located there.

Outside, adjoining the central block of the Erechtheum, were further important shrines. Near the east end of the north side was the precinct and altar of Zeus, father of Athena and king of the gods. The north porch was dedicated to Poseidon, and here were displayed the holes in the rock made by his mighty trident. On the west side was the open-air shrine of Pandrosus, daughter of Cecrops. In this area grew the sacred olive tree offered to the Athenians by Athena in her successful bid to become their patron goddess. Close by was the entrance to the tomb of Cecrops, first king of Athens. The contest between Athena and Poseidon for the possession of Attica was believed to have taken place on the site of the Erechtheum with Cecrops acting as judge.

When Greece became part of the Roman Empire, the west end of the Erechtheum underwent considerable alteration. In the seventh century c.e., the interior was reworked so that the building could be used as a Christian church. Further damage was done to the interior arrangements when the Erechtheum was turned into a harem by the Turkish commander of Athens in 1463. Later, between 1801 and 1803, Lord Elgin carried off one column from the east porch and one of the caryatids; they are now in the British Museum. Today, the remaining caryatids have been placed in the Acropolis Museum to protect them from air pollution. Restoration of the building is ongoing.

Further Reading

Berve, H., G. Gruben, and M. Hirmer. *Greek Temples, Theaters and Shrines.* London: Thames and Hudson, 1963.

Dinsmoor, William B. *The Architecture of Ancient Greece,* 3d ed. New York: W. W. Norton, 1975.

Rhodes, Robin Francis. *Architecture and Meaning on the Athenian Acropolis.* Cambridge: Cambridge University Press, 1995.

HOUSE A vii 4, OLYNTHOS

Style: Classical
Date: Late Fifth–Early Fourth Centuries B.C.E.
Architect: Unknown

The American excavations of the city of Olynthos in Macedonia unearthed more than one hundred houses of the late fifth and early fourth centuries (see **North Suburbs**). The dwellings are roughly square in shape so that they fit into the grid of city streets. Ten houses occupy each city block, and their dimensions —56 by 56 feet—are quite consistent. All of the homes face south to take advantage of the sunlight in winter. Like houses in many Mediterranean countries today, the exterior was undecorated and had few windows on the street. This design emphasized the private character of the house; the Greek family was separated from the public life of the city and secluded from public view.

Because only in very rare cases is the name of the owner of a house known, the excavators have assigned numbers to the buildings based on their location in the grid system of the city. House A vii 4 is a typical Olynthian dwelling that is frequently used as the textbook example of classical domestic architecture. The most characteristic feature of the Olynthian dwellings is the pastas, a long room with one side open to a courtyard, that gives the house type its usual designation of "pastas house."

One entered House A vii 4 through a door on its south side that opened directly onto a fairly large court paved with cobblestones. Because the court was open to the sky, it had a drain running from the center of the floor out to the street. Although some houses had an altar in the court, there was none here. Loom weights and other household objects in terra-cotta and bronze suggest that the courtyard was used for multiple tasks. To the north of the court, opening onto it, is the pastas. Wood posts supported part of the roof of the long room and acted as a sort of column screen that divided the pastas from the courtyard. The spaces between the posts allowed for easy access between the two units and permitted light to penetrate the pastas. A variety of domestic equipment was found in the west end of the pastas, which seems to have had storage shelves built against the walls.

Two rooms of almost identical size were located to the north of the pastas and opened onto it. Their function is not well understood, but apparently they were used for more than a single activity. The room on the left was empty except for a single coin, while the room on the right contained numerous loom

weights, pottery, a fibula (dress pin), and an earring. The jewelry and loom weights suggest that the room on the right was used for weaving by the women of the house.

To the right of this room was the kitchen complex, which had two doors opening into the pastas. One door gave access to a small room, called a flue, in which cooking was done. The other door opened into the kitchen proper; this was the space in which foodstuffs were processed. A large stone mortar, two lamps, and some tableware were found here. Behind the flue was a small bath area with a cement floor and a tub. Across from the kitchen at the east end of the pastas was a small room that contained a large storage jar, called a pithos, that was sunk into the floor. Pithoi were used to store all sorts of food, such as grain, dried fruits, or wine, so this little room was probably a pantry of some sort.

On the east side of the courtyard a door opened into the rectangular anteroom that preceded the most important room in a Greek house, the andron, or men's room. Here the men of the family entertained friends and held drinking parties called symposia. The andron was the only public part of the house. Men who were not members of the family were not allowed access to other parts of the home.

Greek men reclined on couches during banquets and symposia. The andron was specially designed to accommodate this practice. A raised platform, attached to the walls, ran around the room and was only interrupted by the door. Seven dining couches were placed on the platform. Because bits of food and bone were thrown down onto the floor during dinner, the platforms kept the diners away from the refuse. A drain in the center of the floor ran out to the street.

The andron was traditionally the most decorated room in the house. In A vii 4, the andron and anteroom were the only painted spaces in the dwelling. The anteroom had yellow walls and a black baseboard with a red horizontal band at the top. The platform around the andron was bright yellow, and the walls were red with a white baseboard and yellow horizontal band. In some homes in Olynthos both anteroom and andron had mosaic floors made of natural-colored pebbles. Geometric designs and mythological figures were popular subjects for this early type of floor decoration.

Across the court from the andron complex was a large room that opened onto both the court and the street. In some Olynthian houses, rooms in this position have no access to the outside and are therefore interpreted as storage rooms. In A vii 4, the double access has led the excavators to identify the room as a shop. The discovery of weights and possibly a scale in the pastas suggests that the shop was used for retail trade. One omission in the planning of Olynthian houses is evident: no traces of latrines have been found.

There was a second story over the north side of A vii 4, but its layout is uncertain. Wood stairs would have given access to this space, which was probably illuminated by small high windows. The fourth-century orator Lysias describes his house as having two stories: the lower rooms for the men's use and the upper for the women's use.

Lysias's description suggests that there were gendered spaces in the Greek house. The andron complex was restricted for masculine use; proper women were forbidden entry. Only prostitutes, courtesans, and female musicians were allowed to participate in the symposia. The Greeks sequestered their women-folk, and it was customary that any man who was not a member of the household was not permitted to see them. Wives and daughters could spin, weave, cook on portable stoves, and attend to children in the courtyard when no strange men were present. Otherwise, they were confined to the *gunaikonitis*, or women's quarters. Identifying this space archaeologically or architecturally by examining the contents and plans of the houses is difficult. Most likely, the women would retire to the northern part of the Olynthian house when the male head of household was entertaining his guests.

Further Reading

Dinsmoor, William B. *The Architecture of Ancient Greece*, 3d ed. New York: W. W. Norton, 1975.

Lawrence, A. W. *Greek Architecture*, 4th ed. R. A. Tomlinson, ed. Harmondsworth, England: Penguin Books, 1983.

Wycherley, R. E. *How the Greeks Built Cities*. Garden City, N.Y.: Doubleday, 1969.

HOUSES, MYKONOS

Style: Cycladic Vernacular
Date: Eighteenth–Twentieth Century C.E.
Architect: Citizens of Mykonos

The tiny island of Mykonos is famous among travelers for its glittering white houses, narrow streets, and more than three hundred small churches (see **Churches, Mykonos**). A visit to the main town, called both Chora and Mykonos Town, provides a timeless example of the vernacular, or folk, architecture typical of all the Cycladic islands. Mykonos Town, which stands on a level area on the west side of the island adjacent to the major harbor, is a maze of tiny streets lined with row houses of uniform height that have been constructed over the past few centuries. The narrowness of the streets and their meandering courses protect the inhabitants and their homes from fierce winds and, in the past, from pirates who roamed the Aegean Sea.

Two kinds of houses—narrow-fronted and broad-fronted—are most common in Mykonos Town. Both are row houses that can share party walls with their neighbors. They front directly onto the street and are two stories tall. The houses are organized in blocks, and all the houses in a single block are of the same type. This gives the streets a uniform appearance that is varied only by the colors applied to the wood details of the homes and the brilliant flowers of all kinds that flourish in pots and tiny areas of soil.

The narrow-fronted house is a long slender rectangle with a facade, 13 to 16 feet wide, on the street. The ground floor of the house is about 8½ feet tall, while the upper story is 10 to 16 feet in height. The front wall is the dominant feature of the building, and its mass is broken by only two openings, a door and a single window, in each of the two stories. These are the only sources of light and ventilation for the interior of the house. Access to the upper story is provided only from the outside by a masonry (or rarely, wood) staircase attached to the front wall. This arrangement is necessary because the house is frequently inhabited by two families—one on each story. Wood banisters and railings are attached to the stairway, and a balcony, also made of wood, connects the top step with the door in the upper story. All the houses are white with the exception of the wooden details, which are colored with the red, blue, green, or turquoise paint that is used on the island's fishing boats. Marble, imported from the islands of Paros and Naxos, is used to frame the doors and windows and occasionally for balustrades or railings.

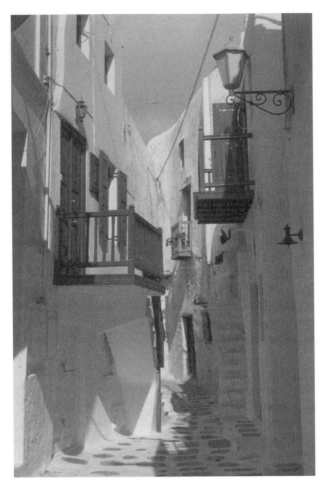

Houses, Mykonos. © *Kevin Schafer/Corbis.*

The interior of each story of a narrow-fronted house is divided into two rooms by a light wall made of wood or a combination of wood and plaster. On the ground floor, this wall is sometimes omitted when this level is used for storage. The front room, which overlooks or opens directly onto the street, is the larger of the two. It is a multipurpose space that functions as a living room, dining room, and workroom. Often a fireplace, used for cooking rather than heating, is found in the front room. The smaller back room is used as a sleeping area and sometimes contains the fireplace. Since the only sources of light and ventilation are the front door and window, the sleeping room is dark and can be stuffy.

Broad-fronted houses have the same basic elements as the narrow ones except that they are wider: they are rectangular and generally two stories tall with an exterior staircase on the street and a balcony in front of the door of

the upper floor. A major difference from the narrow-fronted house is the greater number of windows in the front wall and the inclusion of fanlights to increase the amount of light and ventilation in the front room. The interior of the house is divided into two unequal parts, as in the narrow-fronted house, but frequently the back room is subdivided to form two very small bedrooms.

The Mykonos houses have thick walls made of rubble masonry or flagstone. They are covered with a thick coat of plaster that rounds off the corners and softens the angles in an organic sculptural style. A fresh coat of whitewash is applied to all the outside surfaces once every year just before Easter. Although the aesthetic effect of the blinding white buildings against the azure Aegean sky is magnificent, the real purpose of the whitewash is hygienic—whitewash is an effective disinfectant that has been used for centuries.

Since Mykonos is an island made up mostly of granite, wood has to be imported and is at a premium. Its use is restricted to the railings, doors, balconies, and shutters and to the construction of ceilings, floors, and roofs. Inside a narrow-fronted house, wood beams are set parallel to the front wall. Because of its greater width, the broad-fronted house has ceiling beams placed at right angles to the wall that are supported by one or two large beams set parallel to the front wall.

The flat roof of each house has an interesting method of construction. Resting on the beams of the ceiling are wood planks or cane. On this is placed a layer of seaweed that is about two inches thick. Next is four to five inches of earth covered by a bed of mortar made of lime and sand. This method of roofing is watertight and is an excellent example of the exploitation of simple natural products that are found on the island.

Although there are some larger and more ornate homes on Mykonos—largely those of well-to-do captains and merchants—it is the traditional vernacular buildings that give Mykonos Town its charm. Despite the fact that their plans and exteriors are nearly identical, each dwelling achieves an individual character as a result of the owner's choice of color accents, flowers, and discreet decorative motifs.

Further Reading

Melas, Evi, ed. *DuMont Guide to the Greek Islands: Art, Architecture, History.* Russell Stockman, trans. Cologne: DuMont Buchverlag GambH & Co. Limited, 1985.

Romanos, Aristeidis. *Greek Traditional Architecture: Mykonos.* Philip Ramp, trans. Athens: MELISSA Publishing House, 1992.

KATHOLIKON, DAPHNI

Style: Middle Byzantine
Date: Last Quarter of Eleventh Century C.E.
Architect: Unknown

At some time during the sixth century, a monastery was founded beside the ancient Sacred Way that connected Athens with the sanctuary of the mystery cult of Demeter at Eleusis (see **Telesterion**). The monastery was located on the site of the classical sanctuary of Apollo Daphnaios that had been destroyed by invading Goths in 395. Apollo's epithet referred to the laurel tree, his sacred plant. According to myth, Apollo pursued the nymph Daphne, who resisted his advances. When he continued to press her, her father, who was a river god, turned her into a laurel. From that mythical time onward, the laurel tree bore the name of Daphne. The monastery takes its name from its geographical connection to the pagan sanctuary.

Little is known about the sixth-century community at Daphni except that it was reduced to ruins by barbarian raiders and then abandoned. It was refounded late in the eleventh century by an unknown patron and dedicated to the Dormition of the Virgin. This was a popular subject in monastic communities. According to the stories of the life of the Virgin Mary, she did not actually die at the end of her life, but rather slept (hence the word "Dormition") for three days before her resurrection and assumption into Heaven by Christ. This, and other scenes from the life of the Virgin, are among the magnificent mosaics for which the katholikon, or principal church, of Daphni is justly famous. The church is one of only three in Greece in which a nearly complete cycle of middle Byzantine interior decoration survives (see also **Katholikon, Nea Moni**; **Katholikon, Osios Loukas**).

Although there is no documentation concerning the founding and construction of the katholikon, most scholars date the building to the last quarter of the eleventh century or to 1080. The date is arrived at by stylistic evidence in the mosaic decorations. There is documentation of remodeling at the beginning of the thirteenth century when Athens came under French domination after the Latin Conquest of Constantinople in 1204. The lords of Athens were Burgundians who gave Daphni to monks of the Cistercian order in 1207 and stipulated that it would be their official burial place. Thus, the monastery served as a western Catholic community until the Turks returned it to the Orthodox faith in 1458.

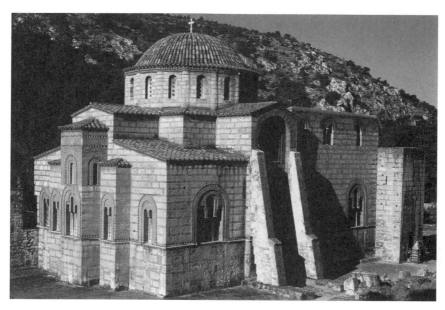

Katholikon, Daphni. © *Archivo Iconografico, S.A./Corbis.*

The katholikon of Daphni has a simple Greek cross-octagon plan in which the various parts of the church are arranged in a hierarchal order by height and illumination. At the center of the building is a square bay, or spacial unit, covered by a broad dome. The transition from the square to the circle of the dome is achieved by the use of squinches carried by the very tall L-shaped piers that form the four corners. A squinch is a small half-dome that spans the corner of a square. The four squinches in the square bay transform it into an octagon. Above the squinches, the wall surfaces fan out at the top where they join together to form the circular base of the dome.

Four arms of equal length project from the center bay, forming a Greek cross. These are barrel-vaulted and are half the width of the central square. A barrel vault is a continuous arched ceiling that is semicircular in shape. Between the arms of the cross are small bays covered with groin vaults that give the building its rectangular shape. A groin vault is a ceiling made up of two barrel vaults that intersect at right angles. The bays that fill in the cross are clearly subordinated to the height of the Greek cross core by being only one-story high and dimly lit.

The eastern arm of the katholikon is the sanctuary where the altar is located. Very shallow curved niches are set into its sides, and the arm terminates in an apse, which is a semicircular space covered by a half-dome. An iconostasis, or screen that carries icons and has a narrow door in the center, closes off the eastern part of the church. To either side of the apse are two small rooms, the prothesis and the diaconicon, with shallow apses. The prothesis, on the north,

is used for storage and preparation of the paraphernalia of the Eucharist (Communion). On the south is the diaconicon where holy books and vestments for the clergy are kept.

One enters the church via the narthex, which is a long transverse hall with three doors opening into the main block of the building. The narthex is divided into three bays that are covered with groin vaults. Today, the narthex is preceded by an outer narthex that was added to the katholikon by the Cistercian monks in the fourteenth century. This narthex is not built in the Byzantine style but rather imitates the architecture of the Cistercian monastery of Cîteaux in France. The facade has a large central door flanked by twin arches supported on a central column. The arches are pointed like those in Western Gothic designs, and the columns that support them are reused classical building parts. One of the reused columns is in the Ionic order and was part of the Temple of Apollo in the nearby ancient sanctuary. Although the roof of the outer narthex has collapsed, there is plentiful evidence that it was groin-vaulted. A square tower, now in ruins, was also added to the north side of the outer narthex by the Cistercians in the fourteenth century.

The exterior of the Daphni katholikon is worked in the cloisonné style that was very common for middle Byzantine churches in Greece. Cloisonné is a decorative type of masonry in which rectangular blocks of stone are separated, or framed on all four sides, by bricks. By the end of the eleventh century, many of the fussy ornamental details added to earlier cloisonné, such as those on **Agioi Anargyroi** in Kastoria, were omitted. This plain cloisonné style gives the walls of the Daphni church a monumental simplicity that encourages the viewer to contemplate the arrangement of the architectural volumes and masses that are so carefully balanced against each other.

The progress is upward from the low subsidiary bays to the arms of the cross and finally toward the crown of the dome. The base of the walls is topped by a projecting horizontal molding that serves as the lower sill of the widows. These are tall and narrow with either double or triple arches. The windows are set off from the cloisonné work by arched frames made of brick. Thus, the light color of the stone blocks of the cloisonné is contrasted to the reddish bricks and to the orange of the roof tiles. The result is subdued and understated in a very sophisticated way.

Inside the katholikon, the interplay of spaces and light and the verticality of the center bay and cross arms are most elegant. The outer bays are low and dark; the cross arms are moderately lit; and the center bay is bright because of the windows at the base of the dome. Thus, as the spaces become taller, they also become brighter. The decoration of the walls and vaults also adds to the sense of graduated height. Although most are now missing, the lower parts of the walls were decorated with marble veneers in numerous colors arranged in geometric patterns and by fresco paintings. Above these, on the vaults and dome, the wall surfaces come to life with radiant gold-ground mosaics everywhere.

In Byzantine theology, the church building was considered to be an architectural allegory of the Christian universe. Great emphasis was placed on the

interior of the building, for it was here that the worshiper could see, and thus experience, a reflection of the splendor of the celestial kingdom and the history of the church. In the middle Byzantine period, a standard program was established that codified the subjects to be represented and specified their location in various parts of the building. This was hierarchical and specifically related to the architecture. The dome and the apse were reserved for the most sacred characters. Below the dome, narratives and personages were arranged from higher to lower levels that corresponded to their degree of sanctity and their position in the dogma of the church.

The narthex of the Daphni katholikon has six scenes that are narratives from the Passion and from the cycle depicting the life of the Virgin Mary. In the north bay are three scenes: the Betrayal of Judas, Christ Washing the Feet of His Disciples, and the Last Supper. The bay at the south end of the narthex begins the life of the Virgin: the Prayer of Joachim and Anna, the Benediction, and the Presentation of Mary in the Temple.

In the barrel vault of the west arm of the nave, beyond the entrance door, is the Dormition of the Virgin to which the katholikon is dedicated. The other vaults in the building and the squinches carry stories from the Gospels related to the Twelve Feasts of the Church and further episodes from the life of the Virgin. On the north cross arm are the Birth of the Virgin, the Crucifixion, the Raising of Lazarus, and the Entry into Jerusalem. The arm to the south shows the Three Magi, the Resurrection, and the Incredulity of Thomas. In the squinches under the dome are the Annunciation, the Nativity, the Baptism of Christ, and the Transfiguration.

Everything in the church is dominated by the stern face of Christ Pantocrator (Lord of the Universe), who seems to look down threateningly from the crown of the dome. At the base of the dome, sixteen Prophets stand in between the windows that create a ring of light below the great portrait of Christ.

The east arm of the cross, which is the sanctuary, has in the lower level images of healing saints, hierarchs, and deacons, above which are images of the archangels Michael and Gabriel. In the semidome of the apse appears the beautiful figure of the Virgin Mary with the infant Christ, which is now damaged and incomplete. Finally, John the Baptist occupies the apse of the prothesis, while Saint Nicholaos is in the same position in the diaconicon. In addition to all these subjects are a great number of saints, martyrs, prophets, and healers who are represented on the walls.

The katholikon of Daphni is surely one of the most beautiful buildings in Greece. To enter into its fluid spaces and let the eye travel ever upward from the earthly lower zone, through the saints, martyrs, and prophets, to the narratives of Christ's history, then upward again to the benign figure of Mary, Mother of God, and finally above everything to encounter the awesome face of Christ is a powerful spiritual and aesthetic experience.

Fortunately, the church at Daphni has remained in good condition. Its history after it was returned to the Orthodox community in 1458 is quite strange. The monks abandoned the monastery during the Greek War of Independence

in the 1820s, and it was used as a garrison. After this, the church served as a barracks for Bavarian troops, and then the monastery became an asylum for the mentally ill. Somehow, most of the mosaics survived this troubled period in the history of the katholikon. After earthquakes in 1889 and 1897, the Greek Archaeological Service undertook restoration of the structure and brought in a team of Italian artisans to clean and repair the mosaics. In 1920, the structure was stabilized and buttresses were installed on the north side. The Ministry of Culture carried out further conservation and repairs to the mosaics in 1955–1957, 1960, and 1968.

Further Reading

Hetherington, Paul. *Byzantine and Medieval Greece: Churches, Castles and Art.* London: John Murray Publishers, Ltd., 1991.

Krautheimer, Richard. *Early Christian and Byzantine Architecture.* Harmondsworth, England: Penguin Books, 1975.

Mango, Cyril. *Byzantine Architecture.* Milano: Electa Editrice/Rizzoli, 1978.

KATHOLIKON, NEA MONI, CHIOS

Style: Middle Byzantine
Date: Last Quarter of Eleventh Century C.E.
Architect: Unknown

Byzantine legend has it that sometime around 1040, during the reign of Emperor Michael IV, a pair of hermits named Niketas and John found a miraculous icon of the Virgin Mary on Mount Provateion in the center of the island of Chios. These men claimed to be prophets, but some people thought they practiced magical arts. Nevertheless, Niketas and John revealed to the exiled nobleman Constantine IX Monomachus that he would become emperor. When he indeed did take the throne in 1042, Constantine remembered the hermits and rewarded them by donating the Nea Moni, which means "new monastery." Imperial support of the community included not only money but land, fruit trees, and exemption from taxation.

The Nea Moni is located in a wooded valley in the foothills of Mount Epos not far from the discovery spot of the icon. Its katholikon, or principal church, was built in 1045 by artists and masons furnished by the emperor. Most likely, the church was dedicated to the Virgin Mary, Mother of God. Although the monastery is today very dilapidated, the church remains in fairly good condition. The katholikon of Nea Moni is a very important monument; it is the earliest known example of the simple domed octagon plan and also is one of only three churches in Greece that preserve the middle Byzantine mosaic system (see **Katholikon, Daphni**; **Katholikon, Osios Loukas**).

The katholikon has a complex design made up of four distinct sections. It measures roughly eighty feet long and forty-five feet wide at its broadest part. At the west end is a large outer narthex, or transverse hall, that has three bays, or spacial units, covered with domes. At the north and south ends of the narthex are apses, or semicircular spaces, covered with half-domes. The small porch and adjoining bell tower to the west of the narthex is a late addition, not part of the original plan. Three doors in the east wall of the outer narthex open into the inner narthex, the second part of the building. It is narrow and dark and has three bays, two of which have barrel vaults while the one in the center carries a dome.

The third part of the plan, the nave, is highly sophisticated and complex in its development. Its interior walls are divided into two zones, or stories, separated by a projecting horizontal cornice. At ground level, the nave is a square measuring twenty-six feet on each side. There are no aisles around the outer

sides of the nave as is typical of middle Byzantine Greek churches. Instead, a wide shallow rectangular niche, topped by a flattened arch, is recessed into each wall. The right angles at the four corners of the square are disguised by narrow deep niches.

In the second story, the pattern of wide wall and narrow corner niches is duplicated except that here the niches are semicircular rather than rectangular. Those in the walls have flattened half-domes, while those in at the corners are covered with squinches, which are a series of gradually projecting arches placed diagonally across the corners. The squinches transform the square of the first story into an octagon on the second story.

Yet another transformation of the space of the nave occurs above the second story. The wall surfaces between and above the niches fan out at the top and join together to form the circular base for the dome, which is illuminated by a row of windows. With a span of nearly twenty-three feet, the dome is quite large in proportion to the dimensions of the nave. In contrast to most Greek churches, there are no columns or barrel vaults supporting the dome so that the sweeping vertical space of the nave is uninterrupted and therefore powerfully impressive. The shape of the nave changes from square to octagon to circle in a complex interplay of mass and space and light that culminates in the crown of the dome, where the portrait of Christ Pantocrator (Lord of the Universe) looks down on the worshipers.

The fourth section of the church is the east end where three apses are joined to the nave. Each apse is preceded by a barrel-vaulted bay. The central apse is slightly wider and deeper than those on either side. These smaller spaces function as the prothesis, where the paraphernalia for the Eucharist (Communion) are kept, and the diaconicon, which houses the sacred books and vestments for the clergy. On the half-dome of the central apse is an image of the Virgin Mary. Archangels Michael and Gabriel are represented in the two smaller apses.

The exterior of the katholikon of Nea Moni is very plain today; it is covered with white plaster, which to some extent obscures its original appearance. The walls are built in the recessed brick technique in which alternating courses of brick are set back from the wall plane and are covered by mortar. This gives the walls a richly textured surface. The walls are enlivened by recessed blind arches, that is, arches that are filled with masonry. Above the block of the building, the windows in the large central dome are framed by slender columns supporting arches that create a scalloped roofline. The three small domes on the outer narthex have a simpler design. Except for the large dome, the building is roofed with tiles.

Nea Moni's katholikon is famous for its well-preserved interior decoration. On the lower parts of the nave, the original deep-red marble facing is enlivened by details in various colored stones. Above these decorations are mosaics that reflect and refract the light and sparkle like crystals. On the surfaces of the partial domes above the niches, on the dome, and on the half-domes of the apses individual figures as well as narrative pictures are worked in bright colors on gold ground. Scenes from the Gospels represent the Twelve Feasts of the

Orthodox Church, while images of saints, prophets, and archangels are arranged in a canonical pattern throughout the nave. They are some of the finest works of the eleventh century. The inner narthex also has most of its original mosaic decoration, contemporary with the nave, that includes several Gospel scenes, representations of the Passion story, and portraits of holy men. In the outer narthex are paintings of the Last Judgement that date to the fourteenth century.

Nea Moni is now a convent inhabited by a small number of nuns. Many of its buildings are in poor condition due to damage during an attack by the Turks in 1822. Fortunately, the katholikon was not vandalized at that time. In 1881, however, an earthquake damaged some of the mosaics in the building and caused the large dome to collapse. Although the dome was rebuilt, its glittering mosaic of Christ Pantocrator was lost.

Further Reading

Bouras, C. *Nes Moni on Chios: History and Architecture*. David A. Hardy, trans. Athens: Commercial Bank of Greece, 1982.

Hetherington, Paul. *The Greek Islands: Guide to the Byzantine and Medieval Buildings and Their Art*. London: Quiller Press, Ltd., 2001.

Krautheimer, Richard. *Early Christian and Byzantine Architecture*. Harmondsworth, England: Penguin Books, 1975.

Mango, Cyril. *Byzantine Architecture*. Milano: Electa Editrice/Rizzoli, 1978.

KATHOLIKON, OSIOS LOUKAS, STIRIS

Style: Middle Byzantine
Date: 1011–1022 C.E.
Architect: Unknown

Osios Loukas (Holy Luke) of Stiris, a beatified holy man and healer, should not be confused with the evangelist Saint Luke, whose Greek name is Ayios Loukas. Osios Loukas was born in 898 in Delphi after his parents left the island of Aegina when it was invaded by Saracens. Beginning around 910, he lived as a hermit in the region of Phocis in central Greece. He miraculously survived cruel treatment from the Moors and Saracens and was known to have the gift of prophecy.

In 940, Osios Loukas and several other hermits settled in Stiris, an isolated spot atop a hill looking out onto the slopes of Mount Helikon. The hermit died there in 953 after developing a small monastic complex. Some support for the monastery was provided by Emperor Romanos II, who seems to have built a church there. Two connected buildings now occupy the courtyard of Osios Loukas. The earlier is dedicated to the Theotokos, Mary the Mother of God, and is dated 997–1011. The later, the preeminent structure of the monastery, is the beautiful and justly famous katholikon built as a pilgrimage church for worshipers who revered Osios Loukas as a local saintly man and healer. His sarcophagus is located in a subterranean crypt, and his relics are displayed in the church. There is no documentary evidence for the katholikon; therefore, it is not known who was responsible for building it or precisely when it was constructed. Scholars have used the style of the mosaic decorations in the church to arrive at a date somewhere between 1011 and 1022.

The katholikon of Osios Loukas is a complex and refined Greek cross-octagon plan, one of the most perfect examples of the type ever built. In plan, the building has a central core, or nave, shaped like a cross with four arms of equal length. The central bay, or spacial unit, of the cross is square and carries a large dome. Filling the spaces in between the arms of the cross are smaller bays covered with groin vaults that give the building its rectangular outline. A groin vault is a ceiling made up of two semicircular barrel vaults that intersect at right angles. The rectangular block is bordered on all sides by lower passages resembling aisles that are groin-vaulted and support a second-story gallery. These are not true aisles because they are discontinuous; they are broken up into bays and chapels by the heavy transverse walls that help to support the central dome. The east end of the nave terminates in an apse, which is a semicircular

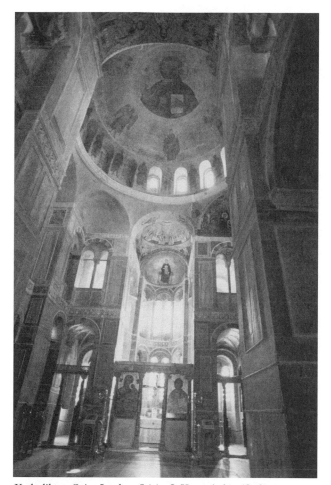

Katholikon, Osios Loukas, Stiris. © *Vanni Archive/Corbis.*

space covered by a half-dome. On the west end is the narthex, or vestibule, that is a long transverse hall.

The exterior of the katholikon is truly impressive. At approximately eighty-five feet long, the church is quite large in comparison to other middle Byzantine churches (see **Katholikon, Daphni**; **Katholikon, Nea Moni**). Seen from the outside, the building is a cube crowned by shifting rooflines and an octagonal drum pierced by windows framed with white marble arches. Above the drum, the silhouette of the dome is gently curved and rather squat.

On its west facade, the narthex is divided horizontally into two stories and vertically into three bays, or tall rectangular units, by the two-story projecting buttresses that flank the entrance door and the triple window above it. This forms the centerpiece of the wall and is visually set off from the rest of the facade by the deeply recessed door and window. The openings for the door and the

window are really shallow barrel vaults that contrast to the slanting eaves of the roof crowning the centerpiece. On either side of the central bay, the eaves are horizontal. The double windows flanking the door are only slightly recessed into the plane of the wall. They are contained in blind arches (arches that are filled in with masonry) with decorative dog-tooth brick moldings.

Directly above the lower-story windows are wider double windows set back into shallow barrel-vaulted frames. The play of flat wall surfaces, shallow blind arches, and deeper barrel vaults gives the facade a monumental sculptural quality that is quite impressive. Interestingly, the walls of the facade are built primarily of irregular marble blocks taken from classical buildings in the region.

A mixed type of masonry, typical of middle Byzantine Greek churches, appears on the flank walls of the katholikon. The lower parts are made of reused marble blocks, while the upper areas have cloisonné work. Cloisonné is a decorative type of masonry in which rectangular blocks of stone are separated, or framed, by thin bricks. Bricks are also used to frame the windows and to fill in the blind arches. Triple windows are placed above the side entrances to the narthex and at the ends of the north and south arms of the cross. The latter also have monumental facades with colonnettes under a tall triple window. On the exterior of the apse is the most sophisticated masonry work on the katholikon. Cloisonné work that is tidy and quite simple is introduced into the base. Above this the wall is broken into horizontal bands by courses of dog-tooth moldings. Kufic designs, which imitate an abstract style of Arabic writing, are worked into the horizontal bands to create a tapestry-like effect.

The interior of the Osios Loukas church is almost impossible to describe with any accuracy and completeness. A complicated spacial design is combined with colorful wall surfaces and subtle effects of light and shadow. The mosaics, which cover the upper parts of the katholikon, are breathtaking with delicate colors set in a glittering gold background. Indeed, sparkling gold seems to be everywhere, reflecting and refracting the light and animated by the motion of the viewer when observing it from various lines of sight.

One enters the church via the two-story narthex that carries three vaults. Here begins the canonical and hierarchical arrangement of mosaic subjects that represent the dogma of the Orthodox faith. In the narthex are narratives illustrating the themes of death and resurrection. A bust of Christ is placed over the entrance to the nave, and on either side are the Crucifixion and the Anastasis (Harrowing of Hell). In the central vault, the Virgin Mary appears with archangels Gabriel and Michael and John the Baptist. On the north and south ends of the narthex are Christ Washing the Feet of His Disciples and the Incredulity of Thomas. Around these images are figures of the Evangelists and many saints.

The nave is sumptuously decorated. Its lower zone and piers are sheathed with slabs of colored marble—purple, white, olive, and two shades of gray. In the west arm, which is barrel-vaulted, appear the figures of six saints. To the left and right of the arm are the small chapels that fill in the square. The

mosaics here continue the celebration of the Orthodox saints: there are eight in the north chapel and nine in the south.

The square bay, 30 feet across, that forms the center of the nave extends dramatically upward above the subsidiary spaces and is capped by a ribbed dome. Squinches, or gradually projecting arches placed diagonally over the four corners of the square, transform it into an octagon. Above the squinches, the wall surfaces fan out at the top and join together to form the base of the dome. The dome is wide—29½ feet—and covers the central bay almost completely.

Mosaics depicting scenes from the Gospels that correspond to four of the Twelve Feasts of the Orthodox year are placed in the squinches. These include the Nativity, the Presentation in the Temple, and the Baptism of Christ. The fourth scene, an Annunciation, no longer survives. Tragically, the mosaic decoration of the dome is lost and has been replaced by painted images. At the top is Christ Pantokrator (Lord of the Universe) surrounded by the Virgin Mary, John the Baptist, and the archangels Raphael, Uriel, Gabriel, and Michael. Between the windows at the base of the dome are standing figures of sixteen prophets.

The barrel-vaulted north and south arms of the Greek cross nave are divided into two stories. At the lower level, a triple arcade (three arches supported on two columns and springing from the flanking piers) supports an open gallery. The end walls of the arms are pierced by windows that backlight the galleries and provide medium light in the spaces behind the arcades. Although much is lost, the remains of the mosaics on the north and south arms over the galleries indicate that in each one a number of saints and Osios Loukas himself were depicted in the presence of the Theotikos (Mother of God) and Christ.

On the eastern end, the nave is extended to form the sanctuary. This part of the church was closed off from the laity by a barrier called a templon that is made of columns bearing a lintel with an iconostasis in the center. The iconostasis is a screen with a door in the center that carries icons. Those at Osios Loukas were the work of the Cretan painter Mihalis Damaskinos, the teacher of El Greco.

Behind the iconostasis, the eastern arm of the Greek cross is elaborated by shallow apses on the north and south sides. Instead of vaults, this area is covered by a dome on pendentives decorated with a representation of the Pentacost. Pendentives are curved triangular wall surfaces, bordered by arches, that fan out at the top and join to form the circular base of a dome. The sanctuary terminates in an apse, where shimmering gold mosaic covering the entire half-dome creates a celestial background for the enthroned Virgin Mary holding the infant Christ on her lap. She wears lapis lazuli blue robes that symbolize her exalted role as the Queen of Heaven and the Throne of Wisdom. Mary and the infant Christ seem to hover above the iconostasis in a burst of divine light as they observe the faithful gathered in the center of the nave to worship and to experience the mystery of the Communion.

To the south of the apse is the diaconicon, a small chamber used for the storage of holy books and vestments for the clergy. The theme of the mosaic pictures here is salvation represented allegorically by two stories from the Old Testament. One shows the Three Hebrews in the Fiery Furnace, while the other depicts Daniel in the Lions' Den. There is no prothesis. The subsidiary spaces and chapels that surround the nave are lower in the hierarchy of ornamentation and dogma. Therefore, instead of mosaic, the decoration there is carried out in fresco painting.

The katholikon of Osios Loukas is remarkably well preserved. Perhaps owing to its location, away from major urban centers, it was never used as a mosque as were so many other important Byzantine churches. In 1593, the large dome collapsed as the result of an earthquake. It was subsequently rebuilt and its mosaic decoration replaced with fresco painting. A second earthquake in the seventeenth century further damaged some of the mosaics. The Greek Ministry of Culture began restoration of the katholikon in 1939. In 1943, during World War II, the building was seriously damaged by bombardments. Major repairs were made to both the structure and the mosaics after this time. Toward the end of the twentieth century, the beautiful icons on the iconostasis were stolen. They have been replaced with copies.

Further Reading

Hetherington, Paul. *Byzantine and Medieval Greece: Churches, Castles and Art*. London: John Murray Publishers, Ltd., 1991.

Krautheimer, Richard. *Early Christian and Byzantine Architecture*. Harmondsworth, England: Penguin Books, 1975.

Mango, Cyril. *Byzantine Architecture*. Milano: Electa Editrice/Rizzoli, 1978.

KATHOLIKON OF THE GREAT LAVRA, MOUNT ATHOS

Style: Middle Byzantine
Date: 963–1004 C.E.
Architect: Unknown

In 963, Saint Athanasios the Athonite founded the first monastery, known as the Great Lavra, on Mount Athos (see **Monasteries**). According to his biography, Athanasios first built defensive walls around the community and then immediately began the construction of its katholikon. A katholikon is the principal church of a Greek Orthodox monastery and is located in the central courtyard; it is the major focus of worship and the most honored place in the complex. The katholikon of the Great Lavra is the oldest church on Mount Athos and became the model for all the katholika on the peninsula. Its design eventually became the basis for most of the monastic churches in northern Greece and the Balkans. Originally, the katholikon, which was completed in 1004, was dedicated to the Annunciation to the Virgin. But, in the fifteenth century, it was reconsecrated to Saint Athanasios.

The plan of the katholikon is derived from the cross-in-square design that was common in Constantinople (modern Istanbul), the capital of the Byzantine Empire. In its traditional form, the cross-in-square plan is a centralized structure divided into nine spacial units, or bays. At the center, the largest bay is square in shape and supports a dome. The bays that form the four arms of the cross project from the central bay and are of identical length, forming a Greek cross. They are roofed with barrel vaults, arched ceilings semicircular in shape. Since the sanctuary is located in the east arm, it terminates in an apse, a semicircular space covered by a half-dome. Between the arms of the cross, small square bays are inserted to fill in the cross and give the building its square shape. These bays are either domed or have groin vaults. A groin vault is a ceiling made of two barrel vaults intersecting at right angles.

The cross-in-square is modified at the Great Lavra by the addition of apses to the north and south arms of the cross. Presumably, the change in design was necessary to enlarge this part of the church, which is called the choir, so that large numbers of monastic cantors could stand and sing in it during the services. Another adaptation that became typical of the katholika of Mount Athos is the incorporation of a chapel at either end of the narthex, or vestibule, at the west end of the building. These chapels are miniature versions of the traditional cross-in-square plan.

From the exterior, the katholikon of the Great Lavra presents a long horizontal facade with large arched windows surmounted by three domes. Although most of the exterior of the church is middle Byzantine, the present facade belongs to an outer narthex, or vestibule, that was built in the nineteenth century and does not harmonize with the older part of the building. The walls of the katholikon are painted red, a color preference that is found frequently in the later monasteries of Mount Athos. Decorative details, painted white, are minimal and mostly limited to the frames of windows and doors. The roof is covered with lead sheathing. In contrast to the nonmonastic churches of the middle Byzantine era, which frequently have decorative brick and tile work, the katholikon is very austere and simple.

Behind—that is, to the east of—the new narthex is the original narthex of Saint Athanasios's church. The original narthex is a deep vaulted transverse hall where the monks meet to recite prayers of mourning for the dead. One enters the Greek cross core through a central door that is on the longitudinal axis of the church. At each end of the narthex is a chapel that takes the form of a tiny cross-in-square church with a central dome supported on four columns arranged in a square. The chapel on the north is dedicated to Saint Nikolaos. On the south side is the Chapel of the Forty Martyrs, which contains the tomb of Saint Athanasios, who is said to have been killed by a piece of falling masonry in his church. Both chapels have two doors, one on the west end and a second that opens directly into the narthex.

The Greek cross core of the katholikon has barrel vaults over the west and east arms and half-domes over the north and south apses. Above these rises the central dome, which rests on four piers and has eight large arched windows. Light pouring down from the dome emphasizes this central bay. On the surface of the dome is the awesome image of Christ Pantokrator (Lord of the Universe), who appears to look down into the hearts of the worshipers. The east end of the katholikon contains the chancel, where the altar was located, and the apse. This part of the church was visually separated from the rest of the building by an iconostasis, which is a screen with three doors decorated with icons. The inside of the apse is semicircular, but outside it is a half-octagon; this feature is known as a faceted apse. Also faceted are the two narrow rooms on either side of the apse, the prothesis on the north and the diaconicon on the south. These chambers are used for the storage of the Communion paraphernalia (prothesis) and the Gospel books (diaconicon). Each has two doors—one into the chancel, the other into the choir—to facilitate processional movements during the Mass.

An inscription in the katholikon states that it was painted by the famous artist Theophanes of Crete in 1535. The program for the frescoes follows the strict set of rules that governed the decoration of all Orthodox churches. At the lowest level of the walls are images of saints and holy men. Above them are scenes from the lives of Jesus and Mary. In the central bay, the four evangelists appear under the dome that carries the image of Christ Pantokrator at its summit. The Virgin Mary looks down from the half-dome of the apse, and

illustrations of the Fathers of the Church, the Divine Liturgy, and the Communion of the Apostles occupy the walls. Theophanes' style is dramatic with strong highlights and the sure touch of a great artist in his maturity. The paintings in the two narthexes are late additions of the nineteenth century. Damage to the katholikon over the centuries has necessitated repairs, but the building remains substantially as Saint Athanasios had planned it.

Further Reading

Hetherington, Paul. *Byzantine and Medieval Greece: Churches, Castles and Art*. London: John Murray Publishers, Ltd., 1991.

Kadas, Sotiris. *Mount Athos: An Illustrated Guide to the Monasteries and Their History*. Louise Turner, trans. Athens: Ekdotike Athenon S.A., 1979.

Mango, Cyril. *Byzantine Architecture*. Milano: Electa Editrice/Rizzoli, 1978.

MAUSOLEUM OF GALERIUS, THESSALONIKI

Style: Roman
Date: Circa 293 C.E.
Architect: Unknown

When Diocletian took the throne in 284, the Roman Empire was in crisis. After more than sixty years of anarchy, barbarian invasion, massive inflation, and a general lack of confidence, the empire was in serious danger of collapse. Diocletian's great work was the restitution of order and civil society as well as the defense of the many boarders of the state. Because it was impossible for the emperor to be in all areas that needed defense and administration, Diocletian adopted three co-rulers to help him. This institution, called a tetrarchy (meaning "four rulers") was quite successful in reestablishing order and security. The empire was divided into four zones, each with a tetrarch in residence who took responsibility for defending the area and implementing Diocletian's reforms.

Galerius, one of the tetrarchs, was born in 250 at Serdica (modern Sofia, Bulgaria) to a peasant family. Although uneducated, he worked his way up through the military ranks and was totally loyal to Diocletian. Galerius was said to be a huge man with rough manners and great ambitions. Successful campaigns on the Danube frontier and against the Persians were demonstrations of his daring military exploits. In 293, Diocletian appointed him tetrarch with responsibility for the eastern part of the empire. Galerius established his official residence at Thessaloniki and immediately built a palace there. Unfortunately, despite his positive qualities, Galerius is mainly remembered for his zealous enforcement of the edicts of persecution against the Christian cult from 303 until 311, when he retracted the edicts on his deathbed.

The Mausoleum of Galerius was part of a group of imperial structures that included a palace and a hippodrome (racetrack). An impressive ceremonial approach from the Via Egnatia, a major east-west highway, was provided by a triumphal arch and a colonnaded street 328 feet long. The street opened onto a large octagonal courtyard with the building in the center. Although conventionally called a mausoleum or rotunda, the function of the building during Galerius's lifetime is uncertain. It is possible that the building served as a temple, perhaps to Jupiter, but was also intended to hold the remains of the tetrarch after his death.

Galerius's mausoleum is a large circular building covered with a dome. The massive walls are twenty feet thick and are made of mortar and rubble rein-

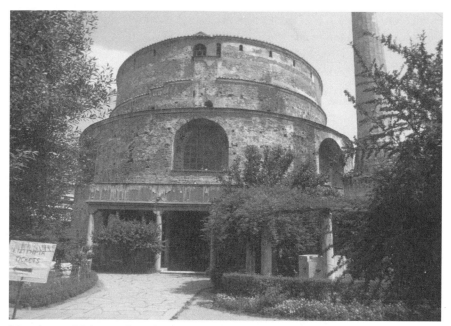

Mausoleum of Galerius, Thessaloniki. *Courtesy of Michio Yamaguchi.*

forced with bands of brick. This rather unattractive material is faced with brick and courses of small squared blocks of stone. A porch with marble columns marked the entrance that was on the south facing the colonnaded street. This is the only ornament on the exterior, which is kept very simple to provide a striking contrast with the interior.

The inside of the building is a carefully shaped and articulated space that is seventy-nine feet in diameter and about ninety feet tall. The circular wall is divided horizontally into three stories linked visually by curved forms and by quality of light. In the first story, eight barrel-vaulted recesses are cut deeply into the wall, while in the piers between them are small niches with rounded tops. The second story has eight slightly smaller arched windows directly above the recesses. This arrangement contrasts the indirect illumination of the first story with the light flooding through the windows in the second. Above the windows, the third story is a course of lunettes, or low semicircular openings, that double the rhythm of the windows and recesses below.

The dome that covers the interior space without internal supports has an unusual design. Most Roman domes, such as that in the Pantheon in Rome, are hemispheres with a single curvature, but the dome of the Mausoleum of Galerius has two different curvatures. The lower, from the base up to a height of twenty-three feet, is a segment of a hemisphere with a span of seventy-nine feet. Above this, the dome is based on a smaller curvature, one that is only sixty-two feet wide. This design made the dome stronger and more stable than

single-curvature domes. Decoration, no longer extant, would have disguised the transition from one curvature to the other.

The ornamentation of the interior was sumptuous. The mortar and rubble walls were veneered with sheets of stone arranged in multicolored patterns. The vaulted recesses and arched windows were framed by imitation pilasters (flat columns) and horizontal entablatures (lintel, frieze, and cornice molding) that created a contrast of two-dimensional right angles to the three-dimensional curved openings. Roman architects frequently used the contrast of angle and curve to enrich the walls of buildings. The Colosseum in Rome has this scheme on its exterior. Obviously, the unknown architect of the mausoleum knew the buildings of Rome in considerable detail. In fact, the plan of the mausoleum is based on the caldarium, or hot room, of the Baths of Caracalla in the capital city.

Galerius died in Serdica and was buried nearby. His successor, Licinius, refused to allow Galerius's body to be transferred to Thessaloniki for interment in the grand tomb he had built for himself. At the end of the fourth century, the mausoleum was converted to a church and was later dedicated to Saint George. A sanctuary was added behind one of the vaulted recesses, and an ambulatory, or covered processional hall, now destroyed, was built around the outside. The rear walls of the first-story recesses were opened up to provide entrances from the ambulatory. In the fourth century, the building was redecorated inside with mosaics of superb technical quality and color. Frescoes were added in the ninth century. The Ottomans turned the mausoleum into a mosque in 1591. A single minaret close to the mausoleum is the only one that still stands in Thessaloniki. Today, the Mausoleum of Galerius is a lapidary museum.

Further Reading

Ramage, Nancy H., and Andrew Ramage. *Roman Art: Romulus to Constantine*, 3d ed. Englewood Cliffs: Prentice Hall, 2000.
Ward-Perkins, J. B. *Roman Imperial Architecture*. New Haven, Conn.: Yale University Press, 1994.

MONASTERIES, MOUNT ATHOS

Style: Middle Byzantine
Date: Tenth–Twentieth Century C.E.
Architect: Unknown

For more than a millennium, Mount Athos has been a spiritual center of the Orthodox faith and the ideal model of Greek monasticism. Called Agio Oros, or "Holy Mountain," by the faithful and "Garden of the Mother of God" by its inhabitants, Mount Athos is the easternmost of the three peninsulas of Chalcidice in northeastern Greece. The peninsula is twenty-seven miles long and just three miles wide, and its wild, mountainous landscape is forested with chestnut, oak, and pine. At the very end of the peninsula, the white limestone peak of Mount Athos rises to a height of 6,670 feet. Since the peninsula is surrounded on three sides by the Aegean Sea and is connected to the mainland by a very narrow isthmus, it is quite isolated and was difficult to access until modern times. This is why, of course, the area was attractive to religious hermits and holy men who renounced life in the cities of the Byzantine Empire and retreated to caves and huts in the wilderness to devote themselves to God.

Exactly when these men first settled on Mount Athos is not known, but various legends attribute the founding of the monastic community to the Virgin Mary, to Saint Helena (mother of Constantine, the first Christian emperor), and to one or another of the Byzantine emperors of the fourth century. Historical documentation in the church's library indicates that the first Lavra, or community of monks, was instituted by Saint Athanasios of Trebizond in 963. Athanasios was encouraged and supported financially in this venture by his friend, Emperor Nikephoros Phokos, who thus became the first great benefactor of the Holy Mountain.

The Great Lavra, the first community, was originally strictly coenobitic, which means that the monks lived a communal life without personal possessions, adhered to a strict diet, and attended church services for at least eight hours every day. In 1060, Emperor Constantine Monomachus issued the order, still in force today, that forbid women, children, eunuchs, female animals, and persons without beards from setting foot on the peninsula.

By the thirteenth century, the number of monasteries on Mount Athos began to multiply rapidly because of the support and protection of Byzantine rulers, such as Alexius I Comnenus, and their families. In 1312, Andronikos II renounced his authority over the Holy Mountain and placed it under the authority of the patriarch of Constantinople, thereby removing all secular control.

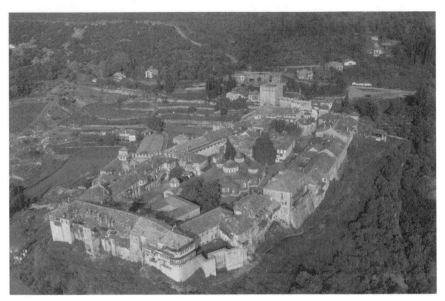

View of a monastery on Mount Athos. © *Yann Arthus-Bertrand/Corbis.*

After the fall of the Byzantine Empire in 1453, the monks of Mount Athos were careful not to alienate the Turks. The monks thus preserved their communities and Mount Athos became a center and symbol of the survival of Orthodoxy within the Muslim world. By the sixteenth century, there were thirty monasteries and some thirty thousand monks on the peninsula.

In the Treaty of London of 1913, Mount Athos was declared independent and neutral. Later, in 1926, it became a theocratic republic with its own capital at Karies. Mount Athos is still a part of Greece, but it has its own administration and governs itself. Today there are twenty monasteries on the Holy Mountain that house about fifteen hundred monks. While seventeen of the communities are Greek, the remaining three are Russian, Bulgarian, and Serbian. The rule of Constantine Monomachus has been relaxed to allow female cats and chickens to live among the monks, and men with shaved faces are now allowed to visit.

The monasteries of Mount Athos are of two types. The first is the coenobitic, or communal, rule discussed above. Second is the idiorrhythmic, which is a milder rule requiring that the monks worship in common but otherwise allowing them to practice their own ways of life and devotion. There are also monks who do not stay in the monasteries but live apart, either in small groups of three or four or all alone in remote areas of the peninsula.

The major monasteries of Mount Athos are very large and, indeed, resemble small towns or villages. Since their plans are all very similar, a generic description will provide an overview of the organization and types of buildings

included in the complexes. Occasional references to the Great Lavra, the earliest monastery on the peninsula, will provide details about the important parts of the monastic layout.

A typical monastery has the shape of a rectangle or trapezoid surrounded by thick stone walls fortified with one or more rectangular towers. In the past, one tower functioned as a keep, or stronghold, where the monks could go for protection from pirates and other would-be intruders. Often the extensive library of the monastery is housed in the keep. Entrance to the community is through a single gate near one of the corners of the circuit wall. At the Great Lavra, the entrance is a long winding corridor that contains several heavy iron gates.

Inside the walls, the primary space of the monastery is the expansive courtyard. At its center—and thus at the very heart of the community—is the katholikon, or primary church, with its multiple domes and brightly painted, yet restrained, exterior (see **Katholikon of the Great Lavra**). Also in the courtyard are chapels dedicated to Christ, the Virgin Mary, and various saints. The number of chapels is variable.

On the long sides of the rectangle, facing inward, are workshops, stables, and storage rooms. Also against the long walls and facing inward are the cells of the monks. These small rooms are arranged in long rows that open onto a continuous loggia, or corridor, with either an arcade (masonry piers supporting a series of arches) or a row of wood columns on the side overlooking the courtyard. Depending on the size of the monastery, the building containing the cells can be as many as four stories tall.

Built against one short wall of the rectangle, usually opposite the entrance to the katholikon, is the trapeza, or dining hall. This is generally a long hall with an apse (a semicircular space roofed with a half-dome) at one end where the abbot presides over the daily meals. The trapeza at the Great Lavra is the oldest and largest at Mount Athos. It has a cross-shaped plan and an impressive pitched wood roof with exposed beams and dates to 1512. The walls are beautifully decorated with paintings depicting the Last Supper, the Last Judgement, the death of Saint Athanasios, and other themes. Although they are unsigned, the paintings are attributed to Theophanes of Crete, who worked at the Holy Mountain between 1535 and 1560. Adjacent to the trapeza in all monasteries were the kitchen, the bakery, and the wine storage vault.

Located in between the katholikon and the trapeza is the phiale, which is a wellhead or fountain covered by a canopy and used for the ceremony of blessing the water. The phiale of the Great Lavra, built in 1635, is a very elegant small structure with an ancient porphyry basin containing an ornamental bronze fountain. This basin is surrounded by a low wall decorated with relief sculpture in Byzantine style and columns with Turkish capitals that support a dome. Inside the canopy is a painting of the baptism of Christ.

Against the other short wall of the monastic enclosure is the guest house. This area is set aside for pilgrims who reside at the monastery for various periods of

time. The guest house has small sleeping rooms, a kitchen, and reception rooms. Some monasteries have a separate library building and a treasury where relics, expensive offerings, and vestments are stored.

Other structures used by the monastic community are located outside the walls. These include a bathhouse and an infirmary. Many of the monasteries have small harbors where there are boathouses with docks and areas for storing cargo. These are interesting small buildings that are usually two stories tall and have a short lookout tower.

The primary building materials of the monasteries are brick, mortar, and stone. Almost every room is vaulted, and the dome is a major design element in every katholikon. There is some wood lath (narrow strips of wood used to make the groundwork for plaster), and wood is also used for doors, windows, loggia columns, and balconies. Because all the monasteries except the Great Lavra have suffered from fire damage over the centuries, the buildings have been reconstructed several times. Even the Great Lavra is a mix of chronological periods and building styles.

Mount Athos welcomes both Orthodox pilgrims and other men who come for retreat. The serenity of the Holy Mountain, its natural beauty, and the simplicity of the lives of the monks are praised in the fascinating memoirs of many visitors.

Further Reading

Hetherington, Paul. *Byzantine and Medieval Greece: Churches, Castles and Art*. London: John Murray Publishers, Ltd., 1991.

Kadas, Sotiris. *Mount Athos: An Illustrated Guide to the Monasteries and Their History*. Louise Turner, trans. Athens: Ekdotike Athenon S.A., 1979.

Mango, Cyril. *Byzantine Architecture*. Milano: Electa Editrice/Rizzoli, 1978.

NATIONAL LIBRARY, ATHENS

Style: Hellenic Neoclassical
Date: 1885–1892 C.E.
Architect: Theophilos Hansen

In 1834, Athens was selected to be the capital of the newly formed independent state of Greece. The new ruler of the country, Otto Wittelsbach of Bavaria, arrived in the city in 1835 and found it in ruins from nearly a year of bombardment by Ottoman forces. Because of the city's condition, Otto was in a position to build a new city designed according to the romantic neoclassical style that had originated in Europe during the Greek War of Independence. The rebuilding of Athens was begun by architects from Denmark, Germany, and France. Among the Danes who had settled in the city in the 1830s were the Hansen brothers, Christian and Theophilos. They were trained at the Copenhagen's Academy of Fine Arts, where they studied neoclassical architecture and developed a passion for classical Greek art.

Christian arrived in Athens in 1833 and was soon appointed court architect by Otto. In 1838, Christian summoned his younger brother to assist him in the building of the **University of Athens**. Theophilos made a fine reputation for himself and remained in Athens after Christian left in 1857. While living in Athens, Theophilos took part in the restoration of the **Parthenon** and the **Temple of Athena Nike**. He made measured drawings of the **Choregic Monument of Lysicrates** and the **Erechtheum**, which he later published. Hansen's archaeological studies were inspired by his belief that classical Greek architecture was pure perfection. He wanted to create for Athens a specifically Greek, or Hellenic, neoclassicism that was descended from the great monuments of the age of Pericles. From the ancients, he learned proportionality, the Greek orders, and details as well as the integration of architecture, painting, and sculpture. These were the guiding principles of his designs.

Although he left Athens in 1846 after the completion of the **Observatory**, Hansen continued his affiliation with Greece. In 1859, he submitted a design for the **Academy of Sciences**, which was built on the south side of the University of Athens. At the same time he proposed the building of an Athenian Trilogy, which would include these two buildings and a library to the south. Nothing came of the plans for the library.

In 1868, however, the vice-chancellor suggested that a laboratory should be built on the north side of the university. The architect Ernst Ziller, who

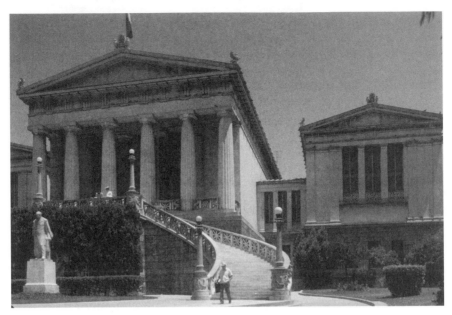

National Library, Athens. *Courtesy of Michio Yamaguchi.*

designed the **Schliemann House**, realized that such a building would distract from the appearance of the academy and the university. Therefore, he began a campaign to persuade the vice-chancellor and the prime minister of Greece to build Hansen's library instead. After considerable discussion, Hansen was asked to submit plans for the building in 1884. He agreed to design the building at no cost—it was to be his gift to the Greeks in appreciation for all that he had learned from ancient Greek art and architecture.

Construction of the National Library began in 1885 under the supervision of Ziller. Funds for the work were supplied by the Public Endowment Fund and by the Vallianos brothers (Maris, Panagis, and Andreas), shipping magnates living abroad. The library is often called the Villianos Library in honor of this family.

The National Library—the only Athenian Trilogy building that is in the Doric order—is composed of three rectangular units connected by three corridors. The central section houses the reading room and administrative offices, and the flanking units are the book stacks. As in Hansen's Academy of Sciences, the central unit is emphasized. It is wider and taller than the other units, and it projects forward beyond the facades of the outer blocks. The building has two stories in contrasting materials: the walls on the first story are limestone, and the walls of the second story are Pentelic marble.

A large curved double staircase leads up to the entrance of the library, which is on the upper floor of the central block. The staircase has highly decorative

balustrades with griffins worked in relief sculpture and large lampposts at the top and base. Above the stairs, the imposing facade is based on the **Temple of Hephaestus** and has six tapering Doric columns across the front. The columns support a plain architrave, or lintel, and above this runs a Doric frieze composed of alternating triglyph and metopes. Triglyphs are rectangular blocks with vertical grooves cut into their surfaces; metopes are the flat panels between the triglyphs. A horizontal molding above the frieze forms the bottom of the pediment, a long low triangle formed by the sloping eaves of the gabled roof. Hansen's drawings for the building show sculpture on the metopes and in the pediment; however, these were never executed, so both areas are blank.

The facades of the outer blocks are two stories tall and are identical. The bottom story is made of plain masonry blocks and has three rectangular windows in the center without ornament. On this base stands the upper story, which is shaped like a temple facade but has no colonnade. Instead, there are three windows in the center resting on a parapet. The windows are directly above those on the ground floor and are separated and flanked by Doric pilasters. To either side of this central feature are two pilasters engaged in a plain solid wall. The facade is topped by a pediment that is blank. The long sides of the outer blocks are a variation of the facades. At either end are two pilasters enclosing a blank wall. Between these is a row of twelve columns with windows in between. Directly below each of these windows, on the ground floor, is a rectangular window without decoration. The windows here provide ample illumination for the book stacks inside.

As in the Academy of Sciences, the interior of the main block is similar to the shape of a Greek temple. Behind the two center columns of the facade are a pair of Doric columns flanked by doors leading to staircases. A door in the center of the block opens into a transverse rectangular vestibule with a pair of Ionic columns on either side. Access to the reading room is through a door in the center of the rear wall of the vestibule.

Most of the interior design of the reading room as well as the room itself are the work of Ernst Ziller. The room is a long rectangular hall with Ionic colonnades on all four sides. There are four columns at the front and back and eight (counting the corner columns twice) on the flanks. The columns carry a three-band architrave with a blank frieze above. Outside the colonnades along the exterior walls are metal bookcases and balconies specially designed to harmonize with the neoclassical style of the room. Since there are no windows in the exterior walls, a flat glass ceiling covers the central area of the reading room to provide light.

The National Library building was not completed until 1892, a year after the death of Theophilos Hansen. In 1903, the Greek National Library was officially installed in the building. The library houses an estimated one million titles and nearly two million books, newspapers, periodicals, medieval manuscripts, and other texts.

Further Reading

Bastea, Eleni. *The Creation of Modern Athens: Planning the Myth*. Cambridge: Cambridge University Press, 2000.

European Union's Culture 2000. www.culture2000.tee.gr.

Jorgensen, Lisbet B., and Demetri Porphyrios. *Neoclassical Architecture in Copenhagen and Athens: Architectural Design Profile 66*. London: The Academy Group Ltd., 1987.

Travlos, John. *Neo-Classical Architecture in Greece*. Athens: The Commercial Bank of Greece, 1967.

NORTH SUBURBS, OLYNTHOS

Style: Classical
Date: Fifth Century B.C.E.
Architect: Unknown

With rare exceptions, the Greeks did not practice systematic town planning until the fifth century. Most cities consisted of a public square, or agora, that functioned as a market, meeting place, and location for civic buildings; areas sacred to the gods, which contained shrines or temples; irregular streets, which were generally narrow and unsanitary; and housing, which was randomly arranged around the civic and religious sites. The idea of designing a geometrically regular city that was planned before it was built seems to have originated in Ionia, the region of the eastern Greeks on the coast of modern Turkey. Hippodamus of Miletus, a physician, was the legendary inventor of town planning. His city, Miletus, was totally destroyed by the Persians in 494 and was rebuilt according to a grid system with regular streets that formed city blocks. Pericles, the leader of Athens, was said to have engaged Hippodamus to lay out the port city of Piraeus and to plan the Athenian colony of Thurii in southern Italy. Because the Greeks attributed the invention of the city grid to Hippodamus, modern scholars refer to such a town plan as a Hippodamian grid system. It is also referred to as an orthogonal city plan.

An excellent example of the Hippodamian grid system was the Macedonian city of Olynthos that was destroyed by Philip of Macedon in 348. The site was excavated by the American School of Classical Studies from 1928 until 1934 C.E. Olynthos occupies two flat-topped hills; the south hill was the site of the original city, which had an irregular plan. In the last third of the fifth century B.C.E., the population swelled to thirty thousand inhabitants. To accommodate this influx of people, Olynthos was enlarged by adding a new suburb on the north hill. The north suburbs were residential and provide a great deal of information about late fifth-century houses and the way in which they were organized within the urban grid (see **House A vii 4**).

Four main avenues running north and south are crossed at right angles by thirteen streets running east and west in a regular checkerboard pattern. The avenues (designated A, B, C, and D) are graduated in width according to their prominence in the city plan. Avenue A is 19½ feet wide; Avenue B, the main street, is 22¾ feet wide; Avenues C and D are 16¼ feet wide. All the cross streets are 16 feet in width. The avenues are 283¼ feet apart; the cross streets are 116½ feet apart. This creates a series of city blocks that each measure 283¼ by 116½

feet. An alley 4½ feet wide bisects each block into two units of 283¼ feet by 56 feet. These units are subdivided into five house lots measuring 56⅔ by 56 feet, or 3,173 square feet.

The Hippodamian grid system was not a rigid imposition of order on an urban space. Cities other than Olynthos—such as Miletus, Selinus, Rhodes, and Priene—demonstrate that the system could be used on hilly terrain as well as on level ground. Areas for civic buildings and traditional sacred spaces could easily be incorporated into the grid, and slight deviations within the system are frequent. The grid served as a basis for organizing new communities such as the colonies founded all around the Mediterranean by the Greek city-states. Even Alexander the Great had recourse to the Hippodamian grid system when he established cities in his newly won eastern territories.

Further Reading

Dinsmoor, William B. *The Architecture of Ancient Greece*, 3d ed. New York: W. W. Norton, 1975.

Lawrence, A. W. *Greek Architecture*, 4th ed. R. A. Tomlinson, ed. Harmondsworth, England: Penguin Books, 1983.

Wycherley, R. E. *How the Greeks Built Cities*. Garden City, N.Y.: Doubleday, 1969.

OBSERVATORY, ATHENS

Style: Hellenic Neoclassical
Date: 1842–1846 C.E.
Architect: Theophilos Hansen

When Greece was liberated from the Ottoman Empire in 1833, Athens was chosen as the capital of the new independent state. After years of war, the city had been reduced to rubble and had a population of only six thousand inhabitants, mostly poor. King Otto arrived in Athens in 1835 and inaugurated the rebuilding of the city in the neoclassical style, which was then the prevailing architectural style of the major European capitals. Not only would the new Athens be homogeneous in design, it would also evoke memories of the glorious history and achievements of classical Greece. The ancient monuments that remained and the new buildings that were to be constructed would share a similar vocabulary of forms and details based on careful study of the classical ruins.

The rebuilding of Athens was primarily the work of architects from Denmark, France, and Germany. A small group of Danes settled in Athens in the 1830s; the most important and successful of them were Christian and Theophilos Hansen. The brothers dominated the group and became the leaders of a movement to create a modern Hellenic architecture based on the buildings on the **Acropolis**. The Hansen brothers had been trained at Copenhagen's Academy of Fine Arts, where they learned the importance of proportion, the principles of the Greek orders, and a reverence for the monuments of Athens.

Theophilos Hansen arrived in Athens in 1838 at the age of twenty-three. He made careful measured drawings of the **Choregic Monument of Lysicrates** and the **Erechtheum**, studied the **Parthenon** in great detail, and assisted in the reconstruction of the **Temple of Athena Nike**. Theophilos taught at the Zentners Technical School, where he trained Greek craftsmen in the materials and techniques of classical architecture. He also assisted his brother Christian in the building of the **University of Athens** and designed a church and several houses. But the project that made Theophilos Hansen's reputation as a neoclassicist of great talent was the design of the Observatory.

In 1840, the expatriot Georgios Sinas donated five hundred thousand drachmas to the government to fund the development of science in Greece. Sinas was born in Epirus, but he settled in Vienna where he amassed a fortune by founding the first railroad in Europe, working as the governor of the

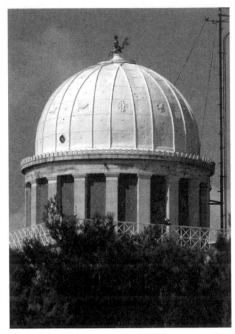

Astronomical Observatory, Athens. *Courtesy of John Kurtich.*

National Bank of Austria, and serving as the Greek consul. At the suggestion of his friend the Austrian ambassador to Athens, Sinas designated that the money he donated be used to establish an astronomical observatory.

Plans for the building were submitted to King Otto by the German architect Eduard Schaubert but were rejected because the neo-Byzantine style he proposed was considered inappropriate for a national monument, especially one that was to be located in view of the Acropolis. Hansen's neoclassical design was approved by Otto, and with great fanfare the foundation stone was laid on June 26, 1842, the day of a solar eclipse.

The Observatory, situated on the Hill of the Nymphs to the west of the Acropolis, stands on a platform made of rectangular masonry blocks that provides a level base for the building despite the irregular terrain of the hilltop. This treatment owes its inspiration to the Erechtheum, which was also built on irregular ground levels. The Observatory is cross-shaped in plan with a square central block from which project short wings on the east and west and long wings on the north and south. An ornamental balustrade surrounds the top of the central square, and above this rises a dome carried on a circular drum. The drum is ornamented with Doric pilasters that flank several windows and twelve niches in which images of the Olympian gods are depicted in the style of sixth- and fifth-century B.C.E. vase-painting.

The entrance to the Observatory is on the west side, which has a large central door framed by a heavy molding modeled on classical prototypes. The rest

of the west facade is blank except for a Doric pilaster at each corner and a double architrave, or continuous horizontal band, that appears to rest on the pilasters and the upper edge of the door frame. Above this is a pediment, or low triangle formed by the eaves of the gabled roof, decorated with floral scrolls in relief sculpture. Each of the side walls of the west wing is divided into two by a horizontal molding. A tall pilaster at the western corner unifies the two zones vertically. In the center of the wall, directly on top of the molding, is a window flanked by Doric pilasters. The double architrave of the facade continues on the side wall. The short east wing that forms the back of the building is identical to the west wing except that its rear wall has the double-zone division and the central door is replaced by two windows famed by pilasters.

On the north and south sides the wings are about twice as long as the east and west units but are beautifully integrated into the whole by their details and proportions. Each of the wings ends with the same design as the rear of the east wing. The long sides of these units have the tall Doric pilaster at the corner, the double-zone division, windows flanked by pilasters above the horizontal molding, and the double architrave. Instead of two windows, the number is increased to five. Painted decoration in the style of ancient vase-painting represented the ancient Greek astronomers such a Pythagoras, Meton, and Phaeinus.

Theophilos Hansen was able to transform a utilitarian structure into a masterpiece of neoclassical architecture that was based on the real classical buildings of Athens. For example, the proportions of the entrance facade and its Doric pilasters are based on those of the Parthenon. From the Erechtheum, Hansen derived the regularizing base and the rows of windows set high in the walls and separated by pilasters. Furthermore, all three types of stone found in buildings on the Acropolis—local limestone, marble from Mount Pentelicon, and bluish marble from Mount Hymettos—are used in the Observatory to give the building a subtle polychromy. Finally, the paintings on the Observatory were inspired by Hansen's study of the polychrome decorations on classical buildings, which he wanted to revive.

The Observatory opened in 1846 c.e. It is the oldest research establishment in Greece and is the home of the Institute of Astronomy and Astrophysics. Because of political instability in the city, Theophilos Hansen left Athens when the Observatory was complete and settled in Vienna, where he became one of that city's most important architects. However, Hansen continued his interest in neoclassical Athenian projects and designed the **Academy of Sciences** and the **National Library**.

Further Reading

Bastea, Eleni. *The Creation of Modern Athens: Planning the Myth.* Cambridge: Cambridge University Press, 2000.

European Union's Culture 2000. www.culture2000.tee.gr.

Jorgensen, Lisbet B., and Demetri Porphyrios. *Neoclassical Architecture in Copenhagen and Athens: Architectural Design Profile 66.* London: The Academy Group Ltd., 1987.

Travlos, John. *Neo-Classical Architecture in Greece.* Athens: The Commercial Bank of Greece, 1967.

ODEUM OF HERODES ATTICUS, ATHENS

Style: Roman
Date: 161 C.E.
Architect: Unknown

Herodes Atticus of Athens was an extremely wealthy statesman who rose to high office in the second century, serving three successive Roman emperors: Hadrian, Antoninus Pius, and Marcus Aurelius. He married Annia Regilla, an aristocratic woman of impeccable virtue and impressive Roman lineage, and divided his career between Athens and Rome. Herodes is best remembered for his ostentatious generosity to his native land. Apparently, he intended to imitate the emperor Hadrian, who spent a good deal of his reign visiting provincial cities and leaving behind an elegant architectural legacy.

Herodes financed projects in several Greek cities and sanctuaries. Building on a lavish scale was expected of wealthy citizens and indeed made the life of the not-so-rich more pleasant. However, philanthropy on a large scale was also a form of self-promotion that enhanced the prestige and reputation of the giver. Aristocrats in Rome and the provinces manipulated public opinion, gained political support, and advertised their social and financial superiority by raising imposing buildings in their communities.

In 160, Herodes's wife Annia Regilla died. His grief was so great that, in typical Roman fashion, he set up memorial statues of her in several sanctuaries and, in 161, financed the building of an odeum in Athens dedicated to her memory.

An odeum is usually a small roofed theater designed for intimate performances. These included recitations, lectures, and musical events. The shape of the odeum is an abbreviated form of the large Roman theater, and both building types vary considerably from the plan of Greek theaters (see **Theater**). Most significantly, the Roman theater was a structural unity in which the auditorium and stage building were joined to completely enclose the interior space. The auditorium was exactly semicircular and was supported by a heavy external wall and a series of arches and vaults. Roman stage buildings tended to be large and elaborately decorated and were joined to the auditorium by projecting wings. Stage buildings were the same height as the top of the auditorium. The actual stage was tall so that it overlooked the semicircular orchestra. Roman theaters were too large to be roofed, but the smaller odea had ceilings made of wood.

The Odeum of Herodes Atticus was unusual because of its size; it was nearly four times as large as a typical concert hall. Because it was built into the south

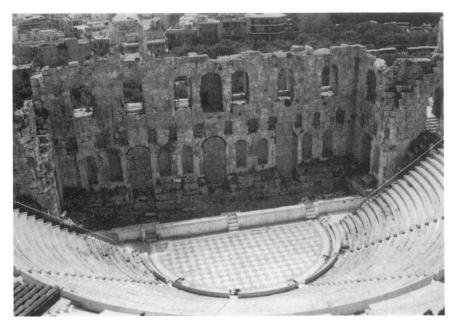

Odeum of Herodes Atticus, Athens. *Courtesy of Jennifer Tobin.*

side of the Acropolis, the auditorium, or seating area, was only partially free-standing. Some of the lower tiers of seats were placed directly on bedrock, while foundations of brick and mortar supported the higher tiers. The auditorium was 125 feet in diameter and had thirty-two rows of marble seats. It was divided into two levels by a walkway that was connected to flights of steps that divided the lower level into five wedge-shaped sections and the upper level into twelve. At the top of the auditorium was a second walkway that facilitated the movement of spectators. As many as forty-eight hundred people could be seated in the auditorium.

At the foot of the seating area was the orchestra, which was thirty-one feet in diameter and paved with white and gray marble. Directly behind the orchestra were the marble parapets that supported a wooden stage.

The stage building was a long rectangular structure that provided a decorative backdrop for the stage and also could be used for storage and performer preparation. Today it is preserved to a height of ninety-two feet, but it was probably taller when it was complete. The structure was perhaps originally four stories tall, although the top story no longer exists. The first story had the most elaborate decoration. Three arched doorways gave access to the backstage area. A series of eight niches with round tops were distributed in pairs between the doors and the ends of the facade. These niches most likely contained statues. At the base of the facade was a ledge that seems to have supported a file of marble Corinthian columns arranged in pairs flanking the

doorways. The upper level of the first story had a row of small rectangular niches recessed into its surface. Their function is not clearly understood.

The second story of the building is punctuated by six large arched windows arranged symmetrically on either side of a slightly larger central arch. This arrangement seems to have been repeated in the third and fourth stories. The four-story decorative scheme, including the windows, was continued on the flank walls that joined the stage building to the auditorium. Such a large number of windows was necessary to provide adequate lighting in the covered interior of the odeum.

Behind the facade of the stage building was a long rectangular hall, three stories high, roofed with a barrel vault. Traces of mosaic pavement and colored stone found in the ruins indicate that the floors were decorated and that the walls of the building were sheathed with brightly hued marble imported from various parts of the empire. Flanking the stage building were two enormous staircases that carried spectators up to the middle and upper walkways.

In *Lives of the Sophists*, Philostratus's biography of Herodes states that the odeum was a marvel of size and beauty and that it had a roof made of cedar. Many scholars have discounted Philostratus's claim because there is no evidence for internal supports of any kind and because the roof span would be about 250 feet. Recently, however, careful reexamination of the original excavation documents has provided evidence that indeed there was a wood roof.

The building was destroyed by a raging fire so hot that it caused the marble seats to crack and explode. A thick layer of ash and burnt debris covered the orchestra and much of the lower level of seats. The heat of the fire and the amount of ash confirm the presence of a great deal of wood that fell from above into the odeum. Also, numerous roof tiles were found in the ruins. This evidence seems to confirm the accuracy of Philostratus's report that the odeum was covered by a cedar roof. Exactly how the roof was constructed is not certain, but since Roman engineers were famous for their ingenuity in roof design, Philostratus is believable.

No one knows exactly when the fire that destroyed the Odeum of Herodes Atticus occurred. Some suggest it was part of the devastation of Athens that took place during the Herulian raids of 267. The auditorium and orchestra of the odeum have been rebuilt in the twentieth century, and it is now the site for the annual Athens Festival featuring musical events and dramatic performances. There is no roof on the building.

Further Reading

Tobin, Jennifer. *Herodes Attikos and the City of Athens: Patronage and Conflict under the Antonines*, Vol. 4. Amsterdam: J. C. Gieben, 1997.

Travlos, John. *Pictorial Dictionary of Ancient Athens*. London: Frederick A. Praeger, 1971.

PALACE OF MINOS, KNOSSOS

Style: Minoan
Date: Seventeenth Century B.C.E.
Architect: Unknown

A king named Minos who ruled all the Mediterranean. A queen who lusted after a bull. A horrible monster called the Minotaur. A gigantic maze built to confine the creature. An architect named Daedalus who fashioned wings of feathers and wax to escape from Minos. Young Athenians sacrificed to the Minotaur every nine years. Theseus, hero of Athens, who killed the beast. A grieving Athenian father, Aegeus, who threw himself into the sea that now bears his name.

These and other fragments of memory concerning the island of Crete in the Bronze Age were incorporated into Greek myth and history. Long believed by scholars to be imaginary tales with no historical validity, the stories were reevaluated in the nineteenth century C.E. In 1878, Minos Kalokairinos, a native of Crete, identified a huge sprawling ruin at the site of Knossos on the north side of the island as the Labyrinth, or maze, built by the legendary King Minos to contain the monstrous Minotaur. The British archaeologist Sir Arthur Evans took over the site in 1900 and began a series of excavations and reconstructions that would link his name to Knossos and give him credit for discovering the palace there.

Evans called the Bronze Age culture of Crete "Minoan" after the mythical king Minos, but it is not known what they called themselves. Two types of writing have been found in the palace, but neither can be read. For that reason, Minoan life and culture has to be reconstructed (or constructed) on the basis of architectural remains and the artifacts found at various sites in Crete, the Aegean islands, and elsewhere. Evans posited a peaceful, goddess-worshiping society living in palaces that were open to the surrounding landscape and needed no defenses. His King Minos dominated trade with a large navy that traded at ports all around the Mediterranean. In addition to maritime commerce, Evans's Minoans invested a lot of time in dancing, court ceremonies, bull-leaping exhibitions by young men and women, and religious rituals.

This romantic picture of a peaceful, nature-loving culture has now largely been abandoned. Paintings of naval battles and the stone walls and towers that guarded the palaces on Crete indicate less than peaceful conditions. There is also some evidence that suggests child sacrifice. These three factors, and many

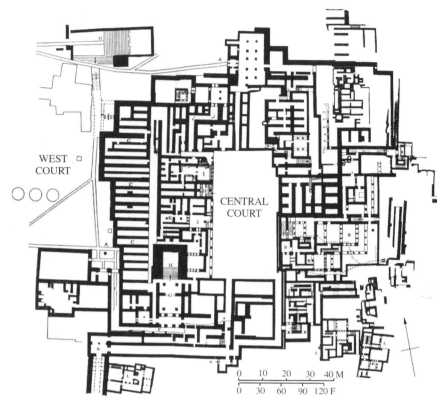

WEST
COURT

CENTRAL
COURT

0 10 20 30 40 M
0 30 60 90 120 F

Plan of the Palace of Minos at Knossos, Crete.

more, are leading archaeologists to reevaluate Evans's findings, reconstructions, and conclusions.

The Palace of Minos is an extensive building complex situated on Kefala hill, a site that was occupied continuously from Neolithic times (7,000–3,000 B.C.E.). The history of the site is extremely complicated because of the constant repairs, renovations, and rebuilding that resulted from fires and earthquakes. The first palace on the hill was built near the city of Knossos in the nineteenth century and was destroyed, perhaps by an earthquake, sometime in the seventeenth. Some of the features of the old palace layout were preserved and much expanded in the massive rebuilding that followed. The second palace was the largest on Crete, which suggests that Knossos, with a population of fifty thousand or more, was the most powerful city on the island.

Although the building is always referred to as a palace, the use of this designation is now simply conventional. There is no solid evidence that it was a residence for kings, queens, or any other political or religious official. Reevaluation of the Palace of Minos, supported by information from the other Minoan palaces on Crete, indicates that it was a multifunctional complex that acted as a sort of

civic center. Its functions were extensive and included commercial, manufacturing, warehousing, religious, political, social, and ceremonial activities.

The palace is a large multistoried compound covering six acres and has more than one thousand rooms. The roofs of the various blocks and stories are flat and are supported by many columns of a very distinctive shape. Each column tapers toward the bottom so that the base is smaller in diameter than the top, which carries a big round capital. The walls of the palace were made of rubble and mud brick with timber used to frame and brace them. The wood provided the walls with a certain amount of flexibility to withstand earthquakes, but it was also dangerously flammable. Floors were made of plaster or slabs of stone.

A large courtyard, 197 feet long and 95 feet wide, is the center of the complex. All of the blocks of buildings are organized around it, and many open onto it. There are four entrances to the palace and three entrance porticoes on the southwest, north, and northeast. The main ceremonial entrance seems to be located on the southwest and opens into a corridor, which Evans called the Corridor of Processions, that runs along the side of the building and then turns south. Access to the central courtyard from any of the entrances involves a number of turns, which probably gave rise to the myth of Minos's maze.

There are so many rooms in the palace complex that only a few can be addressed here. They will be considered in the order of their position relative to the courtyard. On the west side are rooms for religious use. Two vestibules flanking a staircase face the courtyard. One provides access to the throne room that contains a built-in bench and an ornamented gypsum throne. Across from the throne is a small stairway that descends into a chamber sunk below ground level and lined with slabs of stone. This constant feature of Minoan architecture, usually referred to as a lustral area, is not clearly understood, but most scholars agree that it had some sort of ceremonial or ritual function. A rare decorated example on the island of Thera seems to indicate that initiation rituals for adolescent girls were staged in the lustral areas. Evans's suggestion that the throne room was designed for royal engagements has now been largely dismissed in favor of a religious interpretation, which suggests that the room and its adjacent spaces were used by a high religious official. The second vestibule leads to two pillar crypts, which were used for ritual activities, and a treasury where cult objects, including the famous Snake Goddess, were stored. To the west of these cult rooms, extending the whole length of the palace, are long narrow storage rooms.

Evans identified the complexes of rooms on the east side of the courtyard as royal apartments, but there is no clear evidence of domestic use in this part of the palace. Instead, this area appears to contain a series of hall systems that were used as political meeting rooms, commercial offices, or reception spaces. Hall systems frequently are built in pairs with larger and smaller rooms arranged either parallel or perpendicular to one another. There are four stories of rooms here: two above the level of the courtyard, and two below it that are built into the slope of the hill. Light wells—vertical shafts of several sto-

ries that are open to the sky—provide illumination and ventilation for the numerous rooms, which are interconnected by corridors and staircases. A grand staircase leads down to a long room containing numerous columns that could be partitioned into two rooms when necessary. Evans called this the Hall of Double Axes, a name derived from the labrys, or double ax, that is found everywhere in Minoan decoration and cult.

Also on the lower level is the queen's megaron, a suite made up of a hall with windows all around, an anteroom, and a light well. The megaron also has a small bathroom with a terra-cotta tub. Close to the Hall of Double Axes is a larger suite that Evans assumed was the king's living quarters.

To the north and east of the hall systems are the outbuildings that were used for manufacturing and storage. There is evidence for the work of potters, silversmiths, tailors, stone workers, and goldsmiths, indicating that this part of the palace was a manufacturing site for luxury items perhaps intended for trade. The storerooms contained huge jars that held grain, wine, and other edibles in vast quantities.

In the past, scholars have described the organization and development of the Palace of Minos as lacking in architectural clarity, planning, and logic. The compound was believed to have developed around the central court in a confused ad hoc manner, with additions constructed at various times without consideration of their relation to preexisting structures. This interpretation of the development and architectural style of the palace has recently been called into question. New studies and methodologies have led to quite opposite conclusions and suggest that the palace was laid out with precision, that its harmonic design and relationship to the surrounding landscape is brilliant, and that there is indeed logic in the division and location of rooms, halls, and suites to appropriately house the numerous activities that took place in the compound.

In its original state, the Palace of Minos was a lively and colorful place. The hundreds of columns were painted red and had black capitals. Many of the rooms, corridors, balconies, and hall systems were decorated with brightly colored frescoes of marine life, court ceremonies, imaginary beasts, military motifs, and flowers. Particularly lovely is the ornamentation of the queen's megaron with rosettes, running spirals, and a frieze of dolphins. The Corridor of Processions takes its modern name from the subject of its decoration that shows a ceremonial parade. In the throne room, the gypsum chair is flanked by painted griffins and palm trees in a fantasy landscape. The frescoes one sees today at Knossos are reconstructions that Evans based on the fragments of paintings he found in the rooms of the palace.

The geological instability of Crete and the expansion of the power of the Mycenaean Greeks on the mainland threatened and eventually destroyed the Palace of Minos. Major damage was done to the compound sometime before 1450, perhaps as the result of an earthquake. Soon after this, the Mycenaeans invaded part of the island and seem to have settled at Knossos. Some scholars posit that a Mycenaean prince ruled the city and was installed in the palace. A wave of destruction overcame Crete in 1400–1375, during which all the

palaces on the island were destroyed and Minoan culture ceased to be an important entity in the Mediterranean. The Palace of Minos was consumed by fire at this time, and the site was deserted.

Sir Arthur Evans's work at Knossos ended in 1931 c.e., but excavation and consolidation of the site have been continuous since then. The British School of Archaeology at Athens has conducted excavations in both the palace and the surrounding countryside. Further exploration has been undertaken by the 23rd Ephorate of Prehistoric and Classical Antiquities. Currently, the Archaeological Service of the Ministry of Culture is in charge of preserving and safeguarding the remains of the Palace of Minos.

Further Reading

Hood, Sinclair. *The Arts in Prehistoric Greece.* Harmondsworth, England, and New York: Penguin Books, 1978.

Matz, Friedrich. *The Art of Crete and Early Greece.* Ann E. Keep, trans. New York: Greystone Press, 1962.

Preziosi, Donald, and Louise A. Hitchcock. *Aegean Art and Architecture.* Oxford: Oxford University Press, 1999.

PALACE OF NESTOR, PYLOS

Style: Mycenaean
Date: Circa 1300 B.C.E.
Architect: Unknown

The Palace of Nestor occupies the leveled-off top of the hill of Epano Englianos not far from modern Pylos. Positioned next to the main north-south road on the western shore of the Peloponnesus, the site enjoys clear views of the port at Naverino Bay to the south and the Aigalion mountain range to the north. According to myth, the ancient settlement on the hill was invaded and taken over by the hero Neleus, son of the sea god Poseidon, who then became king of all the surrounding territory. Neleus was succeeded by his son Nestor, the second most powerful king in Homer's *Iliad*. So great and secure was the wealth of the ruler of Pylos that he was able to send ninety well-equipped ships to fight against the Trojans.

Archaeologists have identified four separate structures built in sequential order around 1300 in the palace compound on the level top of Epano Englianos hill. The oldest of these, once identified with Neleus's initial residence, is on the southwest. Although not well preserved, a king's hall, or megaron, and numerous storage rooms can be identified in this structure. In the center of the compound is the main building, or new palace, that is slightly later in date than the southwest building and therefore was once identified as the palace Nestor built after he succeeded his father. Third in chronological sequence is the wine magazine, and last is the northeast building that appears to have been associated with manufacturing. Although the mythological designation "Palace of Nestor" is firmly attached to the compound, there is, in fact, no evidence to identify the names of the real rulers who built and lived in the residence at Pylos.

Fortunately, the plan of the new palace is intact and provides an excellent example of a Mycenaean royal house. The residence of the *wanax*, or king, was the hub of a largely rural community, dominating the surrounding countryside where the common people lived and drawing into itself all manner of agricultural and manufactured items produced by the king's subjects. The palace also served as a manufacturing center where textiles, pottery, weapons, and armor were made. Storage magazines for wine, oil, and other goods made for trade were important parts of the palace complex. In the center of all this was the great megaron, or king's meeting hall, where political activities, military planning, trading transactions, and entertaining took place.

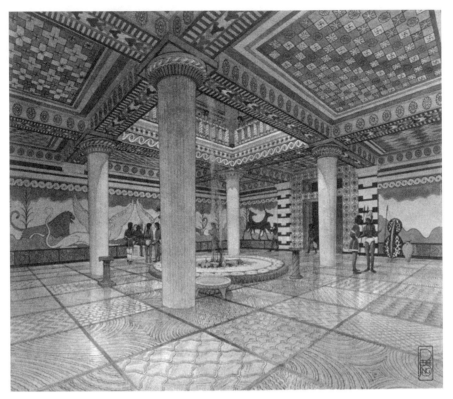

Recreation of the throne room at the Palace of Nestor at Pylos. *Courtesy of the Department of Classics, University of Cincinnati.*

Nestor's palace is unique among Mycenaean palaces in its lack of huge fortification walls (see **Citadel, Tiryns**). The reasons for this are not entirely clear, but apparently the builders relied on the natural rugged and mountainous terrain of the surrounding area and the elevated position of Epano Englianos hill to reduce the time and expense necessary for constructing massive bastions. Some scholars identify the influence of Minoan architecture in the lack of defensive walls and other details of the construction of the palace.

The propylon, or entrance porch, to the main building of Nestor's palace was a modest structure with a single wood column on each face. On the right, projecting beyond the front of the propylon, was a guard tower that allowed the king's followers who were stationed there to survey the surrounding countryside and the port at Naverino Bay. To the left of the propylon was a pair of rooms that did not have access to the interior of the palace. The outer room was a place where officials and scribes collected and recorded taxes on the products made or grown by the rural population. An enormous jar, six feet tall, received olive oil, one of the most precious commodities in the Pylos economy. The inner room functioned as a temporary archive where the detailed

records of tax payments and other contributions to the king were stored on wood shelves. These records were inscribed on clay tablets in Linear B script, the earliest form of Greek writing. The tablets contain lists of goods, persons, gods, and other important information about life in the palace.

The propylon opened into a large courtyard surrounded by rooms of various sizes. On the left, a recessed doorway provided entrance into a room commonly referred to as a waiting room that had painted benches built into two of its walls. A door connected this room to a storage room that housed hundreds of wine jars and cups.

Across the courtyard, roughly on axis with the entrance propylon, was the imposing entrance to the megaron, or king's great hall, that was the nucleus of every Mycenaean palace. A two-storied porch with a pair of columns at the front and a single door at the back was brightly painted to impress the visitor with the wealth and prestige of the king. Behind this was a shallow rectangular anteroom with a single door, across from the one in the porch, that opened into the megaron. Doors in each of the short sides of this room provided access to storage areas and to the residential part of the palace. Fragments of paintings indicate that the walls of the anteroom were decorated with representations of a procession of offering bearers and a great bull being led to sacrifice.

The megaron was truly magnificent in scale and decoration. It was thirty-seven feet wide and forty-two feet long. In the center was a circular hearth, about twelve feet across, made of clay covered with painted plaster. Four great columns arranged around the hearth supported balconies on all four sides of the hall. The vertical space above the hearth rose two stories to a lantern that allowed smoke to escape and light to enter the building.

In front of the center of the right wall, a depression in the floor probably marked the location of the king's throne. Also marking his place was the decoration of the painted plaster floor that had a checkerboard design with abstract patterns filling the squares. The only representational device on the floor was an octopus directly in front of the space for the throne. Painted on the walls of the megaron were reclining griffins and lions, traditional symbols of power and protection; a banquet scene; and a bard playing a lyre. The themes of these paintings alluded to the ceremonial life of the king. In this impressive formal space, he presented himself to the public as an all-powerful ruler protected by the supernatural creatures and the king of beasts. Here he conducted state business, administered justice, met with his warlords, received visitors, and enacted the sacred rituals of hospitality, or guest-friendship, as described by Homer. The banquet scene is reminiscent of the visit of Telemachos to the Palace of Nestor in Book three of the *Odessey*, while the bard in the megaron may represent a professional singer such as Demodokos who entertained Odysseus at the court of Alkinoos in Book seven.

Corridors flanking the megaron led to service rooms and to staircases going up to the second floor. Because the Linear B tablets found in the palace are inventories of goods either produced or stored there, archaeologists have a great deal of information about what the service areas were used for. A file of

small rooms opening off the left corridor contained thousands of terra-cotta cups and vases that would be sold locally or exported to sites all around the Mediterranean. Large terra-cotta vessels, which are identified in the Linear B tablets as oil containers, are imbedded in the stucco floor in the rooms behind the great hall. Three rooms on the corridor to the right of the megaron were areas where products such as olives, barley, wheat, figs, honey, and even spices such as cumin and coriander could be stored.

The residential, or private, quarters of the palace were located in the area to the right of the courtyard. They were entered through a portico with two columns supporting a balcony that could be used by members of the court to watch the processions and ceremonies that were such an important part of palace life. A door on the left side of the portico led to a suite of three rooms, a walled private courtyard, and a bathroom whose ancient tub and water vessels are still in place. On the right side of the portico, a doorway opened into a corridor that led to another suite of rooms and a second enclosed courtyard. The largest of these had a round hearth in the center and probably served as a location for intimate private receptions. Although often called the queen's megaron, there is no sound archaeological evidence to support such an identification, and the painted decoration of the room depicting life-sized lions and griffins argues against it. A corridor separated the large room from two small rooms that abutted the front wall of the main building. One was a latrine, and the second may have served as a dressing room. This room had painted walls, and its plaster floor was decorated with abstract patterns and figures of octopuses, dolphins, and fish. Stairways indicate that there was an extensive second story, but it did not survive the destruction of the palace.

Outside of the main building, near its northeastern corner, was the large rectangular wine magazine. Inside the magazine, great jars labeled with the word for wine, *woinos*, and an indication of place of origin were located. The fourth structure in the palace compound was the northeast building. This was a workshop and industrial complex where chariots were repaired, armor was made, leather was worked, pottery was produced, hundreds of bronze projectile points were cast, and women spun yarn and wove textiles.

The exterior walls of Nestor's palace were faced with square blocks of limestone, while those inside had a core of rubble (coarse masonry containing broken and irregular stones) covered with plaster. Mud bricks framed with wood beams were used for the walls of the second story. Wood was also used for all the columns and was applied in panels to the lower portions of some walls in a fashion similar to wainscoting. Water from a spring a half-mile away was brought to the palace by a raised wooden aqueduct. Tubs for washing and watering animals were incorporated into the channel. Terra-cotta pipes carried water through the workshop area and into the palace and then flushed it into a system of underground channels lined with stone.

The Palace of Nestor was attacked at some time between 1230 and 1200. Apparently, because the inventory tablets indicate an increase in the production of weapons, the residents knew that hostile forces were approaching. An

enormous fire, fueled by the stores of oil and the wood in the walls, consumed the palace. The site was abandoned and forgotten until 1939 C.E., when the American archaeologist Carl Blegan, of the University of Cincinnati, began systematic excavations. His discovery of the Pylos Linear B tablets (which occurred on the very first day of the excavation!) is one of the most important archaeological finds in Greece. The records of the scribes of Pylos have opened a window onto the Bronze Age that has greatly expanded the understanding of Mycenaean culture.

Further Reading

Chadwick, John. *The Mycenaean World*. Cambridge: Cambridge University Press, 1976.

Preziosi, Donald, and Louise A. Hitchcock. *Aegean Art and Architecture*. Oxford: Oxford University Press, 1999.

Samuel, Alan E. *The Mycenaeans in History*. Englewood Cliffs: Prentice Hall, 1966.

Vermeule, Emily. *Greece in the Bronze Age*. Chicago: University of Chicago Press, 1972.

PANAGIA ACHEIROPOIETOS, THESSALONIKI

Style: Early Byzantine
Date: Circa 470 C.E.
Architect: Unknown

Panagia Acheiropoitos is one of the earliest Christian churches in Greece still being used for services. The church seems to have been built in honor of the Virgin Mary sometime after the Council of Ephesus declared her Theotokos (Mother of God) in 431. Her position in the sacred hierarchy of the church had been in dispute until then. Although details of the construction history are uncertain, the building was certainly complete by 470. The name of the church means "the Virgin not made by human hands" and originated after the twelfth century when the clergy acquired an icon of the Virgin believed to be of divine origin. The earlier name of the church is not documented.

Panagia Acheiropoietos is a basilica, which is basically a nave, or long hall, aligned west to east that is flanked on the north and south by lower spaces, or aisles, and closed at the east end by an apse, or semicircular termination. The church is incomplete today because portions of the western entrance complex have disappeared. Originally, the plan included an outer narthex, or vestibule, aligned north and south and flanked by two low towers. In the rear wall of the outer narthex were two doors that opened onto a second, interior, narthex.

The interior narthex, which is twenty feet deep, is carefully integrated into the nave and aisles. Entry into the nave is through a central doorway that is a triple arch with the central arch supported by two green marble columns. At each end of the narthex is a rectangular space, or bay, with an entrance door to one of the aisles. This configuration creates a continuous corridor of space around the nave on three sides. The design thus emphasizes the nave and makes it the focus of the plan. Such emphasis on the nave can be explained by the dictates of the early Orthodox liturgy. In contrast to the western church, where the congregation stood in the nave and the aisles, in the eastern rite, the nave and apse were reserved for the clergy only.

The nave and the terminal apse together form a continuous processional space that is 120 feet long. The sweep of the central volume of space is now interrupted by the iconostasis (a screen partially blocking the view of the apse) that was installed at a much later date in the history of the church. A contin-

uous open timber roof covers the nave and aisles, while the apse has a half-dome that was once decorated with brightly colored mosaic. The floor of the nave has a beautiful marble pavement that visually reinforces its prominent position in the design of the building.

On either side, the nave is flanked by colonnaded arcades in two stories that separate it from the aisles. A colonnaded arcade is a long file of columns that supports a series of arches rather than a horizontal lintel, as in classical architecture. Above the arcades, the upper walls of the nave probably had a third-story clerestory, a wall pierced by row of windows. Light from the clerestory would have filtered down diagonally into the nave to provide illumination.

The aisles flanking the central hall are long continuous spaces behind the arcades. Their subordination to the nave is signaled by their lesser width and lower ceilings. On the ground floor, a series of parapets between the twelve columns on each side prevented access to the nave. In the upper story there are galleries behind the arcades to provide more space for the congregation. The arcades here have twelve columns placed directly above those on the ground floor, but their scale is reduced. Another gallery, which no longer exists, was located above the narthex at the level of the second story. This gallery's arcade continued the pattern set up in the north and south galleries so that an unbroken band of columns and arches enclosed the nave from above. Both aisles and the three galleries have windows in their exterior walls that supply plentiful lighting.

What remains of the original decoration of Panagia Acheiropoietos suggests that its interior was splendid. The walls of the aisles were veneered with sheets of marble. Mosaics decorated the apse and the soffits, or undersides, of the arches in the upper and lower arcades. These showed lush compositions of birds, fruit, and flowers. Pale marble is used for the monolithic columns. The beautifully sculpted composite capitals in the lower arcades have a double row of acanthus leaves set under a band of palmettes with four tendril scrolls at the corners.

Panagia Acheiropoietos is an excellent example of the grandeur of early Byzantine churches in Greece. Its great value lies in the fact that so many of the Greek basilicas are now either reduced to rubble and known only by their ground plans or have been rebuilt and altered numerous times. Panagia Acheiropoietos allows the visitor to experience a little of the mystical awe that churches inspired in worshipers more than fifteen hundred years ago. The church has survived earthquake damage in the seventh century and conversion into a mosque in 1430. Although the Turks removed the north gallery, the basilica is still largely intact.

Further Reading

Hellenic Ministry of Culture. www.culture.gr/home/welcome.html.

Hetherington, Paul. *Byzantine and Medieval Greece: Churches, Castles and Art.* London: John Murray Publishers, Ltd., 1991.

Krautheimer, Richard. *Early Christian and Byzantine Architecture.* Harmondsworth, England: Penguin Books, 1975.

Mango, Cyril. *Byzantine Architecture.* Milano: Electa Editrice/Rizzoli, 1978.

PANAGIA TON CHALKEON, THESSALONIKI

Style: Middle Byzasntine
Date: 1028 C.E.
Architect: Unknown

From the middle of the seventh century until the beginning of the eleventh, Greece and the Byzantine Empire in general suffered turmoil and trouble. There were economic crises, poor harvests, bitter religious controversies, and invasions by both Slavic tribes and Arabs. Although Thessaloniki was the second most important city in the empire, after Constantinople, it was not spared from these catastrophes. Not until Emperor Basil II subjugated the Bulgars in 1018 did Thessaloniki experience a recovery from barbarian occupation, poverty, and attacks by pirates. Panagia ton Chalkeon is a symbol of the city's revival and a product of the renewed building activity that took place in the middle Byzantine period.

The church, built in 1028, was the first significant structure erected in Thessaloniki since the construction of **Agia Sofia** in the eighth century. An inscription over the west entrance announces that the building was founded by Christophoros, governor of Longobardia in southern Italy; his wife, Maria; and their three children, Nicephoros, Anna, and Catacele. Panagia ton Chalkeon, dedicated to the Mother of God, was probably situated in a monastery; private monasteries, funded by wealthy families for the salvation of their souls, became common in cities in the middle Byzantine period. Christophoros probably intended that Panagia ton Chalkeon would house his family's tomb. Although the original name of the church is not known, its modern name means "the Virgin of the Coppersmiths" and dates to the fifteenth century when the church was converted into a mosque that was frequented by local metalworkers.

Panagia ton Chalkeon has a cross-in-square plan with four columns supporting its major dome. The cross-in-square church is a centralized structure divided into nine bays, or spacial units. At the center is a square bay with a dome. The bays that form the four arms of the cross radiate from the central square and are of identical length. Between the arms of the cross are small bays that fill in the cross and give the building its square shape.

The cross-in-square plan forms the core, or nave, of Panagia ton Chalkeon. To this is added a narthex, or transverse vestibule, on the west side. The narthex has a second story, or gallery, that carries a small dome with an octagonal drum at each end. Three doors in the east wall of the narthex provide

access to the nave. The four arms of the cross are roofed with barrel vaults, which are ceilings of semicircular shape. In the smaller corner bays, the ceilings are groin-vaulted. A groin vault is made up of two barrel vaults that intersect at right angles.

At the corners of the central bay are four columns with decorated capitals that support the pendentives, which are curved triangular wall surfaces bordered by arches (in this case the ends of the barrel vaults in the arms) that fan out at the top and join together to form the base for a drum. The dome of Panagia ton Chalkeon rests on an unusually tall octagonal drum pierced by two tiers of arched windows. The space of the center bay is thus accentuated by its height and by the illumination of the dome.

At the east end of the nave is the sanctuary that includes a barrel-vaulted bay and three apses. An apse is a semicircular space covered by a half-dome. The central apse is the largest and is polygonal on the exterior. On either side, the smaller apses serve the liturgical functions of the prothesis, where the paraphernalia for the Communion are kept, and the diaconicon, where the sacred books and priests' vestments are stored.

Viewed from the exterior, Panagia Chalkeon is impressive for such a small building—it is only about sixty-two feet long. The walls are worked in the recessed brick technique, in which every other course is set back from the wall plane and covered by a band of mortar. A sense of monumentality is created by the powerful forms that articulate the outside of the church. First, the building is emphatically divided into two stories by a strongly projecting molding made of marble that runs completely around the exterior. Second, a variety of forms—some projecting, some recessed—are played off against one another to create a sculptural effect. Third, the complication and three-dimensionality of ornamentation increase vertically.

The facade has a central door flanked by windows that are set back slightly into the flat plane of the lower-story wall. Above this, three large blind arches spring from engaged columns. Blind arches are arches filled in with brickwork. At Panagia ton Chalkeon, the blind arches have numerous setbacks so that the wall surface that fills them is recessed more deeply than the door and windows below. Above the setbacks, the arches are decorated with two bands of dentils (bricks set to look like projecting cubes). There is a deep arched niche recessed into the lower part of the wall inside each arch, and above that is a window. The curved tops of the arches create a scalloped roofline above which rise the two small domes on the narthex. These are octagonal and have a row of arched windows alternating with niches, echoing the scalloped roofline below. Behind and between the narthex domes is the large dome of the nave. This dome has a taller octagonal drum than the smaller domes with two tiers of windows set into a blind arcade. In contrast to the smaller domes, the large dome has a straight roofline.

On the flanks of Panagia ton Chalkeon, the arched roofline of the narthex is contrasted to the triangle formed by the gabled roof that covers the north and south arms of the cross. All of the windows, which are traditionally small

in Greek churches, are contained in blind arches. Rectangular pilasters on the lower story support engaged columns on the second, and in both stories the blind arches are framed by double or triple recessed jambs.

An inscription states that the mural paintings inside the church were also commissioned by Christophoros, but only a small portion of them are preserved. Most notable is the image of the Virgin Mary flanked by two angels in the half-dome of the central apse. A few of the Gospel scenes that represent the Twelve Feasts of the Church survive, as do paintings of saints and prophets. The central dome has the Ascension. In the narthex, as at Nea Moni, are scenes from the Last Judgement (see **Katholikon, Nea Moni**).

After the Turks conquered Thessaloniki in 1430, Panagia ton Chalkeon was turned into a mosque and its paintings were covered over with plaster. The plaster was removed after the city was liberated from Turkish rule in 1912 and the church was returned to the Orthodox faith. An earthquake in 1932 damaged the narthex and the gabled roof on the south flank. These areas were later restored. In 1978, a second earthquake shook the church and repairs were subsequently made to preserve this beautiful example of middle Byzantine architecture.

Further Reading

Hellenic Ministry of Culture. www.culture.gr/home/welcome.html.

Hetherington, Paul. *Byzantine and Medieval Greece: Churches, Castles and Art.* London: John Murray Publishers, Ltd., 1991.

Krautheimer, Richard. *Early Christian and Byzantine Architecture.* Harmondsworth, England: Penguin Books, 1975.

Mango, Cyril. *Byzantine Architecture.* Milano: Electa Editrice/Rizzoli, 1978.

PANAGIA HODEGETRIA, MISTRA

Style: Late Byzantine
Date: 1310–1322 C.E.
Architect: Unknown

After the warriors and traders of the Fourth Crusade seized Constantinople on 12 April 1204, the Byzantine Empire was dismantled and its territory divided among the various groups who had participated in the attack. The mainland of Greece was given over to the Franks, who divided the territory into several feudal states. In the Peloponnesus, there was constant strife as the various self-styled lords and princes vied with one another for more land and/or commercial cities. In 1249, William de Villehardouin built a fortress at a site near Sparta to protect his properties from the constant threat of Slavic invaders. The fortress was located on a steep spur of Mount Taigetos overlooking the Eurotas Valley. As was so often the case in the Middle Ages, settlers came to work in the fortress and to take advantage of its protection. Thus the town of Mistra (also spelled "Mystras" or "Mistras") grew up in two sections, one higher and the other lower, on the sides of the spur.

In 1259, when the future Byzantine emperor Michael VIII Palaeologus began the process of recovering the Peloponnesus, Villehardouin was taken prisoner and forced to surrender his fortress at Mistra. It was then used by the Greeks as a base from which to drive out the Franks. In 1262, the Despotate of Morea was created with Mistra as its capital. Gradually, the Peloponnesus was freed from foreign rule, and by 1432 the despotate, traditionally ruled by a son or brother of the reigning Byzantine emperor, was in control of the whole region.

The despots of Morea transformed the Frankish settlement into a center of politics and culture. They built an imposing palace, funded monasteries and churches, and supported an intellectual life that was to have long-lasting consequences in western Europe. The philosopher Manuel Chrysoloras began a revival of serious interest in Platonic philosophy and at the end of the fourteenth century visited Italy, where he taught Neoplatonism and was a friend of the Renaissance architect Brunelleschi. Chrysoloras's work was overshadowed by Plethon, who founded a school in which he advocated a synthesis of the Christian religion and Platonic theories. When Plethon went to Florence in 1438, he inspired Cosimo de' Medici to set up the famous Platonic Academy that fostered the Neoplatonism of the Italian Renaissance. Contacts between philosophers in Mistra and Florence continued until the beginning of the sixteenth century.

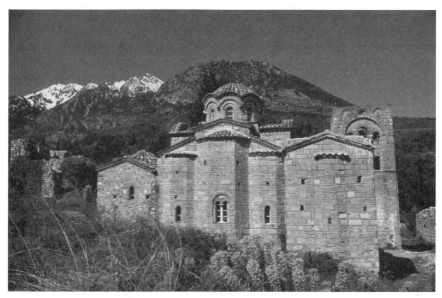

Panagia Hodegetria, Mistra. © *Lawrence Gresswell; Eye Ubiquitous/Corbis.*

Religious architecture was always an important element in Byzantine culture because of the strong link between the church and the state. The rulers and churchmen of Mistra supported the foundation of monasteries and churches, and because of their generosity and piety the city has some of the finest examples of fourteenth- and fifteenth-century architecture found in Greece. Architects working in Mistra created a new church building design that is now known as the Mistra type.

Panagia Hodegetria (Virgin Mary Who Shows the Way), the katholikon of the Brontocheion monastery, is the first example of Mistra type and is also the largest church in the city. In addition to its formal name, the church is also known as the Aphentiko (Belonging to the Master). This seems to refer to Pachomios, a cleric (eventually an abbot) of great energy and ambition who was active in Mistra from 1290 to 1322. He was responsible for the completion of the church of Agioi Theodoroi in the Brontocheion and for raising the money and obtaining tax-free imperial grants of property and land that allowed him to pay for the construction of Panagia Hodegetria. A good deal of information about the founding, properties, and privileges of the monastery are recorded in copies of imperial decrees that are painted on the walls of one of the chapels.

Panagia Hodegetria was built between 1310 and 1322. It has an innovative design that combines a basilican plan on the ground floor with a domed cross-in-square plan above. The church is relatively small in size, measuring thirty-six by twenty-eight feet on the inside, but it has a monumental quality that results from the width of the basilica and the height of the central dome.

From the exterior Panagia Hodegetria looks complex because of its complicated rooflines with multiple domes, open porches on the west and north sides, belfry, and the projecting masses of the chapels and polygonal apses. The walls are made of cut stone with narrow horizontal courses of brick and are without the ornamental cloisonné work that is so typical of Byzantine churches in Greece.

The entrance to the church was through an arcaded porch (now destroyed), which was a Western feature borrowed from Cistercian architecture. A single door in the center of the back wall of the porch provides access to the narthex, or vestibule. This is a transverse vaulted hall with a second-floor gallery that opens into the interior of the building. Two chapels have been added at the ends of the narthex. In the northern one are the tombs of Theodore Palaeologus, who was one of the despots, and Pachomios. The chapel at the south contains the painted copies of imperial decrees mentioned above.

Three doors in the east wall of the narthex open into the lower part of the building, which is in the form of a basilica. A basilica is a nave, or long hall, that terminates in an apse, or semicircular space covered by a half-dome, flanked by parallel lower spaces, or aisles. The nave is divided from the aisles by a file of three columns on either side. These support transverse arches that divide the aisles into four spacial units, or bays; a fifth bay has an apse added at its east end. The fifth bay on each side is connected to the large apse of the nave by a doorway and has a special function in the Orthodox service. That on the north, the prothesis, is where the paraphernalia for the Communion is kept and prepared. On the south, the fifth bay is the diaconicon, a storage place for the holy books and the vestments of the clergy. Each aisle is roofed by five shallow domes that carry the floor of an upper gallery. The nave is barrel-vaulted except in the center, where there is a dome. A barrel vault is a continuous ceiling that is semicircular in shape.

The second story of Panagia Hodegetria takes the shape of a cross-in-square plan. At the center of the design is a square bay covered by a dome that is supported by four piers. Four arms of equal length project from the center to form a Greek cross. Between the arms of the cross are four small bays covered with domes that fill in these spaces and give the plan its square shape. The uniqueness of the Mistra type church is the superimposition of this design over the basilica. In the typical Greek cross-in-square, the four piers that support the dome rise directly from the floor—that is, they are an integral part of the lower level—and the columns do not bear much weight but rather only support the galleries. Like Panagia Hodegetria, the Mistra type church gives the columns flanking the nave and the vaulting over the aisles a greater role in supporting and stabilizing the galleries. This is necessary because the masonry piers that support the dome are based on the floors of the galleries, which need to be strong enough to support the weight of both dome and piers.

Resulting from this ambitious design is a greater spaciousness and lightness than is typical of the cross-in-square church. Panagia Hodegetria's central bay rises up two stories to the wide dome resting on pendentives that spring from

the tops of the piers. Pendentives are curved triangular walls bordered by arches that fan out at the top and join together to form a circular base for the dome. On all four sides, the barrel-vaulted arms of the Greek cross arch gracefully at a somewhat lower level than the dome. In between the arms, lower yet, are the four end bays of the galleries, each bearing a small dome. All five domes are supported by polygonal drums and have tall arched windows.

The desire to build a church that successfully and harmoniously combines a basilica and a centralized domed plan was a very old idea in the fourteenth century. In the sixth century, when Justinian wanted a sanctuary that would symbolize the size and wealth of his new Roman Empire, Isidorus of Miletus and Anthemios of Tralles designed for him the great Agia Sofia, in Constantinople, that combined the basilica with a centralized plan. But this masterpiece of early Byzantine architecture is so distant in time from Panagia Hodegetria that it is hard to verify its influence on the later building. Also, Agia Sofia differs from the Mistra type because it is really a domed basilica rather than a composition that fuses two entirely different building types. In view of this, it seems best to accept the originality of the Mistra type, which set the standard for church buildings in the city for more than a century.

Originally, the interior of Panagia Hodegetria was beautifully decorated. Marble veneers graced the walls, and marble was also used for the colonnades in the nave. Splendid paintings, dated from 1312 to 1322, representing saints, martyrs, holy men, and scenes from the Gospels that symbolize the Twelve Feasts of the Church covered the walls and ceilings. Unfortunately, only parts of the decorative system survive, but they are sufficient to suggest the richness and brilliance of the church that served the rulers of the Despotate of Morea.

Panagia Hodegetria was fairly well preserved for several centuries. However, in 1863 most of the columns were removed from the church, and this resulted in the collapse of the major dome and parts of the vaulted ceilings. In 1938, A. Orlandos with the assistance of the Committee for Restoration of the Mistra Monuments carefully reconstructed and restored the building. Conservation of the surviving paintings came later and is now complete. Today Mistra is a deserted site. Its population dwindled under Turkish and Italian domination, and eventually the few inhabitants who remained were moved to modern Sparta in 1834.

Further Reading

Chatzidakis, Manolis. *Mystras.* Alison Frantz and Louise Turner, trans. Athens: Ekdotike Athenon S.A., 2000.
Hellenic Ministry of Culture. www.culture.gr/home/welcome.html.
Hetherington, Paul. *Byzantine and Medieval Greece: Churches, Castles and Art.* London: John Murray Publishers, Ltd., 1991.
Laconian Professionals. www.Laconia.org/Mystra1_Holy_Hodigitria.htm.

PANAGIA KOUMBELIDIKE, KASTORIA

Style: Middle Byzantine
Date: Eleventh Century C.E.
Architect: Unknown

Kastoria is a city of furriers in western Macedonia. Legend has it that the fur industry began there during the Byzantine era. Whether or not this is accurate, it was certainly an active trading center throughout the Middle Ages. Kastoria is also a city of churches. These are small buildings paid for by rich local families, trade guilds, and exiles from the capital city of Constantinople (see **Agioi Anargyroi**). Many are funeral chapels or shrines for the relics of special saints. Of the original seventy-two churches, fifty-four remain in various states of preservation. Seven of these belong to the Byzantine period. Although not in the mainstream of Byzantine architectural history, the Kastoria churches are extremely valuable as examples of popular art or folk architecture. Panagia Koumbelidike is both typical and unique.

Nothing is known of the patron or architect or the reason for the construction of the little church. It is dedicated to the Virgin Mary, and its name means "Church of the Virgin with the Little Dome." Koumbelidike is derived from the Turkish word *koubeh*, which means "dome" or "domed building." Although there is no documentary evidence for a foundation date, most scholars agree that the church was built in the eleventh century.

Panagia Koumbelidike is typical of Kastorian churches in scale—it is quite small, not much larger than a chapel in a traditional Byzantine church. A second typical characteristic is the cloisonné masonry of the exterior. This is a decorative type of masonry in which rectangular blocks of stone are separated, or framed, by thin bricks or pieces of tile. Like the other Kastoria churches, the interior of Panagia Koumbelidike has fresco paintings instead of mosaics.

The uniqueness of the church is found in its plan. The building is a triconch, a design that features a dome on a tall drum supported by semicircular apses, or chambers, roofed with half-domes on the north, east, and south sides and a short rectangular barrel-vaulted bay, or spacial unit, on the west. A barrel vault is a continuous arched ceiling that is semicircular in shape. Panagia Koumbelidike is the only church in Kastoria with a dome and the only one with a centralized triconch plan. The triconch resembles late Roman and early Christian mausoleums and martyr shrines, which may have been its ultimate source. A variation in the traditional triconch shape is the slightly later addi-

Panagia Koumbelidike, Kastoria. © *John Heseltine/Corbis.*

tion of the narthex on the west end. Like the western arm of the triconch to which it is connected, the narthex is barrel-vaulted.

On the exterior, the side walls of the narthex display typical cloisonné work with the addition of a series of Kufic designs, which imitate an abstract style of Arabic writing, at the base of the wall. In the center of each wall is a blind arch, that is, an arch filled in with masonry. A dog-tooth molding made of bricks projects from the plane of the wall and frames the upper part of the arch. The front (west) wall of the narthex has a small entrance door in the center that is framed by frescoes instead of cloisonné masonry. A gabled tile roof that disguises the barrel vault inside covers the narthex.

Cloisonné work also ornaments the triconch and the drum of the dome, but it is much more elaborate than that of the narthex. Courses of dog-tooth brick patterns are introduced at intervals on the walls and are also used as frames

above the arches of the windows and as accents along the rooflines. Kufic designs are repeated in horizontal bands separated by courses of stone blocks and bricks.

From the east, the building looks heavy and blocky. The drum of the dome towers over the apses of the triconch with seemingly no attention paid to harmonious proportions. The mass of the walls is relieved only by a very narrow window in each apse and four others at the base of the drum. An interesting geometry in the arrangement of the masses of the east end of the church shows a certain deliberation on the part of the architect. The semicircular volumes of the three apses are played off against the right angles of the walls that connect them. Above the curved roofs of the half-domes, a wall terminating in a gable introduces a pair of diagonal lines, while behind and above this is the horizontal parapet at the bottom of the circular drum. Curves, diagonals, and horizontal elements are arranged in a three-dimensional sequence that is visually interesting and rather sophisticated.

The interior of Panagia Koumbelidike is dominated by the dome, which is very tall in proportion to the rest of the church. Light enters the building from high above through the four narrow windows in the drum. This illumination emphasizes the verticality of the spacial unit where the altar was located. In the lower part of the building, subdued illumination is provided by the narrow windows in the apses and by an arched window on either side of the western arm.

Fresco paintings from several different time periods decorate the walls of the little church. The earliest are dated to the twelfth century and include a depiction of the Nativity and scenes of the martyrdoms of the two Saints Theodore in the narthex. An Ascension of Christ decorates the triconch section of the church, and in the dome the portrait of Christ Pantokrator, the austere lord and creator of the Universe, looks down upon the worshipers and the celebration of the mystery of the Mass.

During World War II, the church of Panagia Koumbelidike was bombed and parts of the dome and vaulting were seriously damaged. A complete restoration of the building using as much of the original fabric as possible followed in the 1950s. This accurately reproduced the appearance of the building and preserved its distinctive domed silhouette. The church is now the official emblem of Kastoria.

Further Reading

Hellenic Ministry of Culture. www.culture.gr/home/welcome.html.

Hetherington, Paul. *Byzantine and Medieval Greece: Churches, Castles and Art.* London: John Murray Publishers, Ltd., 1991.

Krautheimer, Richard. *Early Christian and Byzantine Architecture.* Harmondsworth, England: Penguin Books, 1975.

Mango, Cyril. *Byzantine Architecture.* Milano: Electa Editrice/Rizzoli, 1978.

PANAGIA PARIGORITISSA, ARTA

Style: Late Byzantine
Date: 1283–1296 C.E.
Architect: Unknown

Although officially the purpose of the Crusades between the eleventh and thirteenth centuries was to free the Holy Land from the Muslims, the invasions launched from western Europe had a disastrous effect on the Byzantine Empire. The Frankish knights used their religious obligation as a means to acquire land, and the Italian maritime states, such as Venice and Genoa, sought commercial benefits. All were hungry for plunder when the Fourth Crusade set out for the east in 1204. Rather than proceeding to the Holy Land, the Crusaders diverted their course and attacked Constantinople. They installed a westerner on the throne of the Byzantine Empire who ruled the much-reduced state until the Crusaders were ejected by Michael VIII Palaeologus in 1261. This sad period in Byzantine history is called the Latin Conquest.

At the time of the Latin Conquest, several independent states were formed in previously Byzantine territory. These were ruled by members of the extended royal Byzantine family, who managed to avoid domination by the Franks as they took over much of Greece. The Despotate of Epirus, in a remote western area of the mainland, maintained its independence for a little over a century. For the capital of the despotate, its rulers chose Arta, a city nestled in a bend of the River Arahthos on a site that had once been an important ancient Greek community. The despots built a large citadel on a bluff overlooking the city—a good indication of the unrest caused in Greece by the marauding Franks—and also supported various building projects so that Arta would have the splendid visual quality of a capital city.

The church of Panagia Parigoritissa is undoubtedly the most interesting of these projects. It is a large impressive building that combines Byzantine and western details and has a unique support system for its major dome. Panagia Parigoritissa, which means "Virgin Mary of Consolation," was the most important church in Arta and may have been the building in which coronations of the despots took place. The church was built between 1283 and 1296 by the despot Nikephoros I and his wife Anna Palaeologus. Nikephoros was a member of the Comneni, a family clan that had ruled the Byzantine Empire from 1081 until 1204. Anna's family, the Palaeologi, were rulers of the Empire of Nicaea, an autonomous state in western Turkey. The Comneni of Epirus were very skilled in using marriage as a form of political alliance and control.

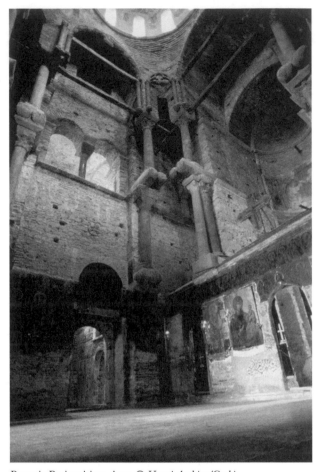

Panagia Parigoritissa, Arta. © *Vanni Archive/Corbis.*

They had intermarried with Italians, French, and German families as well as
with elite Byzantines such as the Palaeologi. Nikephoros I also traveled to Italy
in 1259. All this interaction may explain the inclusion of various western fea-
tures in Panagia Perigoritissa.

In plan, Panagia Perigoritissa is based on the traditional Greek cross-octa-
gon design, but its proportions are heavier and bulkier. The building is also
very large in comparison to middle Byzantine churches (see **Katholikon,
Daphni**; **Katholikon, Osios Loukas**; **Katholikon, Nea Moni**). This increase
in scale may reflect a changing aesthetic following the Latin Conquest, or it
may signal an imperial, or at least self-aggrandizing, agenda on the part of the
despot. Since it was the major church of Arta, Panagia Perigoritissa had to pro-
ject sumptuous and grandiose effects.

From the exterior, the church appears as a heavy cubic mass with a simple
horizontal roofline. The west facade and north and south flank walls are

divided into three stories. At the ground floor level, the walls are made of rather unattractive rough rubble masonry with vertical buttresses projecting from the surface. Originally, this area would have been covered with marble veneers to disguise the actual building material. Some scholars have suggested that the ground floor was surrounded by a porch made of wood with a shed roof. There is just one door in the center of each of the three facades.

The middle story has a file of arched windows—four on the sides and five on the front. These numbers are repeated on the top story except that the windows here are taller and wider than the ones below. All of the windows are aligned vertically, which unifies the composition of the walls and creates a heavy but pleasant rhythmic effect.

Cloisonné work further enlivens the walls. This is an ornamental type of masonry in which rectangular blocks of stone are separated, or framed, both horizontally and vertically by thin bricks. The cloisonné here is quite simple compared to Greek churches of the middle Byzantine period such as **Agioi Anargyroi** and **Panagia Koumbelidike** in Kastoria. Only one horizontal band of inlay work at the base of the upper story of the flank walls is added to the basic cloisonné pattern. The band, which continues around the corners to the front wall but terminates at the outer frame of the first window on either end, is made up of square tiles in two colors that are set on their corners and therefore appear as rhombuses. A single dog-tooth molding separates the stories and frames the windows.

All three exterior walls of Panagia Parigoritissa are simply flat planes slightly relieved by the frames of the windows and the two-dimensional cloisonné work. They do not express in any way the shape of the interior space they enclose. Their inspiration is not drawn from their middle Byzantine predecessors but rather from the facades of central Italian palazzi. Some scholars have suggested that Nikophoros may have brought Italian artisans to Arta when he returned from his journey to Italy.

The Italianate flavor of the exterior of the church ends with its horizontal tile roofline. Above this rise traditional Byzantine domes in octagonal drums. There are six of these domes: three across the front, a single large tall one in the center, and two on the outer corners of the back. Five of them have brick and dog-tooth window frames and low conical roofs. The sixth dome, in the center of the front facade, is actually an open lantern that covers a dome below and may have functioned as a belfry.

One enters Panagia Parigoritissa through the door of the west facade, which opens into a wide narthex, or vestibule. The ground floor is divided into bays, or spacial units, by the arrangement of the vaulting. The central bay is emphasized by being covered by a dome that is flanked by vaults. On the second floor of the narthex is a gallery open to the nave, or central core, that carries the three small domes described above.

The nave of Panagia Parigoritissa is astonishing in its verticality and design even though it is basically a Greek cross-octagon plan. Quite small in comparison to the total area of the church, the nave occupies only one-third of the

interior floor space. As in the traditional plan, the center of the nave is a square bay with four projecting arms of equal length that form the shape of a Greek cross. Here, the arms are abbreviated—they are both narrower and shorter in proportion to the central square than the arms of most Greek churches.

On the east side, the arm is joined to the sanctuary, where the altar is placed, and terminates in an apse, which is a semicircular space covered with a half-dome. Both sanctuary and apse were closed off from the laity by an iconostasis, a screen that carries icons and has a door in the center. Flanking the apse are two narrow spaces that also have apses on the east end. The one on the north is the prothesis, where the paraphernalia for the Eucharist (Communion) was kept. On the south is the diaconicon, an area for storing holy books and the vestments of the clergy.

What sets the central square of the nave of Panagia Parigoritissa apart from its middle Byzantine predecessors is its scale and the originality of its design. Like most Greek churches, the transition from the square to the octagon is achieved by means of squinches. The squinches here are thick arches placed diagonally over the four corners of the square to give it eight corners instead of four. In Panagia Parigoritissa, the squinches are an unusual type and are supported in a very inventive manner that incorporates ancient columns looted from the nearby Roman city of Nicopolis.

Sections of columns are inserted into the walls that form the corners of the square in such a way as to create eight projecting brackets. The first set of brackets is located halfway up the walls on the ground floor. A second set, with a greater projection, is placed at the level of the second story where there are galleries on three sides. The lower brackets support a pair of columns, while single columns are placed on the upper ones. Above these, just below the dome, are pairs of colonnettes that straddle the corners of the squinches and carry Italianate trefoil arches. The linear accents of the three tiers of columns increase the sensation of verticality and provide continuous lines of vision that carry the eye upward to the dome, which crowns at a little more than seventy-eight feet above the floor. Such vertical linearism resembles Gothic architecture more than Greek. Sixteen windows at the base of the dome create a ring of light that illuminates the dome mosaic of Christ Pantocrator (Lord of the Universe), shown with a number of prophets.

The Greek cross is encased on three sides by double-storied subsidiary spaces that are unusually wide in comparison to the nave. This is what gives the exterior its cubelike shape. The narthex at the west end has already been described. On the north and south sides of the nave the arrangements are symmetrical, so it seems reasonable to describe just one of them. The last bay of the narthex is linked to a western chapel by a single door that opens into its barrel-vaulted space. A barrel vault is a continuous ceiling that is semicircular in shape. This adjoins a central bay that carries a dome and has direct access to the shallow arm of the nave. Directly to the east of the center bay is a second chapel that is groin-vaulted and terminates in an apse. A groin vault is a ceiling made up of two barrel vaults that intersect at right angles. In a very

original way, the shapes of the vaults identify the chapels as separate entities that focus on the domed bay in the center. Access to the nave from the chapels is limited to a single arched doorway in the center bay.

On the second level, the narthex and the north and south subsidiary spaces carry galleries. These form an elevated belt around three sides of the nave that is subtly backlit by the large windows in the exterior walls. Over the eastern-most bay of the north and south galleries is a dome on a drum pierced by windows that would have provided additional illumination.

The exterior of the east end of Panagia Parigoritissa deserves brief mention. Its flat surface, worked in cloisonné, is broken up by five faceted, or polygonal, apses that vary in height and three-dimensional projection. The central apse, which adjoins the sanctuary, is the largest and the tallest—as tall as the back wall itself. This apse is flanked by the much lower and flatter apses of the prothesis and diaconicon. Beyond these are the apses of the eastern subsidiary chapels, which are somewhat shorter than the central apse. The arrangement here is quite practical but lacks integration with the facades of the other three sides of the church. From the east, the view of the building resembles a fortress more than a palazzo.

In contrast to the rather plain exterior, the interior of Panagia Parigoritissa was decorated with great splendor. Unfortunately, much of the ornamentation is gone. However, there is evidence for the use of marble veneers on the wall surfaces, and mosaic was used to represent the Pantocrator in the dome. This mosaic decoration is unusual in Arta, because after the twelfth century mosaics were used only in Thessaloniki and Constantinople due to the expense of installing them. The mosaic's appearance in the dome suggests competition with the two greatest cities in the Byzantine world and the aspiration of the despots of Arta to elevated status. Columns and other building parts from Nicopolis, a city founded by Augustus, the first Roman emperor, were incorporated into the design of the church. Relief sculpture on some of the arches indicates the influence of western Christian art in its subject matter and carving technique. Finally, a great deal of painting was also incorporated into the decorative scheme. Most of the frescoes that survive today are work of the sixteenth and seventeenth centuries.

Panagia Parigoritissa might be thought of as an imperial church, one that projects the power and affluence of the despots of Epirus. Apparently, no expense was spared—both architect and patron perhaps wanted a church that was totally unique yet retained the spaces and organization appropriate to the Orthodox service.

At some time in its history the Panagia Parigoritissa became a dependence of the Kato Panagia monastery. A document of 1578 mentions the church as a convent for nuns. Redecoration of the sanctuary and some parts of the nave took place in the sixteenth and seventeenth centuries. Not until the twentieth century was serious conservation begun on Panagia Parigoritissa. In 1989 excavations were undertaken in the floor of the building, and in 1991 the southwest part of the church was consolidated and reinforced and the mosaic

was cleaned and restored. Scholars' opinions about this unusual and monumental church are curiously mixed. They have called Panagia Parigoritissa "inarticulate," "complex even though crude," "the masterpiece of the Epirote school," "majestic," and finally, "the most bizarre major church in Greece."

Further Reading

Hellenic Ministry of Culture. www.culture.gr/home/welcome.html.

Hetherington, Paul. *Byzantine and Medieval Greece: Churches, Castles and Art.* London: John Murray Publishers, Ltd., 1991.

Krautheimer, Richard. *Early Christian and Byzantine Architecture.* Harmondsworth, England: Penguin Books, 1975.

Mango, Cyril. *Byzantine Architecture.* Milano: Electa Editrice/Rizzoli, 1978.

PANATHENAIC STADIUM, ATHENS

Style: Classical; Roman
Date: Mid-Fourth Century B.C.E.; Second Century C.E.; 1896 C.E.
Architect: Unknown; Anastase Metaxis

The largest building in Athens is not a temple, a theater, a church, or a library, but rather a stadium—the Panathenaic Stadium, a memorial to the ancient Greek passion for athletic excellence and the drama of competition. The modern stadium, which is closely associated with the history of today's Olympic Games, occupies the site of Athens' ancient racetrack in a narrow valley between the Agra and Ardettos hills.

In the middle of the fourth century B.C.E., the statesman and financial administrator Lycurgus built the first stadium building on the site of the old Panathenaic racecourse. The building served to monumentalize the contests and rituals of the Great Panathenaea, a religious festival celebrated every four years in honor of the goddess Athena. Athletes came from all over the Greek world to compete in the games and to win glory for themselves and their city-states.

The old racecourse had no formal seating; the spectators sat on the natural slopes on either side of the valley. Lycurgus built his stadium of limestone with tiers of stone benches arranged around the U-shaped racecourse. The track itself was 669 feet long and 110 feet wide. When the U-shaped stone seats were added, the length of the stadium building totaled 850 feet. The structure could accommodate approximately fifty thousand spectators.

By the second century C.E., the stadium was in need of major repairs. The great philanthropist Herodes Atticus undertook the complete rebuilding of the structure at his own expense. Herodes was an Athenian with strong connections to the Roman imperial family, who took pleasure in using his great wealth to enrich the cities and sanctuaries in Greece. This type of generosity was expected of wealthy citizens. In the Roman period, financing architecture was an honorable way for the elite to advertise to the community their social, financial, and political superiority.

The new stadium was a truly impressive building. It retained the shape and dimensions of Lycurgus's structure but was made completely of Pentelic marble. No other Greek stadium was made of such expensive material. The continuous rows of seats were divided by twenty-nine staircases into thirty sections. At the end of each row of seats, where the row intersected the stairs, was a decorative relief sculpture of Athena's sacred owl. Herodes added a vaulted passage under the east bank of seats for the ceremonial entrance of wild animals

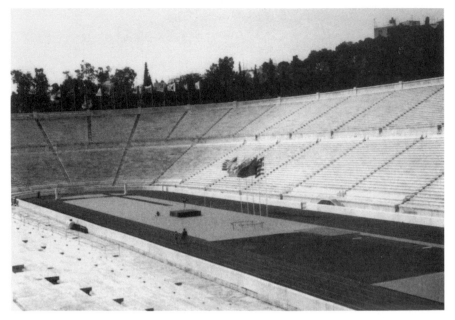

Panathenaic Stadium, Athens. *Courtesy of Jennifer Tobin.*

that were part of the beast hunts held in the stadium during the Roman period. Although the evidence is very fragmentary, there was apparently a Doric colonnade at the top of the curved end of the stadium. A row of Corinthian columns across the open north end of the racetrack may have been a screen in front of an open hall where the athletes prepared for their contests. Work on Herodes's stadium began in 140 and was completed in 144.

After pagan celebrations were outlawed by Emperor Theodosius in the fourth century, the Panathenaic Stadium fell into ruin. Although its location remained obvious to Athenians, its significance was forgotten and a field of wheat covered the site. At the end of the War of Independence, in 1830, Greece became a sovereign nation free of Turkish domination. Independence brought with it a revival of interest in Greece's classical past. Athens was declared the new capital, and examination and excavation of its ancient sites began. Patriotic Greeks wanted to restore their ties to their ancient ancestors by reviving classical institutions.

Evangelis Zappas, an expatriate millionaire, was inspired to recreate the Olympic Games and succeeded in gaining the support of the new king of Greece, Otto I. A series of four proto-Olympics, financed by Zappas, was held in Athens between 1859 and 1889. These were as much trade shows and agricultural exhibits as athletic events. When Zappas died in 1865, he left his fortune to the Olympic Games. He also encouraged and funded the excavation of the Panathenaic Stadium. In 1869, the German Ernst Ziller excavated the site.

The founding of the modern Olympics was the work of the Greek writer Dimitrios Vikelas and the French baron Pierre De Coubertin, who formed the

International Olympic Committee in 1894. De Coubertin also designed the five-circle logo of the Olympics.

The first Games were held in Athens in 1896. Athens was chosen because the **Altis** at Olympia, where the ancient competitions were held, was completely in ruin. Without doubt, those who promoted Athens as the new capital of Greece believed that the international Games would increase the prestige of the city, not only in Greece but also in the international community. As a venue for the track and field events, the committee sponsored a careful recreation of the Herodes Atticus Panathenaic Stadium.

The Greek architect Anastase Metaxas was responsible for the construction of the stadium. He duplicated the dimensions and design of the second-century structure, arranging the tiers of seats around the U-shaped track. The new building, which could hold up to seventy thousand spectators, was built completely of marble. Its nickname, Kallimarmaron, means "beautiful marble" and reminds visitors that it is the only marble stadium in the world. The project was so expensive that the Greek government ran out of funds before the stadium was completed. Responding to a plea from Prince Constantine, the magnate Georgios Averof of Alexandria donated more than one million drachmas to finish the work in time for the first international Games. A statue of Averof by the sculptor George Vroutos was dedicated in the stadium to commemorate his generosity to his country of origin.

Greek national spirit was boosted by a particularly important victory in the first Olympiad. The marathon race, which commemorated the great Athenian victory over the Persians in the fifth century B.C.E., had its finish line in the Panathenaic Stadium. A Greek athlete, Spyros Louis, was the first man to complete the grueling 26 mile 385 yard run. Another aspect of Greek nationalism was the role played by Zappas and Averoff in reinstituting the Olympics. They were typical of a group of wealthy expatriates who invested heavily in the building of modern Greece. Their patriotic generosity continued the tradition of civic gift-giving that originated in antiquity with men such as Herodes Atticus.

The Panathenaic Stadium is still in use today, hosting a number of activities in addition to track and field events. When the Olympics returned to Athens in 2004, the stadium was the site for ceremonial activities. Its function as the official racecourse has been taken over by the Olympic Stadium, outside Athens, that was built in 1982.

Further Reading

Ancient Olympics, The. Perseus Digital Library. www.perseus.tufts.edu/Olympics.

Dinsmoor, William B. *The Architecture of Ancient Greece,* 3d ed. New York: W. W. Norton, 1975.

Olympics through Time. Foundation of the Hellenic World. www.fhw.gr/olympics/ancient.

PARTHENON, ATHENS

Style: Classical
Date: 447–438 B.C.E.
Architect: Ictinus and Callicrates

The centerpiece and crowning achievement of the Periclean redevelopment of the **Acropolis** was the Parthenon, the temple dedicated to Athena the Virgin. The Parthenon was a symbol of the dawn of a golden age for Athens, an age in which philosophers, politicians, and citizens alike believed that human progress and social institutions could create a perfect society. This humanistic and anthropocentric worldview, often summarized by the phrase "man is the measure of all things," implied that man, not the gods, could fashion the ideal community. When Pericles told his fellow citizens that the Athenian democracy would be a school for Hellas (Greece), he meant that their city-state was just such an ideal society. Athens should be the role model for all the other Greeks, not only in military and political matters, but also in the arts, cultural institutions, and philosophy.

The Parthenon can be said to be the creation of four men: Pericles, the politician; Phidias, the sculptor; and Ictinus and Callicrates, the architects. Politics, art, and the application of theoretical and material knowledge were thus key elements in the design and symbolism of the building. But, it was also a symbol of the Athenians' religious devotion to their patron deity, Athena, who had led them to a great victory over the Persian Empire and then to a position of imperial power in the Greek world. In more practical terms, the Parthenon also was a huge public works program that provided jobs for hundreds of Athenians, both skilled and unskilled, who were all paid, very democratically, the same daily wage.

Work on the Parthenon began in 447 on a terrace at the highest point of the Acropolis. From this position, slightly south of the central axis of the sanctuary, the building would dominate all the surrounding structures and also be visible from the lower city and from a distance on the Attic plane. Pericles' Parthenon actually occupied the site of two earlier Athena temples, the sixth-century Hekatompedon and the unfinished fifth-century Older Parthenon (see **Acropolis**). The architects were able to incorporate the Older Parthenon's terrace, parts of its foundations, and many of its column drums in their new building. This was not only economical but also allowed for the rapid construction of the Parthenon, which was substantially complete by 438.

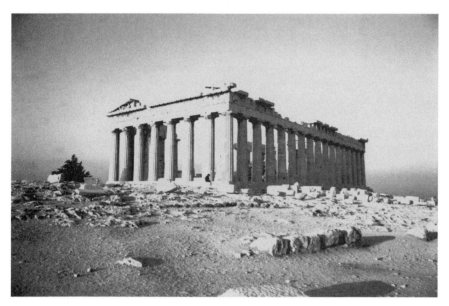

Parthenon, Athens. *Courtesy of Caroline Buckler.*

The temple, including the roof tiles, was built entirely of Pentelic marble, which required an enormous amount of planning and physical labor. An estimated twenty-two hundred tons of marble had to be transported from the quarry that was nearly ten miles away.

Athena's temple was the largest and most sumptuous Doric temple in mainland Greece. Its design and elevation were governed by a system of ratios among all its elements so that all parts of the building were harmoniously interrelated. The basic module was the average radius of the columns on the exterior. Mathematical calculation from the module assured that the proportions of the building would be perfect.

The Parthenon stands on a rectangular platform of three tall steps; the platform is 110½ feet wide by 237 feet long at the base and 101½ feet wide by 228 feet long on the top step. A file of forty-six columns surrounds the central block of the building. There are eight columns across the front and rear and seventeen on each of the flanks. This follows traditional Doric practice, which stipulates that the number of columns on the flanks must be one more than twice the number on the ends. The columns are a little more than 34 feet tall, are 6 feet in diameter at the base, and are spaced 14 feet apart. Eight columns on the front and rear is an unusual number for mainland Doric architecture, which traditionally uses only six. As we shall see, there were practical design reasons for arriving at this number.

Above the colonnade was the architrave (lintel) that supported a horizontal band, or Doric frieze, made up of alternating triglyphs and metopes. Triglyphs are rectangular blocks with vertical grooves cut into their surfaces;

metopes are the flat panels between the triglyphs. A triglyph is placed over the center of each column and at the center of the space between the columns except at the corners where two triglyphs meet. In traditional Doric practice, all of the metopes were blank or a small number had sculptural decoration. There are ninety-two metopes on the Parthenon, and all are sculpted. On each side of the building, the metopes depict a series of vignettes taken from a single myth. The Battle of the Gods and the Giants, the Greek Lapiths defeating the half-man half-horse Centaurs, Athenians overcoming Amazons, and scenes from the Trojan War were the stories told in the Doric frieze. All four of these subjects were to be read as allegories of the Athenians defeating the Persians, of civilization triumphing over barbarism, and of reason subduing irrationality.

On the front and rear of the Parthenon, above the frieze, were the pediments. A pediment is the long low triangular space formed by the sloping eaves of the gabled roof at the top of the facade. Statues, worked completely in the round, were placed in the pediments where they were held in place by metal clamps and dowels. These were not completed and installed until 432. The Parthenon pediments contained representations of the two most important events in Athenian mythic history. On the front of the building, facing east, was the birth of Athena, interpreted as the birth of a golden age for Athens. The west pediment showed the contest between Athena and Poseidon for possession of Attica. Poseidon offered a salt spring to the Athenians, while Athena promised them an olive tree. The choice was made, and Athena became the patron god of Athens. Also decorating the outside of the building were sculpted lions' heads at the corners, decorative attachments along the eaves of the roof, and finials of elaborate floral form atop the three corners of the pediments.

Inside the surrounding colonnade, the interior block of the temple had porches at both ends; the one on the east is called the pronaos, and the one on the west is called the opisthodomos. Their design is unusual for a Doric building. Instead of a pair of columns between extensions of the flank walls, the Parthenon has six Doric columns raised two steps above the top of the temple platform arranged in a row parallel to the wall behind them. The columns are 33 feet tall and about 5½ feet in diameter. They thus have slimmer proportions than those on the exterior. Some scholars have suggested that this arrangement of exterior and interior columns was borrowed from the deep porch with double colonnades found in Ionic temples. If this is correct, the design of the pronaos and opisthodomos would be the first of a series of Ionic features incorporated into the Parthenon.

A Doric architrave was supported by the porch columns but above this, instead of a frieze of triglyphs and metopes, was an Ionic frieze with sculpted decoration. The frieze was 524 feet long, 3 feet 4 inches tall, and ran across the porches and along the flank walls of the internal block. Although abbreviated Ionic friezes are found in the pronaos and opisthodomos of the **Temple of Hephaestus** and a continuous Ionic frieze decorated the interior of the **Temple of Apollo Epicurius** at Bassae, there is no precedent for the location,

length, and complexity of the Parthenon frieze. The subject depicted in the frieze was an idealized and generic Panathenaic Procession. As the culmination of the Panathenaea, the most important religious festival in Athens and the venue for pan-Greek games every four years, the procession celebrated both the power of Athena and the humanistic optimism of her people. Incorporation of the citizens of a city-state—or even references to them—in the sculptural program of a Greek temple is most unusual. But in the Parthnon frieze, the citizens of Athens celebrated themselves as the golden children of Athena. Perhaps a bit of humility, or a fear of hubris, can be detected in the obscure location of the frieze, which was placed forty feet above the floor directly under the roof. There were no windows or skylights, so the frieze would have been in shadow and almost impossible for visitors to see.

The interior block of the Parthenon was divided into two unconnected rooms of unequal length. That to the east was the cella, or cult room, and was nearly one hundred feet long and sixty-three feet wide. Inside the cella, Doric colonnades of two stories ran parallel to three of the walls. There were ten columns on each flank and five across the back of the room. The colonnades were necessary to support the ceiling, but they also functioned as a visual frame for Phidias's spectacular image of Athena Parthenos. The statue depicted Athena as both virgin and warrior and was made of ivory and gold. It was forty feet tall, including the pedestal. There were no windows in the cella walls, so the only source of illumination for the statue was light filtering in through the great door, thirty-two feet tall and fourteen feet wide, at the east end.

Since housing Phidias's statue was the major function of the Parthenon, the building was designed around the dimensions of the cult image. This is unusual for sixth- and fifth-century temples, which were designed primarily as exteriors with very little attention given to the interior space. Increasing the width of the cella relative to the proportions of traditional Doric temples was necessary because of the size of the gold and ivory statue. Because the cella was so wide, the number of columns on the front and rear of the building had to be increased from the usual six to eight.

To the west of the cella was a smaller room entered through the opisthodomos. Inside were four Ionic columns in a square arrangement that supported the roof. This room was originally called the Parthenon (which means "chamber of the virgin") and seems to have been the treasury where the funds from the Delian League were kept. The cella was called the Neos Hekatompedos, or New Hekatompedon, after the sixth-century Hekatompedon that had occupied roughly the same site. Not until more than a hundred years after construction was the temple as a whole called the Parthenon.

The Parthenon is the most extensive example of the use of optical refinements in Greek architecture (see the Introduction). The structure has been carefully surveyed in modern times, so its subtle architectural variations are well documented. Constructing optical refinements was a labor-intensive and enormously expensive process that Pericles' contemporaries would have appreciated as integral to the splendor of the most perfect temple in Greece.

To counteract the monotony of repetitious shapes, there were slight differences in dimensions in all parts of the temple. For example, the column capitals on the east and south sides of the building differed by an average of 2¼ inches. There was variety in the spaces between the exterior columns of up to 1¼ inches. The spaces between the columns on the facades became slightly smaller from the center outward. This necessitated a variation in the size of the metopes in the Doric frieze and also subtly emphasized the center of the facade.

The departure from strict geometric shapes in the Parthenon is well illustrated by the columns. Their cylindrical shafts tapered upward from diameters of 6 feet 2 inches at the bottom to 4 feet 10 inches at the top. In addition, the columns had entasis, which means a slight convex curve, or bulge, introduced into their vertical contours. Entasis counteracts the optical illusion that the sides of the columns are concave and creates the impression of vitality and elasticity. The four corner columns were about two inches thicker than the other columns to make them visually more substantial when back lit. Finally, on all four corners, the spaces between the last two columns were reduced to give the building a firm outline.

Further optical refinements were introduced to counteract the apparent sagging of long horizontal lines and surfaces. The platform and the temple floor were slightly bowed upward toward the center in both directions from the corners. On the flanks, the curvature was 4½ inches; on the front and back, 2½ inches. To compensate for the slight rise in the floor, all the horizontals above it had to parallel its curvature. Thus, the architrave, Doric frieze, and the molding at the bottom of the pediment were all slightly curved upward in the center. Even the pediments were affected—the sloping sides of the triangle were constructed of oblique curves instead of straight lines.

Finally, there were a series of inclinations, or deviations from vertical, that were carried out consistently through the whole building. The columns slanted inwards 2½ inches, and those on the corners had a double inclination inward and toward the center. Inward inclination also occurred in the architrave, the frieze, and the walls of the central block. There was also outward inclination of the roof decorations and the finials on the pediments.

The meticulous planning and execution of the optical refinements in the Parthenon gave a sense of dynamism and muscular strength to a structure that was based on rather static rectangles and horizontal and vertical lines. The potential monotony of traditional Doric design was alleviated by a certain amount of intentional unpredictability. In the Parthenon, the carefully calculated proportions of its parts were adapted to the subjective visual experience of the viewer by the introduction of almost imperceptible adjustments. Ictinus wrote a book about his design of the Parthenon in which he seems to have explained the subtlety of his calculations and variations. Although the book no longer exists, the Roman architect Vitruvius preserved an elaborate set of rules for optical refinements that clearly owed much to the theories of the architect of the Parthenon.

The Parthenon is now an empty shell of columns surrounding the ruins of its interior block and lacking its splendid sculptural decoration. The structure survived with alterations to the interior until the seventeenth century C.E. In the sixth century it was converted into a Byzantine church. During the thirteenth century it served as the cathedral of the Frankish dukes of Athens, and in 1456 the Ottoman Turks used the Parthenon as a mosque. Unfortunately, they also used the building as a powder magazine, and in 1687, during a bombardment by the Venetians, the Parthenon was blown up by a grenade. Lord Elgin salvaged much of the Parthenon sculpture in 1801 and transferred it to the British Museum. Restoration work on the temple began in 1834 and has continued until the present. Controversies rage about how to protect the Parthenon from terrible air pollution that causes deterioration of the marble. Chemicals and gasses rising up to the Acropolis from modern Athens cause the stone to crumble into dust. In another ongoing controversy, Greece has demanded that the British Museum return the Parthenon sculptures to Athens, their city of origin. There is no resolution to this problem in sight.

New information based on discoveries made by the restorers of the Parthenon since the early 1990s suggests that the traditional interpretation of the building's function and some aspects of its decoration need to be reconsidered. Apparently, the finials at the four corners of the roof were not floral designs but rather huge winged Nikai (Victories). Most surprising are discoveries indicating that the frieze was not part of the original plan of the Parthenon and that the columns surrounding the cella were reduced in thickness to enable viewers outside the building to view the frieze. The restorers have also found evidence that there was another frieze over the entrance to the cella. The implications of this new information have yet to be determined.

Further Reading

Beard, Mary. *The Parthenon.* Cambridge: Harvard University Press, 2003.

Berve, H., G. Gruben, and M. Hirmer. *Greek Temples, Theaters and Shrines.* London: Thames and Hudson, 1963.

Pollitt, J. J. *Art and Experience in Classical Greece.* Cambridge: Cambridge University Press, 1972.

Rhodes, Robin Francis. *Architecture and Meaning on the Athenian Acropolis.* Cambridge: Cambridge University Press, 1995.

PROPYLAEA, ATHENS

Style: Classical
Date: 437–Circa 431 B.C.E.
Architect: Mnesicles

In 437, when the **Parthenon** had been completed, work began on a new monumental entrance to the **Acropolis**. The new entrance structure replaced the old propylon—a structure from the sixth century—that was in poor repair and was far too small and simple to fit into Pericles' plan for rebuilding the most important cult center in Athens. The structure was called the Propylaea, the plural form of "gate," because it had five doorways. Standing on the crest of the west slope of the Acropolis rock, the Propylaea was a place of awesome transition from the everyday secular space of the city to the sacred space containing Athens' most ancient and holy shrines. The Panathenaic Procession, the culmination of the most important religious holiday, made its way up to the Acropolis via the Sacred Way on a steep ramp, which passed through the Propylaea and gave way to a splendid view of the Parthenon and the statue of Athena Promachos (Athena First in Battle).

The Propylaea was an extremely expensive building made almost entirely of Pentelic marble. Because it was located on a steep slope, the structure that housed the actual gateway had to be designed as a long hall on two levels. Pericles entrusted the challenge of designing and overseeing this unusual monument to an architect named Mnesicles. His plan had to create a visual relationship between the entrance gate and the Parthenon but also keep the gate subordinate to the temple. To harmonize the two buildings, Mnesicles used the Doric order and incorporated moldings and architectural details that imitated those of the Parthenon. He also included Ionic features in the interior of his building, as did the architect of the Parthenon. The original plan for the Propylaea proposed a building that would have been 224 feet wide, but in 432 the outbreak of the Peloponnesian War interrupted construction and the project was abandoned. What remained was a structure that is 156 feet in width, a considerable reduction of the architect's vision.

In plan, the Propylaea is made up of three units: a rectangular central building and two wings that project at right angles on the west side forming a U-shaped entrance focused on the Sacred Way. The central hall has facades resembling Doric temples on the east and west ends but no decoration on the flank walls. An entrance ramp, which is twelve feet wide, runs at a steady incline through the center of the hall from west to east.

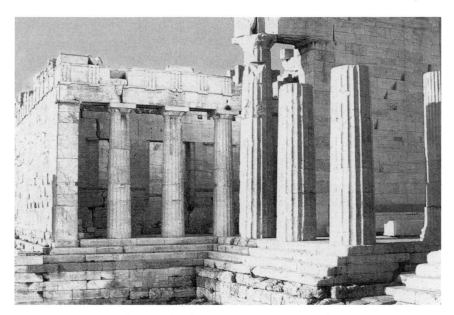

Propylaea, Athens. *Courtesy of Judith Snyder Schaeffer.*

Except for their height, the two facades of the hall are identical. Because of the difference in ground level, the lower west facade has a base of four steps while the higher one on the east has no steps. The western columns are twenty-nine feet tall (with minor variations in height); those on the east are about a foot shorter. Each facade has six Doric columns. The space between the two center columns is one and a half times as wide as the flanking column spacings. This serves to accommodate the entrance ramp that was used for processions of sacrificial animals and also creates visual emphasis on the central passageway.

The architrave, or lintel, supported by the columns is not purely horizontal but is bowed slightly upward. This accounts for the small variations in the heights of the columns, which become progressively taller toward the center. All of the horizontal members above the architrave parallel this curvature. The curving of horizontals is also found in the design of the Parthenon and is one of a number of optical refinements that were built into Doric temples to correct for visual distortion (see the Introduction).

Above the architrave is the Doric frieze, a horizontal band composed of triglyphs and metopes. Triglyphs are rectangular blocks with vertical grooves cut into their surfaces; metopes are the flat panels between them. In traditional Doric design, there should be a triglyph over each column and one over the center of the space between the columns. Because of the greater space between the center columns of the Propylaea, Mnesicles had to vary the arrangement of the frieze by adding a second metope in the space between the columns that flank the ramp. All of the metopes are blank; that is, they do not have sculpted

decoration as do those on the Parthenon. The pediment—the long low triangular space that is created by the sloping eaves of the gabled roof—is the crown of the facade and traditionally is the site of elaborate sculptural groups depicting mythical narratives. The pediments on the east and west ends of the Propylaea do not have sculpture. This is in contrast to the Parthenon, which is the most highly decorated of all Doric temples. In the hierarchy set up by expensive ornamentation, the facades of the Propylaea are clearly subordinate to those of the temple.

The interior of the central hall is divided by a cross wall that is parallel to the two outer facades. This is the gateway proper, pierced by five doors, that divides the hall into two distinct parts, or vestibules. The vestibule on the western side of the gate wall occupies two-thirds the length of the building. In here the ramp is flanked by elevated sidewalks for the use of pedestrians and by two rows of three Ionic columns. The columns are thirty-four feet tall and support an Ionic three-band architrave and a marble ceiling. Ancient visitors to the Acropolis marveled at the marble ceiling beams, which have eighteen-foot spans and weigh eleven tons each. In this impressive space, crowds of visitors could wait until the doors to the Acropolis were opened each morning. A touch of polychromy was introduced by wall benches and other decorative details worked in black Eleusinian limestone.

A flight of five steps leads up from the pedestrian sidewalks to the doors and creates the transition between the levels of the two parts of the hall. The east vestibule, which has no interior supports since it occupies only one-third of the length of the building, has a marble ceiling that was decorated by coffers, or recessed panels, filled with painted designs.

The west side of the Propylaea, which faces the city and welcomes worshipers, is flanked by two projecting wings. Although these structures were intended to be symmetrical, the location of the precinct of Athena Nike to the south made modifying the south wing necessary. Nevertheless, Mnesicles was able to create the illusion of symmetry by disguising the lack of space on the south side.

Each of the wings is fronted by a colonnade of three Doric columns. In the north wing, built according to Mnesicles' original plan, the space behind the columns is a porch in front of a rectangular room that has a door and two windows. This was the Pinakotheke, or picture gallery, that was actually a ritual dining room in which paintings were displayed. The south wing appears to balance the north wing, but in reality it is only a facade. Behind the Doric colonnade there is simply an empty space that gives access to the Athena Nike precinct. Mnesicles had intended to construct two large halls adjacent to the north and south walls of the central hall and behind the wings. These were never built because of the beginning of the Peleponnesian War.

The Propylaea suffered much disfigurement and alteration after the end of the Roman period. From the twelfth to the fifteenth centuries c.e., the building served as a defensive fortification that was part of the residence of the bishops and Frankish dukes of Athens. On the south wing was a square tower, the

so-called Frankish Tower, that was actually constructed by the Florentine duke Nerio Acciaiuoli in the fourteenth century. In the seventeenth century, the central hall was destroyed by an explosion of ammunition stored there. The medieval and military additions to the Propylaea were removed in 1836. The famous archaeologist Heinrich Schliemann demolished the Frankish Tower in 1875. Serious restoration began in 1909 and continues today.

Further Reading

Berve, H., G. Gruben, and M. Hirmer. *Greek Temples, Theaters and Shrines*. London: Thames and Hudson, 1963.

Dinsmoor, William B. *The Architecture of Ancient Greece*, 3d ed. New York: W. W. Norton, 1975.

Lawrence, A. W. *Greek Architecture*, 4th ed. R. A. Tomlinson, ed. Harmondsworth, England: Penguin Books, 1983.

Rhodes, Robin Francis. *Architecture and Meaning on the Athenian Acropolis*. Cambridge: Cambridge University Press, 1995.

SANCTUARY OF APOLLO, DELPHI

Style: Orientalizing; Archaic; Classical; Roman
Date: Seventh Century B.C.E.–Second Century C.E.
Architect: Unknown

The oracular Sanctuary of Apollo lies in the gorge between the peaks of the two Phaedriades, or Shining Rocks, on the south slope of Mount Parnassus. Travelers, ancient and modern, agree that it is the most awesomely beautiful site in all of Greece. To the ancient Greeks, the springs and rocky precipices, the earthquakes and violent thunder storms, and the mists rising from deep crevasses in the mountainside indicated a holy place that was believed to be the center of the world.

Legend has it that Delphi was sacred to the earth goddess Ge and to Poseidon, the god of the sea and of earthquakes. As early as the second millennium B.C.E., an oracle associated with Python, a serpent who was the child of Ge, was located in a cave at Pytho, the site of Delphi. At the end of the Mycenaean period, the cult of Apollo usurped the site and took control of the oracle. Myth explains the advent of the god as the result of his slaying of Python. Apollo spent eight years in exile to purify himself from the murder. When he returned to the sanctuary, he was called Pythian Apollo, god of oracles and purification.

Like other Greek sanctuaries, Apollo's was surrounded by a circuit wall that marked the boundary of the sacred space and also served the practical function of protecting the numerous buildings, monuments, dedications, and statues located on the site. Also like other sanctuaries, Delphi did not have a regular axial or grid plan. Instead, the buildings were located rather randomly along the Sacred Way, which is a switchback road that leads up the steep slope of the hillside to Apollo's temple. The sanctuary was not designed at one specific time but rather developed in a historical process that was determined by the difficult terrain of the site (see **Altis** and **Sanctuary of Hera**).

The Sacred Way enters the sanctuary through a gate near the southeast corner at the bottom of the precinct. The road runs westward at an incline and was flanked by numerous works of art dedicated to Apollo from individuals as well as city-states. More than one hundred statues, made of bronze, marble, ivory, gold, and silver, stood along the first one hundred feet of the road. These were primarily votive offerings that commemorated military victories and were paid for by a percentage of the booty taken from the defeated.

To the west of the dedications, a series of treasuries built by city-states flanked the Sacred Way. Treasuries—mostly small single-room buildings

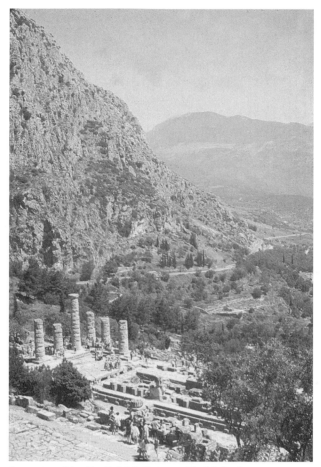

Sanctuary of Apollo, Delphi. *Courtesy of Judith Snyder Schaeffer.*

fronted by a porch with two columns—housed the precious offerings left at Delphi by pious visitors. The treasuries were artistic showpieces meant to project the wealth and prestige of the city-states that built them (see **Athenian Treasury** and **Siphnian Treasury**). Some also served as triumphal monuments and thank offerings to Apollo for successful military campaigns and for important historical/political events. For example, the first treasury on the Sacred Way was a Doric building in limestone built around 500 by the ruling party of Sikyon after it had seized power from a family of tyrants. Although most of the treasuries are now ruinous, those of Siphnos, Thebes, Boeotia, and Megara have been identified.

The Sacred Way takes a sharp turn toward the east and passes the treasury of the Athenians. On the west side of the building is a triangular space where the spoils from the great victory at Marathon in 490 were displayed. To the

east of the treasury was the Bouleuterion, a simple long rectangular building where the administrative officials of the sanctuary conducted their business.

Close by the Bouleuterion were the sanctuary of Ge and the Great Rock of the Sibyl. This was the site of the legendary primitive oracle that was guarded by Python. According to legend, the Great Rock functioned as the podium where the first Sibyl stood when she delivered her holy messages. She is said to have predicted the Trojan War.

Strategically placed across the Sacred Way from the Athenian treasury was the Doric treasury of Syracuse, built after the Sicilian city's devastating victory over Athens in 413. The location is a perfect example of the kind of political theater that could be created by architecture. Treasuries of Cnidos, Klazomenai, and Cyrene were located to the east of the Syracusan building.

The Sacred Way continues across a roughly circular area, about fifty feet in diameter, called the Halos, which means "threshing floor." It was the venue for sacred dramas that enacted the killing of Python and a place of assembly for processions going up to the Temple of Apollo. On the east edge of the Halos stood the Corinthian treasury, the oldest building of this type at Delphi. It was built in the seventh century by Kypselos, tyrant of Corinth, and contained some of the most exotic and expensive votive gifts dedicated to Apollo.

To the north of the Halos was a great wall, 272 feet long, built in the sixth century to support the terrace of the Temple of Apollo. The wall was constructed of polygonal masonry, which is masonry made up of random-shaped pieces of limestone instead of rectangular blocks. Inscribed on the wall were more than eight hundred notices of the emancipation of slaves. Against this wall, the Athenians built a stoa—a multipurpose long hall with solid back and side walls and a colonnade across the open front—in the early fifth century. The Stoa of the Athenians was 98 feet long and 13 feet deep. It stood on a platform of three steps and had eight Ionic columns spaced 13 feet apart. Because of the long spans between the columns, the lintels and roof must have been made of wood. The stoa was clearly a monument to Athenian naval power and leadership in the Persian Wars. Inside were displayed numerous trophies, most importantly the ropes used by the Persian king Xerxes to build his famous pontoon bridge over the Hellespont for the invasion of Greece. Outside, on the roof of the building, the actual figureheads of Persian ships were used as finials.

At the east end of the stoa, the Sacred Way turns sharply and rises steeply, running almost parallel to the front of Apollo's temple. On the east side of the Sacred Way was the gilt bronze Tripod of Plataea dedicated by the Greeks in commemoration of the decisive victory over the Persians in 479. The monument took the form of a great cauldron supported by a tripod with a central vertical support in the form of three entwined serpents. Engraved on the bodies of the serpents were the names of the thirty-one city-states that contributed to the victory. On the west side of the Sacred Way was the great altar of Apollo, a large rectangular structure of white and black marble built by the people of the island of Chios.

The Sacred Way turns west and runs parallel to a terrace that was filled with monuments and statues. Here stood the Temple of Apollo Pythias, the center of the sanctuary where the oracle was located (see **Temple of Apollo Pythias, Delphi**). The building was in the Doric order with colonnades on all four sides. There were six columns across the front and back of the temple and fifteen along the flanks. Very little of the temple has survived the ravages of time, but ancient descriptions of the building and archaeological evidence indicate that it faced east and had the traditional arrangement of pronaos, cella, and opisthodomos. The oracular shrine, called the adytum, was located in the western end of the cella. Evidently, the shrine was a partially underground chamber that contained the omphalos, or navel of the world, and the oracular chasm.

The oracles were given on the seventh day of each month, except for three months in the winter when Apollo was thought to be away from his sanctuary. Only men were admitted into the temple. They submitted their questions, written on lead sheets, to the Pythia (also known as the Delphic Sibyl), a woman who was at least fifty years old and lived in the sanctuary. After drinking from a sacred stream and chewing laurel leaves, the Pythia sat on a sacred tripod and inhaled vapors rising from the oracular chasm. She would fall into a trance, and the words she uttered would be written down and interpreted by priests.

The Sacred Way continues along the flank of the temple and then climbs to the theater. Originally constructed in the fourth century, the theater was remodeled by the Romans in the first century c.e. Its thirty-five rows of seats, carved into a hollow in the mountainside, could accommodate five thousand spectators. The orchestra, or circular dancing floor, measured fifty-nine feet across. Because the surrounding landscape is so spectacular, the stage building was kept very low so as not to obstruct the marvelous view of the Pleistos River valley with Mount Kirphys in the distance. The theater was used for musical and dramatic performances that were part of the Pythian Games, held every four years in honor of the god.

To the east of the theater was the Lesche of the Knidians, a building famous in antiquity for its mural paintings by Polygnotos. Dedicated in 450, the Lesche was a clubhouse that was used for ritual dining. The building was rectangular in shape and had walls of unbaked brick and a wood roof supported by eight wood pillars.

Above the sanctuary proper, outside the circuit wall, a path winds upward to the stadium, which was originally built in the fifth century b.c.e. An inscription from that time forbids spectators to carry wine out of the structure. The stadium was 584 feet long and 84 feet wide and had stone slabs to mark the starting and finishing lines of the racecourse. Originally, the spectators sat on earth terraces that bordered the U-shaped track. In the second century c.e., the Athenian philanthropist Herodes Atticus built a triple-arched entrance for the athletes and judges and paid for rows of limestone seats. Because of the slope of the ground, there were twelve rows of seats on the north side and six on the south. Flights of stairs at intervals provided access to the seating and

facilitated the movement of seven thousand spectators. Gymnastic contests, footraces, and musical contests that were part of the Pythian Games were held in the stadium.

Delphi remained the most important oracular site in the Mediterranean region even during the Roman Empire. Nero is said to have stolen more than five hundred statues from the sanctuary to punish the Pythia when she condemned him for murdering his mother. The emperors Hadrian, Antoninus Pius, and Marcus Aurelius conducted extensive restoration work on the buildings. With the rise of Christianity, the importance of the Sanctuary of Apollo diminished greatly. The oracle was finally closed by the Byzantine emperor Theodosius I in the fourth century.

Excavation and restoration of Delphi by the French School began in 1892. A museum was built not far from the modern entrance to the site to house the numerous statues and architectural fragments and the rich collection of epigraphic material that have been recovered from Apollo's sanctuary.

Further Reading

Hellenic Ministry of Culture. www.culture.gr/home/welcome.html.

Lawrence, A. W. *Greek Architecture*, 4th ed. R. A. Tomlinson, ed. Harmondsworth, England: Penguin Books, 1983.

Perseus Building Catalog. Perseus Digital Library. www.perseus.tufts.edu/cgi-bin/ptext?doc=Perseus%3Atext%3A1999.04.0039.

Petracos, Basil C. *Delphi*. Athens, Greece: Hesperus Editions, 1971.

Princeton Encyclopedia of Classical Sites. Perseus Digital Library. www.perseus.tufts.edu/cgi-bin/ptext?doc=Perseus%3Atext%3A1999.04.0006.

SANCTUARY OF HERA, SAMOS

Style: Geometric; Orientalizing; Archaic
Date: Circa 950–Sixth Century B.C.E.
Architect: Unknown

Samos, the easternmost of the Sporades islands, was an important early cult center for the worship of Hera. Her sanctuary, the Heraion, was a place consecrated to the goddess that contained altars, a temple, subsidiary buildings, and offerings. The complex was located by the Imbrasos River, where legend has it that the goddess was born and later married her brother Zeus.

Early in the first millennium, a primitive wooden image of the goddess was discovered on Samos and became the focal point of an annual festival celebrating the sacred marriage, a ritual that had its origins in Near Eastern religious beliefs. In preparation for Hera's yearly wedding celebration, the ancient statue of the goddess was given a purifying bath to restore her virginity and dressed in a gown made by the women of Samos. Worshipers attending the annual rite came from many different parts of the Mediterranean. Offerings left for the goddess include Greek pottery and sculpture, Egyptian statuettes, and ivories from Syria and Assyria.

The site of the Heraion was first settled in the Bronze Age; the remains of houses, a circuit wall, and a Mycenaean tomb have been recovered. However, the earliest altar definitely marking the location as a sacred space was not constructed until about 950. There is some evidence for a modest chapel housing the ancient cult statue in the ninth century, but the first true temple was not built until the eighth century. This temple was replaced by a second temple and associated structures in the seventh century. In the sixth century, two more temples were built on the site (see **Temple of Hera, Samos**). The building history of the Heraion preserves an important record of the early development of temple design and of the architectural organization of a sanctuary space.

The first temple in the Heraion, built around 775, was a long, narrow, rectangular cult room, or cella, with mud brick walls seated on a foundation of flat stones. Access was from the east end, which was left open for its full width and featured three columns placed between the ends of the walls. The building was 21 feet wide and 108 feet long, making it the earliest hecatompedon (hundred-footer) in Greek architecture. Inside, a file of thirteen columns, including the central one in the open east end, ran down the longitudinal axis of the cella. These were necessary to support the roof, but they caused some aesthetic problems. First, the columns divided the cult room into two long narrow aisles only

about 8 feet wide. Second, the line of supports obscured the central axis of the back (west) wall, making it necessary to place the pedestal for the cult image of Hera off-center to the right. The columns, spaced 8 feet apart, were most likely made of wood and rested on stone slabs to protect them from moisture. There is no evidence from which to determine the height of the building or the form of the roof.

About a half-century after the temple was built, a row of columns surrounding the whole building and supporting a roof connected to the cella walls was added. This colonnaded portico was not part of the original design, as indicated by the fact that its foundation level is ten inches higher than the foundation of the cella walls. The addition was most likely needed for the practical purpose of shielding the mud brick walls from the elements. But the file of columns would also have added to the impressive appearance of the building.

On the east facade of the temple were seven columns carefully aligned with the features of the older structure. The three in the center were placed in line with the older columns in the entrance to the cella; the next two stood opposite the cella walls; and the outer columns were in file with those on the flanks. The long north and south flanks of the temple had seventeen columns each, and the west end had only six. These columns, like those in the cella, were made of wood and rested on stone bases. The addition of the colonnade increased the overall dimensions of the temple, making it 31 feet wide and 121 feet long. The combination of cella and colonnaded portico in a single structure represents the first known peripteral temple plan, which would remain the standard for ancient Greek sacred architecture.

After a flood in the seventh century, the sanctuary underwent extensive renovation and systematic architectural organization. This is the first formal layout of a religious site discovered so far. A new temple, constructed over the site of its predecessor, exhibited refinement in plan, proportions, and design of the interior. The length of the original hecatompedon cella (108 feet) was retained, but its width was enlarged to 22¼ feet and the width of the colonnade was increased. These adjustments increased the building to a little more than 38 feet wide and 124 feet long, creating a more harmonious relation of width-to-length dimensions.

In the interest of symmetry, the front and rear facades of the temple each had six evenly spaced columns, and the flanks had an even number of columns—eighteen. The plan was enriched by an increase in the depth of the front portico to accommodate a second row of six columns behind and in line with the outer six. This created a subtle transverse accent that contrasted to the longitudinal axis of the cella and served as a sort of porch, giving visual emphasis to the entrance.

Perhaps the greatest contrast to the old temple occurred in the design of the cella, in which the center was unobstructed and thus provided a long uninterrupted view down the axis to the ancient cult statue. The necessary internal support for the roof was displaced to the sides, where six columns, each in line with every other column of the exterior colonnade, were placed close to

the flank walls. This alignment of the internal and external columns would allow for the introduction of horizontal beams forming the base for a gabled roof. Since no terra-cotta roof tiles have been found, the roofing material must have been mud or thatch. Both the internal and external columns were wood resting on stone slabs, and the cella walls were made of mud brick.

A second innovative feature of the seventh-century renovation was the structure built to the south of the temple along the bank of the Imbrasos River. This building was 228½ feet long, open in front, and divided internally into three separate spaces. A wooden colonnade, running along the front, and an internal row of wood posts or columns supported a single pitched roof that sloped from back to front. This structure was the prototype of the stoa, the most characteristic of Greek secular structures, that was used for centuries to frame public spaces and became the setting for multiple activities ranging from shopping to education and philosophical discussion. At Samos, the stoa provided shelter for the worshipers and also created a visual link between the temple and the sacred pool where the statue of Hera received its ritual bath.

Late in the seventh century, a circuit wall enclosing and formalizing the sacred space was constructed. A gateway, or propylon, was inserted into the wall on the north side. This created an impressive entrance into the precinct of the goddess and served as a visual and physical demarcation of the division between the sacred and the profane.

The design of the propylon was simple: a central passageway flanked by two symmetrical wings. Each wing was divided internally into two rectangular rooms, which could be entered through doors that opened onto the passageway. A single continuous roof covered all three spacial units, and a gabled porch at each end of the passage provided visual emphasis in contrast to the unadorned walls of the wings.

The propylon afforded a corner view of the temple, simultaneously revealing its front and side; this was to become the preferred line of sight in subsequent temple complexes. Also visible from the entrance gate would have been the large altar in front of the temple and numerous small personal shrines and statues given as gifts to the goddess.

The second Temple of Hera and the stoa were demolished in the sixth century to make way for the grandiose temple built by Rhoecus and Theodorus. The Heraion remained a popular place of worship well into the Roman imperial era. Constant rebuilding and embellishment of the site attest to the importance and wealth of the cult. The marital unit, or *oikos*, was the basis for the structure of the Greek polis, or city-state. As patron of marriage, Hera was both the personal deity of brides and the civic goddess who tended the stability of the polis.

The ruins of the Heraion were first explored by the amateur archaeologist J. Pitton de Tournefort in 1702. Further exploration of the site waited until 1879 and was initiated by the French. The Archaeological Society of Athens conducted some excavations in 1902–1903. Then, in 1910, the Koenigliche Museen of Berlin sponsored work at the Heraion that was interrupted in 1914

by World War I. The German Archaeological Institute at Athens began systematic excavations in 1925, but World War II caused the work to be suspended in 1939. The Germans returned to the Heraion in 1951 and continue to examine the sanctuary.

Further Reading

Dinsmoor, William B. *The Architecture of Ancient Greece*, 3d ed. New York: W. W. Norton, 1975.

Hurwit, Jeffrey M. *The Art and Culture of Early Greece, 1100–480 B.C.* Ithaca and London: Cornell University Press, 1985.

Lawrence, A. W. *Greek Architecture*, 4th ed. R. A. Tomlinson, ed. Harmondsworth, England: Penguin Books, 1983.

Princeton Encyclopedia of Classical Sites. Perseus Digital Library. www.perseus.tufts.edu/cgi-bin/ptext?doc=Perseus%3Atext%3A1999.04.0006.

Schweitzer, Bernhard. *Greek Geometric Art.* Peter and Cornelia Usborne, trans. London and New York: Phaidon Press Limited, 1971.

SCHLIEMANN HOUSE, ATHENS

Style: Renaissance Revival
Date: 1878–1880 C.E.
Architect: Ernst Ziller

In September 1869, Heinrich Schliemann, the famous excavator of Troy, Mycenae, and Tiryns, married a young Greek woman named Sophia Engastromenos. By 1871, with Sophia expecting their first child (who would be named Andromache), the Schliemanns decided to "establish our principal domicile in Athens," as Schliemann wrote in a letter to one of his friends. He bought a property on Panepistimiou Street between the university and the Parliament building and hired the architect Ernst Ziller to design a house that would reflect his personality and his passion for the heroic world of Homer.

Ziller was an architect and archaeologist who was trained in Dresden and worked for Theophilus Hansen in Vienna in 1858 and 1859. Hansen took Ziller to Athens to assist in the building of the Academy of Sciences, and Ziller fell in love with Greece and its antiquities. He settled permanently in Athens after 1868, became a Greek citizen, held positions in the National Technical University, and in 1884 was director of Public Works. In addition to excavating the Theater of Dionysos and the Panathenaic Stadium, Ziller designed many important public buildings, including the Municipal and Royal Theaters and the Palace of the Crown Prince in Athens, churches in the Peloponnesus, a summer home for King George I, and many country houses. He was one of the most prolific of the architects who worked in Athens in the nineteenth and early twentieth centuries.

The initial plans for the house were put on hold by Schliemann because of financial insecurity resulting from the Franco-Prussian War. But, the birth of a second child (named Agamemnon) in 1878 made a permanent residence for the Schliemanns necessary. Built between 1878 and 1880, the Schliemann house—known as Iliou Melathron, or Palace of Ilium (Troy)—is one of Ziller's most important buildings and is designed in the Renaissance Revival style. By the time of construction, Schliemann's finances were in order and no expense was spared in the quality of materials and furnishings. The house was to be not only a family dwelling, but also a setting for Schliemann where he would receive important visitors, hold a literary salon, have balls for as many as six hundred guests, and display his collection of antiquities.

Iliou Melathron is more Italian than Greek in inspiration. In fact, Schliemann referred to it as a palazzo. In plan it is a square block with large public

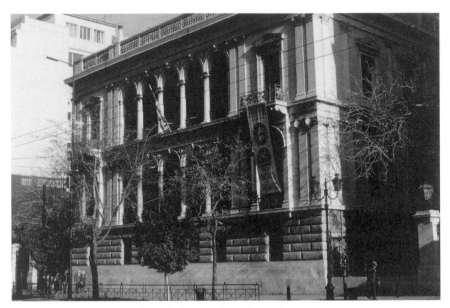

Schliemann House, Athens. *Photo by Jim Steinhart/PlanetWare.*

rooms in the center flanked on two sides by smaller, more intimate, spaces. There are gardens on three sides, while the main facade fronts directly onto Panepistimiou Street. On the exterior, Iliou Melathron is divided into three stories following the traditional arrangement of an Italian palazzo. The facade is most impressive.

The ground floor is made of long horizontal blocks with recessed edges. This creates a heavy solid base that contrasts to the more delicate details on the upper stories. Rectangular windows punctuate the wall of the ground floor and are aligned with the windows and arched openings of the upper stories to create visual linkage that unifies the facade vertically.

The second and third stories are nearly identical. They are divided into three parts. In the center of each is a loggia, which is a gallery that is open on its front side. This open area is screened by an arcade with Ionic columns supporting five arches. The back walls of the loggias are painted dark red and contrast nicely with the white marble of the columns and arches. At either end of each loggia is a bay, or rectangular unit, that is defined on its left and right sides by pairs of pilasters with Ionic capitals. Each bay has a window in its center. On the second story, the windows are arched; on the third, they are rectangular, have projecting balconies, and are topped by triangular pediments.

On the horizontal cornice that separates the second and third stories, gold letters prominently spell out the name of the house: Iliou Melathron. The top of the third story has a heavy projecting cornice and, above that, a balustrade that surrounds a flat roof that functions as a terrace. Statues of ancient Greek gods and goddesses made of terra-cotta originally perched on the balustrade.

The treatment of the side walls is less ornate than the facade but incorporates the same details. On the north side two pilasters decorate the end bays, and there are three windows and a door on the second story that are aligned with four windows above. A balcony projects from the window over the door to visually emphasize the main entrance to the house, which has an impressive curved stairway. On the nearly identical south side of the building, both stories have four windows. The contrast of arched windows below rectangular ones with pediments is maintained on both sides.

The rear facade of the building faces a private garden. Like the front facade, it has pairs of pilasters flanking a bay with a window at each end. On the second story is a cluster of three doors in the center flanked by two small rectangular windows that imitate those in the ground floor. In the third story, three windows close together are aligned with the doors below. The windows have triangular pediments and are joined by a balcony. As in the second story, the triad of windows is flanked by small rectangular openings.

Ziller's use of vertical linkage, played off against the strong horizontals of the ground floor, cornices, and balustrade on the roof, are especially beautiful and create a unity of design that is perhaps the finest example of Renaissance Revival work in Athens. The contrast of white marble pilasters, columns, and window frames with the pale yellow of the wall surfaces is highly effective yet not strident. This is indeed the house of a most ambitious and successful man.

The interior space of Iliou Melathron is designed as both a public space and a private family space. On the ground floor are utilitarian rooms (kitchen, storeroom, servants' quarters) and a museum where Schliemann displayed his collection of antiquities. The second story is dedicated to public functions such as the reception of visitors, dinner parties, balls, and Schliemann's occasional salons. Access to this story is via an impressive stairway that leads to a reception room with an apse at its far end. A large rectangular salon opens onto the second-floor loggia, and another room with an apse, perhaps the dining room, overlooks the garden behind the house. Flanking these large ceremonial spaces are guest rooms and a reading room. The third story, completely separated from the public rooms of the second, is the actual living quarters. Here are located Schliemann's large library, which opens onto the loggia, and his two studies. There are also sitting rooms and bedrooms for the family.

As one might expect, the rooms of Iliou Melathron are lavishly decorated. The walls and ceilings are painted in careful imitation of Pompeian murals. Some are Pompeian red, some black, others pale yellow, and still others a pale blue that was popular in the Roman houses of Herculaneum. Innumerable graceful details, both architectural and figural, enliven the broad expanses of color. Especially charming are the scenes of putti, or baby cupids, engaged in excavating an ancient site. The paintings were executed by the Slovinian painter Yuri Subic. On the floors are mosaics with abstract designs and stylized representations of some of Schliemann's antiquities from Troy and Mycenae. The mosaics were installed by Italian craftsmen.

Throughout the house are inscribed quotations, worked in gold letters, from ancient Greek thinkers and writers. The furnishings were chosen by Schliemann himself from exclusive dealers in London and Vienna. So that family and guests would always be comfortable, central heating and a sophisticated natural air conditioning system—representing the most advanced technology of the period—were built into Iliou Melathron.

When Schliemann died in 1890, he left the house to Sophia. As her fortune declined, she found it necessary to sell the house, and in 1926 it was purchased by the state. From 1934 to 1981, Iliou Melathron served as the seat of the Supreme Court of Greece. Finally, in 1984, the Numismatic Museum moved into the house. After the second floor was carefully restored, the museum opened to the public in 1998. Conservation is currently in progress in the third story. In addition to its collection of ancient Greek, Roman, medieval, and modern coins, the museum also houses Schliemann's personal collection, donated by Sophia after her husband's death.

Further Reading

Aslanis, Ioannis, et al. *Troy: Heinrich Schliemann's Excavations and Finds.* A. Doumas and M. Krikou-Galani, trans. Athens: Greek Ministry of Culture, 1985.

Numismatic Museum. www.nm.culture.gr.

Touratsoglou, Ioannis, and Eos Tsourti. "The Iliou Melathron: Its Owner and Architect," in *Coins and Numismatics.* Athens: Numismatic Museum, 1996.

Traill, David A. *Schliemann of Troy: Treasure and Deceit.* New York: St. Martin's Griffin, 1995.

SIPHNIAN TREASURY, DELPHI

Style: Archaic
Date: Circa 525 B.C.E.
Architect: Unknown

A few years before 525, the people of the small western Cycladic island of Siphnos built the most beautiful of all the treasuries in the **Sanctuary of Apollo** at Delphi. The legendary wealth of the island was based on its silver mines. Herodotos, the fifth-century historian, wrote that the Siphnians were the richest of all the island peoples of Greece—until their community was sacked by the Samians and their mines were flooded. Their treasury at Delphi was apparently only barely completed when this catastrophe occurred.

A treasury is a small one-room building with a front porch that was built to house and preserve the expensive objects that had been left as offerings to a god, in this case Apollo. City-states from all over Greece had treasuries in the major sanctuaries as monuments to their prosperity and piety. In the competitive spirit that was such an important factor in Greek culture, each community used its treasury to project an image of social and cultural preeminence.

The Siphnian Treasury resembled a miniature temple in a highly elaborated Ionic order. It was, in fact, the only example of the use of this order by a western Greek community in the sixth century. Made entirely of marble imported from the island of Paros, the treasury was one of the first marble buildings set up in the sanctuary.

In plan, the Siphnian Treasury was quite simple. The room for storing the offerings was rectangular with solid walls on three sides and a door in front. Sheets of marble, 1¼ inches thick, lined its interior walls. Decorating the base of the walls outside was a wide bead-and-reel molding. A bead-and-reel molding was a horizontal band made up of round fat beads alternating with narrow disc-shaped reels. The door was framed by a variety of moldings carved with floral designs and the bead-and-reel motif. The doorway of the Siphnian Treasury was the most richly decorated of the Ionic order in its time. For reasons of security, the storage room was not open to the public. The flank walls of the room were extended beyond the front wall to form a porch. This was the same design that was traditionally used for the internal porch of a temple. All together, the Siphnian Treasury was twenty feet wide and twenty-eight feet long.

In the front of the porch, between the ends of the extended flank walls of the storage room where a pair of columns were usually found, were two caryatids,

statues of young maidens that functioned as columns. Substituting women for columns in the Ionic order would be appropriate since the Greeks considered the Ionic to be the feminine order; Doric was considered the masculine order. The young girls are exquisite examples of late sixth-century sculpture. Their beautifully arranged hair and expensive decorative garments, which were originally brightly painted, project an image of aristocratic pride and wealth.

The caryatids look out toward the space in front of the treasury like sentinels guarding the storage room. In Greek gender relations, the wife was the mistress of the house and one of her chief functions (after childbearing) was to guard the family fortune contained there while her husband went out each day to participate in the masculine activities of the city-state. Each caryatid stood on a square pedestal, and on her head was a tall cylindrical drum carved with figures of Satyrs and Nymphs (followers of the wine god Dionysos). Above this was a cushion with animals in relief that functioned as a support for the upper part of the building.

The horizontal lintel above the caryatids was undecorated, but above it two ornamental moldings appeared as the lower boarder of a frieze that ran all around the building. In the Ionic order, the frieze is a long uninterrupted band that sometimes carries scenes worked in relief sculpture. The frieze of the Siphnian Treasury is considered by many scholars to be the finest example of relief sculpture from the sixth century. It is about two feet high and more than ninety feet long.

Stories from mythology and Homeric epic were represented, one on each side of the building. Although some details of the myths are not certainly identified because of damage to the frieze, there is general agreement about the following: the west/front frieze depicted the Judgement of Paris; on the south flank, some sort of abduction took place; the east/back showed the Council of the Gods and a battle scene from the Trojan War; and the north flank contained the Battle of the Gods and the Giants. The frieze was brightly painted in red, green, and blue, and bronze spears, chariot wheels, and horse harnesses were attached to make the work even more splendid.

Above the frieze, on the front and back of the treasury, were the pediments, the triangular areas shaped by a horizontal molding and the slanting eaves of the gabled roof. Both pediments were enriched with sculpture, an unusual feature for the Ionic order, but only the east one survives. The myth represented there told the story of the struggle between Apollo and Hercules for the sacred tripod of Delphi. The tripod was not only a symbol of Apollo, it was also the seat on which the Delphic prophetess sat when she recited the oracles given by the god. On the top angle of the pediment was a finial of a flying Nike (Victory), and seated Sphinxes were placed on the two lower angles.

The Siphnian Treasury was a tour de force of sixth-century Greek art and architecture. Many have described it as a jewel box because of the extensive use of ornamental moldings and painted sculpture. The building itself was not extraordinary, but its exterior must have been most impressive. Certainly, the Siphnians spared no expense in broadcasting the enormous prosperity of their

island community to visitors from all over the Greek world who came to Delphi to consult the oracle and to worship. Today, only the foundations of the magnificent little building, close to the Sacred Way, remain in place. Sculpture from the Siphnian Treasury is displayed in the Delphi Museum.

Further Reading

Berve, H., G. Gruben, and M. Hirmer. *Greek Temples, Theaters and Shrines.* London: Thames and Hudson, 1963.

Hurwit, Jeffrey M. *The Art and Culture of Early Greece, 1100–480 B.C.* Ithaca and London: Cornell University Press, 1985.

Lawrence, A. W. *Greek Architecture*, 4th ed. R. A. Tomlinson, ed. Harmondsworth, England: Penguin Books, 1983.

Osborne, Robin. *Archaic and Classical Greek Art.* Oxford: Oxford University Press, 1998.

STOA OF ATTALOS, ATHENS

Style: Hellenistic
Date: Circa 159 B.C.E.
Architect: Unknown

When Alexander the Great died in 323 B.C.E., the vast territory he had conquered was divided among his generals, who set up kingdoms for themselves. The kingdom of Pergamon, located at modern Bergama in north-western Turkey, became one of the most magnificent of the Hellenistic monarchies. Ruled by the Attalid dynasty, who were skilled generals and crafty politicians as well as great patrons of art and letters, Pergamon became the Athens of the east.

The Attalids considered themselves preservers and promoters of Greek culture and had a particular attachment to Athens. They used their great wealth to embellish their city with buildings and fine works of art intended to rival the golden age of Periclean Athens. The dynasty patronized philosophers, funded scholarship, and collected two hundred thousand volumes for their library, the second largest collection of manuscripts in the ancient world.

As Philhellines, or "lovers of Greece," the Attalids gave gifts to major Greek sanctuaries and funded building projects in the oracular **Sanctuary of Apollo** at Delphi. Kings Eumenes II (ruled 197–160) and Attalos II (ruled 159–138) had been educated in Athens, and they demonstrated their reverence for the city by building stoas there. Eumenes' stoa was situated on the south side of the **Acropolis**. Attalos built his stoa in the lower city in the **Agora**, where important schools of philosophy and rhetoric were located.

After the temple, the stoa was the most important design in ancient Greek architecture. Stoas were long buildings with solid back and side walls and a colonnade across the open front. They were used to frame urban spaces, such as the Agora, and had the practical function of protecting people from the sun and rain. Stoas were multipurpose structures that accommodated all sorts of daily activities. Legal proceedings, commerce, religious celebrations, education, and philosophic discussion took place in the stoa. People enjoyed walking in the stoa, where they met friends, looked at works of art, or viewed processions. Here they could rub shoulders with famous statesmen and orators as well as with beggars, street musicians, and eccentric philosophers such as Socrates. The Stoic school of philosophy takes its name from the word "stoa."

After he ascended the throne of Pergamon in 159, Attalos II funded the construction of a splendid stoa on the east side of the Agora. It was common

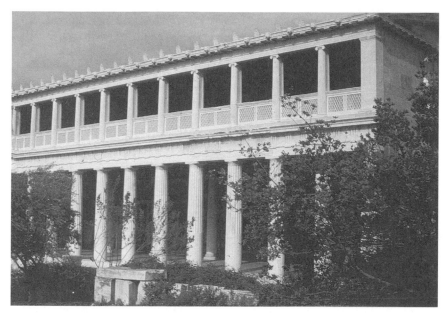

Stoa of Attalos, Athens. *Courtesy of Judith Snyder Schaeffer.*

for statesmen and rulers to give gifts of public buildings to cities to boost their reputations for generosity and to support their political ambitions. In the case of Attalos, his gift to Athens was a token of his appreciation for the education he obtained from the city's famous scholars and a reminder of the strong cultural ties he and his relatives shared with Athens. A large inscription, picked out in red paint, once occupied a prominent position in the lintels carried by the colonnade. It read, "King Attalos, son of King Attalos and of Queen Apollonis." Thus Attalos ensured that every person entering the stoa from the Agora would know who had given the building to the city.

The Stoa of Attalos is an excellent example of the elaborated stoa design that was favored by the Pergamene dynasty. It is the most easily studied building in the Agora because it has been carefully reconstructed by the American School of Classical Studies. The stoa—380 feet long, 64 feet wide, and 36 feet high—was one of the largest in the Agora. In contrast to the earlier Agora stoas, the Stoa of Attalos had two stories. Across the front ran a double colonnade of forty-five marble columns. The use of marble in a stoa was unusual and expensive; limestone was far more common. Marble added to the sumptuousness of the building and enhanced the play of light and shade along the extended facade. On the ground floor the columns were in the Doric order. The lower third of each had no flutes to prevent damage by daily traffic. Shorter, more slender Ionic columns linked by marble parapets stood above the Doric colonnade on the upper level. The combination of the two orders was carried through in the long horizontal members where an Ionic architrave, or lintel,

with three projecting bands supported a Doric frieze of triglyphs and metopes. Above was a very low-pitched gabled roof covered with terra-cotta tiles.

The interior of the lower story was divided into two long aisles by a row of twenty-two marble Ionic columns. These were aligned with every second column in the exterior colonnade, and the wider spaces between them accommodated a smooth flow of traffic inside the stoa. The flat roof of the lower hall was made of large solid wood beams. Instead of the usual unbroken back wall, the Stoa of Attalos had a limestone wall pierced by doorways that gave access to twenty-one rooms, which were used as shops.

The plan of the upper story was identical to that below: twenty-two columns divided the hall, and there were twenty-one shops. Here, the ornamental quality of the internal colonnade was enriched by the use of exotic palm capitals atop the columns. Access to the upper floor was provided by outside stairways on either end of the stoa.

Beneath the stairs was an arched alcove with marble benches on three sides. This is the earliest recognized use of a visible arch in an Athenian building. At the top of the staircase was a small entrance pavilion with two columns and a gabled roof. Around 100 c.e., the exterior staircase on the south end of the stoa was removed to make way for the widening of a street and replaced by an interior flight of steps located in the southernmost shop.

After four centuries of use, the Stoa of Attalos was damaged by fire during the barbarian raids of 267. The rear wall and shops were then incorporated into a hastily built defensive wall. All the columns, parapets, and lintels were removed and used to support the back wall. Between 1859 and 1902, the stoa was partially excavated by the Greek Archaeological Society. The work was completed by the American School of Classical Studies, which rebuilt the structure in 1953–1956. Half of the cost of the reconstruction was provided by John D. Rockefeller Jr., and the balance was collected from private American donors. All of the ancient material that was discovered, including the back wall, two shops, and parts of the exterior and interior colonnades, was preserved and incorporated into the rebuilding. Today, the great Stoa of Attalos houses the Agora Museum and allows visitors to experience the long sweep of its facade, the spaciousness of its interior hall, the variety of its orders, and an excellent view of the Agora.

Further Reading

Dinsmoor, William B. *The Architecture of Ancient Greece*, 3d ed. New York: W. W. Norton, 1975.

Pollitt, J. J. *Art in the Hellenistic Age*. Cambridge, Cambridge University Press, 1986.

Thompson, Homer A. *The Athenian Agora*, 3d ed. Athens: American School of Classical Studies, 1976.

TELESTERION, ELEUSIS

Style: Archaic; Classical; Roman
Date: Sixth–Fourth Century B.C.E.; Second Century C.E.
Architect: Unknown; Ictinus; Koroibos; Metagenes; Xenokles; Philon

One of the most tantalizing aspects of ancient Greek religion is the existence of mystery cults. These were secret religious organizations that were highly personal—as opposed the public cults of the city-state—and were accessible only through individual initiation. The Greek word *myesis* means "initiation," and the related *mystai* refers to one who is a member of a cult. Only the initiates knew the rituals, and they were sworn to maintain secrecy. By far the most popular mystery cult was that of Demeter at Eleusis. The celebration of the mysteries there lasted for nearly one thousand years and drew people from all over Greece and later from all over the Roman Empire. Several Roman rulers, including Hadrian and Marcus Aurelius, were initiated.

According to the foundation myth of Eleusis, Demeter's daughter Kore was abducted by Hades, god of the underworld. Demeter went in search of her daughter and roamed all over the Greek world. Because Demeter was the goddess of agriculture, particularly of grain, while she grieved the world became barren and food crops would not grow. Eventually, King Keleos offered the goddess a place to rest in Eleusis, and it was here that Kore returned from the underworld. Demeter allowed the crops to grow again and established a fertility cult that came to be known as the Eleusinian Mysteries. The secret rites were open to both men and women who could prove that they had not committed murder and that they spoke Greek. Initiates were sworn, on pain of death, never to reveal details of the rituals. In Greek literature there are only allusions to the mysteries, so little is known about the specific details of the cult, which is reported to have brought comfort and joy to initiates and to have led them to accept death without fear and look forward to a better fate in the afterworld.

The sanctuary at Eleusis is located on the coast of Attica about ten miles west of Athens. It nestles against the east slope of a low rocky hill overlooking Eleusis Bay and the island of Salamis. The focus of the sanctuary was the Telesterion, or initiation hall, from the Greek *telein*, meaning "to celebrate" or "to initiate." It was a large structure designed to hold several thousand people who would participate in the religious ceremonies and perhaps watch a sacred drama. The focus of the Telesterion was the Anaktoron, a long rectangular stone structure with a door on one of its flanks. Only the officiating priest

Telesterion, Eleusis. *Author's Photo.*

could enter the Anaktoron, which seems to have marked a sacred place and therefore remained unmoved throughout the many phases of construction and reconstruction of the Telesterion.

The earliest structure built on the site was a Mycenaean megaron (see **Palace of Nestor**). This was replaced by a U-shaped hall that seems to be the first true Telesterion, dated to the Geometric period, around 750. In the sixth century, after Athens had taken control of Eleusis, a larger building, associated with the lawgiver Solon, replaced the earlier hall. The Solonian Telesterion, constructed of blue-gray Eleusinian stone, was seventy-nine feet long and forty-six feet wide.

Pisistratus, tyrant of Athens from 546 to 527, fostered the Eleusinian Mysteries, and the resulting increased number of initiates made enlarging the Telesterion necessary. The Pisistratid building was square, measuring eighty-three feet on each side, and faced east with three doors that opened into a porch with ten columns that were probably Doric. Inside the hall, five rows of Ionic columns supported the roof. In the southwest corner, the Anaktoron took the place of the last three columns of the southernmost row. On three sides of the room were tiers of nine continuous steps, interrupted only by the Anaktoron. Since the steps were too narrow to serve as seats, the initiates probably stood during the enactment of the rites. Lighting seems to have been provided by windows placed high in the walls. The building was constructed of limestone but had Parian marble moldings, roof tiles, and finials.

In 480, the Pisistratid Telesterion was destroyed by the Persians. Very quickly thereafter a new Telesterion was begun, perhaps by the Athenian

leader Cimon. The new structure retained the width of the earlier building but doubled its length so that the Anaktoron was centered on the south side. Inside the hall, three rows of seven columns, probably Ionic, supported the roof. Along three of the walls were seven tiers of steps to accommodate a large number of worshipers. Three doors in the east wall provided access to the cult building. For reasons unknown, this rebuilding of the Telesterion was never completed.

Epigraphical and literary evidence indicates that during the classical period, when Pericles was the leading statesman of Athens, two different buildings were attempted. The first was designed by Ictinus, architect of the **Parthenon**. Ictinus's ambitious plan called for a square building of 170 feet per side, or four times the size of the Pisistratid Telesterion. The building was designed around the Anaktoron so that the shrine was approximately in the center of the hall. A colonnaded porch was to be located on the east side, where there would be two doors. To facilitate the movement of the crowds of initiates, there were four additional doors: two each on the north and south sides. Inside, there were five rows of columns aligned north to south but only four aligned east to west, making a total of twenty. Like its predecessor, Ictinus's Telesterion was never completed. The design was probably abandoned because of the difficulty of constructing the great spans necessary for the roof.

The second Periclean Telesterion was designed by Koroibos, Metagenes, and Xenokles. It was slightly smaller than Ictinus's building, measuring 167 feet on all four sides. Inside there were seven rows of six columns each. The rows had two stories; the large floor columns supported a second tier made of lightweight material. As in Ictinus's plan, the Anaktoron was centered in the hall. Tiers of eight steps, large enough to function as seats, ran around all four sides of the building and were interrupted by a pair of doors on the north, east, and south sides.

The Telesterion could accommodate a group of approximately three thousand initiates. Light entered the building from the center where a skylight of some sort provided both illumination of the Anaktoron and ventilation. The skylight was the special design of Xenokles. When it was completed, the Periclean Telesterion lacked a monumental entrance.

In the fourth century, the architect Philon constructed a Doric colonnaded porch on the east side, or front, of the building. It was made of Pentelic marble to contrast with the blue-gray stone of the rest of the building. The porch, nicknamed the Stoa of Philon, was 178 feet long and 37 feet deep.

During the second half of the fourth century, the sanctuary of Demeter was one of the most important cult centers in the Greek world. The celebration of the mysteries in the month of *Boedromion* (September) attracted thousands of people who walked in procession from Athens to Eleusis to participate in the secret ceremonies. The Telesterion was at the very heart of the cult and survived until it was burned by the Kostovoks in 170. In the second century C.E., the Roman emperor Marcus Aurelius rebuilt and slightly enlarged the hall. The Telesterion remained an active cult center until a decree of Theodosius I closed

pagan centers of worship in 390. The deserted sanctuary was destroyed by the Visigoths in 395.

The earliest archaeological work at Eleusis was undertaken by the British Society of the Dilettanti in 1812. Systematic excavations by the Greek Archaeological Society began in 1882. A grant from the Rockefeller Institution in 1930 supported further exploration, and after World War II a great deal of very complicated work was done on the Telesterion by Greek scholars. The building is now in a very ruinous state, but traces of all phases of construction can be identified.

Further Reading

Dinsmoor, William B. *The Architecture of Ancient Greece*, 3d ed. New York: W. W. Norton, 1975.

Lawrence, A. W. *Greek Architecture*, 4th ed. R. A. Tomlinson, ed. Harmondsworth, England: Penguin Books, 1983.

Mylonas, George E. *Eleusis and the Eleusinian Mysteries.* Princeton, N.J.: Princeton University Press, 1969.

Princeton Encyclopedia of Classical Sites. Perseus Digital Library. www.perseus.tufts.edu/cgi-bin/ptext?doc=Perseus%3Atext%3A1999.04.0006.

TEMPLE A, PRINIAS

Style: Orientalizing
Date: Seventh Century B.C.E.
Architect: Unknown

In the eighth and seventh centuries, the Greeks came into contact with the ancient cultures of Egypt and the eastern Mediterranean. They were quick to incorporate into their own culture the themes, compositions, and production techniques they encountered in a style that is now called Orientalizing. When Greeks went to Egypt in the seventh century as traders and mercenary soldiers, they discovered monumental stone architecture that was built using the post-and-lintel system and decorated with sculpture. This greatly influenced the development of stone architecture and sculpture in Greece.

At Prinias, in central Crete, the remains of two temples were found in 1906 C.E. The better preserved of the two, called Temple A, reflects a fusion of indigenous traditions and the new ideas and techniques imported from the East. Temple A was built in the middle of the seventh century B.C.E.; there is no evidence to indicate which god or goddess was honored there.

The building was made of limestone and apparently had a flat mud roof. Its design was quite simple: a long, roughly rectangular cult room, called the cella, and a deep front porch. The cella was 32 feet long and 19½ feet wide at the front, but because the flank walls were slightly splayed, the width at the rear was about 20½ feet. Access to the cella was provided by a door in the front wall that faced east, the traditional orientation for Greek temples. The door had a central post that supported a large lintel, 2 feet 9 inches tall, with a rectangular opening (like a window) above it.

The lintel has carved decoration that is clearly inspired by Eastern prototypes. On its front face is a procession of panthers, a modern designation for felines with bodies in profile and heads turned outward to face the viewer. There were no such animals in Crete in the seventh century, but they are common in Near Eastern art. On the underside of the lintel, above the viewer's head, are two women wearing tight-fitting gowns, short capes, and cylindrical headdresses worked in relief sculpture. On top of the lintel, statues of two seated women, 2 feet 8 inches high, face each other. They wear the same garments and headdresses as the women on the underside of the lintel. The images of women seen here are typical of the Daedalic style, an early form of Greek sculpture that borrows Eastern conventions. The slablike bodies and tight-fitting garments are similar to Assyrian statues, while the heavy wigs

derive from Egyptian fashion. Unfortunately, we have no idea who these women are—they could be either goddesses or priestesses. The panthers may serve as guardians of the temple door who ward off evil, much like the sculpted lions that guard the gates of the Hittite capital Boghazkoy and the fantastic monsters protecting the gates and doorways of Assyrian palaces of the eighth and seventh centuries.

In the center of the interior of the cella was a rectangular sacrificial pit lined with slabs of stone. The pit was flanked by two columns, probably made of wood, on the long axis of the room. These columns would have helped to support the flat mud roof, which most likely had a smoke hole over the pit. On the inner side of the doorway were two semicircular stone bases that may have received the pivots for a double door or may have simply supported decorative wood half-columns on either side of the entrance.

The porch of Temple A was formed by extending the walls of the cella eastward and connecting them to two rectangular piers. A third pier stood midway between the outer two, oddly obstructing the elaborate cella door. This central pier was probably installed to supply adequate support for the lintel, which supported the roof and carried a limestone parapet, 2 feet 9 inches tall, decorated with relief sculpture. A procession of mounted horsemen carrying shields was represented here. At either corner of the porch roof was a finial in the form of a volute, or spiral scroll.

Temple A at Prinias is a fine example of the blending of Greek and Eastern architectural styles. The post-and-lintel system in stone, used rather cautiously at Prinias, and the flat roof can be connected with Egyptian tradition. Sculpture in the round and in relief as architectural embellishments are also common in Egypt. The friezes with felines and warriors are inspired by similar work found in the eastern Mediterranean, and the Daedalic style owes many of its conventions to the Greeks' contact with their neighbors. In fact, Temple A at Prinias appears to be the earliest example known so far of a Greek temple decorated with sculpture.

The plan of the building is traditionally Greek, however. The hall with a central sacrificial pit and the columns supporting the ceiling and a porch are the usual features of the ancient Mycenaean megaron, or royal reception hall (see **Citadel, Tiryns**). A column or columns between the flank walls of the porch are also found in megaron plans. The half-columns flanking the inside of the door at Prinias have antecedents in the tombs at Mycenae (see **Treasury of Atreus**). Greek religious practice required an eastward orientation of the front of the temple; this tradition allowed rays from the morning sun to penetrate the cella and illuminate the cult image. Finally, the scale of the building is very modest in comparison to the gigantic temples of Egypt.

The remains of Temple A at Prinias are poorly preserved, but the sculpture was carefully collected by excavators and is now displayed in the Herakleion Museum, where it has been reconstructed. Exploration of Prinias by the Italian Archaeological Mission of Crete took place during 1906–1908. In 1969,

the Italian School of Archaeology at Athens, part of the University of Catania, initiated excavations that are ongoing.

Further Reading

Demargne, Pierre. *Aegean Art: The Origins of Greek Art*. S. Gilbert and J. Emons, trans. London: Thames and Hudson, 1964.

Lawrence, A. W. *Greek Architecture*, 4th ed. R. A. Tomlinson, ed. Harmondsworth, England: Penguin Books, 1983.

Princeton Encyclopedia of Classical Sites. Perseus Digital Library. www.perseus.tufts. edu/cgi-bin/ptext?doc=Perseus%3Atext%3A1999.04.0006.

TEMPLE OF APHAIA, AEGINA

Style: Archaic
Date: Fifth Century B.C.E.
Architect: Unknown

Aegina (also spelled "Aigina") is an island in the middle of the Saronic Gulf, midway between Attica and the Peloponnesus. By the seventh century, the Aeginetans were able to establish from this location a trading network that was very extensive. Their ships dominated Greek trading and established relations with communities on the coast of Turkey, in Egypt, and even in Spain. The island was renowned for its pottery and bronze and was evidently the first Greek community to introduce coined money. Aeginetan silver coins became the standard for all the city-states on the mainland. Around 650 the merchants of Aegina developed the first system of standard weights in ancient Greece. At the beginning of the sixth century, the naval supremacy of the island led to conflicts with Athens, its chief competitor. The two powers were able to cooperate during the Persian Wars, and the navy of Aegina distinguished itself above all the Greek navies in the great victory over the Persian fleet at the Battle of Salamis in 480.

The Temple of Aphaia was built at the beginning of the fifth century on a site that had long been dedicated to an ancient local deity. Aphaia is thought to have been a variant of the Cretan great goddess who was later identified with Athena. The temple, which is located on a pine-covered ridge that overlooks the sea and provides magnificent views of the Saronic Gulf, is a fine example of the well-developed Doric order.

Aphaia's temple stands on a rectangular platform that is 45 feet wide and 94½ feet long and has three steps. Limestone covered with cream-colored stucco is the primary building material, but marble was used for the sculpture and some of the roof tiles. The building faces east so that the rays of the rising sun could penetrate the interior and illuminate the cult image. There are six columns across the front and back and twelve on the flanks. This is an unusual number, since most mature Doric temples have thirteen flank columns. The six and twelve scheme of columns is apparently a local convention. Almost all of the columns are monolithic—that is, made of a single piece of limestone—and are about 17 feet tall. Those at the corners are thickened to counteract the illusion that they were thinner than the rest of the columns. Aegina is the first instance in Greece of the use of this type of optical refinement (see the Introduction). Another refinement occurs in the columns on the

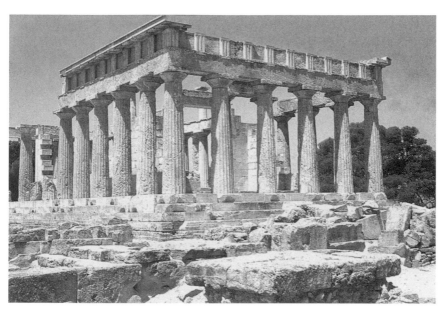

Temple of Aphaia, Aegina. *Author's Photo.*

flanks, which are not purely vertical but incline inward to create the appearance of great strength.

The lintel supported by the columns projects strongly outward, an innovation in the vertical design of the temple. Since the lintel is thicker and therefore stronger than those used in sixth-century temples, enhancing the height of the upper part of the building was possible. This vertical emphasis made the building appear lighter and more impressive than its heavy, squat predecessors in the Doric order.

Color and marble embellishments added to the elegance of the exterior of the temple. The continuous band, or Doric frieze, above the lintel was made up of alternating triglyphs and metopes. Triglyphs are rectangular blocks with vertical grooves cut into their surfaces; metopes are flat panels between the triglyphs. Although the limestone metopes were not decorated, the details of the triglyphs were picked out in red and black paint. The roof tiles at the edge of the roof, which would have been most visible, were made of marble, as were the brightly painted lion's head waterspouts. Palmette finials placed along the eaves and on the ridge of the roof were black and red on a cream-colored background.

The most impressive decorative features of the Temple of Aphaia are the sculptural compositions in the pediments on the front and back of the building. A pediment is the long triangular space between the upper edge of the frieze and the sloping eaves of the gabled roof. In both of the pediments, a large figure of Athena, the patron goddess of heroes, presides over a battle between Aeginetans and Trojans. Since Peleus (the father of Achilles), Ajax,

and Telemon were local heroes and the Aeginetan warriors were Homer's Myrmidons, the pedimental sculptures can be interpreted as patriotic celebrations of the role of Aegina in the epic victory of the Greeks at Troy. The statues were made of marble and were painted; bronze attachments and weapons added visual richness to the compositions. At the apex of each pediment was a finial made up of an elegant floral form flanked by two female figures wearing elaborate drapery. Griffins with raised paws and curling tails perched on the lower corners.

The cult room, or cella, was a long rectangular hall with internal porches on the front (the pronaos) and rear (the opisthodomos). Each porch had two columns between walls extending from the flanks of the cella. At some point during construction, a off-center doorway was opened up in the back wall; the purpose of the doorway is not known. Inside the cella were two rows of five columns each that divided the room into three longitudinal spaces. The colonnades carried a second story of smaller columns that supported the roof. Wood floors behind the upper columns created a gallery space that was reached by means of wood ladders.

At the beginning of the Peloponnesian Wars, around 431, the Athenians expelled the citizens of Aegina and took possession of the island. Remnants of the population were allowed to return from exile in 404, but Aegina never regained the political and naval power or the prosperity of earlier times. Today, the Temple of Aphaia is fairly well preserved. Twenty-four of its external columns still stand, and the lintels and frieze have been reconstructed. The two columns in the front porch survive, and the walls of the cella have been partly rebuilt. Seven of the interior columns, supporting three of the second-story columns, remain in place. In 1811, the pediment statues were recovered and were purchased by Ludwig I of Bavaria. They are now on display in the Glyptothek in Munich.

Further Reading

Dinsmoor, William B. *The Architecture of Ancient Greece*, 3d ed. New York: W. W. Norton, 1975.

Lawrence, A. W. *Greek Architecture*, 4th ed. R. A. Tomlinson, ed. Harmondsworth, England: Penguin Books, 1983.

Melas, Evi, ed. *DuMont Guide to the Greek Islands: Art, Architecture, History*. Russell Stockman, trans. Cologne: DuMont Buchverlag GambH & Co. Limited, 1985.

Princeton Encyclopedia of Classical Sites. Perseus Digital Library. www.perseus.tufts. edu/cgi-bin/ptext?doc=Perseus%3Atext%3A1999.04.0006.

TEMPLE OF APOLLO
EPICURIUS, BASSAE

Style: Classical

Date: 450–420 B.C.E.

Architect: Ictinus

High in the rugged mountains of Arcadia, on a narrow rocky terrace in a glen, the people of the small city-state of Phigalia built a temple dedicated to "Aid-Bringing Apollo," that is, Apollo Epicurius. Pausanias, the Greek travel writer of the second century C.E., states that the temple was a thank offering for deliverance from a plague that threatened Phigalia and that its architect was Ictinus, renowned designer of the **Parthenon**.

Although we often think of Apollo as a sun god, this notion is a late mutation and was not a part of the ancient Greek conception of the deity. In the *Iliad*, the arrows of Apollo signify the plague that beset the Greek army, but the god of sickness is also a healer because he can take the plague away. Apollo is also the god who oversees the arts and creative activity in general. The lyre is one of his attributes, and he presides over the Muses, goddesses of various forms of poetry, prose, dance, and music. Finally, Apollo is also a god of oracles and of purification. Both healing and purification are celebrated in the dedication of the temple at Bassae.

The Temple of Apollo Epicurius is unusual in several respects: it faces north, while most Greek temples face east; it has a long narrow plan with extra columns on the flanks; and the design and decoration of the cult room, or cella, are unique. Also unusual is the combination of the orders. The Bassae temple was apparently built in two stages. Around 450, the platform, exterior columns, and cella walls were erected. The interior of the cella, the sculpture, and the roof decorations were added around 420.

In comparison to most Greek temples, that of Apollo Epicurius is rather small: 47½ feet wide and 125½ feet long. The temple is constructed of locally quarried fine-grained limestone, which is very brittle and difficult to carve. Therefore, marble—which is more easily worked—was imported for the details and sculptural decorations. The temple stands on a three-stepped platform, and the cella is surrounded by a single file of columns. For the exterior, the Doric order—the severe decorative system developed in the western region of Greece—is used. There are six columns at the front and back of the building and fifteen, rather than the traditional thirteen, on the flanks. The columns have no bases, are approximately 19½ feet tall, and have vertical channels, or flutes, cut into their surfaces. Although the columns are made of local

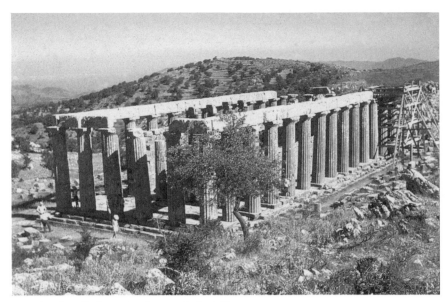

Temple of Apollo Epicurius, Bassae. *Author's Photo.*

limestone, the column capitals are marble. To emphasize the front of the building, the columns there are slightly larger in diameter and have wider spaces in between than those on the flanks and back.

The upper part of the building, which is supported by the columns, is traditional Doric. Above the architrave (lintel) that rests on the column capitals is a continuous horizontal band, or frieze, that consists of alternating triglyphs and metopes. Triglyphs are rectangular blocks with vertical grooves cut into their surfaces; metopes are flat panels between the triglyphs. The alternation of triglyphs and metopes sets up a constant visual rhythm around the exterior of the building that harmonizes with the rhythm of the columns below.

On the front and back of the temple is a large triangular shape, or pediment, defined by the horizontal molding above the upper border of the frieze and the diagonal eaves of the gabled roof. Although sculptural decoration is often included in the pediment and on the metopes of Doric buildings, the Temple of Apollo Epicurius has no decoration in these areas on its exterior. Visual richness was confined to the roof, which was made of gleaming white marble tiles ornamented with floral finials.

The cult room, or cella, had an internal porch (the pronaos) with two columns between the end walls. A metal barrier with gates shut the pronaos off from the colonnade. Metopes with relief sculpture (now mostly lost) were included in the frieze that ran across the walls of the pronaos. To balance the front porch and introduce symmetry, the cella had an internal back porch, the opisthodomos, that also had two columns and a frieze of sculpted metopes but was open to the colonnade and had no entrance to the cella.

The interior of the cella must have been magnificent in its original state. Use of the Ionic order in contrast to the severity of the Doric exterior recalls a similar combination of the orders introduced earlier by Ictinus in the Parthenon. Five Ionic half-columns joined to spur walls creates a series of rectangular compartments along the flank walls. The bases of these half-columns are bell-shaped and project very strongly, while the Ionic capitals that crown the half-columns have three sides instead of the canonical two. This variation in the design of the capitals was introduced so that a complete capital appeared when viewed from any side.

Above the spur walls was a continuous sculpted frieze that ran around all four walls of the cella, an arrangement that appears here for the first time in Greek architecture. The frieze, which is an Ionic feature, is carved in marble and has scenes representing the mythological battles between the Greeks and Amazons and the Lapith Greeks and Centaurs. These two myths were very popular in the fifth century. They functioned as allegories for the Greek victory in the Persian Wars. The Persians were characterized as effeminate, uncivilized, and irrational outsiders who tried and failed to conquer the masculine, civilized, and rational Greeks.

At the south end of the cella is a second chamber, the adytum. The opening between the cella and adytum was spanned by the frieze, which was supported in the center by a single Corinthian column, the first of its kind in Greek architecture. A door on the east side of the adytum that was closed by a metal grill opened onto the colonnade. Fragments of a statue found in the adytum suggest that the cult statue may have been placed there.

In Christian times, the Temple of Apollo Epicurius was deserted and forgotten. The temple was discovered in 1765 c.e. by Joachim Bocher, a French architect working for the Venetians who was murdered while attempting to make a detailed examination of the site. In 1812 an international team excavated the temple precinct, and between 1902 and 1907 Greek authorities conducted major restoration work. The sculptural decoration was removed and sent to the British Museum. Unfortunately, the Corinthian capital, a major innovation, was lost in circumstances that are not clearly understood.

Further Reading

Berve, H., G. Gruben, and M. Hirmer. *Greek Temples, Theaters and Shrines.* London: Thames and Hudson, 1963.

Dinsmoor, William B. *The Architecture of Ancient Greece*, 3d ed. New York: W. W. Norton, 1975.

Lawrence, A. W. *Greek Architecture*, 4th ed. R. A. Tomlinson, ed. Harmondsworth, England: Penguin Books, 1983.

Rhodes, Robin Francis. *Architecture and Meaning on the Athenian Acropolis.* Cambridge: Cambridge University Press, 1995.

TEMPLE OF APOLLO PYTHIAS, CORINTH

Style: Archaic
Date: Circa 540 B.C.E.
Architect: Unknown

On a low hill in the center of town, the Temple of Apollo overlooks the ruins of ancient Corinth. The city-state had a reputation in antiquity for being both cosmopolitan and dissolute because of its enormous prosperity that was based on commerce. Corinth was famous for its courtesans and cult of Aphrodite and was also the residence of St. Paul for eighteen months in 51–52 C.E. Located close to the isthmus between the Aegean and Ionian seas, Corinth controlled the major land and sea routes between the mainland and the Peloponnesus. With its two harbors, the city-state became an emporium and the center of trade and shipping from Greece to both the Near East and the western Mediterranean. Goods from Phoenicia, Egypt, Arabia, Libya, Carthage, and Sicily poured into Corinth. In the seventh century B.C.E., the tyrants Kypselos and Periander developed local industries such as pottery and bronze working, which further enriched the citizens of the city-state. According to Greek tradition, the Corinthians were very innovative in the practice of architecture. They were credited with the invention of terra-cotta roof tiles, temple pediments and their decoration, and the Corinthian order.

In about 540, the Temple of Apollo was built on a site previously occupied by a seventh-century temple. The architect of the Temple of Apollo is unknown. Apollo, one of the most important gods in the Greek pantheon, presided over the musical and literary arts, was known as a healer and god of purification, and was the patron of oracles. People would come to Apollo's Corinthian temple to obtain answers from the god to questions about major life choices. Apollo's temple, rising above the city and visible from any point, was a constant presence in the daily lives of the Corinthians and was a symbol of the god's patronage, powers of revelation, and protection of their society.

The Doric temple stands on a long rectangular platform of three steps that measures 70 by 175 feet on the topmost tier. It is constructed of unattractive rough limestone that was disguised by the application of stucco made from white marble dust. The building faced east, in the direction of the rising sun, as was traditional in Greek religious architecture. A single file of six columns on the front and back and fifteen on the flanks, instead of the usual thirteen, enclosed the cult rooms. Each column was nearly 21 feet tall and was monolithic, that is, hewn from a single piece of stone. The columns are somewhat

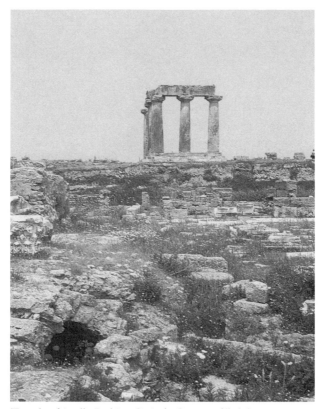

Temple of Apollo Pythias, Corinth. *Courtesy of Judith Snyder Schaeffer.*

thick and heavy, and they taper slightly toward the top. Twenty vertical grooves, or flutes, are carved into their surfaces. On top of the columns are the capitals, which were carved separately. The capitals are fairly wide in comparison to the diameter of the column shafts since the echinus, or lower part of the capital, flares out strongly.

Little remains of the upper part of the temple except for part of the lintel that rested on the columns. On its upper edge are traces of a horizontal band, or frieze, made up of alternating triglyphs and metopes. Triglyphs are rectangular blocks with vertical grooves cut into their surfaces; metopes are flat panels between the triglyphs. There is some evidence for an unusual painted terra-cotta molding above the frieze, but nothing is known of the decorations of the pediments. The roof was covered with terra-cotta tiles.

Unlike many Doric temples on the Greek mainland, the Temple of Apollo had a double cult room, or double cella. Tradition was observed in the inclusion of the internal front and back porches, the pronaos and opisthodomos. Each porch contained two columns between the extended flank walls of the core structure. The two cellas were placed back to back, one opening to the

east into the pronaos, the other toward the west into the opisthodomos. In the eastern, longer, cella were two rows of four columns that supported the ceiling and were shorter than those on the outer colonnade. The smaller western room had only four interior columns and contained the foundation for a statue base between the eastern pair. As was noted previously, the Temple of Apollo has fifteen columns on its exterior flanks instead of the usual thirteen. This increase was necessary because of the extra length of the double cella. Possibly, this unusual plan was necessary to accommodate two cult images— a very ancient one in the east room and one more contemporary with the temple in the west room.

The Temple of Apollo is full of small adjustments, or optical refinements, that were introduced into the structure to give life to the design and to correct optical distortions (see the Introduction). Careful measurement indicates that the exterior columns are not all the same size; the diameter of those on the flanks is four inches smaller than the diameter of the front and rear colonnades, and the flank columns are placed eleven inches closer together. Another adjustment is the visual strengthening of the corners of the building by reducing the space between the last two columns at the end of each colonnade. Finally, the platform on which the temple stands is not horizontal but rather rises slightly in a convex curve in a treatment known as curvature of the stylobate. The Temple of Apollo is the earliest known example of this treatment of the floor of a temple. While consistent use of optical refinements is most characteristic of fifth-century temples, the Apollo temple is evidence for the early development of this important aspect of Greek temple building.

Today the Temple of Apollo is the most conspicuous monument on the site of ancient Corinth. Seven of its original thirty-eight columns remain standing—five on the west and two on the south side. They carry some of the original lintels and reveal, on their upper edges, the carved lower band of the now lost Doric frieze. Four additional columns lie on the ground, and there are traces of the foundations for four more that were removed from the site in 1830.

Further Reading

Berve, H., G. Gruben, and M. Hirmer. *Greek Temples, Theaters and Shrines.* London: Thames and Hudson, 1963.

Dinsmoor, William B. *The Architecture of Ancient Greece*, 3d ed. New York: W. W. Norton, 1975.

Homann-Wedeking, E. *The Art of Archaic Greece.* J. R. Foster, trans. New York: Greystone Press, 1968.

Lawrence, A. W. *Greek Architecture*, 4th ed. R. A. Tomlinson, ed. Harmondsworth, England: Penguin Books, 1983.

TEMPLE OF APOLLO PYTHIAS, DELPHI

Style: Archaic; Hellenistic
Date: 536–513; Circa 346–320 B.C.E.
Architect: Unknown; Spintharus of Corinth; Xenodorus; Agathon

At the heart of the **Sanctuary of Apollo** at Delphi stand the ruins of the famous oracular temple dedicated to Apollo Pythias, god of prophecy, purification, and healing. The first evidence for the cult dates to the eighth century, and legends about the early temples are fascinating. The Greeks believed that the first shrine was built of boughs of laurel, Apollo's sacred tree. This was followed by a building made of wax and feathers, and then by a shining temple of bronze. There is, of course, no trace of these mythical buildings, but there are the remains of three real temples that were erected in association with the chasm of the oracle.

The ancient "Homeric Hymn to Apollo" relates that Apollo laid out the dimensions of his Delphic temple and that Trophonius and Agametes built the stone structure. This reference may be connected to the site's earliest known temple, which dates to the seventh century. The temple was apparently a rectangular hall, or cella, preceded by a simple porch with two columns and built of limestone coated with stucco. Terra-cotta tiles covered the roof, which was made of wood. The building faced east so that, according to Greek religious practice, the rising sun would illuminate the cella. In 548 the temple was destroyed by fire, and today only fragments of columns with wide spreading Doric capitals and some wall blocks survive.

Money was collected from all over the Greek world for the construction of a new temple. The building was to be a canonical Doric structure, slightly elongated, with six columns on the front and back and fifteen on the flanks. The long proportions of the temple were the result of the inclusion of a special chamber, called the adytum, for the Pythian oracle. There is no consensus among archaeologists about the exact location and shape of the adytum, but it was most likely at the west end of the cella and was at a level lower than the floor. Ancient literary sources indicate that the adytum contained the omphalos stone (believed to be the center of the world), a gold statue of Apollo, a laurel tree, and the oracular chasm. Construction, in local limestone, was begun at the west end in about 536.

In 513, the contract for the temple was taken over by the Alcmeonid family of Athens. They had been exiled by the tyrant Pisistratus and undertook the expense of finishing Apollo's temple to win the political support of the

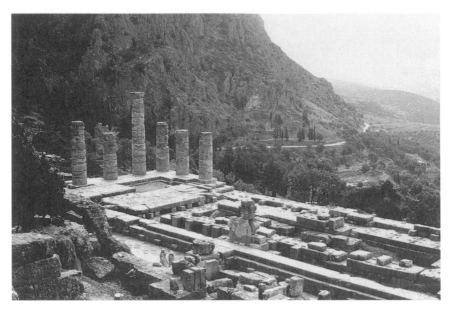

Temple of Apollo Pythias, Delphi. *Author's Photo.*

Delphic oracle and priesthood. No expense was spared, and the east end of the building was finished in Parian marble. The Athenian sculptor Antenor was brought in to design the architectural sculpture, which was very rich. A traditional Doric freize, containing triglyphs and metopes, ran above the lintels supported by the colonnades. Triglyphs are rectangular blocks of stone with three vertical grooves cut into their surfaces; metopes are flat panels between the trigylphs. The tragedian Euripides, in his play *Ion*, indicates that the metopes on the west side of the temple were decorated with relief sculpture depicting a series of combats between famous Greek heroes and monsters. Nothing is known of the east metopes. On the east and west ends of the building, above the frieze, was a pediment—a long triangular space formed by the sloping eaves of the gabled roof. The west pediment contained statues made of limestone that depicted the Battle of the Gods and the Giants. In the east pediment, marble statues represented Apollo entering Delphi to take control of the oracle. On the roof of the temple, figures of Nike (Victory) and the Sphinx were used as finials. Work on the temple seems to have been completed around 510.

In 373 an earthquake and the resulting landslides destroyed the Alcmeonid Temple of Apollo. The oracle again sent out appeals for funds to rebuild, but work on the new building was delayed by war and dragged on for more than forty years. In 346, Spintharus of Corinth began the project; after his death, the architects Xenodorus and Agathon completed the temple in 320. The new building preserved the plan and the order of its predecessor and was only slightly larger. Much material from the old temple was incorporated into the

new, including most of the platform and many of the sixth-century column drums.

Apollo's new temple stood on a platform of three steps. The building was 78 feet wide and 198 feet long. There were six Doric columns on the front and back and fifteen on the flanks. As before, this slightly elongated plan was necessitated by the inclusion of the adytum of the oracle in the cella. The pronaos and opisthodomos each had two interior columns. Inside the pronaos were inscribed the sayings of the Seven Sages and the famous maxims "Know Thyself" and "Nothing to Excess."

The Roman travel writer Pausanias recorded that the east pediment of the temple preserved the subject matter of the earlier building, Apollo's arrival at Delphi. The west pediment had a new subject, Dionysos with the Maenads, his female devotees. Since Dionysos was believed to have lived at Delphi during the three winter months when Apollo left the sanctuary, this subject was appropriate. The statues in the pediments were the work of the sculptors Praxias and Androsthenes. Instead of relief sculpture, Persian shields captured at Marathon were hung on the metopes. After the attempted barbarian incursion of Delphi in 279, the shields taken from the Gallic invaders were also attached to the metopes.

Today, little remains of Apollo's famous temple. The structure was almost totally dismantled during the Middle Ages by people searching for the metal clamps imbedded in the masonry. The foundations still exist, and six columns have been re-erected. In 1939, the three-step platform was partly restored and some of the pavement blocks were repositioned. No trace of the adytum has been found. Although the Pythia has been silenced for nearly two thousand years, the beauty of the temple site, nestled in the spectacular Delphic landscape, still maintains an aura of the sanctity that surrounded the most holy oracle in the ancient Greek world.

Further Reading

Dinsmoor, William B. *The Architecture of Ancient Greece*, 3d ed. New York: W. W. Norton, 1975.

Hurwit, Jeffrey M. *The Art and Culture of Early Greece, 1100–480 B.C.* Ithaca and London: Cornell University Press, 1985.

Lawrence, A. W. *Greek Architecture*, 4th ed. R. A. Tomlinson, ed. Harmondsworth, England: Penguin Books, 1983.

TEMPLE OF ARTEMIS, CORFU

Style: Archaic
Date: 580 B.C.E.
Architect: Unknown

Corfu, also called Corcyra, is the second largest of the Ionian islands and is situated at the extreme northwestern boundary of Greece. According to tradition, in 734 a colony was founded on the island by a group of Corinthians under the leadership of Archias and Chersikrates, members of the Bacchiadai ruling family of Corinth. The Greek designation "colony" differs from the modern definition of the word, which means a settlement dependent on and subject to its mother country. In antiquity, when a city-state became over-populated and could no longer feed its people, or when it sought depots for trade, members of the community moved on to a new location and founded a city-state, or colony. The colony was an independent entity, with few or no political ties to the mother city, that developed its own social, legal, and commercial practices. At times, a colony could come into conflict with its parent city-state.

Such was the case with Corfu. The colony became very prosperous because of its strategic location near the coast of Albania. Because it was the Greek settlement closest to Italy, Corfu became a gateway for trade and travel between the eastern and western Mediterranean. Also, the soil of the island was incredibly fertile (and still is); olives and grapes could be grown in vast quantities, and the resulting oil and wine were exported for profit. Eventually, Corfu founded colonies of its own. In 664, the Corinthians became jealous of the wealth of Corfu and attacked its fleet of ships. In the first recorded naval battle in Greek history, the sailors of Corfu were victorious.

Around 580, the people of Corfu dedicated a sanctuary to Artemis at the site known today as Garitza. Artemis was one of the most ancient Greek divinities and was worshiped in a cult that spread from Lydia in the east to the western colonies of Sicily and southern Italy. As mistress of the animals, Artemis presided over the whole of wild nature outside the city walls. She was the patron of hunters and also of young girls in puberty. Equally important was the role of Artemis as protector of women in childbirth.

The Temple of Artemis on Corfu was the first Doric peripteral building constructed completely in stone. The use of limestone as the primary building material is significant; earlier Greek temples had been constructed mainly of mud brick on stone foundations with wood superstructures and required

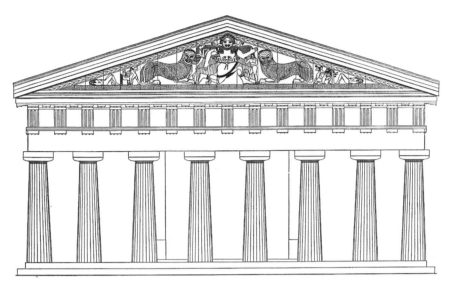

Drawing of the Temple of Artemis, Corfu.

constant maintenance and sporadic rebuilding. Stone construction also represented a major economic investment by the citizens of Corfu.

The temple, which stood on a rectangular platform 77 feet wide and 161 feet long, faced east so that the rays of the rising sun would illuminate the interior. A colonnade of eight columns across the front and back and seventeen columns on each flank surrounded the cella, or cult room. The columns had twenty-four flutes, or vertical grooves, carved into their surfaces and simple Doric capitals that supported an undecorated lintel. Above the lintel was a long horizontal band, or frieze, made up of alternating triglyphs and metopes. Triglyphs are rectangular blocks with vertical grooves cut into their faces; metopes are the flat panels between the triglyphs. There is some evidence that the metopes had figured decoration; several fragments of a relief depicting the heroes Achilles and Memnon have been recovered. On the front and back of the temple, a long low triangular shape, or pediment, was defined by the upper border of the frieze and the sloping eaves of the gabled roof.

The back wall of each pediment was carved in high relief with mythical representations. This is the earliest form of pedimental decoration known in Greece. Only the relief sculpture from the west end of the temple is well preserved. In the center of the triangular composition is a gigantic sculpture, ten feet tall, of the Gorgon Medusa in a conventional pose that indicates she is flying. Her face, which was said to turn all who looked at her to stone, is truly monstrous, with huge eyes, boar's tusks, and a tongue that projects from her leering smile and dangles in front of her chin. She has snakes for hair and wears a belt made of two larger serpents. The Gorgon is flanked by her two children by Poseidon: the winged-horse Pegasus and the giant Chrysaor. To either side

of the central group are large resting felines, usually identified as panthers, who turn their heads outward to survey the space in front of the temple. Behind each panther is a mythical episode that is hard to identify because it is so conventional. The group on the left is usually identified as the murder of the Trojan king Priam by the Greek hero Neoptolemos. On the right, the two figures engaged in combat are thought to represent Zeus fighting a giant. A fallen warrior fills the low angle on either end of the pediment. Fragments of the east pediment suggest that a similar composition was to be found on the front of the building. The symbolic function of the Gorgons on the front and back of the temple was clearly apotropaic—that is, they were guardian figures who kept evil from entering the holy place. The felines, known as gatekeepers in the Near East, would also function here as creatures who protected the building.

The cult room, or cella, of the temple was a long narrow rectangle, 31 by 113 feet, that was divided internally into three longitudinal spaces by two files of ten columns each. Interior porches adjoined the front and back of the cella. The east porch is the pronaos; the porch on the west is the opisthodomos. These porches consisted of extensions of the flank walls of the cella with a pair of columns in between. At Corfu, the flank walls of the cella and its porches were aligned with the third column from each corner of the colonnade, making the temple one of the earliest examples of a pseudodipteral plan. A dipteral temple is one with a double row of columns on each side. In a pseudodipteral temple, the distance between the cella walls and the colonnade is wide enough to include a double row of columns, but the inner row is omitted.

The remains of the Temple of Artemis were discovered in 1910. The temple had been almost totally destroyed, but what remained was sufficient to reconstruct the appearance of the building as just described. Today visitors to Garitza see only foundation trenches, parts of the foundation, and some pavement supports. The building is chiefly known for its Gorgon pediment, which is preserved along with many architectural fragments in the Archaeological Museum in Corfu Town.

Further Reading

Dinsmoor, William B. *The Architecture of Ancient Greece*, 3d ed. New York: W. W. Norton, 1975.

Homann-Wedeking, E. *The Art of Archaic Greece*. J. R. Foster, trans. New York: Greystone Press, 1968.

Lawrence, A. W. *Greek Architecture*, 4th ed. R. A. Tomlinson, ed. Harmondsworth, England: Penguin Books, 1983.

TEMPLE OF ATHENA NIKE, ATHENS

Style: Classical
Date: 427–425 B.C.E.
Architect: Callicrates

High above the city of Athens, with a commanding view of the Attic plane and the Saronic Gulf, stands the little Temple of Athena Nike. The ancient defensive bastion on the western side of the Acropolis was dedicated to Athena, Bringer of Victory, at least as early as the beginning of the sixth century. Solon, the revered early lawgiver, was the first to dedicate an altar there. Later, a small shrine to the goddess was added. When Pericles became the leader of Athens in about 460, he ambitiously set out to rebuild the **Acropolis**, which had been desecrated and largely destroyed by Persian invaders in 480. The Temple of Athena Nike, built entirely of marble, was probably one of the buildings planned for the Periclean program, but it was not constructed until after the leader's death in 429.

An inscription of the mid-fifth century records a decree of the popular assembly appointing a priestess of Athena Nike and authorizing the building of a temple according to the plans of Callicrates. This architect is known for his association with work on the Parthenon and for an Ionic temple on the bank of the Ilissos River in the lower city. Usually, such a sanctioning decree would swiftly be put into action, but for some reason the Temple of Athena Nike was not begun until more than twenty years later.

Scholars debate the reason for this long delay. Most believe that the inscription indicates that a temple to Victory was planned as a thank offering and commemoration of Athens' leading role in the Persian Wars. According to this hypothesis, the building was vowed around 450, when a treaty of peace was finally signed with Persia. The delay in enacting the decree is explained as the result of resources and energies being diverted to the construction of the **Parthenon** and **Propylaea**.

Construction eventually took place during the early years of the Peloponnesian War when Athens was engaged in continuous conflict with Sparta. A disastrous plague and annual invasions of Attica may have inspired the war-weary Athenians to build the temple as a gift to Athena Nike and enlist her aid in the struggle against Sparta and the allies. Proposed dates for the construction range from 427 to 425.

The Temple of Athena Nike is tiny, just twenty-seven feet long and nineteen feet wide. It was the first building in the Ionic order to be constructed on

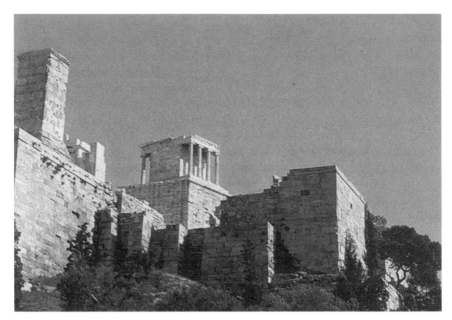

Temple of Athena Nike, Athens. *Courtesy of Judith Snyder Schaeffer.*

the Acropolis, and its plan and size are clearly related to the Ionian treasuries found in many Greek sanctuaries (see **Siphnian Treasury**). However, numerous liberties were taken with traditional Ionic features. For example, a platform of three steps elevates the cult room, or cella, above the ground. This is typical of Doric temples, while Ionian buildings have a two-step platform. The plan of Athena Nike is amphiprostyle, which means that there are porches with columns on the front and back of the building but no colonnades on the flanks.

Each porch has four Ionic columns that stand on circular bases carved with convex and concave moldings. The columns are monolithic—made of a single cylinder of marble—and are thirteen feet tall. On top of the columns are Ionic capitals carved in a rather simple, austere style. The architrave, or lintel, above the columns is divided into the three horizontal bands that are typical of Ionic buildings, but the Ionic zone of dentils (rectangular blocks) above the architrave is omitted. In its place is a frieze of relief sculpture that runs continuously around the whole building. Scenes of Greeks fighting Persians are represented here. One section of the frieze appears to depict an idealized version of the great Athenian victory at Marathon, an event that had taken on legendary proportions in the late fifth century.

Above the frieze on the front and back porches are the low triangular spaces, called pediments, shaped by the slanting eaves of the gabled roof. Statues depicting narratives were placed here, but the subjects are unknown because virtually none of the sculpture survives. Since pedimental sculpture was not

the norm in Ionic buildings, its inclusion in the Athena Nike temple appears to be an Athenian innovation derived from Doric practice. Perched on the corners of the pediments, silhouetted against the sky, were gilded bronze figures of Nike.

The cella is almost square and is open only on the east, where two monolithic piers between the flank walls originally supported bronze grills that functioned as doors. As in a Doric temple, the columns and the cella's flank walls incline slightly inward. Within the windowless cella was the cult image of Athena Nike holding her war helmet in one hand and a pomegranate in the other. This statue was said to be a copy of an ancient wood image that was also housed in the cella.

Callicrates' design for the Athena Nike temple was an Attic, or Doric, adaptation of the Ionic order. The three-step platform, the simplicity of decoration, the inclusion of pedimental sculpture, and the optical refinement of the inclination of vertical elements are all Doric features that have been subtly introduced into the standard Ionic order. Such mixing of the orders is the hallmark of the buildings in the Periclean redevelopment of the Acropolis.

More than a decade after the completion of the Athena Nike temple, a four-foot wall was built along the edges of the bastion to prevent visitors from falling off the site. The wall's outside surface, facing the city, was decorated with reliefs that are some of the greatest masterpieces of classical sculpture. Slender, elegant figures of Nikai (Victories), depicted in swirling ornamental drapery, erect trophics made of captured enemy arms and lead sacrificial bulls to three seated figures of Athena in warrior guise.

The survival of this exquisite temple is little short of miraculous. Beginning in the thirteenth century C.E., the building was incorporated into the residence of Frankish dukes of Athens. In 1686, the Turkish military removed the temple to make a gun emplacement on the bastion. Pieces of the dismantled temple were then built into a fortification wall. The building was recovered from the wall in the nineteenth century by Ludwig Ross and reassembled in 1836. A second, more accurate, reconstruction of the temple was made during 1936–1940. Athena Nike's temple is the first building seen by anyone who visits the Acropolis. The temple's diminutive size and Ionic order contrast with the massiveness of the nearby Propylaea and the austerity of the Parthenon, making the Temple of Athena Nike the little jewel in the crown of the Periclean building program.

Further Reading

Berve, H., G. Gruben, and M. Hirmer. *Greek Temples, Theaters and Shrines.* London: Thames and Hudson, 1963.

Dinsmoor, William B. *The Architecture of Ancient Greece*, 3d ed. New York: W. W. Norton, 1975.

Lawrence, A. W. *Greek Architecture*, 4th ed. R. A. Tomlinson, ed. Harmonds-worth, England: Penguin Books, 1983.

Perseus Building Catalog. Perseus Digital Library. www.perseus.tufts.edu/cgi-bin/ptext?doc=Perseus%3Atext%3A1999.04.0039.

Rhodes, Robin Francis. *Architecture and Meaning on the Athenian Acropolis*. Cambridge: Cambridge University Press, 1995.

TEMPLE OF HEPHAESTUS, ATHENS

Style: Classical
Date: Circa 449 B.C.E.
Architect: Unknown

Although the Athenian statesman Pericles is most closely associated with the rebuilding of the **Acropolis**, he was also responsible for sponsoring other monumental architecture in the lower quarter of Athens and at several sites in Attica. The temple on the hill that overlooks the Athenian Agora is one of these. For many years the building was called the Theseum due to a mistaken belief that it was a hero shrine dedicated to the Athenian hero Theseus. Now it is identified as the Temple of Hephaestus because the evidence of the cult statues, made by the sculptor Alcamenes in 421–415, indicates that Athena and Hephaestus were worshiped there.

Hephaestus was the lame blacksmith, the only one of the Olympians who was not physically perfect and had to do manual labor. He was skilled at metalworking and making armor; the most famous example of his craftsmanship is the armor of Achilles, which Homer describes in the *Iliad*. Although today Athena is commonly thought of as the goddess of wisdom, in antiquity she was also the patron of numerous crafts such as wool-working, carpentry, and ship-building. She and Hephaestus were not only related through their spheres of interest. The pair was also linked in the myth of the birth of Erichthonios. According to the story, when Hephaestus attempted unsuccessfully to rape Athena he impregnated the earth. As a result, Erichthonios was born; he was raised by Athena and became an early king of Athens and the ancestor of all the Athenian citizens.

The Temple of Hephaestus was begun in 449, two years before its famous neighbor the **Parthenon**. Although the name of the architect is unknown, he must have been well respected by the Athenians; he seems to have been involved in designing several other fifth-century temples in Attica that have interesting innovations in design (see **Temple of Poseidon**). Like the Parthenon, the Temple of Hephaestus is a Doric building but incorporates some elements of the Ionic order. It is the first temple in Athens to be constructed of marble, except for the wood ceiling, the terra-cotta roof tiles, and the limestone step at the bottom of the platform.

The building stands on a rectangular three-stepped platform that is 45 feet wide and 104 feet long. It faces east so that, according to Greek cult practice, the rays of the rising sun would penetrate the interior. A colonnade surrounds

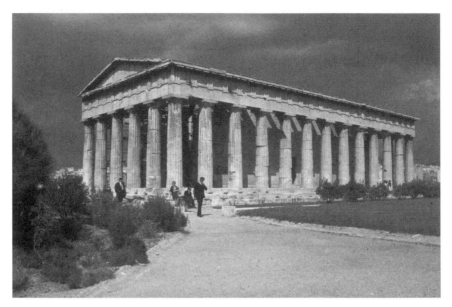

Temple of Hephaestus, Athens. *Courtesy of David A. Hanser.*

the cult room. There are six columns on the front and back of the temple and thirteen on the flank walls. Above the colonnade and the architrave (lintel) supported by the columns is a horizontal band, or frieze, made up of alternating triglyphs and metopes. Triglyphs are rectangular blocks with vertical grooves cut into their surfaces; metopes are flat panels between the triglyphs. Eighteen of the metopes have relief sculpture; the remaining ones are blank.

The labors of Hercules, distributed over ten metopes, are located on the front of the temple. Four metopes each on the eastern ends of the north and south flanks carry the adventures of Theseus. This wraparound distribution of sculpted metopes emphasizes the east end of the building by adding visual richness and color, since the metopes would have been painted. On the front and back of the temple a long triangular shape, called a pediment, is defined by the horizontal upper border of the frieze and the sloping eaves of the gabled roof. Sculpture was included in the pediments to further enrich the building. The subjects depicted in the pediments of the Temple of Hephaestus are not known because the statues were destroyed by Christians who disapproved of pagan mythology.

The cult room, or cella, is twenty-six feet wide and has the traditional internal front and rear porches that are simply extensions of the flank walls with a pair of columns between them. However, unlike most Doric temples, the porches are not of equal size. The front porch, or pronaos, is deeper than the rear, or opisthodomos, and is more carefully integrated with the colonnade to create a strong relation between the outer and inner parts of the structure. This was done by aligning the columns and flank walls of the pronaos exactly

with the third column on either side of the flank colonnades and by using columns in the porch that were equal in height and thickness to those of the front colonnade. The inclusion of large columns here contrasts to the usual Doric practice of reducing the size of the columns in the pronaos.

The introduction of a continuous Ionic frieze that runs across the front of the porch above the twin columns, from the north colonnade to the south, is unique. The frieze frames a rectangular compartment of space in front of the porch that adds dignity to the entrance of the cella. Although the opisthodomos has no entrance to the cella, it is also embellished with an Ionic frieze that spans only the width of the porch and is not connected to the colonnade. On the frieze in front of the cella is a gathering of gods observing a battle; the frieze on the back showed the battle between the Lapiths and Centaurs (see **Temple of Zeus**).

Inside the cella, a double-storied Doric colonnade placed very close to the walls ran along both flanks and across the back of the room. At the west end, in front of the columns, a large rectangular base of black Eleusinian limestone served as the pedestal for the cult statues of Athena and Hephaestus. The base was decorated with reliefs in white marble. There is some evidence that the walls of the cella were prepared to receive plaster that would have been painted, but this decorative project was never completed.

The design of the Temple of Hephaestus incorporates many curves and adjustments, or optical refinements (see the Introduction). These deviations from straight lines were introduced to give vitality and dynamism to a building form that was based on rectangles and horizontal and vertical lines. The top step of the platform is not strictly horizontal but is curved slightly upward toward the center. The rise on the flanks is 1¼ inches, while that on the front and back is ¾ of an inch. These curves are transmitted to the entablature above the columns so that all the "horizontal" lines of the lintels, frieze, and pediment are also convex and thus parallel to the "horizontals" of the platform. The columns taper toward the top, but their contours are not perfectly straight. Instead, a slight convex curve, or entasis, is introduced into the contours. Entasis creates a subtle bulge, which counteracts the optical illusion that the sides of the column are concave. The diameters of the columns at the corners of the temple are enlarged so that they do not appear to be thinner than they really are. Finally, a series of inclinations—deviations from vertical—is carried through the whole structure. The columns slant inward, as do the lintels and frieze above them, and the walls of the cella incline inward as well.

Although the building suffered alterations, the Temple of Hephaestus is the best preserved Doric temple in Greece. In the fifth century c.e., the temple was converted into a church dedicated to St. George. A door was cut into the west end of the cella; the east entrance wall and two columns of the porch were removed to make way for an apse; and the wood ceiling of the cella was replaced with stone vaulting. Much of the sculptural decoration was defaced or damaged because of its pagan subject matter. After Otto became king of Greece in 1834 and the glorious history of Athens became a symbol for the

new Greece liberated from Ottoman domination, the Temple of Hephaestus was converted into a museum.

Further Reading

Lawrence, A. W. *Greek Architecture*, 4th ed. R. A. Tomlinson, ed. Harmondsworth, England: Penguin Books, 1983.

Scranton, Robert L. *Greek Architecture*. New York: George Braziller, 1972.

Thompson, Homer A. *The Athenian Agora*, 3d ed. Athens: American School of Classical Studies, 1976.

TEMPLE OF HERA, OLYMPIA

Style: Archaic
Date: Early Sixth Century B.C.E.
Architect: Unknown

In the sacred grove, or **Altis**, of Olympia, the first monumental temple of the Doric order in Greece was constructed in the early sixth century. The temple, which was dedicated to Hera—wife of Zeus, queen of the gods, and patron goddess of marriage—was located on the south side of the hill of Kronos where the oldest cults celebrated in the Altis were located. Three goddesses, in addition to Hera herself, were associated with the site: Gaia, the great goddess of generation who gave birth to the race of the Titans; Rhea, mother of the Olympian gods; and Eleithyia (Eleuthyia), goddess of childbirth. This constellation of female divinities is associated with fertility, the mystery of birth, and the institution of marriage. Although Olympia was the preeminent shrine of Zeus, it is perhaps ironic that it was his long-suffering wife who received the first permanent temple there. In fact, most of the earliest Greek temples were dedicated to Hera (see **Sanctuary of Hera**; **Temple of Hera, Samos**).

The Temple of Hera, 61 feet wide and 164 feet long, faced toward the east so that the rays of the rising sun could penetrate the cult room and illuminate the statue of the goddess. Local limestone was used for the foundations and lower parts of the walls. The upper parts of the walls were made of mud brick, and the upper sections of the facades and the roof were made of wood. Terracotta tiles protected the roof from the elements, and at the peak of each gable was a large (7 feet 7 inches) round terra-cotta finial, or akroterion, that was brightly painted. The columns surrounding the cult room, or cella, were made of wood and were about 17 feet tall. There were six on the front and back of the temple and sixteen on the flanks. The columns on the flanks were spaced closer to one another than those on the front of the building. This narrow spacing was perhaps intended to increase the rigidity and stability of the long flank colonnades.

From the mid-sixth century until the Roman period, the old wood columns were gradually replaced with limestone columns. There was no attempt to create stylistic unity; each column was in the style of its own respective chronological period, and the diameters of the columns were all different. Thus, the colonnades of the Temple of Hera provide a visual history of the development and refinement of Doric columns. When the Roman travel writer Pausanias

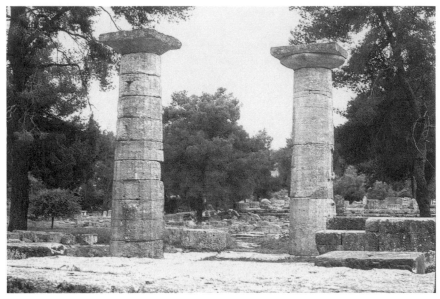

Temple of Hera, Olympia. *Courtesy of Judith Snyder Schaeffer.*

visited Olympia in the second century c.e., he reported that one of the ancient oak columns still stood in the back porch of the cella.

The superstructure, or upper part of the building, that was supported by the colonnades was an early example of the Doric order. Above the lintels that rested on the columns was a continuous band, or Doric frieze, made up of alternating triglyphs and metopes. Triglyphs are rectangular blocks with vertical grooves cut into their surfaces; metopes are flat panels between the triglyphs. On the Temple of Hera, a triglyph would have been placed above the center of each column to integrate the verticals of the columns with the horizontals of the superstructure. Some historians have suggested that terracotta sculpture may have been placed in the pediment, the long triangular space between the frieze and the diagonal eaves of the gabled roof, but this hypothesis is based on very little direct evidence.

The cult room, or cella, was a long rectangle with internal front and rear porches. Two columns stood inside each porch between wood walls that prolonged the flank walls of the cella. Entrance to the cult room was on the east end via an interior porch, or pronaos. At the back of the cella, the interior porch, or opisthodomos, did not provide access but was designed only to create a symmetrically balanced plan.

Inside, the cella was divided into three longitudinal parts by two rows of freestanding columns that alternate with engaged columns on spur walls projecting three feet from the flanks. This design breaks up the spaces on either side of the open central space into a series of rectangular compartments, each with a freestanding column in the center. At the rear of the cella was a stone

platform on which statues of Hera and Zeus were placed. Only the head of Hera is preserved; it is displayed in the Olympia Archaeological Museum. The altar was not located inside the temple but rather stood slightly to the east of the front of the building. Greek religious ritual was conducted outside, and the front of the temple acted as a backdrop to the sacrifices and prayers that were offered to the goddess.

Hera was the recipient of numerous gifts presented by city-states, worshipers, and participants in the Olympic Games. The famous sixth-century B.C.E. Chest of Cypselus, a fabulous cedar wood box decorated with numerous scenes from Greek mythology, was one of the temple's treasures. In the opisthodomos, the text of the Sacred Truce was inscribed on a bronze disc set up by Iphitos, king of Elis, in the eighth century. Both of these objects were examined and described by Pausanias in the second century C.E. During the Roman period, many works of art were moved into the Temple of Hera, which became a sort of museum. The famous fourth-century B.C.E. statue of Hermes carrying the infant Dionysos, made by the prolific sculptor Praxiteles, was found in the remains of the temple. Hera's temple stood for almost one thousand years but was destroyed in the late third century C.E. when the Byzantine emperor Theodosios I forbid worship in pagan sanctuaries.

Further Reading

Barber, Robin, ed. *Blue Guide: Greece*. London: A&C Black, 1995.

Demargne, Pierre. *Aegean Art: The Origins of Greek Art*. S. Gilbert and J. Emons, trans. London: Thames and Hudson, 1964.

Lawrence, A. W. *Greek Architecture*, 4th ed. R. A. Tomlinson, ed. Harmondsworth, England: Penguin Books, 1983.

Yalouris, Nikolaos. *Olympia*. Paul J. Dine, trans. Munich and Zurich: Verlag Schnell and Steiner, 1972.

TEMPLE OF HERA, SAMOS

Style: Archaic
Date: Circa 575–560 B.C.E.
Architect: Rhoecus and Theodorus

The sixth century was a time of great prosperity for the island community of Samos. Its famous sanctuary, the Heraion (see **Sanctuary of Hera**), was refurbished, and on the site of the seventh-century mud brick and wood temple two grandiose structures were constructed in rapid succession. From 540 to 522, Samos was ruled by the tyrant Polycrates, who fostered extensive building projects, such as the expansion of the harbor and the construction of an aqueduct; increased the size of the navy; annexed island territories; and established alliances with Cyrene and Egypt. His magnificent court was famous, and his patronage attracted writers, such as the poet Anacreon, and artists. The Samian school of sculpture produced some of the earliest and most important works in marble and was also credited with the invention of hollow-cast bronze statuary. The two Hera temples of the sixth century were testaments to the wealth of Samos and to the ambition of its extravagant ruler.

The Temple of Hera, designed and built around 575–560 by the Samians Rhoecus and Theodorus, who were both architects and sculptors, was the first of the colossal temples. The structure was dipteral, meaning that it had two rows of columns all around; the dipteral style became characteristic of the eastern Greek, or Ionian, region. The Roman architect and writer Vitruvius states in *On Architecture* that Theodorus wrote a book about the temple, but unfortunately the book no longer exists. Only fragments of the building survive.

Measuring 150 feet wide and 290 feet long, the temple platform, made of limestone, was nearly twice as long as it was wide and had only two steps instead of the traditional three. The outer columns of the colonnaded portico were set back ten feet from the edge of the top step, an unusual arrangement that created an encircling open promenade. On the east facade of the building, two rows of eight columns with carefully graduated spacing and diameters emphasized the entrance. On the long flanks of the temple, the double colonnade probably had twenty-one columns; across the back there were either nine or ten columns.

The rectangular cella, or cult room, was entered through a deep pronaos, or interior porch, that contained two rows of five columns each. Inside the cella, two rows of ten columns provided support for the roof. Visitors in antiq-

uity were amazed by the great number of columns, more than one hundred in all, that may have been inspired by Egyptian columned halls. Today, only pieces of these famous columns survive. They were made of drums of soft limestone turned on a lathe, perhaps invented by the architect Theodorus. The column bases were carved with ornamental designs, and some of the shafts have forty shallow flutes, or vertical grooves, that enhance the play of light and shadow patterns on their surfaces.

Nothing remains of the superstructure, but it most certainly was built of wood, the most suitable material available for spanning the wide spaces between the columns. Fragments of terra-cotta tiles and ornaments suggest a traditional gabled roof. The great temple of the architects Rhoecus and Theodorus was destroyed by fire around 530.

The destruction of the Rhoecus and Theodorus temple during the reign of Polycrates presented an opportunity for the tyrant to associate himself with a building project that would impress the Greek world. His temple would be the largest ever built and would rival all others in its elegance. The huge Ionic structure stood on a tall platform that was 179 feet wide and 364 feet long. As was the case in the previous temple, the number of columns was a significant aesthetic feature of the design. Their great number and decorative quality were surely intended to overwhelm the visitor. The temple had two rows of twenty-four columns on the flanks and three rows in the front and back. There were eight columns across the front and nine across the back, and the Ionic order was used throughout. The ornamental column bases and capitals were of marble, but limestone was used for the shafts, which had twenty-four deeply cut flutes and were 63 feet tall. A deep pronaos, or internal porch, containing two rows of five columns preceded the cella. Possibly, two rows of columns were intended inside the cella, but these were never erected.

When Polycrates was executed by a Persian satrap (governor) in 525, only the cella, pronaos, and part of the east portico had been completed. Work continued on the great temple sporadically in the fifth century and in the Hellenistic period. But by the first century, the site was described as deserted. The Romans added a flight of steps to the front of the platform in the second century c.e. before abandoning further attempts to complete the massive structure. Today, only a single column stands near the Imbrasos River to remind posterity of Polycrates' extravagant plans for his Temple of Hera.

Archaeological exploration of the temple and its environs at Samos has a long history, beginning in the early eighteenth century with small-scale excavation by the amateur archaeologist J. Pitton de Tournefort. The site was excavated by French diggers in 1879 and in 1902–1903 by the Archaeological Society of Athens. In 1910, work at the site was undertaken by the Koenigliche Museen of Berlin but was interrupted in 1914 by World War I. Under the direction of E. Buschor, the German Archaeological Institute at Athens resumed excavation in 1925 and reached the archaic levels of temple and stoa; this work was suspended in 1939 due to World War II. Explorations of the site began again in 1951 and continue to the present day.

Further Reading

Dinsmoor, William B. *The Architecture of Ancient Greece*, 3d ed. New York: W. W. Norton, 1975.

Lawrence, A. W. *Greek Architecture*, 4th ed. R. A. Tomlinson, ed. Harmondsworth, England: Penguin Books, 1983.

Princeton Encyclopedia of Classical Sites. Perseus Digital Library. www.perseus.tufts.edu/cgi-bin/ptext?doc=Perseus%3Atext%3A1999.04.0006.

TEMPLE OF OLYMPIAN ZEUS, ATHENS

Style: Archaic; Hellenistic; Roman
Date: Circa 520 B.C.E.; 174 B.C.E.; 132 C.E.
Architect: Antistates, Callaeschrus, Antimachides, and Porinus;
Cossutius; Unknown

The monumental ruin of the Temple of Olympian Zeus, a building seven hundred years in the making, is the most imposing monument in the quarter of Athens that lies to the southeast of the Acropolis. The temple, also known as the Olympieum, stood on the site of an old outdoor sanctuary dedicated to the supreme god of the Greeks. Shortly before 550, Pisistratus, tyrant of Athens from 566 to 527, was the first to build a temple in the area.

Pisistratus's sons, Hippias and Hipparchos, demolished their father's building after his death and initiated the construction of a colossal temple designed by Antistates, Callaeschrus, Antimachides, and Porinus. Begun in approximately 520, the Athenian temple was calculated to rival, and if possible to surpass, the famous building projects of Polycrates, tyrant of Samos (see **Temple of Hera, Samos**), and the colossal Ionic Temple of Artemis at Ephesus in Asia Minor. The temple was to be a Doric structure, built of local limestone, on a platform measuring 134½ feet by 353½ feet. A double colonnade of eight columns across the front and back and twenty-one on the flanks would surround the cult room, or cella. With the abolition of the tyranny and subsequent expulsion of Hippias in 510, all work on the giant temple ceased. All that had been accomplished was the construction of the lower two steps of the platform, the foundations for the inner file of columns, and the sculpting of some of the column drums.

More than three hundred years later, probably after a visit to Athens, the Hellenistic monarch Antiochus IV Epiphanes revived the project. The flamboyant and extravagant ruler of the Seleucid kingdom was strongly devoted to the cult of Olympian Zeus. Antiochus presented himself as the earthly embodiment of the god and constructed a number of Zeus temples in order to promote the cult and unify the diverse peoples in his kingdom.

In 174, Antiochus entrusted the design and construction of the temple to a Roman architect named Decimus Cossutius. The new building utilized the extant sixth-century foundation and replicated its dimensions. Cossutius's plan called for three rows of 8 columns across the front and back of the building and a double file of 20 on the flanks, for a total of 104 columns. The temple was

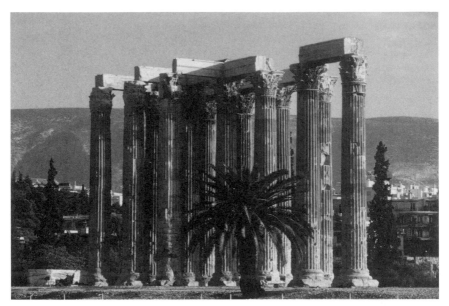

Temple of Olympian Zeus (Olympieum), Athens. *Photo by Jim Steinhart/PlanetWare.*

made of Pentelic marble instead of limestone, and the order was changed from the stately Doric to the elaborately decorative Corinthian. The use of Corinthian here was exceptional. Previously, the Corinthian order had been used only in the interior spaces of buildings such as the **Temple of Apollo Epicurius** at Bassae and the Tholos at Olympia (see **Altis**) or as a decorative feature on the small commemorative monument of Lysicrates (see **Choregic Monument of Lysicrates**). Cossutius's design was the first in the history of Greek architecture to use the Corinthian order on the exterior of a major temple. Work on this ambitious and expensive project ceased with the death of Antiochus in 164 when the temple was only half complete.

In 86, the Roman general Sulla sacked Athens and inflicted great damage to the city and its monuments. As part of the spoils of war, he transported some of the columns from the Temple of Olympian Zeus back to Rome, where they were installed in the sanctuary of Jupiter on the Capitoline Hill. According to the Roman historian Suetonius, an unsuccessful effort was made to complete the temple in the time of the emperor Augustus, but it was not until the second century C.E. that serious work on the temple was initiated.

This final campaign was the work of the emperor Hadrian, who was well known for his admiration of Greek culture and art—he was nicknamed "the Greekling." Hadrian journeyed to the province several times during his reign, and on each occasion he subsidized building projects as gifts to the Greek people. When Hadrian visited Athens in 124–125, he launched a colossal building program that included the completion of the Temple of Olympian Zeus.

A precinct of 424 feet by 680 feet was cleared around the structure, in effect creating a large public space where people could congregate for both sacred and secular affairs.

No major alterations were made in the plan and details of Cossutius's building. The Corinthian columns surrounding the cella were 55½ feet tall and 6 feet 4 inches in diameter. By some estimates, 15,500 tons of marble were quarried to make the columns. A few of the lintels carried by the columns survive, but little is known about the details of the upper part of the building. Virtually nothing remains of the cella, but it has been restored by scholars as a long rectangular hall with two files of monolithic columns inside. An internal porch, or pronaos, preceded the cella, and behind the cult room was a chamber, or adytum, of approximately the same size as the pronaos.

In 132, Hadrian returned to Athens to formally dedicate the Temple of Olympian Zeus. Roman writers describe the numerous statues—portraits of Hadrian and personifications of the Roman Provinces—that stood in the precinct and in front of the temple. The people of Athens expressed their appreciation by erecting a colossal statue of the generous emperor, patron of their city, behind the building. In the cella was a massive gold and ivory statue of Zeus, king of the gods, that was said to exceed all other statues in size except for the colossal images at Rhodes and Rome. As a special gesture of reverence, Hadrian released a snake, brought from India, in the cella—an act of homage to Erichthonius, ancestral hero of the Athenians, who was sometimes portrayed as a serpent.

The Temple of Olympian Zeus was badly damaged in the Herulian sack of 267. After that time, it was used as a stone quarry that provided ready-cut material for the building of houses and churches. Today, only fifteen of the original 104 columns remain, but they have a grandeur that marks them as a focal point in the urban landscape of southeast Athens.

Further Reading

Birley, Anthony R. *Hadrian: The Restless Emperor.* London and New York: Routledge, 1997.

Dinsmoor, William B. *The Architecture of Ancient Greece,* 3d ed. New York: W. W. Norton, 1975.

Ward-Perkins, J. B. *Roman Imperial Architecture.* New Haven, Conn.: Yale University Press, 1994.

TEMPLE OF POSEIDON, SUNIUM

Style: Classical
Date: Circa 440 B.C.E.
Architect: Unknown

The Temple of Poseidon, located in the southeastern tip of Attica, stands at the top of a promontory that drops almost two hundred feet into the sea. From the distance, the temple appears as a dazzling white landmark, a signal to sailors that their journey to Piraeus, the port of Athens, will soon be ended. In the *Odyssey*, Homer called the site "holy Sunium" and told how Phrontis, the steersman of Menelaos, was killed by Apollo and buried there. Cape Sunium was a place sacred to Poseidon, and regattas in his honor were held in the bay below the promontory. Poseidon was the god of the sea, the brother of Zeus, and the ancestor of horses. He competed with Athena to be the patron of Athens but lost. However, his relations with the Athenians remained strong because of the importance of naval power in their military and economic systems.

The earliest evidence for religious activity at Sunium dates to the eighth century. There was no monumental architecture at that time, and the celebration of the cult seems to have been focused only on an altar. In the sixth century, two colossal statues of nude youths, excellent examples of the Archaic style of sculpture, were dedicated in the open-air sanctuary. Only at the beginning of the fifth century did the Athenians start construction of a temple for Poseidon. Before it was completed, the building was destroyed by the Persians in 480. Soon after the middle of the fifth century, Pericles, the leader of Athens, seems to have sponsored the building of new temples in several locations in Attica. Since the temple at Sunium shared the fate of Persian destruction with the Athenian **Acropolis**, the rebuilding of the Temple of Poseidon probably signified triumphant recovery from the invasion, as did the Periclean building program in Athens.

Poseidon's temple was begun around 440. Although the name of the architect is not known, details of the design of the building indicate that he was the same man who laid out the **Temple of Hephaestus**. Like the Temple of Hephaestus, the Temple of Poseidon is a Doric building that incorporates some features of the Ionic order. The slender proportion of the columns in relation to the upper part of the structure is also found in both temples. A subtle emphasis on the front porch and the careful integration of the exterior and interior parts of the building are further characteristics of the unnamed archi-

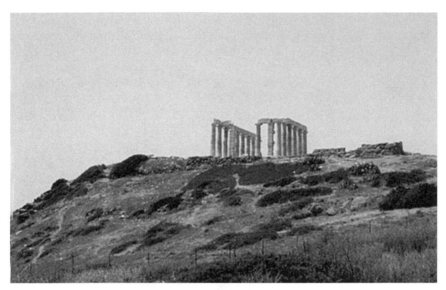

Temple of Poseidon, Sunium. *Courtesy of Caroline Buckler.*

tect. But, Poseidon's temple is not merely a copy of the Temple of Hephaestus; there are details in the plan and decoration of the Temple of Poseidon that are original and reflect the flexibility of Greek architectural design.

The building, which is made of local gray-veined marble, stands on a rectangular three-stepped platform that is 44 feet wide and 103 feet long. It faces east so that the rays of the rising sun can penetrate the cult room and illuminate the face of the god's statue. A Doric colonnade surrounds the cult room; there were originally six columns on the front and back of the building and thirteen on the flanks. The columns are quite slender, a trait that is usually found in the Ionic order, and have only sixteen shallow vertical grooves, or flutes, instead of the usual twenty found on Doric columns. Above the lintel carried on the columns was a horizontal band, or frieze, made up of alternating triglyphs and metopes. Triglyphs are rectangular blocks with vertical grooves cut into their surfaces; metopes are flat panels between the triglyphs. The metopes were blank; that is, they had no sculpted decoration. On the front and back of the building, a long triangular shape, or pediment, was defined by the upper border of the frieze and the sloping eaves of the gabled roof. There were statues in both pediments, but they are now so fragmentary that the subjects depicted cannot be identified.

The cult room, or cella, was a long rectangle with two interior porches, the pronaos at the front and the opisthodomos at the back. The pronaos and opisthodomos had two Doric columns between short walls that were essentially extensions of the flanks of the cella. The ends of these walls were aligned with the third column on each end of the flanks of the external colonnade, and the internal columns were placed in line with the two central columns on the

front and back. By means of this arrangement, the outer and inner parts of the building were carefully integrated. The pronaos and opisthodomos were of equal size, unlike the Temple of Hephaestus where the pronaos is deeper. However, once again the architect used sculpture inside the colonnade to emphasize the front of the building. An Ionic frieze, or horizontal band of sculpture above the Ionic molding, lined all four sides of the rectangular space between the colonnade and the front of the pronaos. The frieze was made of imported Parian marble to contrast with the gray-veined local stone used for the rest of the temple. Three subjects, drawn from mythology, were represented in the frieze: the battle between the Lapiths and Centaurs, the Battle of the Gods and the Giants, and the adventures of Theseus. In the fifth century, the two battle stories were commonly used as allegorical references to the Greek victory in the Persian Wars, and Theseus was the hero of Athenian democracy.

The cella had a door in its east wall and a flat wood ceiling. There were no colonnades inside to support the roof, a characteristic found in other buildings designed by the unknown architect of the Temple of Poseidon. In contrast to the pronaos, no sculptural decoration was associated with the opisthodomos. This suggests a hierarchical organization of decoration that put the major focus on the entrance.

In antiquity, the sanctuary at Sunium became known as a refuge for runaway slaves who were given their freedom by the local inhabitants. In the second century, the Roman playwright Terence referred to Sunium as a base for pirates; after the Roman period, Sunium became a port of call for corsairs. Archaeological interest in the remains of the temple began in the eighteenth century C.E. and continued into the nineteenth. Lord Byron visited Cape Sunium and left his initials carved on one of the columns. Today, the cella of the building has all but disappeared. The ends of the pronaos walls and one of its internal columns have been reconstructed, and nine columns on the south flank and six on the north still stand. Parts of the architrave—the lintel supported by the columns—remain, but the rest of the superstructure has disappeared. In spite of their fragmentary condition, the picturesque ruins of the Temple of Poseidon are a favorite of visitors to Greece, who appreciate their majestic setting and also enjoy the spectacular views of the sea from the promontory.

Further Reading

Berve, H., G. Gruben, and M. Hirmer. *Greek Temples, Theaters and Shrines*. London: Thames and Hudson, 1963.

Dinsmoor, William B. *The Architecture of Ancient Greece*, 3d ed. New York: W. W. Norton, 1975.

Lawrence, A. W. *Greek Architecture*, 4th ed. R. A. Tomlinson, ed. Harmondsworth, England: Penguin Books, 1983.

TEMPLE OF ZEUS, OLYMPIA

Style: Classical
Date: 470–456 B.C.E.
Architect: Libon of Elis

Although Zeus, the king of the gods and the sovereign of Olympia, was the most powerful of all the deities honored in Greece, he did not have a temple of his own in the **Altis** until the fifth century. For more than a century, Zeus shared the **Temple of Hera** with his wife and was also worshiped at a large altar located to the east of the tomb of Pelops. In 470, the people of the city-state of Elis, who administered the Olympic Games, used the spoils from a victory over their neighbor Pisa to begin building a temple for the great god. The temple was largely complete by 456, when the Spartans hung a gold shield on the east gable to commemorate their victory over Tanagra in 457. Libon of Elis, a local architect, designed the building in the Doric order with carefully calculated proportions that harmonized the dimensions of the various parts of the exterior elevation. The majestic scale of the building, 91 by 210´ feet, made it one of the largest Doric temples in all of mainland Greece.

The Temple of Zeus faced east overlooking the hippodrome, the track where chariot races were run, and stood on a three-stepped rectangular platform approached by a sloping ramp. There were six columns across the front and back and thirteen on the flanks. The building was constructed of local shelly limestone that was covered with white stucco and painted. Imported marble was used for the roof tiles, the sculptural decoration, and the gutters. The superstructure—the part of the building that was supported by the columns—had a continuous band, the frieze, made up of alternating triglyphs and metopes. Triglyphs are rectangular blocks with vertical grooves cut into their surfaces; metopes are flat panels between the triglyphs. Above the frieze was the pediment, the long triangular space between the upper edge of the frieze and the eaves of the gabled roof.

The two pediments of the Temple of Zeus contained some of the finest sculpture ever produced in ancient Greece. On the east/front of the temple, overlooking the hippodrome, fifteen freestanding statues depicted the preparations for the chariot race of Pelops and Oinomaos. The awesome figure of Zeus stands in the center of the composition as the competitors prepare for a race in which they will break their vows not to cheat. The mood is quiet, introspective, and tragic—Oinomaos will die, and Pelops will bring a multigenerational curse upon his family. Surely it is no coincidence that this subject was

chosen for the east pediment, which looks down on the hippodrome where the chariot racers must honor their oath of fair play.

On the west/back of the temple, the pedimental sculpture is decidedly different in mood. The story told is the battle between the Lapiths and Centaurs. Lapiths were Greeks; the Centaurs were a bizarre combination of horse and man. At a Lapith wedding, the Centaurs became drunk and attempted to abduct the bride and her female attendants. A furious battle ensued, and the Lapiths were victorious. In the center of the pediment stands Apollo, aloof and radiating godlike beauty and confidence. As the enforcer of the laws of Zeus, he wills the victory to the civilized human Greeks. To either side of Apollo, Centaurs seize Lapith women and Lapith heroes attack and kill the monstrous uncivilized beasts. The battle of the Lapiths and Centaurs was an allegory of the victory of the Greeks over the barbarian Persians in the Persian Wars. Visitors to Olympia would have understood the symbolic meaning of the myth depicted here as a celebration of Greek cultural superiority and integrity. The theme of victory was continued in the roof decorations. At the apex of each pediment was a gilt bronze Nike (Victory), and gold tripods adorned the lower corners.

The cult room, or cella, was a long rectangular hall with front and rear internal porches—the pronaos and opisthodomos, respectively. Each porch had two columns between walls extending from the flanks of the cella. There was no access to the cella from the opisthodomos, but inside the pronaos was a large and impressive door that allowed illumination from the rising sun to penetrate the cult room. Folding gates between the columns and end walls of the front porch could be closed when the temple was not open to the public. An unusual feature found in the internal porches of the Temple of Zeus is the inclusion of a frieze of triglyphs and metopes above the columns. The six metopes in each porch carry relief sculpture of very high quality illustrating the Twelve Labors of Hercules. As the illegitimate son of Zeus, Hercules was the greatest Greek hero who, according to the mythology of Olympia, established the length of the stadium and won the first footrace there. He was thus the inspiration and role model for all the Olympic competitors.

Inside, the cella was divided longitudinally by two rows of seven Doric columns. Each colonnade carried an upper story of shorter columns that supported the roof. Behind these upper columns, two long wooden galleries were constructed with access provided by wood stairways on either side of the entrance door. Access to the central space of the cella was restricted by a gated stone screen wall extending across the space between the second pair of columns and by similar walls linking the second to seventh columns on the flanks. Galleries and screen walls were necessary to provide viewing space and security for the great gold and ivory statue of Olympian Zeus made by Phidias, designer of the Parthenon sculpture and the Athena Parthenos. The statue of Olympian Zeus, forty feet tall, represented the king of the gods seated on an elaborate throne decorated with mythological scenes and holding a Nike (Victory) in his right hand, a scepter in his left. The divine image was deliberately

out of scale with the building—if Zeus were to stand up, his head would have gone through the ceiling—and this only increased the majesty and mystery projected by the statue, which was declared one of the Seven Wonders of the World. In the second century C.E., the Greek writer Arrian stated that "The other Wonders of the World we only admire; this one we reverence as well. . . . It is a great misfortune not to have seen it before one dies."

Earthquakes damaged the Temple of Zeus in the second century B.C.E. and in the fifth century C.E. After the fifth-century earthquake, the great statue of Zeus was taken to Constantinople, where eventually it was consumed in a fire. Flooding of the Alpheus and Cladeus Rivers and landslides from the nearby Kronos Hill buried the remains of the temple under a thick layer of mud. The great Olympian sanctuary was forgotten, and a small village was built on the site.

Further Reading

Berve, H., G. Gruben, and M. Hirmer. *Greek Temples, Theaters and Shrines.* London: Thames and Hudson, 1963.

Lawrence, A. W. *Greek Architecture*, 4th ed. R. A. Tomlinson, ed. Harmondsworth, England: Penguin Books, 1983.

Princeton Encyclopedia of Classical Sites. Perseus Digital Library. www.perseus.tufts.edu/cgi-bin/ptext?doc=Perseus%3Atext%3A1999.04.0006.

Yalouris, Nikolaos. *Olympia.* Paul J. Dine, trans. Munich and Zurich: Verlag Schnell and Steiner, 1972.

THEATER, EPIDAURUS

Style: Classical
Date: Second Half of the Fourth Century B.C.E.
Architect: Polyclitus the Younger

The classical Greek theater originated in Athens in the later sixth century. Unlike modern conceptions of the theater as a place of secular entertainment, the Greek theater was a religious and civic institution. Tragic and comic plays were produced as part of annual festivals honoring Dionysos, the god of wine and disguises. Drama was based on mythology and was a poetic form with music and dance, much more like opera than like modern plays. The actors were all male citizens who wore platform shoes, masks, wigs, and elaborate colorful costumes to make them appear larger than life.

Athenian drama of the fifth century was closely linked to democracy. The shape of the theater developed from the place of assembly, the Pnyx, where citizens came to hear speakers and to debate and vote on state policy. Drama was a unique social institution in which all the citizens of Athens were expected to meet together in good fellowship and to question the values and assumptions on which their society was based. By watching heroic figures brought low, the Athenians were encouraged to examine the destructive, chaotic, or inverted actions of the tragic characters and to apply the lessons learned to their own social and political behavior.

The Theater of Dionysos in Athens became the prototype for theaters in Greece and Asia Minor in the fourth century and the Hellenistic age, but its building history and modifications are problematic. The Theater at Epidaurus, designed by Polyclitus the Younger in the second half of the fourth century, is better suited for understanding the appearance and function of a classical Greek theater because of its fine state of preservation. Epidaurus, in the Argolid, was famous in antiquity for its shrine of the healing god Asclepius. Games were held every four years to honor the god, and in 395 a dramatic festival was incorporated into the celebration.

The Greek word *theatron* means "a place for seeing." And indeed lines of sight were carefully considered in the design of the theater, as were acoustics—one not only saw the plays but had to be able to hear the actors and the chorus. Epidaurus, like all Greek theaters, was built into a natural hillside so that raised seating guaranteed a good view of the performances.

The auditorium, more than semicircular in plan, has curved rows of white limestone benches where the spectators sat and is divided into a series of

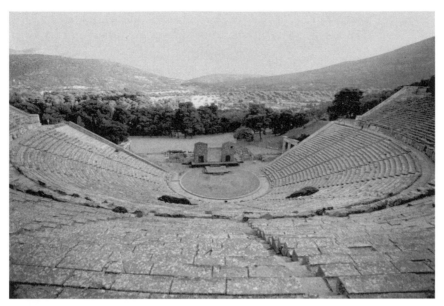

Theater, Epidaurus. *Courtesy of Caroline Buckler.*

wedge-shaped sections separated by staircases. In the second century, a walk-
way, or diazoma, and an upper range of seats were added. Thus, the audito-
rium as it exists today is divided into two parts; the lower range of seats has
thirty-four rows of benches, while the upper has twenty-one. The diazoma
also marks a point at which the number of wedges is doubled from twelve
below to twenty-four above. The auditorium is 387 feet in diameter, and the
fifty-five rows of seats provide the fourteen thousand spectators with an unob-
structed view of the orchestra.

At the bottom of the auditorium, separated from the lowest row of seats by
a gutter that is 7½ feet deep and almost 7 feet wide, is the flat, circular orches-
tra, or "dancing place" for the chorus. The orchestra is 67 feet in diameter and
has the base for an altar of Dionysos in its center. Behind the orchestra was a
long rectangular building, or skene, that functioned as a dressing and storage
area and as a backdrop for the plays. The skene was 64 feet long and 20 feet
wide; only its foundation survives. At each end of the skene was a narrow room
that seems to have projected forward slightly to frame the front wall of the
building.

The skene was not connected to the auditorium. A passage, or parodos,
between the two units provided access to the orchestra and, via the gutter and
stairs, to the auditorium. A large double doorway at the outer end of each par-
odos marked the entrances to the theater.

The acoustics of the Theater at Epidaurus are perfect. A spectator seated
at the top of the auditorium can hear a whisper uttered in the orchestra. Today
the theater is used for a drama festival held annually in July and August that

presents the classical plays of Aeschylus, Sophocles, and Euripides. In 1960 and 1961, the Greek diva Maria Callas sang the operas *Norma* and *Medea* at Epidaurus.

Further Reading

Berve, H., G. Gruben, and M. Hirmer. *Greek Temples, Theaters and Shrines.* London: Thames and Hudson, 1963.

Bieber, Margarete. *The History of the Greek and Roman Theater.* Princeton, N.J.: Princeton University Press, 1961.

Dinsmoor, William B. *The Architecture of Ancient Greece,* 3d ed. New York: W. W. Norton, 1975.

Lawrence, A. W. *Greek Architecture,* 4th ed. R. A. Tomlinson, ed. Harmondsworth, England: Penguin Books, 1983.

THOLOS, DELPHI

Style: Classical
Date: Circa 375 B.C.E.
Architect: Theodorus of Phocaea

Below the oracular **Sanctuary of Apollo** at Delphi lies the smaller Sanctuary of Athena Pronaea. *Pronaea* means "before the temple" and expresses the geographical relationship of the two holy sites. Pilgrims traveling to Delphi from the east would pass by Athena's sanctuary before arriving at Apollo's temple. The area, used for centuries as a marble quarry, is now called Marmaria. By far the most interesting and important structure in the Athena sanctuary is the Tholos that became the paradigm for Greek circular buildings. In the most basic sense, the term "tholos" refers to a building that has a round plan and a conical roof.

The Tholos at Delphi was designed by the architect Theodorus of Phocaea who wrote a book about the building. His task was to adapt the conventions of temple architecture to a circular form. The solution was to construct a circular room, or cella, with concentric rings of interior and exterior columns. To enrich the building and to emphasize the contrast of exterior to interior, Theodorus used two orders, the austere Doric and the newly invented Corinthian. The use of more than one order for a building was probably inspired by the **Parthenon** and the **Temple of Apollo Epicurius** at Bassae.

The Tholos was built in the early fourth century, in about 375, and stood on a circular platform of three steps that was forty-nine feet in diameter and three feet high. Around the exterior was a ring of twenty Doric columns that supported a superstructure divided horizontally into three zones: the architrave (or lintel), the Doric frieze, and the cornice. The Doric frieze was divided into triglyphs and metopes. Triglyphs are rectangular blocks with vertical grooves cut into their surfaces; metopes are the slabs between the triglyphs. Scenes of combat between Greeks and Amazons and between Lapiths and Centaurs were depicted in relief on the metopes. These subjects were also depicted on the metopes of the Parthenon and were traditional allegories for the victory of the Greeks over the barbarian easterners in the Persian Wars. Above the cornice was a gutter richly carved with ornamental lion's-head waterspouts. The exterior of the Tholos was constructed entirely of white Pentelic marble. A sloping roof covered the space between the colonnade and the cella wall.

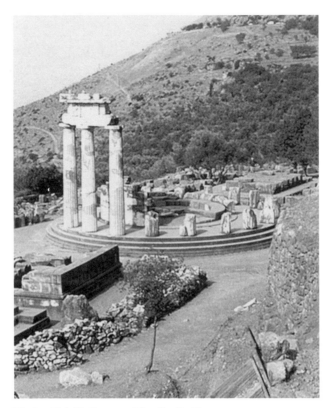

Tholos, Delphi. *Courtesy of Caroline Buckler.*

The cella wall, also of marble, was decorated with a Doric frieze with sculpted metopes that repeated, on a smaller scale, the decoration on the exterior of the building. At the base of the wall, a decorative sill of black Eleusinian limestone ran under a molding of stylized water leaves.

A single door on the south gave access to the interior of the cella, which was twenty-eight feet in diameter. Projecting from the bottom of the wall was a low continuous platform, rather like a bench, that was made of black limestone and was broken only by the doorway. A ring of ten Corinthian columns, positioned close against the wall, stood on the platform. The columns' floral capitals were based on the first Corinthian column in the Temple of Apollo at Bassae. Two rows of small acanthus leaves wreathe the lower part of the capital, while a palmette in the center separates two elongated scrolls that reach up to the corners. Slabs of black limestone with a circle of white marble in the center paved the floor. The circular room had a conical roof ornamented with diamond-shaped coffers that were adaptations of the coffers in the Bassae temple. How the cella was illuminated is not known for certain. The door may have been the only source of light, or there may have been windows in the upper part of the wall.

Without doubt, the Tholos was a very important building. The contrast of two types of stone, white marble and black limestone, was visually dramatic and represented a considerable financial and logistical investment. Pentelic marble was quarried near Athens, while the black limestone was found at Eleusis; both had to be shipped a considerable distance to Delphi. The combination of the two types of stone in a single structure recalls Athenian practice in the later fifth century, as does the mixing of the orders.

Theodorus obviously studied the earlier buildings and used them as a source of inspiration. Great skill and subtlety is characteristic of the sculpting of the decorative architectural details and the scenes in relief on the metopes. A building such as the Tholos must have had some very special significance, but what purpose the building served is not known. Other tholoi were for secular use or could house dedications in sanctuaries, but only the tholos at Epidaurus was as richly decorated (see **Agora** and **Altis**). Some scholars have suggested that the Tholos was a shrine of the earth goddess Ge, who was closely associated with Delphi. However, there is no literary or epigraphic evidence to support this claim.

The great beauty of the Tholos is evident today in spite of its fragmentary state. The platform has been reconstructed, and portions of the cella wall are still in place. Three of the exterior columns have been reerected and carry fragments of the lintel, Doric frieze, and cornice. Most of the extant metopes, one of the Corinthian columns, and a Doric capital from the exterior colonnade are preserved in the Delphi Museum.

Further Reading

Lawrence, A. W. *Greek Architecture*, 4th ed. R. A. Tomlinson, ed. Harmondsworth, England: Penguin Books, 1983.

Perseus Building Catalog. Perseus Digital Library. www.perseus.tufts.edu/cgi-bin/ptext?doc=Perseus%3Atext%3A1999.04.0039.

Petracos, Basil C. *Delphi*. Athens, Greece: Hesperus Editions, 1971.

Princeton Encyclopedia of Classical Sites. Perseus Digital Library. www.perseus.tufts.edu/cgi-bin/ptext?doc=Perseus%3Atext%3A1999.04.0006.

TOWER OF THE WINDS, ATHENS

Style: Hellenistic
Date: Mid-First Century B.C.E.
Architect: Andronicus of Cyrrhus

The Tower of the Winds, an elaborate timepiece located on the eastern side of the Roman marketplace, was designed by the astronomer and engineer Andronicus of Cyrrhus in the mid-first century to illustrate his theory of the eight winds and to house an ingenious water clock, or clepsydra. Andronicus was famous for constructing astronomical instruments and inventing timepieces that were not only functional but beautiful—even marvelous. Before working in Athens, he built a renowned white marble sundial in the sanctuary of Poseidon and Amphitrite on the island of Tinos. The Roman writers Varro and Vitruvius both described the Tower of the Winds, and it was Vitruvius who gave the building the nickname by which it is known today. In Athens, the official title of the building was the Horologion, which means "clock tower."

The tower, an octagonal structure made of Pentelic marble, is forty-seven feet high and twenty-five feet in diameter and stands on a platform of three steps. The octagon is oriented in such a way that each side faces the compass direction of the eight winds that blow in Athens. The lower level of the octagon is undecorated except for the markings for a sundial on each face. In the upper level, personifications of the winds, identified by inscriptions, are depicted in relief sculpture.

The winds are represented as winged males who carry an attribute associated with the type of weather each one brings. All except Zephyrus, who is nude, are dressed in a short tunic, billowing cloak, and boots. Four of the winds have beards to indicate adult status, while the remaining four are beardless youths. Boreas (north) blows into a conch shell to summon the group. Caecius (northeast) pours hailstones from a shield. Apeliotes (east) is young and carries grain and fruit in his cloak. Eurus (southeast) has his arm hidden in his cloak to summon a hurricane. Notus (south) is a youth who pours rain out of a vase. Lips (southwest), also young, leans on the stern of a boat and blows it on its way. Zephyrus (west), shown as a nude youth, scatters flowers. And Sciron (northwest) is an older man who empties a cauldron to signify the beginning of winter.

A semicircular turret attached to the south side of the tower served as the reservoir that provided the steady stream of water to propel the clepsydra. The

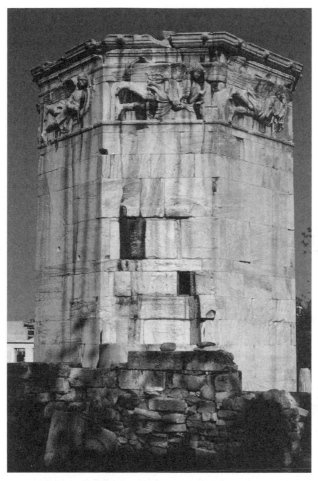

Tower of the Winds, Athens. *Photo by Jim Steinhart/ PlanetWare.*

reservoir seems to have had two chambers for storing water and regulating water flow. The water was transported under high pressure to the Tower of the Winds by means of a lead pipe fed by the Clepsydra spring, located on the north slope of the Acropolis. The Clepsydra is the water source that gave its name to the water clock. A sundial was mounted on the exterior wall of the turret, thus increasing the number of dials on the building to nine.

The roof of the tower is made of twenty-four triangular slabs of marble carved to simulate roof tiles. The marble slabs slope gently upward toward the summit, which is crowned by a finial shaped like an octagonal Corinthian capital. Mounted on the finial was a huge bronze statue of the minor sea god Triton holding a rod that functioned as a wind vane. The mechanism was

constructed in such a way that Triton's rod would point to a sculpted god on the wall below to indicate the direction of the wind.

Access to the interior was provided by two entrances with porches that projected from the northwest and northeast sides of the octagon. Each porch had two columns that supported a gabled roof. The columns, which were a late form of the Corinthian order, had no bases; their capitals were ornamented with a short row of projecting acanthus leaves overlapping tall flat water leaves.

There is a minimum of decoration inside the tower. Only two horizontal cornices, or moldings that project from the wall, articulate the smooth surfaces of the interior of the octagon. The cornices are placed at 6½ and 16½ feet from the floor. At 26 feet above the floor, in the angles of the octagon, small Doric columns standing on circular cornices help to create a visual transition to a circular molding, about 4 feet above, that forms the base of an interior conical-shaped roof.

A central drain and various cuttings in the floor suggest that the clepsydra in the Tower of the Winds was an extremely elaborate mechanism. It was surrounded by a balustrade to keep visitors safely away from the delicate clockwork of gears, discs, and wires—some made of gold. Statues of several gods were quite possibly displayed in the tower, and a series of fountains provided a water display. Some writers have even suggested the presence of automated singing birds and other automata. Although nothing remains of Andronicus's masterpiece, the Tower of the Winds clearly introduced elements of theatrical spectacle, astronomy, geometry, mathematics, and architecture into the practical necessity of knowing the time of day and the direction of the wind.

The Tower of the Winds is one of the few buildings from ancient Greece that remains virtually intact and has been occupied almost continuously until recent times. In the sixth century c.e., the building was converted into a chapel. During the Turkish occupation, it became a tekke, or Muslim convent; Whirling Dervishes used the tower as a monastery in the eighteenth century. By this time, many believed the building to be the tomb of Socrates. The entrance porches of the tower are now mostly destroyed, and the clepsydra and Triton statue have long since disappeared. However, the exterior of the octagon and its sculpture are well preserved, and the floor cuttings and water channels inside the tower have allowed archaeologists to attempt to reconstruct and understand the workings of Andronicus's marvelous timepiece.

Further Reading

Noble, J. V., and D. J. deSolla Price. "The Water Clock in the Tower of the Winds." *American Journal of Archaeology* 72 (1968): 345–355.

Whitrow, G. J. *Time in History.* Oxford: Oxford University Press, 1989.

TREASURY OF ATREUS, MYCENAE

Style: Mycenaean
Date: Circa 1350 B.C.E.
Architect: Unknown

Mycenae, remembered as the home of Agamemnon and the setting for Aeschylus's great dramatic trilogy, the *Oresteia*, was in reality the most powerful and influential of the Bronze Age communities. The ruler of Mycenae seems to have been the overlord of most of the Peloponnesus and leader of a local confederacy that included Tiryns, Midea, and Asine. Kings of Mycenae wielded influence in Attica, Boeotia, the Greek islands, Euboea, and Crete in addition to maintaining trade and military relations with many sites around the Mediterranean Sea. They were warriors and traders who built palaces fortified by massive walls and who buried themselves with riches and military regalia in tholos tombs, or circular monuments.

The Treasury of Atreus, or, as it is sometimes called, the Tomb of Agamemnon, is the largest and best preserved of the nine tholos tombs located outside the citadel walls of Mycenae. Built in approximately 1350, the treasury is also the latest to be constructed. The conventional names for the tomb have no basis in history; who was buried there is not known. For a long time, archaeologists did not know what purpose the building served. Pausanius, the Roman travel writer of the second century c.e., relied on fanciful tales that conjured up images of monarchs, such as Atreus, with legendary wealth, which Pausinius assumed they kept hidden in underground treasuries. However, late in the nineteenth century, the discovery of six skeletons in a tholos tomb at Menidhe (in Attica) disproved the treasury theory and firmly established the funerary significance of the building. There are more than one hundred tholos tombs in Greece, and they are remarkably similar in design. They have two basic parts: the dromos, or entrance corridor cut into the side of a hill, and the tholos, a circular room with a cone-shaped roof covered by a mound of earth.

The Treasury of Atreus is built into the east side of a hill behind a wide terrace, constructed of packed boulders, and an enclosure wall. The dromos is a long level corridor, open to the sky, that is 20 feet wide and 120 feet long. Large squared blocks of dark gray conglomerate laid in approximately horizontal courses line the walls. The floor is made of cement. At the end of the dromos is the entrance wall, or facade, of the tholos. It is 34 feet tall and has a door, 18 feet tall and 8 feet wide, in its center on axis with the dromos. The

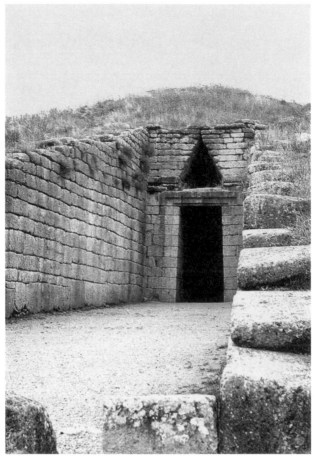

Treasury of Atreus, Mycenae. *Courtesy of Judith Snyder Schaeffer.*

doorjambs, carved with two recessed bands, converge slightly toward the top so that the door is not a perfect rectangle. Above the jambs is a great lintel made up of two stone slabs, one behind the other. The outer slab is inserted into the dromos wall; the inner slab, which is estimated to weigh more than one hundred tons, is 26 feet long, 16 feet wide, and 4 feet high. Above the lintel is a large triangular opening framed by nicely dressed blocks of stone. This feature, known as a relieving triangle, lightens the weight of the wall on top of the lintel to reduce its load and prevent it from breaking.

On either side of the door into the tholos was a half-column of green marble, nineteen feet tall, carved with chevron patterns. The relieving triangle was faced with a thin slab of red marble decorated with horizontal rows of spirals and was flanked by green marble half-columns, half the height of the lower ones, with sculpted abstract designs. Above the lintel, between the bases of the

half-columns, was a horizontal band of green marble carved with a row of discs. A band of connected spirals was placed above the discs, and there was a third band, immediately beneath the relieving triangle, decorated with floral patterns. Color, expensive stone, and richly detailed designs thus frame the entrance to the tomb and project a sense of dignity and wealth. All the decoration around the door was removed and divided between the National Museum in Athens and the British Museum in London.

The entrance passage into the tholos is eighteen feet long and is paved with slabs of limestone. Midway though the passage is a threshold and a door frame that once enclosed a double door of bronze-covered wood that could be folded back against the walls. Entering the tholos is a magical experience. The walls are curved both horizontally and vertically. There are no flat surfaces except for the floor and no right angles except where the wall intersects the floor, so the space seems expansive and fluid.

The room is a circle almost fifty feet wide that rises in a domical shape to a height of forty-three feet, or a little more than four modern stories. Bronze rosettes set into holes in the stone blocks decorated the walls. The Treasury of Atreus was the largest domed structure built in the ancient world until it was exceeded by the Pantheon in Rome, which was constructed in the second century C.E. However, the Mycenaean structure is not a true dome but rather a corbeled cone. Corbeling is a method of construction in which stone blocks are laid in horizontal courses, each course being narrower than the one below. Thus, the dome of the Treasury of Atreus is actually a series of masonry circles that become progressively smaller as they rise and finish in a capstone, or plug, at the summit. Corbeling gives the dome a tall pointed shape like a natural beehive, and thus archaeologists call this type of conical structure a beehive tomb.

Inside the tholos on one side is a doorway, eight feet tall and five feet wide, that has two long lintels with a relieving triangle above. The doorway opens into a chamber, about twenty feet square, that is cut into the rock. The walls and ceiling of the chamber have rough surfaces that were probably covered with sheets of bronze, recalling Homer's descriptions of palace walls that were plated with gold, silver, and bronze. The Treasury of Atreus, like most tholos tombs, was plundered in antiquity, so nothing remains of the splendid grave goods that were traditionally buried with Mycenaean kings. Finds in other tholoi include jewelry, gold and silver cups, gems, amber, and large numbers of weapons. The tholos tomb—a statement of power and a memorial dedicated to a distinguished ruler and his dynasty—remains an enduring symbol of the wealth and energy of Mycenaean civilization at its best.

Further Reading

Chadwick, John. *The Mycenaean World.* Cambridge: Cambridge University Press, 1976.

Preziosi, Donald, and Louise A. Hitchcock. *Aegean Art and Architecture*. Oxford: Oxford University Press, 1999.

Samuel, Alan E. *The Mycenaeans in History*. Englewood Cliffs: Prentice Hall, 1966.

Vermeule, Emily. *Greece in the Bronze Age*. Chicago: University of Chicago Press, 1972.

UNIVERSITY OF ATHENS, ATHENS

Style: Hellenic Neoclassical
Date: 1839–1889 C.E.
Architect: Christian Hansen

After the long War of Independence when the Greeks threw off Ottoman domination, Athens became the country's new capital. When King Otto of the Hellenes arrived in the city in 1835, it was in ruins. Because so little remained, Otto was able to initiate an extensive rebuilding of Athens. He intended to turn the town into a grand, well-planned city that would remind visitors and Greeks alike of the glorious history of Greece and would transform Athens into one of the most beautiful capital cities in the world. The birth of the new Athens became the symbol of the birth of the new free Greek state.

To rebuild Athens, Otto depended on architects who came to Greece from Denmark, Germany, and France. Among these were several Danes who settled in Athens in the 1830s and initiated a new type of neoclassical architecture based on careful study of the ancient monuments. Their goal was not to slavishly copy buildings of the past, but rather to use the secrets of the structures' proportions and details to create a national style of architecture that drew on what they believed to be true art and its sources.

After completing his training at the Academy of Fine Arts in Copenhagen and traveling extensively, Christian Hansen settled in Athens in 1833. He quickly established himself there and in 1835 was appointed architect to the king of the Hellenes. This position was both prestigious and challenging, since Hansen would be responsible for a new city plan and would oversee the restoration of ancient monuments and the the construction of housing, churches, and harbors. During the seventeen years he lived in Athens, Christian Hansen designed many buildings, such as the Mint, the Eye Clinic, the Music Conservatory, and the church of Saint Paul. He also participated in the restoration of the **Parthenon** and the **Temple of Athena Nike**. Hansen was strongly interested in the use of applied color on classical Greek buildings and recorded its use on the Parthenon and **Erechtheum**.

In the summer of 1837, the University of Athens was founded with faculties in theology, law, medicine, and philosophy. The following year, a committee was established to set up a subscription program to collect money for the construction of a university building. Hansen was given the commission for the project, which began in 1839. Because construction depended on contributions, money for the building was often inadequate and construction was

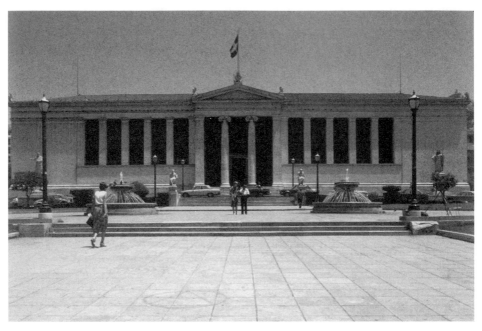

University of Athens, Athens. *Courtesy of Michio Yamaguchi.*

not completed until 1889. When finished, however, the University of Athens was acclaimed one of the finest works of Hellenic neoclassicism and became the model for public buildings in Athens. The university's noble simplicity and human scale recalled the qualities of classical Greek art and architecture and thus raised and strengthened Greek national consciousness—by the nineteenth century, most Greeks had forgotten their ancient history. Hansen's university is the first of the three buildings of Pentelic marble in the neoclassic style that became known as the Athenian Trilogy. The other two are the **Academy of Sciences** and the **National Library** designed by Hansen's brother, Theophilos.

In plan, the University of Athens is really quite simple. There are two transverse blocks that are connected by a longitudinal hall. The plan becomes a rectangle because there are two enclosed courtyards on either side of the hall that make the central part of the building as wide as the transverse units. A single file of piers runs parallel to the walls on three sides of each courtyard and supports balconies. On the ground floor of the front block are four large rooms and two staircases. Offices for the administrative staff are located in the longitudinal hall. The rear block has two amphitheaters and several auxiliary rooms. In the front section of the upper story is the library. A great hall of ceremonies occupies the central hall, and the block at the back originally housed a museum of natural history.

The university's facade—a masterpiece of neoclassical design—is symmetrical and clearly focused on a projecting Ionic porch on the central axis. On

either side of the porch, standing on a parapet wall, is a file of piers with modified Doric capitals. At each end of the facade, the wall surface, covered with marble stucco, is solid. There is a clear hierarchy in this composition that is based on the arrangement of the shapes and the ornamentation. The projection of the decorated porch contrasts with the simplified surfaces on either side that become less decorative and more solid as they move away from the center. In fact, the arrangement suggests an ancient Greek treasury, such as the **Athenian Treasury** at Delphi, standing in front of a stoa, such as the **Stoa of Attalos**. The side walls of the porch are solid and terminate in pilasters with capitals identical to those of the piers to either side. This detail integrates the porch facade with the rest of the building. Hansen's work on the **Temple of Athena Nike** is evident in the porch: the university's three-stepped base, slender Ionic columns, and low triangular pediment with finials on its corners ultimately derive from the Nike temple.

There is no sculpture in the pediment of the porch facade, but there is a great deal of painted decoration on the walls behind the files of piers. Hansen was particularly interested in the use of brightly colored paint on classical buildings and frequently introduced color into his designs. The long wall behind the piers is painted solid red and has a long horizontal frieze of figures at the top. This position is similar to that of the Parthenon frieze. In the central section of the frieze is an allegorical representation by the Viennese painter Karl Rahl and the Polish artist Lembietsky of the rebirth of the arts and sciences in Greece under King Otto. The king is shown seated on a throne directly above the main entrance; to his right and left are the Muses. On either side of this composition are scenes of Greek cultural history, including Prometheus giving fire to mankind and Saint Paul converting the Greeks.

Christian Hansen left Athens in 1857 and returned to Copenhagen, where he taught at the Academy of Fine Arts and continued to practice architecture. His brother Theophilos supervised work on the University of Athens based on Christian's drawings. Then Theophilos, too, left Athens. When Christian Hansen died in Vienna in 1883, his masterpiece, the university building, was not yet completed.

Further Reading

Bastea, Eleni. *The Creation of Modern Athens: Planning the Myth*. Cambridge: Cambridge University Press, 2000.

European Union's Culture 2000. www.culture2000.tee.gr.

Jorgensen, Lisbet B., and Demetri Porphyrios. *Neoclassical Architecture in Copenhagen and Athens: Architectural Design Profile 66*. London: The Academy Group Ltd., 1987.

Travlos, John. *Neo-Classical Architecture in Greece*. Athens: The Commercial Bank of Greece, 1967.

Bibliography

Aeschylus. *Oresteia/Aeschylus*, trans. C. Collard. Oxford: Oxford University Press, 2002.

Ancient Olympics, The. Perseus Digital Library. www.perseus.tufts.edu/cgi-bin/ptext?doc=perseus%3Atext%3A1999.04.0039.

Arrian. *Arrian*, trans. P. A. Brunt. Loeb Classical Library, nos. 236 and 269. Cambridge: Harvard University Press, 1976–1983.

Aslanis, Ioannis, et al. *Troy: Heinrich Schliemann's Excavations and Finds*. A. Doumas and M. Krikou-Galani, trans. Athens: Greek Ministry of Culture, 1985.

Barber, Robin, ed. *Blue Guide: Greece*. London: A&C Black, 1995.

Bastea, Eleni. *The Creation of Modern Athens: Planning the Myth*. Cambridge: Cambridge University Press, 2000.

Beard, Mary. *The Parthenon*. Cambridge: Harvard University Press, 2003.

Berve, H., G. Gruben, and M. Hirmer. *Greek Temples, Theaters and Shrines*. London: Thames and Hudson, 1963.

Bieber, Margarete. *The History of the Greek and Roman Theater*. Princeton, N.J.: Princeton University Press, 1961.

Birley, Anthony R. *Hadrian: The Restless Emperor*. London and New York: Routledge, 1997.

Bouras, C. *Nes Moni on Chios: History and Architecture*. David A. Hardy, trans. Athens: Commercial Bank of Greece, 1982.

Cato and Varro. *De Re Rustica*, trans. W. D. Hooper and H. B. Ash. Loeb Classical Library. Cambridge: Harvard University Press, 1979.

Chadwick, John. *The Mycenaean World*. Cambridge: Cambridge University Press, 1976.

Chatzidakis, Manolis. *Mystras*. Alison Frantz and Louise Turner, trans. Athens: Ekdotike Athenon S.A., 2000.

Demargne, Pierre. *Aegean Art: The Origins of Greek Art*. S. Gilbert and J. Emons, trans. London: Thames and Hudson, 1964.

Dinsmoor, William B. *The Architecture of Ancient Greece*, 3d ed. New York: W. W. Norton, 1975.

Euripides. *Ion/Euripides*, trans. W. S. DiPiero. New York: Oxford University Press, 1996.

European Union's Culture 2000. www.culture2000.tee.gr.

Evans, H. C., and W. Wixom. *The Glory of Byzantium: Art and Culture of the Middle Byzantine Era, A.D. 843–1261.* New York: Metropolitan Museum of Art, 1997.

Fullerton, M. D. *Greek Art.* Cambridge: Cambridge University Press, 2000.

"Greek Churches of Mykonos." www.magicaljourneys.com/Mykonos/mykonos-interest-churches.html.

Hellenic Macedonia: History. Macedonian Heritage. www.macedonian-heritage.gr/ HellenicMacedonia/en/C2.5.2html.

Hellenic Ministry of Culture. www.culture.gr/home/welcome.html.

Hesiod et al. *Hesiod, The Homeric Hymns, and Homerica,* trans. H. G. Evelyn-White. Loeb Classical Library, no. 57. Cambridge: Harvard University Press, 1977.

Hetherington, Paul. *Byzantine and Medieval Greece: Churches, Castles and Art.* London: John Murray Publishers, Ltd., 1991.

———. *The Greek Islands: Guide to the Byzantine and Medieval Buildings and Their Art.* London: Quiller Press, Ltd., 2001.

Homann-Wedeking, E. *The Art of Archaic Greece.* J. R. Foster, trans. New York: Greystone Press, 1968.

Homer. *The Iliad of Homer,* trans. R. Lattimore. Chicago: University of Chicago Press, 1951.

———. *The Odyssey of Homer,* trans. R. Lattimore. New York: HarperCollins Publishers, 1965.

Hood, Sinclair. *The Arts in Prehistoric Greece.* Harmondsworth, England, and New York: Penguin Books, 1978.

Hurwit, Jeffrey M. *The Art and Culture of Early Greece, 1100–480 B.C.* Ithaca and London: Cornell University Press, 1985.

Jorgensen, Lisbet B., and Demetri Porphyrios. *Neoclassical Architecture in Copenhagen and Athens: Architectural Design Profile 66.* London: The Academy Group Ltd., 1987.

Kadas, Sotiris. *Mount Athos: An Illustrated Guide to the Monasteries and Their History.* Louise Turner, trans. Athens: Ekdotike Athenon S.A., 1979.

Krautheimer, Richard. *Early Christian and Byzantine Architecture.* Harmondsworth, England: Penguin Books, 1975.

Laconian Professionals. www.Laconia.org/Mystra1_Holy_Hodigitria.htm.

Lawrence, A. W. *Greek Architecture,* 4th ed. R. A. Tomlinson, ed. Harmondsworth, England: Penguin Books, 1983.

Lysias. *Lysias,* trans. W. R. M. Lamb. Loeb Classical Library, no. 244. Cambridge: Harvard University Press, 1976.

Mango, Cyril. *Byzantine Architecture.* Milano: Electa Editrice/Rizzoli, 1978.

Matz, Friedrich. *The Art of Crete and Early Greece.* Ann E. Keep, trans. New York: Greystone Press, 1962.

Melas, Evi, ed. *DuMont Guide to the Greek Islands: Art, Architecture, History.* Russell Stockman, trans. Cologne: DuMont Buchverlag GambH & Co. Limited, 1985.

Mylonas, George E. *Eleusis and the Eleusinian Mysteries.* Princeton, N.J.: Princeton University Press, 1969.

Noble, J. V., and D. J. deSolla Price. "The Water Clock in the Tower of the Winds." *American Journal of Archaeology* 72 (1968): 345–355.

Numismatic Museum. www.nm.culture.gr.

Olympics Through Time. Foundation of the Hellenic World. www.fhw.gr/olympics/ancient.

Osborne, Robin. *Archaic and Classical Greek Art.* Oxford: Oxford University Press, 1998.

Pausanias. *Description of Greece,* trans. W. H. S. Jones. 5 vols. Loeb Classical Library. Cambridge: Harvard University Press, 1969–1977.

Perseus Building Catalog. www.perseus.tufts.edu/cgi-bin/ptext?doc=Perseus%3Atext%3A1999.04.0039.

Petracos, Basil C. *Delphi.* Athens, Greece: Hesperus Editions, 1971.

Philostratus. *Lives of the Sophists,* trans. W. C. Wright. Loeb Classical Library, no. 134. Cambridge: Harvard University Press, 1968.

Pollitt, J. J. *Art and Experience in Classical Greece.* Cambridge: Cambridge University Press, 1972.

———. *Art in the Hellenistic Age.* Cambridge, Cambridge University Press, 1986.

Preziosi, Donald, and Louise A. Hitchcock. *Aegean Art and Architecture.* Oxford: Oxford University Press, 1999.

Princeton Encyclopedia of Classical Sites. Perseus Digital Library. www.perseus.tufts.edu/cgi-bin/ptext?doc=Perseus%3Atext%3A1999.04.0006.

Ramage, Nancy H., and Andrew Ramage. *Roman Art: Romulus to Constantine,* 3d ed. Englewood Cliffs: Prentice Hall, 2000.

Rice, D. T. *Byzantine Art.* Harmondsworth, England: Penguin Books, 1968.

Rhodes, Robin Francis. *Architecture and Meaning on the Athenian Acropolis.* Cambridge: Cambridge University Press, 1995.

Romanos, Aristeidis. *Greek Traditional Architecture: Mykonos.* Philip Ramp, trans. Athens: MELISSA Publishing House, 1992.

Runciman, S. *Byzantine Style and Civilization.* Harmondsworth, England: Penguin Books, 1975.

Russack, H. H. *Deutsche bauen in Athen.* Berlin: Wilhelm Limpert—Verlag, 1942.

Samuel, Alan E. *The Mycenaeans in History.* Englewood Cliffs: Prentice Hall, 1966.

Schweitzer, Bernhard. *Greek Geometric Art.* Peter and Cornelia Usborne, trans. London and New York: Phaidon Press Limited, 1971.

Scranton, Robert L. *Greek Architecture.* New York: George Braziller, 1972.

Suetonius. *The Twelve Caesars,* trans. R. Graves. London: Allen Lane, 1979.

Terence. *Terence, Edited and Translated by J. Barsby,* 2 vols. Loeb Classical Library, nos. 22–23. Cambridge: Harvard University Press, 2001.

Thompson, Homer A. *The Athenian Agora,* 3d ed. Athens: American School of Classical Studies, 1976.

Tobin, Jennifer. *Herodes Attikos and the City of Athens: Patronage and Conflict under the Antonines,* Vol. 4. Amsterdam: J. C. Gieben, 1997.

Touratsoglou, Ioannis, and Eos Tsourti. "The Iliou Melathron: Its Owner and Architect," in *Coins and Numismatics.* Athens: Numismatic Museum, 1996.

Traill, David A. *Schliemann of Troy: Treasure and Deceit.* New York: St. Martin's Griffin, 1995.

Travlos, John. *Neo-Classical Architecture in Greece.* Athens: The Commercial Bank of Greece, 1967.

———. *Pictorial Dictionary of Ancient Athens.* New York: Frederick A. Praeger, 1971.

Vermeule, Emily. *Greece in the Bronze Age.* Chicago: University of Chicago Press, 1972.

Vitruvius. *Vitruvius: The Ten Books on Architecture,* trans. M. H. Morgan. New York: Dover Publications, 1960.

Ward-Perkins, J. B. *Roman Imperial Architecture.* New Haven, Conn.: Yale University Press, 1994.

Whitrow, G. J. *Time in History.* Oxford: Oxford University Press, 1989.

Wycherley, R. E. *How the Greeks Built Cities.* Garden City, N.Y.: Doubleday, 1969.

Yalouris, Nikolaos. *Olympia.* Paul J. Dine, trans. Munich and Zurich: Verlag Schnell and Steiner, 1972.

Index

About the Author

DR. JANINA K. DARLING is a lecturer in the history of art at the University of California at Santa Cruz, where she teaches courses in the art and architecture of Mediterranean antiquity, and representations of women in classical art. Her articles on Greek and Roman art, and related issues of gender have appeared in *Muse*, as well as in *Hephaistos, Critical Journal on the Theory and Practice of Archaeology and Related Fields*. She was a national lecturer for the Archaeological Institute of America, and leads tours to Italy, where she teaches Roman and Italian art and architectural history.